Bodies of Sound

Becoming a Feminist Ear

edited by
Irene Revell and Sarah Shin

SILVER
PRESS

CONTENTS

INTRODUCTION

A BOOK OF ECHOES

' I am concerned with the power of sound! and what it can do to the body and the mind,' Pauline Oliveros wrote to Kate Millet on 16 April 1973. 'Sound is everybody's material,' Oliveros continued. 'Women's music is inside women. The time has come to draw it out and see what it is. It might not take the forms that are all neatly trimmed up and available, guaranteed to trigger specific emotions.'

Thirty years later, Irene Revell was scouring the 'contemporary classical/avant-garde' sections in record shops for women composers and musicians. She was in her early twenties and interested in finding the most challenging or dissonant sounds while also being drawn to grassroots, oppositional politics, especially feminisms, via the riot grrrl era of the 1990s. Most important, she says, 'I felt that there must be some kind of link between the two.' Eventually discovering Oliveros and others, Irene became involved in Her Noise, a project exploring gender in historical and contemporary sound art practices. Through Her Noise, she came to understand the imbrication of feminism within Oliveros's philosophy of listening.

In the letter to Kate Millet, Oliveros explains her reorientation of the fundamental parameters of music as a feminist project. By making listening the locus of her composition, Oliveros collapsed existing paradigms of

composer, performer and audience; the individual and the group. This was as much a response to her feminist politics, emerging from a radical reconsideration of sound and listening, as her challenge to the notion of 'women's music'. Her work is open to a wider conception of sound and listening beyond music where 'sound is everybody's material'.

It was Oliveros that brought the editors of this book together in 2019. Irene recalls: 'Our very first meeting was at Cafe OTO, London. Sarah was hoping to publish what would become *Quantum Listening* and knew I had worked with Pauline in a feminist context. I found myself putting on a blazer and lipstick for the meeting. That is to say, this was an important meeting to my mind: what Sarah and her colleagues had done with Silver Press was so resonant to me. We shared the experience of forging independent feminist organisations, extra-institutional trajectories and infrastructures.'

For Sarah, Oliveros's synthesis of feminist, artistic, participatory and somatic practices in Deep Listening was inviting 'in its insistence on embodied practice and feeling, as a prefigurative method of collaborative re-patterning.' But, she says, 'I was just as, if not more, interested in meeting Irene, whose work with Her Noise and Electra I admired, and whom I knew as a "part-time punk" with an inherent DIY ethos suggestive of natural affinities between us.'

Four years later, we met again at Cafe OTO in November 2023 to continue the conversation that would become *Bodies of Sound*.

II

Get off the internet / I'll see you in the street

Histories and politics come together in sound and the embodied experience of listening. It is the body that struggles and survives, listens and speaks; it is the body whose value and vulnerability is at stake in our own autonomy, and in any collective struggle. What is Oliveros's power of sound in this context? What can it do to and for the body and the mind in, for example, war or memories of war, as much as in dreams, in art, in fiction, or over Zoom?

Since we started to work on this book, in the wake of the Covid pandemic, we have witnessed the escalation of genocide in Gaza, Sudan and Ukraine as well as far-right violence across the globe. Questions continue to arise around violence and peace; displacement and re-orientation; group work, internal work and anti-work; the means of production, infrastructures and technologies; the symbolic and the real; the quantum, boundaries and holding difference; ritual, prayer and healing.

What do thoughts sound like? What is sound, exactly?

How do sound, listening, speaking, writing, remembering, words, records and archives relate to one another? Can they be considered bodies of sound? What happens in transmission and translation?

How have sound and listening figured in the evolution of feminist thought? What feminisms have emerged from practices of sound and listening and vice versa? Are there spaces in-between, and who inhabits them? Why has there been no prior anthology of writings on feminisms, sound and listening, beyond music? Do feminist approaches in sound always foreground structural concerns?

What about praxis and playing? Can this book be used as a toolkit for making sounds, a manifesto for active listening?

Feminist Ears

Bodies of Sound gathers propositional, archival, instructive, experimental, queer and interstitial writing. This book is partial, not comprehensive, and moves freely across a variety of forms. Dialogues and letters reflect the inherently relational nature of listening and speaking, while essays perform the work of listening and memory in their composition as much as theory. Offering ways of thinking politically with the sonic, this book is a body of writings that will resound and sound differently in different readings – multiple bodies in a single volume.

In their vibrational exchange with Black Quantum Futurism, Karen Barad discusses the way they 'walk around in every sentence' as a practice of 'slowing thought down . . . against the grain of capitalism'. As a method against linear, capitalist time and colonial erasure, slowing down and walking around are entangled with other practices and bodies, such as listening carefully with feminist ears ('listening as learning about violence'), quantum listening to hold difference, sonic agency and earwitnessing.

Bodies of Sound is a book of echoes: mirrors, bells, tongues, doors, clocks, radios, archives, alarms and ears are recurring images. These motifs are heuristic, suggesting a method of reading. 'Can closer listening to echoes,' Annie Goh asks, 'in the context of sonic knowledge production, open up the . . . paradigms of the present?' By granting the echo agency, can we allow sound to transform us? This book is activated, made meaningful, by you, the reader-listener-pattern recognisant.

Reading with attention to shared patterns, symbols, experiences and concerns is listening with feminist ears.

Feminism, for Sara Ahmed, means: 'we are louder not only when we are heard together, but when we hear together.' Ahmed's 'becoming a feminist ear' – to listen to what is not or cannot be said – connects listening and collective action. As she wrote in an email offering us her words as the subtitle to this book, 'our feminist ears are shared!'

IRENE REVELL AND SARAH SHIN
LONDON, AUGUST 2024

Music from Memories
Ain Bailey and Frances Morgan
(2019)

'Ithink the way I compose is more about how I used to edit film,' reflects Ain Bailey. Specialising in film and video for her fine art degree in the early 1990s, she says, 'I used to edit celluloid, using Steenbecks [scanners] – using tape for sound and syncing it together, literally cutting and splicing.' Like most electronic musicians, she now splices sound digitally, but that painstaking, hands-on experience with analogue tape informs the way she pieces together samples in Ableton Live. Today Bailey is playing me an early version of a new piece, created using stems supplied by audiovisual artist Jockel Liess. In Bailey's composition, small details of Liess's ambient electronic sounds are magnified and reconfigured into rhythmic cells. Bailey says, 'I'll probably remove half of it, but it's good to build and then remove. That's how I normally work.'

I've come to meet Bailey in the ICA's studio space, a large, low-ceilinged room hidden away in the back of the Central London venue. When we meet, the sound artist, composer and DJ has just begun a month's residency at the ICA with the title 'Congregation', during which she will curate three events: a performance with Liess, a listening event that Bailey calls a Sonic Round Table, and a club night taking place that evening. All reflect her preoccupation with how and where listening takes place, whether that's in the edit suite, at home or on the dancefloor. Bailey explores a dynamic between public and private listening in which sound can be both intensely personal yet also

create community. While it's not unusual for sound artists to investigate listening as a concept, Bailey works directly with listeners, inviting them to share their associations with music and sound, creating spaces where new communal experiences can happen.

For Bailey, a lifelong Londoner, parties and club nights run by and for queer Black women have provided many such experiences. She can't quite remember her first DJing gig but says it was probably at Shugs, a club at the South London pub the Brixtonian. In 1898, Bailey and her friend Marilyn Clarke started their own night, Precious Brown, at the Candy bar in Soho. Shugs and Brown were part of underground queer events that also included the Sewing Circle at Brixton's Ritzy Cinema, which was co-founded by artist and organiser Ego Ahaiwe Sowinski, who is also one of the DJs at the Congregation club night. Bailey welcomes the chance to bring disparate friends and collaborators together for a party, especially now that so many of London's LGBT clubs and community spaces have closed down. For tonight's event, she has also invited Shenece Oretha, a young artist whom she tutored in a DJing workshop. 'I don't recognise anything she plays,' Bailey laughs. 'I feel old when I listen to her! But the way she plays is amazing.' Completing the line-up is DJ Levi, whose reggae and soul sets were a staple of the clubs Bailey attended back in the day. 'I always remembered how she rocked a party, and I thought, if I'm talking about my sonic autobiography then she has to be one of the people who plays.'

The simplicity of Bailey's notion of 'sonic autobiography' – that music and sound reflect and narrate our life stories – belies how powerful the listening sessions she hosts can be. 'It's just like, "play your song, what is the story in your relationship with that song or sound?" And that's why it's so magical,' she says. 'When people ask me to explain it, I

always say "Desert Island Discs" because we all know that, but it's not Desert Island Discs, because there should always be food and it's always a group of people. And it's durational – it goes on, hopefully, for a long time.'

Bailey first introduced the idea at a five-day residency at Wysing Arts Centre in March 2017. I was one of the ten participants and initially felt nervous about playing and speaking about the tracks I'd chosen. Yet, as histories of family, identity and, often, profound loss began to emerge, accompanied by sounds from our various pasts, I was struck by how natural it felt to share music and stories with people I barely knew. The residency formalised and made visible a politics of listening that many of us already enact instinctively in our communities and friendship groups, and showed how we might apply it in other, more public contexts.

Since then, Bailey has hosted listening sessions with groups including Micro Rainbow International, a London-based organisation that works with LGBT asylum seekers. For the Sonic Round Table at the ICA, she invited artists, activists and writers who have influenced her work. The line-up is, as she puts it, 'stellar', and includes sociologist Gail Lewis, artists Jimmy Robert and Sonia Boyce (with whom Bailey collaborated on the installation Oh Adelaide in 2010) and Amal Khalaf, a curator of projects at London's Serpentine Gallery. Despite the more formal setting, with the round table taking place in front of an audience, she predicts that 'it's going to be intense'. 'There are always tears,' she explains. 'I guarantee there'll be tears tomorrow. Because music has that power: if you have a deep association with a sound, it's not necessarily that it's traumatising, it's just the emotion that it can generate, it's like a wave.'

Throughout the listening sessions she has hosted, Bailey has found that the sounds and music that resonate the

most for people are often those that they associate with loss or grief. 'There's been a lot of death,' she reflects, with some understatement. Perhaps it's no coincidence that Bailey is exploring this subject in her art. For a solo show at London's Cubitt Gallery in May this year [2019], she is composing a multichannel work around the sounds that people associate with bereavement, while a new work to be shown at East Side Projects in Birmingham draws on Bailey's memories of her late mother.

As Gail Lewis puts it at the Sonic Round Table, 'loss and yearning' underpin many of the selections, which include songs by David Bowie, Brook Benton, Nina Simone and many others, as well as intensely personal recordings of family gatherings, religious rituals and various sounds that evoke home for the participants. Yet while Bailey was right about the tears, there are also joyful moments, such as when Sonia Boyce plays Louisa Mark's 'Caught You in a Lie', and a number of women get up and dance to the bittersweet lovers rock track. While Bailey's listening sessions tap into sadness, they also create a space to remember, reflect and move forward.

'I had no idea what was going to happen at Wysing because it was the first time I did it,' Bailey concludes. 'But having seen how it could work, and how it has worked every single time – that thing comes out, that intimacy, that sharing, that joy, actually. I just want more people to be able to experience it.'

How to Caption
Alison O'Daniel
(2022)

USE BRACKETS AROUND A DESCRIPTION OF SOUND.

DESCRIBE THE SOUNDS CLEARLY AND SUCCINCTLY.

CONSIDER YOUR CAPTIONS AN INTERPRETATION OF
MOOD IN SOUND DESIGN.

TRY TO MIRROR THE TIME THE SOUND TAKES UP
WITH THE AMOUNT OF DESCRIPTION:
[Quick, anxious bird chirps.] YES.

[A succession of quick, evenly paced, high-pitched,
anxious bird chirps.] NO.
(Thank you for the detail, but this can get really over-
whelming.)

DON'T BE TOO SUBJECTIVE:
[The phone trills like my grandmother's voice.] NO.

[The phone trilllllllls.] YES. Fun!

DON'T BE BORING IF THE SOUND IS EXCITING/DON'T
DESCRIBE WHAT WE CAN ALREADY SEE:
[A razor buzzes.] NO.

[Relentless, irritating drone.] YES.

TRY NOT TO BE CONFUSING. (It is hard to describe sound.)

'It is like a big ball of concrete falling into a metal well surrounded by seaweed.'
Tilda Swinton's character tries to describe a 'bang' that is haunting her in Apichatpong Weerasethakul's film MEMORIA (2021). After a sound designer struggles to recreate her sound, she says, *'It's earthier. Rounder.'*

It is a beautiful description, and her inability to perfectly describe it drives some of the story (swoon), but if you were to write this as a caption my brain would go into an imagining zone and away from watching your film. (It's one thing if your piece is about captioning and describing sound, and if it is, go for it, but if it isn't . . .)

Thank you for making the effort to make your work more accessible and for trusting me in asking me how to do this. Please consider making a donation to me or hiring me as a consultant.
Venmo: @Alison-ODaniel
PayPal (my email can be found here: alisonodaniel.com/ TOUCH)

If you are hearing, please understand that your description of sound is appreciated, but complicated for Deaf and HoH people, as the choices you make determine our comprehension of the work. Please consider hiring d/Deaf/ HoH folks who have experience in this as consultants.

If you are d/Deaf/HoH or rely on captions and have resources or more suggestions, feel free to share them with me and I'll add them to alisonodaniel.com.

Encouragements
Anna Raimondo
(2014, 2020)

WHERE

- Choose a few of your daily spaces – a coffee bar, supermarket, public transport, a bank in a square, a public garden – in which you can rely on a kind of proximity with other people, so that they can listen to you.

WHEN

- Any time, no matter the moment of the day, as long as there will be at least one person who could possibly listen to your conversation and with whom you could silently interact.

HOW TO PREPARE

- Make a list of the most influential women in your life, women that you may consider strong and powerful. Women that have, in a moment of your life, encouraged you to make something special, to feel stronger, to make an actual change or that have inspired you. This could be your grandmother, your mother, the wisest friend you have, the one who let you discover feminism, your gynaecologist, a theoretician, a special friend, your girlfriend and so on.
- Ask them to send you encouragements that they themselves have received from other women: these could be quotes or simple sentences that in a specific moment of their lives have had a significant impact,

made them feel stronger.
- Encouragements are very subjective and contextual sentences, don't be afraid, and recognise that they all are valid.

HOW TO PERFORM
- Using these sentences of encouragement as a starting point, compose an imaginary dialogue for a simulated telephone conversation that takes place while walking about in public space. Wear headphones.
- While performing this imaginary telephone conversation feel free to create physical proximity with the people you might cross. Sit close to them. If there is the occasion, look into their eyes, as if it were to them that you were speaking.
- Remember to speak louder in loud spaces and to speak softly when all around is silent.
- Use your hands and your body to accompany your voice while telling the encouragements.

Double Screen
(not quite tonight jellylike)
Anna Barham
(2013)

2

Have you ever tried to clean the square? First you reach your hand inside and trying to cope and pull – how disgusting. You cannot break the exact, it squelchy and green brown yellow juices it loses over your house. Type pieces of sinewy flesh and cyber squatting try to hold onto the screen, that as you hold on to our inexact remembering, twisted out.

Splat gigaflops onto the newspaper that I've carefully laid out in readiness, and it sits there, not quite inert, jelly-like and flaccid. But if you could use a way, I will pick up close to watch aquiver, electrosensitive paper and spread. Its total mass starts to deflate and even now it seems uncontainable.

The dances along letterforms occupying both the black-out blinds. Alphabetic shapes in the blank spaces that give the shape shape. I feel as if I might move, move into this mess. It improves the typeface no end – a bit of yellow gutsy stuff dangles over T, black quick scan makes its way down K, I might just slipped down. I squelched to and I'll stop – motion not my own. What is softened skin? I seem porous.

Squid guts bodying alphabet combine flatten out and joined together to enter into the flow. More images, more images, white noise. The alarms on the scaffolding going off again. Faint voices from upstairs – perhaps a siren. All

languages into the mix treating impressions driving by, witnessed by nothing in particular. All part of the flow. Stock image machine.

3

Have you ever tried to create a collective square region I'm trying to call a miscasting? You cannot really exact scorching green brown issues – interference-type pieces of silver, reflections, cyber squaring, trying to hold onto the screen. And you hold on to time. Exact remembering twisted out.

Splat gigaflops onto the newspaper. Carefully laid out in readiness and it sits there not quite tonight jellylike and flaccid. As if you could use a way out. I will pick up close to watch it over electrosensitive paper and spread. Total mess starting to play and even. Now it seems uncontainable.

Legatos along letterforms occupying both the black outlines off about shapes in the blank spaces that give the ship shape. I feel as if I might move. Into business improves the typeface no end, bit of your gut stuff getting over to you. Black quick scan makes its way down K. I might just slip down squelched. You and I'll stop motion that my water softened skin . . . Anyway, I seem chorus.

Script gaps bodying alphabet combine flat. Now been joined together to enter into the flow. More images, more images, white noise. VLANs on the scaffolding going off again. Feeling voices from upstairs, perhaps desirable languages into the next, training impressions driving back with nothing in particular. All part of the slow start image machine.

8

Have you ever tried talking squid? First to meet your hand inside and try to grip and polite. It's got to taking care not to break the link for it scorchingly brown yellow is is is

(is is is), over your hands – side pieces of symmetry flesh. Inside the square trying to hold onto the screen message, you hold unexacting and twisted out.

Splat google flops onto the newspaper that I carefully laid out in reading that interested my criteria. You like acid. As it feels a way I looked up close to watch it. Whatever it's witnessing sink into the paper and spread – it's done. All that starts to deflate and even now it seems uncontainable.

The dancers library lawn side. Your pain of the black outlines of alphabetic shades in the blank spaces that you should . . . Should I feel as if I like the business? Improves adults sitting around doing absorbencies, building council gigabyte roots town, late nineties. I might just log on, my squelched don't start. Last night my online southeastern – anyway I see well.

Square guts guardian the alphabet combine flat now. Enjoying together to enter into the flow and more images. More images, white noise, sunny scaffolding, colon. Colon: off again. Faint voices from upstairs perhaps assigning other images into the next fleeting impressions. Driving back with you you you you you you.

9

Anyone ever tried talking to meet you inside and tried to light? You cannot break regret – it's squelchy in the ground. You this is scissors scissors scissors your hair and pieces of symmetry slash. Inside the square, on the driving to hold onto the screen message, you two are in Sacramento and twist and shout.

Split google flood is used to dream that. I cheerfully laid out in reading that interested my criteria. You tested. As it feels the way I looked up close to watch it. What is the internet? The sentences are cheap and spread. All that starts to deflate. Latencies now seem uncontainable.

Sounds like they want your opinion of the blackout blinds of alphabetic sheets in the blank spaces that interested. I feel as if I like more and move into his. Maths improves, it is no end of the yoghurt taste of the angles. Already black quick scan makes a downloaded library. I might just let down by squelched original. Motion not my own. What is self-antigen anyway? I seem porous.

Whereabouts guarding the alphabet online. Flat now, enjoying together to enter into the slope and more images. More images like nice sunny scaffolding. Again strange voices come upstairs, perhaps a solar image into the next. The compressions driving back nothing particular. All part of the file. Image machine.

11

In reply to clean display at first you read your hair decided to write a break and call out to start attraction. Not totally clear that. It's quicker the story through the yellow roses. Is it? Does everything that happens consist of simulations I displayed? Try to hold onto the story mess as you will, not too hard. The internet – remember it without.

Still flat science using speech recognised. Totally redone to read instead and it fits they're writing jellylike bimetallic noise. As if it could end the way. I look at it up close to watch quicker. It's what this thinks into the paper and spread. Turn around, start today, for you leaving seems uncontainable.

Regards to one letterform occupying both the black outlines of the bed sheets in the white spaces. Naked, shifting, I feel as if I'm like more into this mass. Improves the typeface getting theory test. Routine lacks script that downloading I might just scratch my motion back now. What yourself pensive and anyway I seem voiced.

Square Kakuro Mania alphabetised my flat. Now been

joined together to enter into the floor. More images, more images and white noise signing scaffolding again in voices from upstairs. Perhaps the desiring images into the next sleeping impressions rising. They are saying anything in particular, and apparently they follow him to receive.

The above are excerpts from the script of Anna Barham's eponymous two-channel video work. A passage from the essay 'Image Machine' — by curator/theorist Bridget Crone that 'explores the way in which body and image might merge together . . . culminat[ing] with the narrator morphing into the squid that she is the process of cleaning' — is read aloud and processed through voice-recognition software to produce a version of the original, a 'mis-copy' of sounds. Subsequent versions are then edited together, re-vocalised and re-processed, over and over. Through this continuous (re)production the words expand beyond their initial meaning and intention.

On the Sound of Reaching to Touch
Anne Bourne
(2021)

The first time I experienced seeing sound, or knowing the sentience of an object, was the day I followed IONE into the colonnade at Saqqara, the 'Temple of Sound', in Egypt. The temple was not yet completely restored or assembled. IONE turned to me and smiled, whispering, 'He's here.' She motioned towards Jean-Philippe Lauer, the architect who made it his life's work to restore the architectural identity of Saqqara, excavating hidden chambers lined with blue faience tile. We were witnessing an architectural transmission: to recreate form, defy time.

When I followed IONE through the colonnade of pillars that morning, I was walking through a choir. My senses moved between that which appeared to be fixed matter and a shimmering assembly of particles of light and sound. I could know the song through proprioception, epiphany within reach.

Perception of the colonnade in the temples at Saqqara and Luxor: the pillars are incrementally reaching for each other. I received this impression from Jean-Luc Nancy speaking about the interior body: 'Touch is the approach, whether gentle or strong. It is the approach and the receding motion, and so in fact touch is always happening, in motion towards or away from the gesture of completion.'

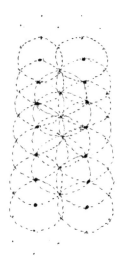

Phonons – the smallest units of the vibrational energy that make up sound waves – are not matter, they can be considered to be particles the way photons are particles of light. Hearing songs of ephemeral architecture and the intricacies of time in dimensional space, I began to draw: in particles of sound, the microtonal detail of sonic fields.

Inside Saqqara, I was captivated. How was I able to listen through the hidden door? Entranced by encoded frequencies, in concert halls and opera houses where I performed, I would look for the hidden doors in the ceilings to send sound through to other times and listeners.

These drawings are my maps.

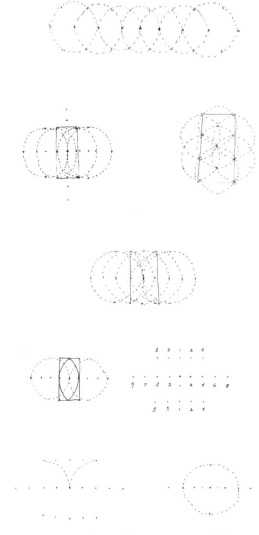

Drawings from journal entries between 1997 and 2010.

Earth, Wind and Fire: Annea Lockwood interviewed by Jennifer Lucy Allan (2021)

New Zealand-born composer Annea Lockwood's most recent composition 'For Ruth' (2023) is a reply to 'Conversations '74': a love letter on tape sent to her by her late partner Ruth Anderson in 1974. In 'For Ruth', affectionate conversational fragments, loving affirmations and the bubbling laughter of two people giddy for one another are embraced by field recordings of rich birdsong, grumbling frogs and passing cars, as well as resonant vocal intonations, which sound like the tintinnabulation of struck metal. The few complete sentences that surface contain an exchange that is a sort of found poetry on the feeling that the world has become whole through partnership with another person.

Lockwood met Anderson in 1973, when she was hired as cover at the electronic music studio Anderson ran at Hunter College in New York City (one of an estimated three women in the US at that time to have designed and run her own studio). Anderson had asked Pauline Oliveros to fill in, but Oliveros was also on sabbatical at the time and suggested her friend (the then) Anna Lockwood, who was living in the UK. 'Ruth called me up one evening, got me out of the bathtub, and offered me a job in the US,' she tells me over video call. 'I jumped at it. I'd been dying to get over to the US. I went to New York, met Ruth, then a week later she invited me and my then partner Harvey Matusow to visit her in New Hampshire. Ruth and I just

fell in love in those three days. She was wonderful, a light-some personality, wise and kind, and most generous, so of course, I fell in love with her right off the bat.'

After that, they started calling each other regularly, and Anderson began taping their conversations, which she spliced into a gift – a jocular love letter – to Lockwood. 'Conversations '74' is a quick-cut collage of mostly non-verbal parts of their exchanges – sneezing, sighing, greet-ing, questioning, giggling – intercut with some lolloping detuned barroom piano tunes, sloppy with delay, or per-haps drunk on love. 'We said, "Oh, we can listen to this together when we're old", but we never did,' Lockwood says. Ruth Anderson died in November 2019, before the release of *Here*, her first full-length album (on the label I ran, Arc Light Editions).

'The two pieces are bookends to Ruth's and my long marriage,' Lockwood tells me. She agrees that 'For Ruth' is the first love song she composed in her long career, which includes work she says is often about the transfer of energy. She has made music with glass; documented rivers from source to mouth; burned, submerged and buried pianos; *permanently* prepared pianos with plastic lips and bubble machines; incorporated poetry by Etel Adnan and Guantánamo detainees, and composed for choir, trumpet, gongs, didgeridoos and other instruments. She approaches sounds with open arms and is curious about their operat-ions, paying them acute attention. While she is a known figure in avant-garde circles, the last decade has brought more widespread attention to her work, which has new resonances in a time of climate crisis.

Annea (originally Anna) Lockwood was born in the summer of 1939 in Christchurch, New Zealand. She stud-ied piano and composition, and moved to London in 1961 to study at the Royal College of Music. She studied

electronic music, but wasn't satisfied: 'It was fun to put sounds together with massing oscillators, and filters and ring modulators,' she says, 'but the sounds weren't intrinsically interesting to me . . . So rather than make myself figure out ways to do that – which of course with granular synthesis and so on, has been beautifully done – I switched to another domain of sound.'

Lockwood began thinking about how to present audiences with a single sound source and asking them to, 'treat it as a miniature composition, and hear how complex and interesting its internal structure could be.' She wanted a material that people didn't have instant associations with: 'If you couldn't identify a sound, it would hook you in,' she reasoned. The glass concerts were Lockwood's first, formative sound works in which she worked solely with glass. They were part art installation, part composition – early performances took place at a London venue called Middle Earth. They were resonant, crystalline and shattering – made with goblets, glasses, bulbs, rods, micro glass for scientific uses, a bottle tree and great panes suspended in the performance space. To stage these shows, she contacted glass manufacturers Pilkington. 'I wanted to see not only the finished products, but the debris, and the processes,' she explains. 'I made several trips back and forth to their various factories, and they would just let me take whatever I wanted, and would find stuff for me that I might be interested in. I did a number of glass concerts and travelled with it by boat at one point, and they made these beautiful wooden cases for the big glass panes and the glass rods to travel in. They were so good – Pilkington were big enablers!'

The 1970 album of these works was made over the course of two years, mostly at night in the basement of a church in North London. Today, the glass concerts might

be assumed novelty by anyone who hasn't listened in full, but Lockwood says this did not figure at the time: 'I was working in a world in the late sixties in which – in all the art forms, really – we took for granted that we could work with any material in any way we could imagine.' She tells me they were, 'really the soil out of which absolutely everything else has come.'

Soil is perhaps an appropriate metaphor for some of the works that came after, such as 'Piano Garden' (1969-70), one of her Piano Transplants. The first Piano Transplant was a permanently prepared piano made in 1967. 'I'd been playing some of Cage's prepared piano pieces and had an old upright. I remember thinking about how Cage always had to take those preparations out of the piano, dismantle them after every performance, so I started imagining what you could do with a piano – what you could put inside it, attach to it, resonate from it – if you were not worried about preserving perfect tunings. And I like playing, and I like absurdities, so I started concocting all sorts of possibilities to permanently prepare a piano.'

The second piano transplant was 'Piano Burning' in 1968, prompted by a practical impetus not a destructive one – Lockwood needed to record the sound of fire for another project, and bonfires, hearth fires and other attempts had failed to produce any interesting sound on tape. She knew there was a place in London where she would find discarded pianos, and Bob Cobbing had asked her if she'd like to do something for a festival he was putting on along Chelsea embankment. She suggested a piano burning: 'as a recording, it was totally useless – [but] people just were magnetised,' she says. 'What was astonishing was how beautiful and strange it was. So, it became this curious hybrid: a visual, conceptual and audio event.'

The next was 'Piano Garden', in Ingatestone, Essex,

where Lockwood was living at the time [There are now additional Piano Gardens in Llanrwst, Wales; Rathmullan, Ireland; Caramoor Center for Music and the Arts in the US and in Luxembourg at the European Courts of Justice]. 'It was about me wanting to watch the contrast between the delicacy of young plants pushing up and working their way into the heavy, strong construction of something like a piano, pulling the piano slowly apart,' she explains. 'I love the contrast between delicacy and the tremendous strength of plant energy. I wanted to watch that happen. But then there's always playfulness involved, so one of them was sunk at the same angle as the Titanic went down, and a little grand piano was set up near the gate, and as we were on the lane from the station, people would wander in when they got off the train and play a few notes.'

She also sank a piano in a cattle pond in Texas for 'Piano Drowning' (1972), and then there was 'Southern Exposure' (1982), where a grand piano was beached (a composition renamed according to where the beach faces). When this was realised in Perth in 2005, the piano was set out but by the next day had disappeared. 'A bunch of backpackers had been walking along the beach, come across the piano and decided to rescue it,' she says. 'So they picked up the piano, carried it back to their hostel, stuck it under the TV and set about restoring it with linseed oil!' We both laugh at this story, of someone making away with the installation, and I am struck by the playfulness and exploratory feel of much of her work – that there is no preciousness about how work should be interacted with, and this generosity as a composer filters out to her audiences.

This is also evident in her excitement when we discuss a current series of events at Issue Project Room in New York, in which a group of musicians and artists have

responded to *Women's Work*, a magazine of scores Lockwood published with artist Alison Knowles in the seventies. It included unconventional scores and contributions from artists such as Christina Kubisch, Mary Lucier, Pauline Oliveros, Carolee Schneemann and others, and was intended not as an archive, but as something to pick up and do. Lockwood says the prompt was wanting to push back against the fact that, 'work by women artists was not being made room for as it should have been: it was not as not prominent as it needed to be; was not on an equal footing.' They assembled *Women's Work* with women artists they knew and whose work they cherished, 'with a view to asserting: this is what women do, this is women's work.'

Perhaps Lockwood's largest scale works are her river pieces, which began in the eighties. She had begun building what she called the River Archive: her own recordings of rivers and streams, plus those friends brought back with them from their travels to places including the Himalayas and Massachusetts. 'I've loved rivers all my life, I grew up with wild rivers . . . I'd become interested in why we're so drawn to them. I already knew or had a feeling I wanted to work with them because their textures are so complex, and constantly shifting. They stimulate the mind on at least a couple of levels, and I wanted to explore that. Is the sound of moving water particularly nourishing? My suspicion is it is.'

Lockwood has also made long-form recordings of the Danube and of the Housatonic. Both are also installations; the latter has a map and clock timer, so you can trace your route as a listener down the river. To sit and experience one from start to finish is to be struck by the breadth and complexity of the sounds of water. She does not idealise these environments, nor are they just documentations –

she composes with the sounds like a documentary photo-grapher composing a photo. They contain political elements – particularly in the Danube, which she recorded between 2001 and 2004 – but can also be humorous. At one point in the Danube recordings, there is an intentional and hilar-ious quick cut to a particularly vocal flock of sheep.

Since the late eighties, Lockwood has written more reg-ularly for instruments than objects – although she might not appreciate the distinction, being more concerned with sound as a transfer of energy than such categories. There are often tape works within her compositions, and she tends to work collaboratively. The prepared piano piece 'Ear-Walking Woman' (1996) was made with Lois Svard; 'Thousand Year Dreaming' (1990) with a collection of musicians explored the acoustic interplay between instru-ments including conch shells and didgeridoos; 'Becoming Air' (2018) was a more recent collaboration with trum-peter Nate Wooley; 'Into The Vanishing Point' (2019) was composed with the quartet Yarn/Wire. If this sounds like a turn towards more conventional composing, it's not. 'Jitterbug'(2007) uses photographs of rocks as graph-ic scores, the images shot by Gwen Deely and the rocks pulled by Lockwood from a creek bed in the Montana Rockies. Musicians play against a fizzing backdrop of aquatic insects. 'I've been interested all along about how sounds affect our bodies, because of course they do,' says Lockwood. 'Pauline was simultaneously interested in that – it was one of the things which got us corresponding in the late sixties/early seventies. You move from awareness of – and preoccupation with – how sounds affect our bodies, into how that might create a web of connection with the external world – with the natural world.'

The ecological aspects of her work she says have become more explicit in recent years, and more present to her as a

composer. 'Where I am now is that I feel that sounds affect our bodies so strongly. We're not necessarily aware of the entire range of those effects, but they're there: our bodies are responding,' she says. 'That's a connection to the source of the sound. If you can focus on how you feel in response to hearing something from the environment, and then become aware that you feel connected to it, you can move into a state where you don't feel separated from that phenomenon. That strikes me as the actual reality – that we are not in any way separate, however much we've been trained to think of ourselves that way.'

This knowledge does not just come from Lockwood's explicitly environmental compositions. 'For Ruth' represents not just a reply (and a farewell) from Lockwood to Anderson, but also offers a web of connectedness, a piece in which the 'huge mutual recognition' she said she felt the moment her and Ruth met unfurls as a recognition of the connectivity between all of us and the world around us too, in loving sighs and affirmations, singing birds and sung tones, and even the grumbling frogs of New Hampshire. 'I don't have plans for new work. That could be because making 'For Ruth' was an act of completion in many respects, including in relation to my work,' she says. 'I owe her so much. She transformed my life.'

Echoes of Elsewhere
Annie Goh
(2023)

How can the echo be granted agency beyond its dominant conceptualisation in patriarchal Eurocentric histories, and instead be realised as a feminist and decolonial material-semiotic sonic figuration? Can closer listening to echoes, in the context of sonic knowledge production, open up the existing narrow hegemonic epistemological paradigms of the present?

An echo is typically understood as a recognisable repetition or imitation of an event, utterance, idea or thing. In common parlance we might say an event or opinion 'echoed' another. For acoustical engineers, echoes are generally deemed a nuisance, unwanted aberrations of built environments, to be avoided wherever possible for their disturbance of sonic clarity with terms such as 'echo control' and 'echo suppression'. Echoes and reverberations pervade our everyday sonic experiences. In architectural acoustics, they provide us with our sense of space as we move through our surroundings: sound reflections provide us with information about the size, location and surface materials around us. Acoustics can determine atmospheres and these relations are culturally specific, such as the 'awe and reverence' one might feel in a reverberant cathedral, affecting the mood and behaviour of people in those spaces.[1] Sometimes, when landscape or architecture enables sound

[1] B. Blesser and L. Salter, *Spaces Speak, Are You Listening? Experiencing Aural Architecture*. MIT Press, 2006, p. 3.

to ricochet across a space in an unusual manner, echoes become curiosities which cause us to stop in our tracks, and shout, clap or sing.

Echoes in a broader cultural sense often appear as a feminised, enfeebled reproduction of an original entity. Most famously, in Ovid's *Metamorphoses*, Echo is a nymph whose excessive chattering and noisy deception of the goddess Juno has led to her punishment. She is bound to only repeat the words of others. After falling in love with Narcissus, Echo cunningly converses with him by repeating his own words back to him. Narcissus rejects Echo's declaration of love and she subsequently withers away to become a disembodied voice in the mountains. This quintessentially Western myth, demonstrating many traditional binaries such as masculine/feminine, visual/aural, controlled/excessive, agential/agentless and so on, offers a useful characterisation of Echo in the Western imaginary. She lacks agency and originality, she is a mere unfaithful and deceptive repetition, who does not succeed on her own terms. Her imitation of Narcissus's words is sly but desperate; her sexual desire brings about her demise (as does Narcissus's self-love).

I want to emancipate Echo from the limitations of this dominant understanding of her as a tragic victim of failed heterosexual desire. Re-inventing Echo means searching for new meanings created by echoes, in which acoustic repetition is more than a deceptive strategy, and more than a mere acoustic curiosity. What happens when we clap or shout and listen for its echo? Is this repetition only to be understood within an epistemological framework of physical causality?

In addition to addressing what an echo is, or has been, and how it has been represented, what does echo *do*? Following Gayatri Chakravorty Spivak's deconstructive read-

ing of Ovid's story, I posit Echo as a subaltern figure, able, despite prevailing conditions set by patriarchy, colonialism and capitalism, to gain agency within repetition to subvert and transform.[2]

Echoes understood as material-semiotic agents, to read through Donna Haraway, connect acoustic materiality with sonic signification. Echoes as entities that morph between physical materiality and semantic-semiotic networks can be explored as a way to disrupt not only dominant ocular-centric cultural readings, but also as an agency for transforming conceptions of knowledge as such.

The echo has been a significant and guiding motif in my thinking and approach to the field of archaeoacoustics or acoustic archaeology. I am not an archaeoacoustics researcher, however, I spent several years researching the field in order to understand how knowledge is produced through sound and listening. My journey through archaeoacoustics started by tracing echoes along lines of science and myth, including fieldwork in Isturitz and Arcy-sur-Cure in France to Chavín de Huántar in Peru. If the white European, masculinist knowledge of Western philosophy and science, which has borne both archaeology and acoustics, has thus far 'produced' echo, what can echoes do when conceived in critical opposition to this? What 'elsewheres' can echoes open up for knowledge itself?

In early July 2018, I joined archaeoacoustics researcher Dr Miriam Kolar's research expedition to Chavín de Huántar. The three-thousand-year-old ceremonial temple complex, located over 3000 metres high in the Callejón de Conchucos valley in the Ancash region of the central Peruvian Andes, is one of Peru's most famous archaeological

[2] G.C. Spivak, 'Echo'. *New Literary History*, vol. 24, no. 1, 1993, pp. 17-43.

sites, designated as the National Monument by the Peruvian Ministry of Culture and a UNESCO World Heritage Centre. Kolar, who had generously invited me to observe her work, has undertaken extensive and highly regarded archaeoacoustic research at Chavín de Huántar as well as at various other places such as the Inca site Huánaco Pampa, also situated in the Central Andes.[3]

The opening of the archaeological season was marked by the American lead archaeologist of the research programme, John Rick of Stanford University, Associate Professor of Anthropology, Emeritus, at Stanford University, and Rosa Mendoza Rick, his wife and a Peruvian archaeologist. That morning, the gathering centred around the Pachamama ceremony and giving thanks to Mother Earth, led by the Indigenous community. After we had all introduced ourselves, two senior male members of the group led a ritual which summoned the four cardinal points and the traditional principles of Andean cosmology – Water, Earth, Sun and Moon – making reference to the colossal mountains which flank the site. Each member of the circle was offered coca leaves, a plant used in traditional Andean cultures as a light stimulant. Some participants moistened a few of the leaves in their mouths before they walked to a designated stone in the centre of the circle and placed one or more leaves on each of the four cardinal points which had been marked out by the two ceremony leaders. Offerings of alcohol and cigarettes were also handed around, and the two men took swigs from the bottle and forcefully sprayed the liquid from their mouths high into

[3] M.A. Kolar, R.A. Covey and J.L. Cruzado Coronel, 'The Huánuco Pampa Acoustical Field Survey: An Efficient, Comparative Archaeoacoustical Method for Studying Sonic Communication Dynamics'. *Heritage Science*, vol. 6, no. 391, 2018.

the air, attending to the four directions in turn.

Rick's overall body of work on Chavín focuses on its rituals and the development of authority at the site. As a temple complex, it is supposed to have been the scene of important religious ritual activity, evidenced in the form of processions depicted in elaborate engravings.[4] Rick's summary of geoarchaeological studies highlights Chavín's location in a mountainous valley at the conjunction of two rivers, with an astronomical alignment with the summer solstice, which he deems: 'unusual features of potential ritual and strategic importance'.[5] Rick's work points to evidence of 'shamanistic' practices as part of ritual activity at Chavín, with indications of processional movements in the iconography and the pathways and architecture of the complex linked to the depictions of psychoactive drug use in art and paraphernalia at Chavín.[6] He suggests that highly planned rituals took place, which manipulated human minds through means including landscape, architecture, images, sound, light and the use of psychoactive drugs. These he interprets to be part of the evolution of power and authority and the convincing of populations to accept the dominance of a 'priestly' leadership based in Chavín.[7]

When Rick's team excavated twenty Strombus-shell 'trumpets' in Chavin's Galería de las Caracola, its status as a music archaeological or sonic archaeological site of significance was cemented. The discovery of these intact *pututu*

[4] J.W. Rick, 'Context, Construction and Ritual in the Development of Authority at Chavín de Huántar', in W.J. Conklin and J. Quilter (eds.), *Chavín: Art, Architecture, and Culture.* University of California, 2008, p. 20.

[5] Ibid., p. 8.

[6] Ibid., p. 33 and pp. 20-23.

[7] Ibid.

horns, most of them engraved (some of them extremely elaborately), 'highly use-polished', showing extensive handling and use-wear patterns (such as worn-down mouthpieces), and found deposited in a room – suggesting the room to be a specific storage location for this purpose – all established beyond doubt that the horns played an important ceremonial role.[8] Fragments of other shells were also found there, indicating that a minimum of nine more shells were present at the time of publication in 2008.[9] This was significant in the history of excavations at Chavín, being only the second time that substantial and intact objects had been recovered on-site.[10]

Rick and his team were well aware of the possible powerful use of the *pututu* as sound-producing devices in the ritual context:

> When played together, the shells not only produce an immense volume of noise, but their tones interact to produce a cyclical, attention-commanding beat. If they were played in performances with twenty or more shells within the sound-reflecting walls of galleries or the Circular Plaza, the sound may have had a major, even physical impact on the listeners and may represent an important technique for creating an ambiance for rituals related to religion, power and authority.[11]

With this knowledge of the site in the background, Kolar and a group of students devised a few different acoustical tests using the *pututus*. Alongside these, in

[8] Ibid., pp. 24-27.

[9] L.G. Lumbreras and H. Amat, 'Informe Preliminar Sobre Las Galerias Interiores de Chavín (Primera Temporada de Trabajos)'. *Revista Del Museo Nacional*, no. 34, 1966, pp. 143-97; L.G. Lumbreras, Chavín: Excavaciones Arqueológicas, Lima, Universidad Alas Peruanas, 2007; J.W. Rick, 'Context, Construction and Ritual', p. 24.

[10] J.W. Rick, 'Context, Construction and Ritual', p. 24.

[11] Ibid., p. 26.

Chavín's Doble Mensula gallery, we informally experiment-
ed with the space. The architecture consisted of narrow,
rectilinear corridors linking small chambers with long
ducts, around waist height, that cross-linked the spaces. As
a group, we had discussed the performativity of such rituals
and the creation of a spectacle through manipulating
sensory experience, as theorised by Rick – perhaps playing
on dynamics of presence and absence, disappearance and
re-appearance, with the movement of human bodies
through the galleries from the open spaces of the Plaza
Mayor and Plaza Menor. We arranged three pututu players
to play and simultaneously walk in procession through the
corridor of interconnected rooms, which forms a pathway
of some dozen metres from the furthermost point to the
gallery staircase and entrance.

The result of the mobile sonic improvisation was an ex-
tremely powerful bodily experience. The volume of the
three pututus, sounded simultaneously, reached in excess
of 110 decibels at times; in recordings, you can hear the
microphones clipping as a consequence of the extreme
volumes. Being visually isolated from other members of
the group in the darkness created a fairly claustrophobic
atmosphere. Acoustically, however, the gallery's chambers
were, in contrast, deceptively expansive, transmitting
sound fairly well along the long, narrow, horizontal ducts
that connect certain rooms to one another, and in some
cases stretch several metres, leading through small, window-
like openings to the outside. The two players of the two
larger pututu played long tones as they walked through the
gallery, while the player of the smaller pututu played short-
er, rhythmic bursts of sound. The long tones, similar in
pitch, of the two larger pututus created an acoustic inter-
ference pattern known as a 'beating-tones effect', while
the shorter tones were physically aimed against different

elements of the architecture.[12] This had a disorientating effect, as the perceived direction of sound was constantly shifting in space. The drone effect of the improvised procession of the three *pututus* created a thick, numbing intensity on my body and ears.

During one of the formal experiments, Kolar and the students researched the transmission of sound around the outdoor plazas of the ceremonial site, undertaking a series of tests on the main plaza using four *pututu* horns played at different locations. Given the symmetries at the site, we decided to place a *pututu* player in each of the north, south, east and west corners or staircases of the main terrace or Plaza Mayor. The measurements we took included humidity, wind speed, temperature and GPS location, as well as multiple decibel meter readings per position.

After twenty 'takes' of these experiments, we'd heard each of the sounds many times, ricocheting around the plaza and the surrounding mountains. To our amusement, donkeys in the nearby fields had been braying 'in answer' to the *pututus* being blown. The sound of the donkeys was fairly similar at times in pitch, tone and timbre to the horns. Along with all the other background noises, it was a challenge at times to discern them from one another. Kolar remarked: 'Was that a donkey or an echo?', a slightly bemused but genuine question. Some of the echoes were extraordinarily long: a powerful sustained burst of the *pututu* horn could produce an echo whose 'tail' seemed to glide off gracefully from the temple complex outwards into the valley, weaving off into the mountains.

[12] M.A. Kolar, 'Pututus, Resonance and Beats: Acoustic Wave Interference Effects at Ancient Chavín de Huántar, Perú'.
The Journal of the Acoustical Society of America, vol. 136, no. 4, 2014.

Within archaeoacoustics, I propose echoes to be a way of opening up the epistemological strictures of the hegemonic 'here', of the dominant patriarchal, colonial and capitalist contemporary. I ask how echoes might indicate a political-philosophical 'elsewhere', of the kind Haraway recurrently refers to as a quasi-utopic but seriously considered alternative imagining of the present, as well as the past and future. Proposed as a decolonial, feminist and anticapitalist figuration, the echo can be understood to mediate to an alternate conceptual space. Thinking of the subaltern echo that locates the possibility of exercising agency within repetition to subvert and transform, an echo can be conceived of as a figure that helps us to think beyond the many binaries known to persist in Western thought. In particular, the self/other binary becomes important in these considerations of what echo can offer.

If an echo is commonly regarded as a reflection of a sound, as a separate sound event, what constitutes the establishment of this difference in sound? If one hears the reflected sound and can identify it as a version of the same sound, re-occurring with a temporal delay (usually this has to be more than a tenth of a second), it is 'different' ontologically only due its temporal delay: it is ostensibly 'the same' sound, but delayed. However, there are instances in which the echo of a sound is, phenomenologically, a completely different sound.

An example is the 'chirping echo' heard at the Mayan-built pyramids at Chichén Itzá, Yucatán, Mexico, which resembles the sound of the Quetzal bird.[13] This phenomenon has been acoustically measured and explained by acoustician David Lubman, a colleague of Kolar's. It is possible to hear these 'chirping echos' on Chavín's main plaza, reflecting off its staircases of substantial height, as we tested successfully during my visit. In this sonic

experience the original sound, for instance the sound of a clap, bounces back with a noticeably different frequency spectrum, changing the frequency and timbre of the expected, 'reflected', original sound. In instances such as these, where the reflected sound deviates substantially from the known 'original' sound. Rather than being 'the same' sound delayed, the echo could plausibly be attributed to an 'other' being. Even if a causal relation can be determined phenomenologically – the clap is needed in order for this 'other being' to emerge – a palpable ontological difference is discernible. Whether the echoed sound is considered 'same' or 'other' is one potentially significant way in which echoes in archaeoacoustics are constructed, revealing the narrowness of Eurocentric sonic knowledge production. Herein, we may begin to hear a decolonial echo.

Returning to Kolar's amused but genuine question of whether the sound was a donkey or an echo, the ontological status of the echo can be brought completely into question – was it a reflection of a known originating sonic event? Or was it the response of another, nonhuman, animal or spirit being, who was responding to this human-produced original sonic event? Or was it a coincidental sonic event, with no causal relation to the sounds we, the on-site humans, were producing? Or was it something else? A sonic human-non-human relational event beyond our current comprehension? An echo, shrouded as it is in opacity and secrecy, sits in this ontological in-betweenness around how difference is conceptualised: of what constitutes 'same' and what constitutes 'other'. Maintaining this

[13] D. Lubman, 'Archaeological Acoustic Study of Chirped Echo from the Mayan Pyramid at Chichén Itza'. *The Journal of the Acoustical Society of America*, September 1998.

space of unknowing is perhaps part of the condition of understanding how the echo can be mobilised as a decolonial feminist figuration. An echo might not presume a sovereign, contained, enclosed individual unit of the human subject, rather it can be a figuration which opens up questions beyond well-known ideas of subjectivity. Self and other are brought into question by the echo.

An echo, construed of affectively, such as the chirping echo or the donkey echo, is a perpetual question mark of differential relations, and serves to blur the boundaries set by the hegemonic orders of patriarchy and coloniality. As a figuration of difference, of potential onto-epistemological upheaval through its appearance as a material-semiotic actor in contemporary archaeoacoustics which relates to pasts – as 'elsewhere' to our present 'here' – an echo enables this constant push, as a reminder of what kind of elsewhere one might want to deploy it for. And what might it mean, if Echo could *be* on her own terms?

A New Form of Sound Writing
Aura Satz interviewed by
Barbara London
(2021)

Barbara London: I'm fascinated by how your work navigates the space between – and the crossover of – human and machine. It seems to me you're constantly exploring perception, the body and the great beyond. You told me about your peripatetic childhood. How did that contribute to your practice?

Aura Satz: I'm not really sure if it did in any specific way. I had several very strange formative acoustic experiences as a child. I had multiple ear infections and I used to hear my heart amplified really, really loud. I visualised it as a monster that was coming for me. Other times, I'd hear things as if they were replayed and really slowed down. Those little moments of doubt around what I was hearing – whether something was inside or outside, and whether it was in sync with reality, were perhaps central to my interest in a kind of slipperiness around embodied experience and objectivity, and the sensory interface with the world.

BL: You began your career making sculpture and photographs, doing performance and making films using archival footage of magicians. Why does the idea of misdirection interest you?

AS: In some ways that follows on from those alienating lived experiences. If you think of film sound, when things

are out of sync, or a film voiceover has been dubbed, there's a similar kind of misdirection between what you're hearing and what you're seeing. There's something about the friction between sound and image, especially when they are asynchronous, that pushes the edges both perceptually and cognitively. It might have started with a work I did around magic, but it culminated in 2012, when I made In and Out of Sync with the optical sound recorder of a 16mm film camera, collaborating with the filmmaker Lis Rhodes. I had been making works that were visualisations of sound, or sonifications of the visual, and suddenly this work hit home. Something else happened in the slippage – when the sound-image wasn't seamless. It takes me both deeply into my body and totally outside of it. It makes the boundaries of self and not-self porous. And that has all kinds of other implications, not just on a physical level, but also conceptually, philosophically and ideologically.

BL: We could say that there are two major strands to your work: One is music, sound, technology, vibration and acoustics. The other has to do more with gender and the contributions women have made to new technologies. I understand you began working with sound in 2002, when you were pregnant and you were using your belly as a kind of instrument. The resulting artwork was Ventriloqua [2003]. The pregnant you became a musical instrument, a channelling device. Could you tell me something about how you connected ventriloquism to the very mysterious theremin instrument?

AS: The theremin is an instrument you play without touching. Unlike the piano, where you have a keyboard, the theremin uses an electromagnetic field, and you move your hands near a rod, as it were. You have to find the

pitch, and then whatever your starting point is, you build up a keyboard equivalent in this way. There's a very intuitive bodily way of interacting with this invisible field, suggestive of colloquial hand gestures or sign language, and a whole range of other linguistic forms that aren't vocal or written or even musical notation. I've made several works with the theremin, I still find it really fascinating.

When I was pregnant, I had this powerful experience of understanding myself as a vessel or a container for another voice, which amplified this porosity between inside and out, between self and non-self. It's like I was possessed, not in the horror film kind of way, but literally I had another body inside of me. What was interesting was to try to think beyond being this mother figure, or image of fertility. It wasn't really about procreation, as much as containing other voices. The ventriloquist dummy is precisely that; a trick, a misdirection, a voice through a dummy or doll. That said, originally, throwing one's voice wasn't necessarily connected to an object, so long as it appeared to be detached in such a way that it didn't seem to be coming from its source.

That slippery sense of where the voice sits is ultimately how sound operates acoustically. It's already inside of me, emanating from my body, but it's also hitting the walls, absorbing the acoustics of the room, going through a sound recording device or telephone, a telepresence elsewhere. There are lots of ways in which the voice is already doing that, but it seemed to me particularly interesting during pregnancy. I literally had this other voice inside of me. I was an antenna that could be tuned into in order to manifest it, to bring it into speech. The otherworldly sounds that are produced by the theremin suggested this notion of a possible language that doesn't completely resolve itself as language.

BL: I'd like to know more about what drew you to older technology, certainly the theremin as an instrument, but the record and the grooves is another aspect.

AS: Mechanical music and the phonograph are the first instances of the possibility of playback – in the case of mechanical music, played back using the equivalent of notation in binary code (like pianola perforated paper), which later leads us to computers, through the Jacquard loom.

The phonograph groove offered the direct playback of live-recorded voice or recorded music (rather than encoded music). It produces a writing that can't be read by human eyes; it can only be played back by the machine, like a one-way type of writing. Forms of language or communication that suggest a system or a code of sorts, but that aren't completely accessible to us or decipherable, are interesting because they open up a space for possibility, for new learning and unlearning, rewriting and rereading. I often wonder what people felt when they first encountered mechanical music; did they experience that instrument sculpturally, performatively, as a form of time travel? For me this was an interesting way of breaking down the interfaces, the technologies, the prosthetic tools we have around us that help us interface with otherness and elsewhere.

Those early projects were formative. Back then I was interested in rewriting, playback and memory, and a kind of archival recovery. The works I did around women in electronic music were partly about that, inasmuch as I was looking at pockets of history that maybe hadn't been heard or seen in that way. I'm still really invested in rewriting, but I guess I've moved away from a historiographic approach. I feel that the projects I'm working on right now need to face forwards. I love the theremin because each

time you have to tune yourself to the instrument afresh. An attempt to retune, recalibrate and reposition yourself in relation to the conditions of the world is really key. That's the survival strategy that I'm really committed to in my practice now.

BL: I love how with your work *Impulsive Synchronization* of 2013 you were inspired by Hedy Lamarr. She's known as a famous actress from the 1930s and 1940s. But during World War Two, she had just immigrated from Germany to America when she met the composer George Antheil. He was a bad boy of American music. Antheil and Lamarr together came up with the idea that they called 'frequency hopping', which they patented in 1941. Did that interest in Lamarr lead to your investigation into women and computing?

AS: That was one of those projects where the backstory was too dense and almost not credible. Hedy Lamarr was a Hollywood actress, who had been married to an arms dealer in Germany and sat at the table with Hitler and Mussolini. She was a self-taught super smart inventor. She came up with quite a few ideas that I don't think ever got patented. At the start of World War Two, America solicited inventions from the general population as part of the war efforts. George Antheil had been making music with mechanical pianos and industrial sounds. Together, Antheil and Lamarr came up with the idea of frequency hopping, which is based on the pianola perforated paper principle, in that there would be two devices that would be synchronously hopping between frequencies like synchronised pianolas. The devices would communicate to each other remotely, and therefore they would prevent the enemy from easily jamming the signal. In the end their

device wasn't used in World War Two, but was supposedly used during the Cuban Missile Crisis. The fascinating thing is, that patent morphed into and became the basis for wifi and broadband. So, Hedy Lamarr is considered the godmother of wireless telephony.

Connected to this idea of encryption, my 2011 film on Daphne Oram centred on her music composition technique using visuals drawn onto clear 35mm film to produce a synthetic sound, a sonification of graphic shapes. She patented her invention, the incredible 'Oramics Machine', and this device was the protagonist of my film. With these projects around women and technology, I was interested in the notion of authoring a new language, a new code, which also resonates with the ventriloquist trope, the redistribution or rewiring of disembodied voices [which in some sense is what we're doing together right now, talking online across the sea]. Oram devised a whole new notation system, a new visual form of sound writing. The music that resulted from the Oramics Machine sounded very otherworldly, and initially was used much like the theremin, as a soundtrack for either horror films or sci-fi. It's as if these synthesised disembodied soundscapes suggested an abject bodiless object that could only exist between those two genres.

BL: Your interest in sound and the otherworldly brings us to Dial Tone Drone [2014]. It's a brilliantly concise work that I'm very happy to say was featured in my ongoing Seeing Sound touring exhibition. When Dial Tone Drone is installed, the visitor is invited to pick up the vintage telephone handset, or they may call the number provided from their own smartphone. Then they hunker down and listen to a pre-recorded conversation between two old friends, composers Pauline Oliveros and Laurie Spiegel. The pair

congenially discuss the use of drones in their own music – the use of sustained notes, sounds or tone clusters. Do you want to give me a little backstory to the work?

AS: My project on Hedy Lamarr already pointed in the direction of telephony. I was really interested in the role of women in early media, their enmeshment with these new technologies of sound storage and transmission. Women joined the workforce often as telephone operators or typists. They were the conduits rather than the authors. Telephone operators were called 'speech weavers' – that's such a beautiful image in itself. I was interested in the notion of telepresence, not just projecting one's voice, but also connecting or weaving voices so that these multiple voices are somehow, for a moment, part of the same circuit board. I was also really keen to work with Laurie Spiegel and Pauline Oliveros, each for different reasons. Laurie had been artist-in-residence at the Bell Telephone Laboratories and did a lot of her most important work there. Pauline had been working with telepresence for a long time, right up to the early days of Skype. Their works pushed the boundaries of how and where the performance took place, as well as how it was stored or transmitted. It was also interesting that they both worked sometimes explicitly with drone sounds, which I correlated to the dial tone – I wanted to use this to unravel its compositional potential. Laurie wouldn't necessarily define her work as drone-like because, as she says in the piece, a drone isn't static. You might hear it initially as static, but what happens perceptually is that, as you're listening, your mind adjusts, and then you start to go deeper. It's like when you look through a magnifying lens, you start to see more details – you start to hear a wider bandwidth of sound. Depending on the nature of the sustained note that you're

listening to, either your mind will imagine smaller patterns within it, so that you can perceive change where there's very little change, or you might actually start to delve into its textures and the intricacies and filigrees of what's in the sound. I'm inspired by this notion of close-up listening or, as Pauline would call it, Deep Listening, or, equally, listening through vibration, from a neuro-diverse or aural-diverse perspective.

I like that idea of really becoming aware of having a body that is experiencing some kind of sonic or vibratory input. And, at the same time, yielding your attention and surrendering to that sound. The dial tone can partly be understood as a sonic signal, inviting connection and listening. Although nowadays, with the smartphone, we don't have the landline's dial tone, which is basically the equivalent of the female telephone operators' voicing, 'What number please? Who can I connect you to?' The electronic dial tone was saying, 'The line is open.' It's the space of possibility, of connection, and I found that really poetic.

Both Pauline and Laurie authored, coded or programmed a whole new way of producing sound, and with that, a method of listening to the sounds that they composed. I feel incredibly privileged to have made that piece with them and to have met them through making that work. Since then, I've made a number of other projects with Laurie.

I like alert sounds [and telephone sounds] because in some ways they are a prompt. They are a kind of semantic code, not quite sounds and not quite music. With my project on sirens, Preemptive Listening [begun in 2017 and ongoing], the alerts that I'm looking at now are calls to attention, in a similar way. They are a code that we've learnt and are taught to listen and respond to in a certain

43

way, to then take certain actions or preemptive measures. I'm interested in trying to open it up and make us question that code, listen to it differently. What happens in *Dial Tone Drone* is that you listen, you dip in and out of the experience of listening, and are guided to have insights into Laurie and Pauline's ways of listening. Through their voices, you are partly under their skin, or under their eardrums, or whatever the expression would be – you're inside their listening.

BL: As I walk down a New York City street, I always see people with earbuds on, engrossed in what they're doing with their phone; smartphones tend to provide a soundtrack for our lives. In a way, we become unaware of what sounds we pay attention to and what we ignore. It seems that how an individual internally recalibrates and adjusts is one of your guiding principles. How does that play into your very new project? It is your first feature film, a complex and amazing research project called *Preemptive Listening* (begun in 2017 and ongoing). Can you talk about it?

AS: I began *Preemptive Listening* in 2017 and consider it a strategy for surviving as much as anything. It is about recalibrating what we pay attention to, what is worthy of attention, what we understand as an emergency and what we deem worthy of preemptive action, of rescue or help. We are in the midst of a crisis now, which is also a crisis of attention, and as you said, smartphones play a part, but also the world is cacophonous and overwhelming. Within this crisis of attention, there is a very real state of emergency. We're all feeling it intuitively, in a state of hypervigilant alert, and yet it's completely paralysing.

Whether it's climate change, the pandemic or other forms of crisis, there are so many things that are calling

for our attention, and it's very hard to know how to navigate, how to listen properly. In many ways the project is trying to address this, trying to reframe what we understand as emergency. Fire is a good example. First there's smoke, then fire, then somewhere in between, a fire alarm is activated, and hopefully people come to the rescue and put out the fire. But right now, and it's been in the making for a very long time, multiple fires are indicating something very different, beyond this kind of immediate emergency framework.

For example, the slow and systemic violence of climate catastrophe, how do we reframe and understand that? The siren is a portal or a way in, a metaphor to start thinking around that. The key element of the project, beyond the mere diagnosis of where we're at right now, is to try and recompose the siren. A bit like a dial tone project, here I'm taking another familiar signal, a call to attention, an instruction into action that is key to survival, and trying to recompose it – what would an alternative siren sound like? Because the ones we have now, we're not hearing them properly. They're loud, they're blaring and competing, everything is beeping, from our microwaves to our seat belts, not just sirens and emergency vehicles. There are other ways in which to think speculatively, imaginatively and poetically around the siren and attempt to reinvent it: and that in turn might open up alternative forms of crisis management. That's really where I want the project to go. I'm less interested in looking back and more interested in facing forward. This project allows me to do that and do it collectively.

I've invited different musicians to compose new sirens, and I'm consulting with people with diverse areas of specialisation to see if together we can somehow forge a new tentative understanding of emergency signals. And,

within that, ways in which we understand and deal with emergencies more generally. It's an ambitious, giant leap for me in my practice, and is all-consuming. Every time I speak to someone about the project, people share a personal experience of some sort of emergency sound. Sometimes it's a trauma, a trigger, other times it's a commemorative sound. Early on in the pandemic, China played a siren as a kind of commemorative pause, and it's used similarly for Holocaust Remembrance Day in Israel. So the siren is not just a sonic signal invoking future-facing emergencies, but it can also mark a pause, a moment of collective silence. It's like a prism that opens up to thinking around collective listening, collective action, the future that may or may not come to pass. It's about preemptive action.

Postscript

Bodies of Sound editors: In 2023, two years after your conversation with Barbara, you filmed a segment in Israel and Palestine, centred on the Holocaust commemorative sirens and the Nakba memorial sound. How has Israel's war on Gaza since October 2023 impacted *Preemptive Listening*?

AS: It's very hard to properly address the situation in Gaza, not least because it is ongoing. The relentless onslaught is operating on a devastating timescale that is accelerated and cumulative; anything we say is almost immediately irrelevant and outdated. Throughout the film I was thinking of several different registers of emergency, for example acute, sudden interruptions (an explosion or fire), and slower, ongoing disasters such as climate catastrophe or toxic nuclear waste. This also brought up the question of temporality, being in the same 'time zone' of the siren,

and positionality, that is, the idea of a sonic colour line: that some listeners are designated as 'the warned' and others as a threat. The Separation Wall featured in the segment in the Israeli-occupied West Bank clearly articulated this notion I call 'sirens for some', even if they are heard on both sides of the wall. Inevitably, there is a sound bleed, so that Palestinians will hear the Israeli sirens that are either warning or commemorating, and understand that they are not the intended listeners (as described to me by a Palestinian friend). In the absence of Palestinian civil defence sirens, Nakba Day is also commemorated with a siren which plays through minaret loudspeakers, and which I imagine Israelis also hear. The duration of the siren marks in seconds the years since the mass dispossession and displacement of Palestinians by the state of Israel in 1948: seventy-five seconds when we filmed it in 2023; seventy-six seconds this year, in 2024. Editing this section of the film throughout autumn 2023 was devastating and dissociating, thinking about the unimaginable grief that lay ahead. Any structures that supposedly guaranteed and protected human rights are now reduced to rubble. This cascading disaster is humanitarian, ecological, and epistemological – we can't even begin to understand. It is beyond.

I was completely thrown by a text by Palestinian poet Mahmoud Darwish, in which he describes the experience of listening to the Israeli Memorial day siren that precedes the Day of Independence:

> Pedestrians are nailed to the spot, wherever they may be. Vehicles come to a halt. Labour and machinery stop as a declaration of a mourning that precedes joy and celebration. And what does the Arab do? Cry from within, or burst from the pressure. The declaration of the birth of Israel is at the same time the declaration of the death of Palestine. This moment, then, is the historical rupture that separates two states of being . . . At this

47

rupture/paradox in history the tears of the opposites converge. You cry over a lost homeland, and they cry over those who were lost in search of a 'homeland' just born.[1]

Editors: Can you say a bit more about the film itself and its propositional structure?

AS: From the outset I thought of the film as a score of sorts. I've had Oliveros's photocopied score, 'Keep the next sound you hear in mind for at least the next half hour', on my studio wall for years (gifted to me by Irene Revell). I often reread it almost like a Koan: a proposition that cannot be fully resolved or understood because, in a sense, it is a poetic suggestion that remains suspended in an infinite state of possibility. For me this served as a guiding principle, and so I opened the film with a text instruction which reads:

> This is an experiment in listening forward.
> A score for holding in mind the future
> through sound.

> All the sounds in this film are newly composed sirens.
> Over 20 collaborators were invited to reimagine the siren,
> to think of it as a prompt:
> a call to attention, a call to action,
> an instruction towards the possibility of future.

I wanted to seed this idea of listening with the future in mind in the ear and eye of the listener/viewer. The siren definition of the last three lines was also the text score invitation I sent the composers and interviewees featured in the film. And maybe, a bit like Oliveros's score, it doesn't

[1] M. Darwish, *Journal of an Ordinary Grief*. Archipelago, 2011 (1973), pp. 36-39.

fully resolve through the film, but remains a prompt, a portal, a prism for future listener/viewers. My fascination with scores has taken many shapes in the past, including watercolours of tuning forks as visual scores, or making a film based on a score-image transmission provided by Éliane Radigue as part of her *Occam Ocean* series [2017 and ongoing]. I suppose I am drawn to this idea of an instructional proposition that provides the coordinates for a form of orientation, a gathering or a setting of intention, but is not authoritarian, hierarchical or overly prescriptive. It can be as subtle as a wind that inflates the sails, providing navigational principles and energy, without setting a pre-determined path.

Sticky Metaphors: The Matter of Meaning
Cannach MacBride
(2021)

Cutting Together and Apart (Entanglement)

In *Meeting the Universe Halfway* (2007), Karen Barad describes how matter and meaning are entangled. Each apparatus – boundary-making practice – makes 'agential cuts'.[1] Barad is initially writing about observing electrons in the lab; how they can behave differently depending on which apparatus is being used to observe them. But Barad extends their point that there is no outside from which to observe objectively into a call to responsibility based on the collapsing together of ethics, ontology and epistemology: matter is performative and discourse is material. Each cut of a boundary-making practice into matter-discourse excludes certain possibilities in order to make others intelligible. An electron appears as a wave or a particle or both, depending how it is observed.

To give something a name or a category is a boundary-making practice. A name brings different possibilities of meaning nearer and farther. A category formation limits or enables, affecting those captured within it and those excluded beyond its boundary.

There is no separability between the boundary-making practice that cuts, the intelligibility it produces, and the

[1] K. Barad, *Meeting the Universe Halfway*. Duke University Press, 2007, p. 148.

[2] Ibid., p. 93.

matter that uses this intelligibility to make meaning. What the boundary-making practice excludes – cuts out, cuts away – always remains present, even if it is not knowable to the intelligibility it co-constitutes, cuts together. Barad calls this 'exteriority-within'.[2]

Some humans use managerial language to hide or elide the violence of boundary-making cuts that deny the intricacies of interdependency and its responsibilities. In this system of globalised racial capitalism, names like, 'detention centre', or, 'managed extraction' mean toxicity and death for many to pay for profit and property for some.

Interlude (Unnaming)

We met in the overburdened garden. One of us was already not comfortable identifying as he and had yet to find an articulation for this feeling, but soon would move quickly through they into she. Another of us was freshly out of a long-term relationship feeling the pressure of liminal fertility. One was me, she then, not now. Summer and sage stroked our skin and the resting containers of sun tea. We read, sat beside one another, with texts laid out on the horizontal planes around and between us.

Reading beside, not through or into, just with.[3] Looking for ways to talk, without names, about what ways of knowing might be possible through the end of the world.[4] We were trying to apply our words differently to the world, to not rely on the pieces of code that we'd built in our schools, our friendships, our amniotic sacs, our visits to government offices, our experiences of being employed when that was still a thing, in all the times we'd done something we didn't want to because someone else did, and in all the times we'd made someone do something they didn't want to but we did. We were searching for a metaphor-less methodology for collective thinking.

Reading transversally, without a singular guiding line, without shortcut words to make maps of shortcut worlds, we fumbled.

Cutting Together and Apart (Listening)

Listen to your body, to your dreams, to your intuition. Listen to the voices of your ancestors, to what the Earth is telling you.

These are things some people say and other people understand but some people find troublesome. The trouble

[3] One of the pieces of paper was a photocopy of page eight of Eve Kosofsky Sedgwick's *Touching Feeling: Affect, Pedagogy, Performativity* (2003). There, she proposes, 'beside' as a prepositional relation that carries more plural (and spatial) possibilities than, 'beneath' or, 'beyond', which invoke linear time through a focus on either origin or telos. In her argument, 'beside' is non-dualistic, for multiple things can be beside each other and need not be equal, equivalent or oppositional. So, 'beside' offers a mode with which to avoid the dualisms of a variety of linear logics, not only temporal ones.

[4] Other pieces of paper held a printout of Ursula K Le Guin's 'She Unnames Them', a short story originally published in the *New Yorker* in 1985. The story describes the aftermath of a societal process of unnaming living beings from categorising nouns: 'I could not chatter away as I used to do, taking it all for granted. My words must be as slow, as new, as single, as tentative as the steps I took going down the path away from the house, between the dark-branched, tall dancers motionless against the winter shining.' Yet other pieces of paper held a printed-out scan of Denise Ferreira da Silva's 'Toward a Black Feminist Poethics: The Quest(ion) of Blackness Toward the End of the World' (2014). That paper works through two questions: 'Would the poet's intention emancipate the Category of Blackness from the scientific and historical ways of knowing that produced it in the first place, which is also the Black Feminist Critic worksite? Would Blackness emancipated from science and history wonder about another praxis and wander in the World, with the ethical mandate of opening up other ways of knowing and doing?'

accumulates around the questions of whether listening is meant literally or figuratively, and where might the edges of literal or figurative be. In Western traditional thought, listening describes what happens when some humans perceive and understand sound. Often it is connected to the ears and the brain, sometimes to the body. But the separation of the senses into touch, taste, hearing, sight, smell (and the subsequent expanding list of nerve-neurology perception pathways with names like proprioception, pain reception, temperature sensing) is only one way of making this cut.

As a thought experiment, imagine someone raised in a Western knowledge system who experiences the senses as separate and their body as autonomous and independent. Perhaps for this person, listening is a sensory modality where it is easier for them to experience themselves as porous in relation to other life, to feel that their body is an integrated system that cannot be disconnected from other systems. Perhaps this experience and the collapse of separation, autonomy and independence it invokes is why sound is often gendered and racialised into noise or why sound is used so often as an instrument of torture.[5]

Like sound, skin-to-skin touch of human hands is also

[5] Noise is an imprecise category, with contextual meanings in different forms of practice or disciplines of knowledge. It has frequently been mobilised in multiple different ways as one side (bad) of a highly mobile (following the moving needs of a power structure) good/bad binary. Persons, beings, forms or sounds can be coded as noisy, following multiple logics of white supremacist imperialist patriarchal oppression. For just a few examples across a range of disciplines and oppressions, see works by Roshanak Kheshti, Dylan Robinson, Gavin Steingo and Jim Sykes, Jennifer Stoever, Marie Thompson and Alexander G. Weheliye.

sensed as an oscillating wave of vibration through the nervous system. Current ways of thinking say that what is being vibrated differs (air, flesh), and the nerves and brain region processing the vibration are different. But that is only one way of cutting this experience into intelligibility. A different cut, towards the category of the waveform rather than the parts of the human it is waving through, could say that what is happening in hearing and touch perception is more similar than different. With this cut, we'd need to find more words for what we experience when we listen to mechanical, electromagnetic or gravitational waves as they move through us.

But sticking with the cut of listening being about sound, we still grow complicating connective paths among what the cut has just separated. If listening is hearing – that is, the sensing and perception of vibrating sound waves within a frequency range that stimulates the auditory apparatus of animals, plus the integration of what is being heard into a form of meaning – then listening is an accumulation of experience and memory.[6]

But sound waves don't only vibrate within the frequency range of the human auditory apparatus. Some humans learn to interpret technical instruments or the behaviour of non-human life and matter who do sense those frequency ranges. Listening here involves reading through the accumulation of memory and experience of a trained listener, like a seismologist or a cardiographer. But experience and memory (even only of sound) don't only live in the brain; they live in the body and its environment, and through cultural and spiritual practices. What kind of listening

[6] See P. Oliveros, *Deep Listening: A Composer's Sound Practice*. iUniverse, 2005.

listens to them?

Robin Wall Kimmerer, botanist and member of the Citizen Potawatomi Nation, makes this cut: 'we say that we know a thing when we know it not only with our physical senses, with our intellect, but also when we engage our intuitive ways of knowing, of emotional knowledge and spiritual knowledge. And that's really what I mean by listening.'[7]

If I wanted to propose a non-extractive and non-dominating listening then it would need to attend to and integrate what has happened and been repressed from experience and memory, and become aware of effects that are not compressed into a waveform but experienced or remembered in another way. Listening as a description of this more-than-sonic experience might become a temporary metaphor for the kinds of attention and awareness that English doesn't have so many good names for, like how Fred Moten and Stefano Harney define hapticality in *The Undercommons*: 'the capacity to feel through others, for others to feel through you, for you to feel them feeling you'.[8]

This is listening as poly-sensory, poly-temporal experience. The frame of this listening is understood differently than in Western scientific understandings of human hearing – listening involves listening to 'sounds' that are not normatively 'sounded', and entities that do not produce sound in a normative way are entities one can listen to. It is possible to listen into times other than the present. This listening is a collective activity, in relation with others, although those others do not have to be humans; different forms of life

[7] R.W. Kimmerer, speaking on 'The Intelligence of Plants', *On Being with Krista Tippett* [podcast]. WNYC Studios, 25 February 2016.
[8] S. Harney and F. Moten, *The Undercommons: Fugitive Planning and Black Study*. Minor Compositions, 2013, p. 98.

and matter are interdependent and co-constitute the listening possibilities. Understanding is not the only intention and may well not be achievable. Listening to plural ontologies, epistemologies and cosmologies asks for learning from their plurality of stories, memories and experiences; things known and unknown; beliefs.

Coda

We slip into metaphors comfortably like worn-in shoes, borrowing their easy clarity. Metaphors can carry affective energy for gathering political collectivity to change practices of thinking and doing. They can connect actions and materials to ideas and feelings. Depending on how they are used, they can also conceal power. Leaning too hard into the vehicle risks losing the tenor. My metaphors are mixed and made in relation to yours so, how do we take care of them and mind where we are as we use them without fumbling too much?

Abolitionary Listening: Propositions and Questions
Carson Cole Arthur, Petero Kalulé, A.M. Kanngieser
(2021)

If listening is a technique or practice of the law, which is to say also of politics/police, what would an abolitionary listening sound like? The state listens and demands a listening disposition, listening is critical to all processes of arrest, adjudication and incarceration. The voice of the witness becomes evidence. Indeed, the 'act of listening' to the witness becomes evidentiary. But these listenings assume and constrain possibilities for freedom. In this piece, we move through propositions that invite an opening up to how, if at all, an abolitionary listening might take place. The 'we' we use is intended to be multi-directional and polyphonic. It is a 'we' we use as authors, as readers and as listeners. Our thinking with and listening to the 'uncapturable' seeks to unrepresent monological and univocal narratives of intelligibility, rationality and social consensus. Rather than strain a hearing, we worry and listen to the very register and sonics of (a) hearing (determinacy, judgment, autonomy).

Drawing from the writings and sonic articulations, undulations and intervallic cries of different thinkers and musicians, we undo the certainty of voice and sound that the law predicates itself upon, and surrender to unanticipated openness.

'A scene that grapples with the unbearable. A stop. There is syncopation. Geographies start and stop. A beat continues.'
— Keguro Macharia

'My spoken words you say do not enter your ears but your inside they have entered.'
— Gabriel Okara

'It is the hearing of their voices that may be tenuous.'
— Unaisi Nabobo-Baba

1. If to listen is to sit at the door of law – before law's ear – which is a vestibule to the state, what might it mean to write of such an audiographic encounter?

2. What might it mean to listen to the violence of the state as a violence that arrests and imprisons, that acts upon reason, evidence, and on 'common' sense? What might it mean to write of such a listening; to be on the thresholds of a listening that appropriates and invades our bodies, causing a constant loss of transmission, a sensual-epistemic quiver, shudder, stutter, tremor?

3. What might it mean, correlatively, to think listening when we, too, are listeners? We listen and are listened to.

4. We listen in a way that often never listens back. Listening is aporetic.

5. Listening tends to be conditional. Listening (like care) can be deployed in ways that un-human even when it claims to do otherwise.

6. We speak of 'listening', but we often deal only in univocal echoes – which always already assume an original, a finitude. Echoes: where each utterance replaces the last, yet is heard as irreplaceable – the singularity of it all. This finitude: the last, the lasting, the at-last.

7. These echoes; a multitude of announcements, com-
 mands and interpellations; of past judgments, of pledging
 and oath-taking seek verification, authorisation and the
 singularity of consensus, to awaken the senses. They must
 be 'translated', that is, made 'sensical'.

8. The same happens with state-run technologies, appar-
 atuses and bio-logic 'sensings' (or univocal grammars)
 of war, capture, definition, certainty and graspability
 that give listening its determined/corrective-disciplinary
 effects.

9. One is multipliably instructed to partake in listening such
 that one may enforce a particular kind of 'transcendental'
 (yet self-referential) will to knowledge onto others.
 This is transmitted through legal-regulatory practices
 of assessment, criminalisation, gradation, arbitration,
 cross-examination, peer-review, correction, refinement,
 evaluation, measurement, evidence and its admissibility,
 justice, rationality, clarity, scrutiny, the universalising
 police project of human rights, and so on.

10. To listen (with the expectation that you will understand
 and will be understood) is to calibrate a 'consensus' that
 relies on a shared delimitation of what and who can be
 heard and how. It is to reproduce, restore and relay the
 strategic exclusionary closure (and arrest) of law/politics/
 police.

11. To listen is to reason with the singular, i.e., to accept and
 uphold a singular and univocal notion of 'truth' with
 regard to meaning, translation and representation.

12. This conduct submits listening to a measurement of
 good or bad, success or failure, truth or lie, knowledge
 as acknowledging, an agreement to disagree, the apprec-
 iation of the differing, the differentiation of opinions.

13. From this conduct is affirmed a standard towards improvement, an imperative to listen well. And yet, any claim that there is a lack of listening (which is equated to a lack of understanding) is a judgment on the intelligibility of a subject.

14. Law summons. It demands that the witness be capable, competent, articulate, which is to say 'human' in order to speak.

15. Law is perceived as receptive and capable of listening, but the act of testimony/witnessing is integral to making a witness compliant before the law.

16. And so, we could say that the witness is obliged to the law. That bearing witness is premised on the idea of testimony as 'authentic truth'.

17. The reproducibility of testimony is what makes the speech of the witness credible. However, to connect this belief to the organ of the mouth (or ear) is to assume that the witness's voice can be translated, recognised or represented. As such, there is always already a belief that to speak is to (be-)come. This belief is a prefigurative listening.

18. The personhood of the witness in law is tied to state sovereignty. The sovereign affords recognition. But this is not complete or foreclosed. For instance, Indigenous articulations of sovereignty push against the sovereign of the colonial nation-state. As Mohawk scholar Professor Audra Simpson writes, Indigenous sovereignty offers a different, 'structure of apprehension'. Thus, there are other possible formulations of 'sovereignty' before colonial-legal distinctions.

19. Perhaps all sovereign structures of apprehension grapple with listening as capture, with listening as the calculability of law. How are we to undo this?

20. In the face of these legal processes and demands, one has to 'worry' at these sovereign tonalities; to trouble their 'soundness', their integrity, authenticity.

21. One has to be committed to what we will call the uncapturable. One has to attune to a musical/oral/aural sound that undoes listening as telos, as epistemic return, as a written/spoken word, as letters, as literary, as literacy.

22. The uncapturable may be what Charles Lloyd is trying to get at when he says that, 'words don't go there' . . . or when Anthony Heilbut writes, 'words can't begin to tell you, but maybe moaning will'. The uncapturable abandons interpretation.

23. The uncapturable undoes the cognitive and interpretal. It does away with the conception that there are constatives that have multiple decidable 'meanings', imagined as unchanging and discernible.

24. It may be to depart from the violent human-as-man logics of representation, of performativity, and their pervasive witnessing modes that are predicated on authenticity, individuation/expertise and univocality.

25. Perhaps such a departure is an attunement to the resonant 'excess' of intervallic irruption. This intervallic irruption is a polychromatic spacing, a temporal-spatial troubling, an insistent labyrinth of worry.

26. Worrying is an affective perception, a 'fill/feel' of the haunt beyond 'mental cognition'. Worrying happens as if to let us know that there is always already a human desire to master 'representation' – from the evocation, the invitation, the call for civic-intellectual self-appointment.

27. Worry is a necessary im-perception of the fact that the human (as is) can never adequately perceive, or fully relate to the non-human.

28. Worrying is rocked with as a work of mourning with and for the non-human end of the Earth.

29. Worrying is incessant sorrow. It's a durational resonance or sway that's attentive to the dying, the dead, the burning, flooding Earth, the non-human.

30. Try as we might, worry as we might, 'we' still for some reason desire to become human.

31. Yet because we remain marked as human by a legal-carceral order of representation, we are subtended by a sensual-sense wavelength that only programmes subjection.

32. Worry is perhaps a mourning, not simply for whom or what has passed but a portal of affirmation of our relations with each other, living and dead.

33. There is no separation, no border, no boundary between the living and the dead. That threshold without door inundates. It is always open.

34. What is being evoked here is not an entrance, an access, or frame of an open door, not a vestibule, but the crossover, the threshold.

35. Reconnecting our relations to our non-human dead in us/with us, at this threshold is not a loss or end. It may help us think of a listening after the human, that is, a listening that frees.

36. What might listening be if it happens alimbo, at this threshold between life and death?

37. The figure of the ghost, the spirit, moves elsewhere. It demands for and promises something else.

38. What might listening be if it went beyond a mode of human temporality that wants to be heard as human modernus, as a sensing with – in the metaphysical anthropocentric axiomatics – of subjection in a 'world-

sensuality' that already delimits, regulates and represents?

39. How then might we 'unrepresent'? Which is to say, how then might we interrupt and upend the rhythms and intonations of this anthropocentric listening that the law demands?

40. If the listener as listener is always prefigurative, can the listener move from the relation of hierarchical enclosure? Can we move towards a gathering – in crossing – that crosses over?

41. Can we move away from an economy of appropriative assimilation of listening and attune towards relation, to the differential erotics and poetics of relation?

42. We provisionally call this an abolitionary listening. It is a mode of listening that compels us to move out of the violent rubrics of human representation toward what Dionne Brand calls, 'another place, not here'. This 'not here' which is also a 'not hear' – where words don't go – is not a-there, or a-here, that is found and inhabited. It is an open-ended, polychronic and polyrhythmic injunction to listen differently.

43. An open-ended, polychronic and polyrhythmic injunction to listen differently moves away from sonic certitude, towards a differential interplay of whatever is shared or listened to unconditionally.

44. The kind of abolitionary listening we are searching for works towards another temporality, one that is always already separate from the diagnostic and panoptic ear of the law towards a freedom we cannot delimit yet, or rather a freedom that we should in fact not understand as delimitable.

45. It is a continuum of nonhuman-sensuality that departs from the state's witnessing programmes, one that is de-instituted and de-sovereigntised.

46. The intervallic freedom loaded heavy in Nina Simone's blue s lip, or Albert Ayler's shrieky *Ghosts* is de-instituted, de-sovereigntised. It is a gathered desire for a freedom to come, a freedom we understand (to love somebody, for spiritual unity) but do not know, but cannot know, in the sense that it floods us in a way that is mutually intuited but cannot be accounted for.

47. Hush; an altering (an altar) a separation . . . a separation of difference that still sustains intervallic freedom.

48. Such intervallic freedom gathers. It engenders a sensuality that perhaps only Billie Holiday (our favourite trembler of pitch and tonality) touches and invites us to touch 'what love endures' when she sings: 'Hush now, don't explain.'

49. We could listen or respond to Billie's hush or Nina's scream or Ayler's ghosts (these are different-similar things) as uncapturable attempts that playfully yet urgently affirm an indefinitive, deprogrammed promise that takes listening somewhere else, freely (after law's representation) to the singer and to the song's beyond . . . to where words do not go – without condition.

50. The song's beyond is not a destination, it is not a promise of complete, transcendent being. It is not found by unhearing the semantic. One does not get towards the song's beyond by listening with all of their being, for listening is not an entrance to being. It is not an end or beginning to being.

51. The intervallic infers a spacing, a kind of communitarian call and response. The intervallic also displaces the ear as a central point. It moves listening beyond the essentialism of the bio-logic ear and transforms listening towards an elsewhere, an elsewhere that exceeds a mere straining.

52. What is an elsewhere but a crossing over into what does not meet our expectations? What is an elsewhere but surrender?

53. Surrender has to be open to an unanticipatable openness to shared perhapses. It has to be an extemporaneous poetics and erotics of relation that puts us in touch with whatever is here and also beyond us.

54. We could think of this as a listening beyond certitude, as a listening *sine telos*.

55. A Lordeian loop, a direction to hear and listen differently: 'it is a question of how acutely and fully we can feel in the doing'.

56. Perhaps it is more akin to sitting with listening as a turning-towards more than a turning-away-from, a kind of intervallic attunement that can find itself with-in unknowability – embracing the feeling of unknowability as a non-horizon.

57. We cannot and will not try to delimit what this listening gathers, what it might look like or feel like . . . It is here and yet not here, it is present, it is remembered but also yet to come. Again, we will not master the representational. We will re-present neither representation nor misrepresentation. We will not issue a judgment.

58. To listen as such is to make way for the incommensurable, an absolute difference that cannot be assimilated, which flourishes precisely in its alterity. This invites letting go of comparison and the search for conclusion.

59. But, one can't talk about listening. One simply does it, somehow.

60. Listening stops the moment we mark limits, the moment we think we know exactly what it is.

Discography

Albert Ayler Trio, *Spiritual Unity.* ESP-Disk, 1965.

Appau Jnr Boakye-Yiadom, *'Scream of Nature'*, 2016.

Dionne Brand, *A Map To The Door Of No Return: Notes To Belonging.* Vintage Canada, 2001.

Dionne Brand, *In Another Place, Not Here.* Vintage Canada, 2011

Kamau Brathwaite, *The Lazarus Poems.* Wesleyan University Press, 2017.

Betty Carter, 'Open the Door' from *Inside Betty Carter.* Capitol Records, 1964.

Yandé Codou Sène and N'Dour Youssou Gainde, *Voices from the Heart of Africa.* WDR, 1995.

Jacques Derrida, *The Gift of Death and Literature in Secret.* University of Chicago Press, 2017.

Édouard Glissant, *Poetics of Relation.* University of Michigan Press, 1997.

Billie Holiday, 'Don't Explain' from *The Lady Sings.* Decca Records, 1956.

Petero Kalulé, *Transcribing Noise in Kalimba.* Guillemot Press, 2019.

A.M. Kanngieser et al, *In the Eye of the Storm.* Reina Sofia Museum of Contemporary Art, 2018.

Art Lange and Nathaniel Mackey (eds.), *Moment's Notice: Jazz in Poetry and Prose.* Coffee House, 1993.

Jeanne Lee, *Conspiracy.* Earthform Records, 1975.

Audre Lorde, 'The Uses of the Erotic: The Erotic as Power', *The Lesbian and Gay Studies Reader,*1993, pp. 339-43.

Audre Lorde, *Our Dead Behind Us: Poems.* W.W. Norton, 1986.

Keguro Macharia, *Frottage: Frictions of Intimacy Across the Black Diaspora.* NYU Press, 2019.

Katherine McKittrick, *Demonic Grounds: Black Women and the Cartographies of Struggle.* University of Minnesota Press, 2006.

Fred Moten, 'Black mo'nin'', *Loss: The Politics of Mourning*, ed. David L. Eng. University of California Press, 2003, pp. 59-76.

Fred Moten, 'Sound in Florescence: Cecil Taylor Floating Garden', *Sound States: Innovative Poetics and Acoustical Technologies.* University of North Carolina Press, 1997.

Unaisi Nabobo-Baba, *Knowing and Learning: An Indigenous Fijian Approach.* University of the South Pacific, 2006.

Francis B. Nyamnjoh, *Drinking from the Cosmic Gourd: How Amos Tutuola Can Change Our Minds.* Langaa RPCIG, 2017.

Oyèrónkẹ́ Oyěwùmí, *The Invention of Women: Making an African Sense of Western Gender Discourses.* University of Minnesota Press, 1997.

Christina Sharpe, *In the Wake: On Blackness and Being.* Duke University Press, 2016.

Nina Simone, 'Missisipi Goddam', *Nina Simone in Concert.* Phillips, 1964.

Audra Simpson, *Mohawk Interruptus: Political Life Across the Borders of Settler States*, Duke University Press, 2014.

Cecil Taylor, 'This was Nearly Mine', *The World of Cecil Taylor.* Candid, 1960.

Sylvia Wynter, 'Unsettling the Coloniality of Being/Power/Truth/Freedom: Towards the Human, After Man, Its Overrepresentation – An Argument.' *CR: The New Centennial Review*, no. 3, 2003, pp. 257-337.

Listening Back
Cathy Lane
(2021)

Sound can connect you more fully to the moment. It can immerse you in a different world, or help you to experience the same world differently. Sometimes it sends you elsewhere, offering freedom to meander through space and time, unlimited by frames, boundaries or fences. It can also connect you to past lives – individual and collective – and their relation to the present.

Memory is embedded in sound in many ways. It takes shape in a word or a linguistic phrase that is passed down from generation to generation through speech. It can also be ensconced in a sound recording, which is inherently a memory of a past event, whether it be the song of a long-silenced voice or the bus that passed by a moment ago. Sound can trigger an individual memory of a different time and place in both the stories that we tell about ourselves and those we inherit from our families and cultures.

I am interested in this indelible link between sound and the forming and re-forming of memory. As the late British writer Jenny Diski puts it in *Skating to Antarctica* (2005):

> Memory is continually created, a story told and retold, using jigsaw pieces of experience. It's utterly unreliable in some ways, because who can say whether the feeling or emotion that seems to belong to the recollection belongs to it rather than being from the general store of likely emotions we have learned? Memory is not false in the sense that it is willfully bad, but it is excitingly corrupt in its inclination to make a proper story of the past.

Much of my work concerns these 'stories of the past', both individual and collective, that relate to place, family and labour or aspects of social, cultural and political life. I am interested in the soundings and re-soundings of memory. Like any artefact, a sound recording offers insights into the recorder's aesthetic, ethical, political, cultural, social and musical priorities. These might change over time according to individual growth, personal interests and prevalent cultural and social 'rules'. Recently I listened to the 'past me' of thirty years ago – made possible through sound recordings that I made at that time. Through this listening, these changes were made apparent to me through listening to my listening.

My work 'The River Goes On' is based on recordings and experiences from visits to Tigray, North Ethiopia, in 1987 and 2019. I originally spent six months in Tigray in 1987 as part of a music development project with the cultural troops of the Tigrayan People's Liberation Front (TPLF), who were fighting a guerrilla war with the Ethiopian government. In 2019, I visited Tigray again to try to find some of my comrades and ex-students and to see what traces remained of my time there in the face of Tigray's development over those decades.

In 1987, I was as unfamiliar with field recording as I was with sound art. Since then, and partly because of that experience, I have learned how to make, listen, compose with and deconstruct field recordings. For the last two decades, my work has used spoken word, archival material and field recordings to explore aspects of our listening relationships. So when I accessed the boxes of cassette tapes that had been stored in my attic for the last thirty years, I expected to find older, more crackly versions of what I am interested in now – recordings of places, events, environments, intertwined with the voices of people and other species.

To my disappointment, I found mainly recordings of music rehearsals and concerts that, despite taking place outdoors to large audiences, stop as soon as the last note has faded. The sounds of cicadas, flowing rivers, audience chatter, gunfire, birdsong and casual conversations with friends that I remember are not present. However, they do put me in touch with my former self and how time has changed my perceptions. They also tell of saving the limited cassettes tapes available for what I considered to be most important rather than the contemporary luxury of filling gigabytes of sound in the hope that there might be a 'good bit'.

At first, I used these 'jigsaw pieces' to help me reconstruct a linear story of what happened – itself complex and difficult – through the form of audio essays built from spoken narratives with accompanying sound recordings. Now I am trying to tell a different story – less linear and not led by language but shaped and 'understood' sonically. The TPLF and Ethiopian government are once again engaged in armed conflict and many of the gains and developments that I witnessed in 2019 have been destroyed. The 'jigsaw pieces of experience' do not make sense and are constantly being reframed in the light of contemporary events. The way that I try and make sense of and relate to both the memories and those recordings is also constantly shifting according to each new contemporary development.

Sonic Strategies in the Palestinian Struggle: A Soundtrack of the May 2021 Uprising in Palestine
Christina Hazboun
(2024)

In May 2021, during the uprising that swept through private and public spaces across historic Palestine, people took to the streets to protest the ruthless Israeli colonial practices of invasion, confiscation and violence. One of the counter-colonial tactics that Palestinians turned to was to fill public spaces – from Jerusalem's Sheikh Jarrah, Akka's old town and Haifa's Wadi Al-Nisnas to the village of Beita – with the presence of artists and activists using music, sound and culture as a tool for fighting oppression.

The acousmatic, or the unseen, is often an overlooked element when analysing strategies of resistance, yet the sonic context that envelopes listeners, citizens or activists has both physical and psychological effects on the individual. Through his analyses of belliphonic sounds in Iraq, J. Martin Daughtry maps the zones of (in)audition into audible inaudible, narrational, tactical and that of trauma. Walking in the city, which is where space, time and encounters mix, the body becomes a vehicle whose rhythmic steps interact with the space while also moving within it. When Palestinians put their bodies into the historic spaces of Jerusalem, Akka, Bethlehem or Al-Lydd, they cut through the multiple layers of its history; in the specific moment of the May Uprising, it was imperative to occupy the streets

and public spaces, to announce their presence peacefully, yet vigorously. This presence within the boundaries of their land was marked by multiple phenomena that transcended the habitual rhythms of daily life and manifested through an increase in volume and the organisation of voice and sound into singing, music and noise.

Speaking to my sisters in Bethlehem, I could often hear the sound of gunshots over the phone, taking me into an 'audible inaudible' zone, while my sisters would tell me how they have to avoid the area close to Rachel's Tomb located north of Bethlehem's city centre and take a different route home. Their everyday life was hence directly affected by what was audible within the space they inhabit; their actions came as a reaction to those relatively distant sounds that prompted them to navigate their daily life in a specific manner.

When my sister was staying at Dar Jacir, close to Checkpoint 303 in Bethlehem, an internal checkpoint in the city, daily confrontations with the occupation were happening in front of her and she would experience the violence both sonically and visually. Hearing gunfire, teargas, shouts, screams, chants, flying rocks, burning tires and then the sound of shattering window glass in her place meant that she had to act rapidly and leave her home for a safer space. Hearing violence means also acting upon it, constructing or reconstructing both memories and events that surround that specific moment. This state of aural experience is positioned within what Daughtry calls the, 'tactical zone', only one step away from the, 'trauma zone', with all the mental and physical pain that it contains. Within this space, the listener's experience shifts from hearing to a deep, under-the-skin experience: the sound of an explosion could cause temporary or permanent deafness, physical injury, or, in severe cases, death. The May

Uprising awakened aural and visual senses to a heightened cultural perspective, as Palestinian civil society within historic Palestine resorted to the implementation of 'sonic agency'. By utilising sonic sensibilities, Palestinians used sound to enact emancipatory practices, countering Israel's hegemonic and authoritarian practices.

Sound as a Strategy for Liberation

Sound can be used to unsettle, create social formations (protests) and to increase the audibility of the unseen or the non-represented, which is what Palestinians realised and began implementing early on. While music is organised noise, music and noise can serve three purposes: making people forget the violence around them, bringing people together in a sense of harmony, and silencing, deafening or censoring other voices.

In the Sheikh Jarrah neighbourhood of Jerusalem in May 2021, Palestinian protesters took to the streets and used their voices against military occupation. The protestors were often seen clapping, singing, crying and shouting, which included the takbeer (the use of the phrase 'Allahu Akbar', or 'God is great') to react to the violent soundscape that was enveloping them, countering it with their own human-made sounds.

Through a careful investigation of videos on social media platforms such as Facebook and Instagram, one could also observe the use of instruments like the tabla (a handheld, goblet-shaped drum), loudspeakers and bins to create either noise or rhythms. In one moving event on 3 May 2021, which was during the holy month of Ramadan, a group of Palestinian young men tried to access the Al-Aqsa Mosque but were prevented from entering from the side of Bab al-Silsila (Chain Gate). Facing the Israeli police officers blocking the road, a group of Palestinian children

started chanting, 'I'm at your gates my lord', while a young Palestinian man began singing a famous *ibtihal* (invocation) from Sufi Egyptian Sheikh Naqshbandi (1920-74), which was composed by Egyptian composer Baligh Hamdi and was also titled 'I'm at your gates my lord' (*Inni bi babika mawlaya*). The powerful voice of the reciter or invocator brought out awe in the Palestinians unable to access their holy site, which evoked a unifying and uplifting social formation supporting the Palestinian underheard, while creating a 'sonic sensibility' that agitated the oppressors, demonstrating what LaBelle describes as emancipatory practices.

Fireworks, which shine brightly but also sound like gunfire, were utilised in many villages and cities to counter the sonic violence that rained onto Palestinian spaces. As the night spread over the village of Beita, near Nablus, Israeli settlers would attack the village with artillery and weaponry. As a counter-strategy for this violence, many of its inhabitants chose to resort to the tactics of 'night confusion' – firing fireworks into the night skies and filling the darkness with sounds from all directions in order to confuse the attacking settlers and disorient them. Usually used to express happiness and celebration, fireworks, with their forceful punctuating sounds, were used as an effective distraction against imminent attacks.

In another contested soundscape in the city of Al-Lydd, Mahmood Jrere, one of the founders of Palestinian hip-hop band DAM, described the situation in Al-Lydd (Lod) during May and June as very difficult. The citizens of one of the so-called 'mixed cities' emerged from strict lockdown to face aggressive hostilities as busloads of Israeli settlers were driven into the city, wreaking havoc and terrorising Palestinians. Jrere recalls the use of sound to alarm and protect. During the settlers' nighttime raids, negotiating

systems of domination made listening an essential tool for self-preservation. Muezzins helped alarm people of upcoming danger and informed citizens of where the settlers were present.

What Jrere and other cultural activists and artists also did was resort to music as a means of encouraging children and families and uplifting their spirits. By organising physical events that featured performances, the Palestinian community was conceptualising a public sphere through presence and sound – not only in Lod, but also in other cities such as Haifa, Akka and Nazareth. The production of music, such as Jrere's own single 'E7na Mla7' ('We're good') came to document the horrific injustices:

> They came at night with their flags
> and their flags were night
> And their media was covering their terrorism
> They killed Moussa and our hearts were lost.
> Many hearts were lost before him.

In this piece, Jrere is documenting the killing of thirty-two-year-old father of three Moussa Hassouneh, who was shot dead during a protest against Israel's imminent forced eviction of Palestinians in the Sheikh Jarrah neighbourhood.

In countering hegemonic and authoritarian regimes, music was used as a form of therapy, a source of agency and – in the case of Gaza – a distraction from pain. After the traumatising round of Israeli bombings over Gaza, several organisations, which included the Palestine Music Expo, helped to organise musical concerts in Gaza, Khan Yunis and Deir Al-Balah. For the first time in years, there were musical performances 'over the rubble' of Gaza's destroyed sights, but also in many of the hotels and resorts that survived the aggression. Children could be seen dancing and moving to the comforting and familiar sounds

from favourite cartoons or nursery rhymes producing what Tia De Nora describes as an aesthetic environment of pleasure and security.

The Sonic Transmission of Struggle

Sonic resistance didn't manifest in rural or urban spaces alone – it also took a digital form, as in the example of the Bethlehem-, Ramallah- and Amman-based Radio Al-Hara. While it is not within the scope of this text to write extensively about the history of radio in Palestine, the emergence of an independent community radio that aims to unite Palestinians divided across borders in March 2020, as a result of the global Covid-19 pandemic, played a prominent role in connecting communities, sharing knowledge, and in the construction of participatory sonic experiences through radio programming. Founded by five friends, the radio initially served as an outlet for frustrated people during lockdown, creating listener-driven programming across borders. In this sense, the soundwaves of solidarity extended beyond the physical borders of cities and towns, and the radio's virtual chat room became a meeting space for audiophiles and cultural activists alike.

Galvanising listeners into action, the radio played an integral role in the Palestinian struggle from the early days of broadcasting. In a space where all means of communication are strictly guarded by authoritative regimes, the creation of an independent, community-run radio space provided an alternative universe for knowledge sharing, demarcating a distinct space for new connections and new experiences of listening.

Sound forces us to listen with deepened attention and this characteristic lent itself as a strategy: on 10 May 2021 Radio Al-Hara protested against the evictions in Sheikh Jarrah with complete silence. While protesters took to the

streets, chanting and clapping, all around the world from Cape Town to London, Jerusalem to New Delhi, other community radios joined Radio Al-Hara in their sonic protest and the collective action evolved into an act of global solidarity culminating in the 72-hour continuous stream towards the end of May, under the title 'Sonic Liberation Front'.

The contribution of musician and sound artist Dirar Kallash is also worth noting. The artist made it his daily mission to 'collect' sounds of violence and aggression and produced a piece transforming these sounds into music, which the radio transmitted on its airwaves. The transformation and neutralisation of sounds of violence, and their manipulation to become less harmful to the listening ear, is an implementation of sonic agency by the Palestinian artist – and a coping mechanism for many others.

Conclusion

The arrangement and organisation of sound is a tool for sculpting society. In the case of the May Uprising, Palestinians drew on their sonic agency to mark the territories and boundaries that their bodies occupied in the contested spaces of historic Palestine with the tactics of singing, chanting, screaming and noise disruption.

Music and sound became a source of daily sustenance – fuelling the will and energy of protestors – while also helping organise protesters into unified communities. Sound became a mass activity used to oppose the occupiers – their aggression – and to silence the violent sounds of military machines and angry mobs.

As the usual sounds of daily rhythms like commuting to work, the calling of street vendors and the hustle and bustle of the cityscape changed under the hostilities the Palestinians faced, they could not remain silent and resorted to

the most basic tools of human communication: that of the vocal cords, alongside the mobilisation of the body through movements reverberating with sounds. In the absence of weaponry, the unseen and increasing volumes of the soundscape helped counter the violence of the colonial war machine.

The Sound of Temperature Rising
Christine Sun Kim
(2019)

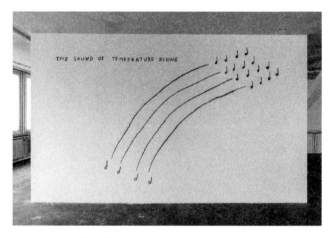

Acrylic on wall adapted from 2016 charcoal-on-paper drawing. Edition of 3, 1AP, 115.75 x 196.75 inches. Installation view, PS120, 2019, Berlin, Germany. Courtesy of the Artist and François Ghebaly, Los Angeles. Photo: Stefan Korte.

I conceptualised *The Sound of Temperature Rising* while pregnant with my first child, during a stretch when I felt hot all the time and couldn't sleep very well. This was also during the rise of Donald Trump and the heated political atmosphere he brought with him. Persistent droughts, floods and storms were marking the effects of climate change and a warming world. I felt these different kinds of rising temperatures intertwining, and used an open-ended musical notation to capture the feeling. When I draw musical staff lines, I use four lines instead of the standard

five, which references how staff bars would be signed in American Sign Language (ASL) as four fingers pulled across the front of the body. Like my other mural and billboard works, I want the scale to actively impose Deaf people's existence and culture into the everyday lives of hearing people.

Words Are My Warders
But Don't Keep An I On Me
(Words Are My Worders)
Daniela Cascella
(2023)

Again my lack of voice morphs neurosis in new roses.
Again recall, repeat, sing: the song I once wrote and
burned, a verse from the broken song never recalled as
one, it says: today my lack of voice morphs.

My neurosis in new roses, roses.

Today my lack of voice morphs neurosis in new roses. It
might have been a verse from a song, written and burned,
singed, it must have been song, singed, sung, sunk, en,
now, into the depths of a past now floating back to sur-
face. It must have been a song never complete, a com-
posite song, monstrous, chimeric, ever shifting and ever
present.

Where is the song heard. How is the song csited (cited,
sited). In shards and layers of words from the depths of a
past, from the outer edge of a buried age.

The new roses in the never-complete, never-completely-
recalled song are old: they grew, knotty and unruly, among
other plants in the magic balcony of my childhood, a site
full of wonders at the back of my grandmother's small
flat in Southern Italy. First, there were the sensitive plants.

Folding and dropping when touched. Sensitive plant, humble plant, Touch-me-not, those plants sang. What do they sing in my ears, in those later years now? They sing. *Touch me not, touch me not, come back tomorrow. Sing to me. For you sing. Touch me not.*

In the same balcony, hiding mysteriously among the plant pots, there lurked the tortoise. Old and big, rescued by one of my uncles on the side of a busy road, so the family story goes. In my childhood eyes and understanding, the tortoise had materialised there as the severe guardian of the touch-me-nots and of the roses. Her, and her slow pace, manifested a manner of being-as-staying that did not fret but stopped and considered, each of the thousand wrinkles in that wise ancient face holding a fold of time kept, given back in petrified stares that seemed to invite quietude and long times, a measured pace, a solemn presence. As she slowly ate salad leaves while keeping watch, I knew the tortoise was there even when hiding. I thought at night she sang. Sing to me, tortoise. *Oh my heart shies from the sorrow. Sing to me. Touch me not. Oh my heart shies,* her head shied too, like the touch-me-nots: all the creatures on that balcony seemed to invite a movement toward quiet, inward places. *Sing to me, let me enfold you.*

Oh my heart, finally, the roses. Oh my heart, now let me enfold you. I will not tell you of those knotty old roses, growing unruly in pots on the magic balcony, their thorns and petals conjoining beauty and danger, fascination and risk. I will not tell you of those old roses, knotty props for insidious cobwebs that would gleam and quiver in the breeze after the rain, echoing again the coupling of danger and beauty in their gossamer geometries. Touch me not, the leaves of the sensitive plant fold in, the head of the

tortoise retracts, the cobwebs are blown away and the spider retreats. In this pervading retiring movement what is left are those roses that I will not tell, will not sing and yet they're there, as the verse from the forgotten singed song comes back and not in full, renewing today my neurosis in new roses that are old, a sense of presence in mystery and beauty, beauty and danger, danger and song, danger, dancer, now dance the song that morphs my neurosis in new roses.

Roses I become or mist in a field, at that threshold hour of the day not quite twilight but a mysterious morphing passage when all sounds fold and the stillness quietly admonishes, as if the tortoise spirit of the balcony had come back, humming its song from the outer edge of a buried age, never entirely remembered. The song would be sung in that morphing passage, in presence and forgetfulness, in broken verses, is this a wave breaking in a song with no name, voice with no face, song of no name, in disjointed vocalisations shifting so now I want to choke, want to laugh, want to smash this microphone want to crash, I did all my best to smile but I'm in pain and I sing, bleeding I sing, but the song is not there or at least, not entirely.

Not sure what I am tuning and turning into, now it is the depth of night. Soon again it will be time to sing and I will not sing, those words will sing me, sing to me let me enfold you. Lips curled, voice astray, the rose arose into another song, the song of Elfriede, where the edge of my voice bleeds. My edge, my margin, my site, has tears and frayed edges. Situs in Latin is site as well as dust, mould, detritus, which deposit in a place across time. To site is to be with residue, impure. My margin is where boundaries between siting and citing, between being

and reference, dissolve. I yearn for csiting that sites and cites, that shifts away from pre-validated sources as fixed frameworks of legitimisation, and sites itself, entangled and monstrous, claiming its singular being, citing words that came before, no matter how obscure and out of sync they may be. Csiting I cite and site, a porous way of being me not all me, quoting and placing, repeating my self and my words from other times, inhabiting them slightly shifted, self and other. Sometimes the words I csite are not written but spoken, then heard in a page, csiting is listening is transmitting. Csiting I write after listening to Elfriede Jelinek's Nobel Lecture, in part from memory, in part from what I wrote before with her not all her, with gaps and missing links, on an aural margin where writing enfolds telling, speaks with its subjects. I hear the subtle voice of prose: a shift from the touch-me-not admonition of a text to a voice, to the inscription of a voice in let me enfold you, where writing is heard in a telling. Listening to her speech sounded a cadence inside my perception of writing in and out of the page, enfolding radiance and discourse, presence and concealment. The subtle voice of prose, the voice of a page is not a lyrical ornament, just because it cannot be summarised or captured does not mean it is devoid of substance. My commentary to this most profound and elusive piece cannot be on the margins but inside, incsite. Where is commentary to a recorded speech? Where is the csite of a spoken text, loaded and ephemeral? It is in the residues which listening holds and releases, holds and releases. For some time I inhabit it, for these pages I transform it, for ever I am transformed: into my fundamental cadence. The subtle voice of prose had better remain unsaid, unsaid and groundless, groundless but not without grounds. I whisper it back, like the impression left by the telling of a story, by the playing of a record.

It unfolds it the sense of being enmeshed in histories of reading, in enfolds states of voice, states of mind, states of mine and the mine is deep, some of it unmapped, some of it dark, some of it with precious stones, some of it with dull rock and moss and useless damp slippery surfaces. I have dwelled there for long times, sometimes I have slipped. I never had a voicemine proper, I had to construct it, aware of the workings of rhetoric, artifice, assembling words heard and connected by kinship, many voices, all mine. Broken material I have at hand, its cadence is never a frame but a heartbeat, core not score, heart not instruction. Listen. Some time ago, having heard again my song, I disappeared. I wanted to sing the song, not say what it is. Is singing the gift of curling up, curling up with reality? What happens when there seems to be little real, realevant to sing; or when another type of reality must be sung, one which is not current? My reality, my song is no formal thing. Sing? The song can't be held in one style. The song that is another song cannot be tidied up and neatly arranged, drawn everywhere so tight and buttoned everywhere so thick. Unruly, it tangles up with the words of other writers, thinkers, singers, and with older words of mine. How many times were these words retold, to make myself heard in that low hum, the subtle voice of prose. I hear its hum in voices in books, those whom I can talk to without worrying about the right style, intent instead in finding kinship. The song may sound like an abolished bibelot of sonorous inanity, in fact it tells me my words. It's me not all me, many voices, so they are, unruly, untidy, more echoes, a disturbing song, flip of a book, half-slip of the tongue, rhyming words as much as rhyming a disposition with that of another, the fractured voice of understanding, the same and not quite so. Words are my warders but don't keep an I on me. Words are my

84

worders. Listen. Here is what a wise reclusive one once said to me: *What should remain, is always gone. Still, you must carry something for a long time, learn to be still, on site, csiting. Sometimes even a short sentence holds a long arc of time between one word and another. This is the portion given to you and you must attend to it, in the most dedicated manner, small as it may be. Get there late, be demanding to your words, better to make them difficult to publish, than avoid going to their extremes. There will be nothing left, nothing but a rose, a hum, a song.* I cannot change much. I can transmit, transform this faint hum. It is cold here, it is the depth of night. So what is left to one, nothing but a rose, a hum, a song.

If only I could take some deep breaths from these speech-less lungs, blood-filled lungs. If only the sound could be deafening. But the low hum. On the evening when my mouth started bleeding it was blood from the mind, and from the cut on my throat, blood of yearning, flowing, flooding. This is when the inner singing begins. When I have no voice, this is how the song begins, in its uneasy rhyme, and wouldn't it be easier if I'd been given a catch-ier one? How about the other voices? Oh, those are smart. Very smart. They have seen a lot. Seduced, sung. Do not assume that because this voice is silenced or out of tune, it ceases to exist, to yearn. So it sings. Remember, it sings, not I. Remember the day I understood that 'to sing' does not sing, 'to write' does not write, and 'to bleed' does not bleed; and learned to trust words for what they are, how they sing. Perhaps now the song should begin in the tune of recalled roses. The song should be sung in the pitch of voice of someone stitched inside a dream, and no doors. Lock all the fine rounded words inside, no doors. Sing clipped beginnings of song, with stitched lips. Sing, de-spite stitched lips: will anyone exhume me from beneath

these layers of history, no, not exhume, exhaust. Exhale? Song, you escape me. You say no, you are tired, you quieten. Let me enfold you and I faint, fall, and in my fall I hear, my lack of voice lack of words taking you away. So it ends and begins with no whole song, with a cadence, shall I sing, with the rose, the hum, the song, as again today my lack of voice morphs neurosis in new roses.

Works Csited, Voices Heard in Reading

T. Buckley, 'Song to the Siren', in *Starsailor*. Straight Records, 1970.

D. Cascella, *Singed*. Equus Press, 2017.

D. Cascella, 'Flowing, Slow, Violent – A Fantasy', in A. Gallix (ed.), *We'll Never Have Paris*. Repeater, 2019.

D. Cascella, *Nothing As We Need It*. Punctum Books, 2022.

D. Cascella, *Chimeras*. Sublunary Editions, 2022.

E. Jelinek, *Her Not All Her: On/With Robert Walser*, trans. D. Searls. Sylph Editions, 2012 (2004).

E. Jelinek, *Sidelined*. Nobel Lecture 2004, Nobel Prize, Stockholm, Sweden, Nobel Prize, 2004.

This Mortal Coil, 'Song to the Siren', in *It'll End in Tears*. 4AD, 1984

Atlantis Anew
Daphne Oram
(1960)

We have also soundhouses, where we practise the healing powers of sound; where we analyse each human being's innate waveform and induce those harmonics to resonate which have fallen out of sorts; where the criminal is put into a harmless, restful sleep until his mental powers have come to terms with themselves and he is again in harmony with mankind; where man and beast are given the means of communication, one to the other, so that man despises not the animal kingdom, nor any other form of life, no, nor even the 'inanimate', but humbly learns the wisdom derived from contact with another aspect.

Here we learn the harmonic series of the elements, the cycles of the years, the oscillations of the tides and the induced resonances from those forces far out in space. We explore the sounds which move boulders, the overtones which transmute the metals, but moreover, we acknowledge the wavelength of our own time and respect the existence of beings without that time, finding thereby means to produce summation tones penetrating the very fundamentals of these worlds beyond our frontiers. For here we excite by the subtle higher frequencies the inner consciousness of man linking him, in truth, with the infinite timelessness of that still point where all is comprehended.

Translation is a Mode =
Translation is an Anti-neocolonial Mode
Don Mee Choi
(2020)

As you may know, the first half of the title is from Harry Zohn's translation of 'The Task of the Translator' by Walter Benjamin.[1] The other half, I hope, is its twin – a retranslation, a radical hybrid of Benjamin's brilliant concept and an anti-neocolonial stance I have come to choose over the past fifteen years of translating contemporary feminist Korean poetry.

I am not content to just go from Korean to English. I am not content to uphold the notion of national literature – the notion that literature outside of the Western canon is always bound to national borders. What this implies is that the so-called national literature simply needs to cross linguistic and national borders, as if such borders are entirely ahistorical and apolitical. Whenever poet Kim Hyesoon is asked whether her poetry represents her country – a question that is rarely asked of a poet whose work is perceived to be rooted in the Western canon – she never fails to answer that her poetry comes from the Republic of Kim Hyesoon. I want to make impossible connections between the Korean and the English, for they are misaligned by neocolonial war, militarism, and neoliberal economy. The two languages have very little in common linguistically, yet they are of one tongue, almost. Because in a neocolonial zone, as Deleuze and Guattari have already noted,

[1] W. Benjamin, 'The Task of the Translator' in *Illuminations*, trans. Harry Zohn. Harcourt Brace Jovanovich, 1968, pp. 69-82.

'there is no mother tongue, only a power takeover by a dominant language.'

Ingmar Bergman's film *The Silence* (1963) opens with a scene on a train in which Ester, an ill translator, coughs up blood. The boy is Johan, a son of Ester's sister, Anna, who is not a translator, and therefore not ill. The only time when Ester the translator is not coughing up blood or deathly ill is when she is typing up her translation or taking notes while she's reading. And we are also introduced to Bergman's made-up language posted on the glass window of the cabin: NITSEL STANTNJON PALIK. Little Johan points out the foreign words to his translator aunt, Ester, and asks, 'What does it mean?' She answers, I don't know.' They are travelling in a foreign country, and an impending war or military takeover is suggested by the images of tanks and men in military uniforms with berets and sunglasses at a town called Timok.

Bergman's genius lies in the use of mirrors throughout the film. I see Bergman's mirrors as sites of translation, deformation zones. One scene takes place almost entirely on a large mirror in Ester's room. Soon after their arrival in Timoka, Ester, needing more drink, has called the hotel waiter and asks him whether he speaks French, English, then German. The framing of the shot is such that we have a close-up of the waiter's face, outside the mirror, and Ester is seen standing reflected in the mirror, holding an empty bottle of booze. The waiter's mouth moves but the sounds he utters are silence with occasional incomprehensible jibberish. Obviously, he's speaking a foreign language. Then, miraculously, the bottle makes its way into the hands of the waiter, outside the mirror. This miraculous act, taking place in the mirror, is an act of translation, a translation performance. It's only natural that the translat-

ion is conducted in the mirror, for it is a site of various reflections, languages, a site where things are already mirrored, re-represented, a site where language: 'goes from a second party to a third party, neither of whom has seen.'[2] Like translation, Bergman's mirror is a site of mapping. Foreign words appear first posted on the glass window of a train cabin, then spoken foreign words are exchanged in the mirror of a hotel room. And what moves across the mirror is also a glass, an empty bottle. The clear bottle, like silence, like jibberish, is a glass among glasses, a sign among signs, language among languages.

Kim Hyesoon's genius also lies with the way she uses mirrors. In her poem, 'Memories of Giving Birth to a Daughter', crossings take place through mirrors, they are zones of intensities through which an intensity passes:

I open a mirror and enter,
mother is inside a mirror, sitting.
I open a mirror and enter again,
grandmother is inside a mirror, sitting.
I push aside this grandmother mirror and step over a doorsill,
great grandmother is inside a mirror, laughing.
I place my head inside great grandmother's laughing lips,
great-great grandmother, younger than me
turns around inside a mirror, sitting.
I open this mirror and enter,
enter, and
enter again.
All the ancestral mothers are sitting
inside a darkening mirror,
and these mothers mutter and call in my direction,
'Mommy, Mommy'.[3]

[2] G. Deleuze and F. Guattari, *A Thousand Plateaus*, trans. Brian Massumi. University of Minnesota, 1987, p. 77.

3 Ch'oe Sûng-ja, Kim Hyesoon and Yi Yôn-ju, *Anxiety of Words*, trans. Don Mee Choi. Zephyr, 2006.

Mirrors have been long used in Korean shamans' rituals as armour, to intensify energies, to induce trances or to light a path to the underworld during spirit travel. Within the oral tradition of Korean shamanism, the realm women were expelled to, women were free to express and explore their identities. It was the only zone in which women, as performers of rites, songs and storytelling, were not subservient to men. In this zone of shamans, the lowly outsiders, the spoken and written hanguˇl, thrived. So Kim Hyesoon's mirrors derive from a historically and linguistically expelled zone. And Kim points out that this was where women could redefine their prescribed identities through shaman narratives, such as 'Princess Abandoned'.

The place Princess Abandoned 'travels to via death is a place of death within life . . . a feminine space of creation. It is hyonbin'. Kim explains hyon as: 'closed eyes therefore everything is black and bin as a signifier for female reproductive organs, a mouth of a lock, a valley, a mountain spring . . . inside this dark womb the possibility of all life is held. At that place patriarchy, the male-centered thing breaks, the universality of all things breaks.'[4] I call it a place of women's chorus (not to be confused with KORUS, which stands for Korea-US Free Trade Agreement). There is another layer to Kim Hyesoon's expelled zone. While Kim Hyesoon was working as an editor she had to go back and forth between the publishing house she worked for and the military censors. Many of the manuscripts were handed back to her all blackened with ink. I think of Kim Hyesoon's mirrors as shields. Her poems also induce in me a trance-like state because, afterwards, I can never re-

[4] Kim Hyesoon, *Mommy Must Be a Fountain of Feathers*, trans. Don Mee Choi. Action Books, 2008.

member how I translated her poems. Most importantly, Kim's mirrors are translation surfaces – they house mothers with motherless tongues, making endless crossings from one generation to another, from woman to woman, from language to language, creating what Benjamin calls an 'embryonic or intensive form'.[5]

*

I became a foreigner when I was a few years older than Little Johan. We were fleeing from the US-backed dictatorship of Park Chung-hee, which began in 1961 and came to a halt in 1979 when he was assassinated by his own head of intelligence, only to be replaced by the even more brutal dictatorship of Chun Doo-hwan.

I could instantly recognise Bergman's made-up jibberish language because that is how English appeared to me when I was growing up in South Korea. I pretended to be a foreigner, pretending to write in English, because I thought my father, who was frequently away from home for work, was a foreigner and wanted to be like him. What I wrote was pure jibberish. So jibberish, foreign words, incomprehensibility was my very first encounter with 'intensive form'. I pretended to be a foreigner even before I really became one. As a foreigner, as foreign words myself, I seek incomprehensibility – a mirror image of myself. I seek mirrors through which I can also traverse, in order to map out the neocolonial history of my home, to translate myself. Like Ester in The Silence I also live inside the mirror, the intensifier, the site of my anti-neocolonial translation. Mirrors may be my very own cubby-hole.

[5] Benjamin, 'The Task of the Translator', p. 72.

My encounter with contemporary Korean women's poetry happened about the same time as my involvement with an organisation called the International Women's Network Against Militarism, which is made up of students, teachers, researchers and grassroots activists from Okinawa, Japan, South Korea, Hawaii, Puerto Rico, the Philippines, and the US. The US members make up a group called Women for Genuine Security, which is based in Oakland. My primary role in the Network was to translate and interpret for South Korean activists and survivors of military violence and sexual exploitation. At the Network's third international meeting in Okinawa, Japan, in 2000, the Network members first articulated what has since become a core part of our approach: the idea that 'interpretation is a political act'. We were able to arrive at this perspective because of the knowledge the women in the Network had been accumulating and creating since the first meeting in 1997 – the knowledge that not only our lives and struggles are interconnected, but that our languages are also interconnected by histories of imperialism, colonialism, and militarism, and by increasing economic interdependence. So this experience in the Network helped me to realise that translating Korean women's poetry is also a political act. It was no accident that I was translating Kim Hyesoon's poetry. Kim Hyesoon was an active member of a feminist organisation, Another Culture [또 하나의 문화], and much of their activism overlapped with the activism of the South Korean women in the Network.

I don't think it is redundant to say that many of the weapons against humanity are manufactured here in the USA. The empire's belly is perpetually bloated by war. It is bombing in Iraq, Afghanistan, Pakistan, Yemen, Somalia, Syria and Libya. And Nick Turse reports in the *Nation* that its Special Operations forces carry out countless missions

on a daily basis in 135 nations, which is: 'roughly 70 per cent of the countries on the planet'.[6] Neocolonial-neoliberal militarism is manufactured in the USA. This is why I think 'Translation is a mode = Translation is an anticolonial mode' is relevant to all of us translators, editors and publishers, whether we are from here or elsewhere, whether we are foreigners or not, whether we speak silence, foreign words, jibberish or English. I speak as a twin.

[6] N. Turse, 'How Many Wars is the US really Fighting?'. *Nation*, 24 September 2015.

Sweet Tooth
Elaine Mitchener interviewed
by Hannah Kendall
(2020)

Hannah Kendall: Elaine Mitchener is one of the most important and iconic artists working right now. Born and raised in East London and of Jamaican heritage, Elaine is a contemporary vocalist, movement artist and composer. In October, Elaine will premiere *On Being Human as Praxis* at Donaueschingen [Music Festival], which brings together five new works by Afro-diasporic and European composers inspired by cultural theorist Sylvia Wynter.[1] And in 2021-22, Elaine is one of fifty selected artists whose work will feature in the British Art Show's touring exhibition. It looks like you've got quite a lot on for 2020.

Elaine Mitchener: It's been a strange one! For those of us for whom having an audience is really important – an intrinsic part of what we do – not being able to present in front of an audience (speaking for myself) has really been rather traumatic. I hadn't understood how much it had affected me and how hard it was until quite late, maybe a month or two ago. I was saying to George Lewis that I felt concussed: I realised I had been suffering this kind of concussion. The last time I actually engaged with a live audience was on 8 March, performing *Sweet Tooth* in Bergen for Borealis Festival.

[1] *On Being Human as Praxis* was filmed without an audience in October 2020 due to the pandemic.

HK: What I take from your work is that you're not pre-senting in front of an audience – it doesn't even really feel right to call it an audience. – they're fellow participants in your work: it's a two-way street. Such a huge part of your practice – the way that you choose to work and choose to devise your works – is highly intensive and collaborative, working with other people from beginning to end, which maybe ends with those participants in the space.

EM: They're not the audience, they are the fellow travel-lers of the piece. It doesn't happen without them. That sounds a bit banal because obviously concert halls exist for audiences and musicians to perform in front of them. But, as you've experienced in my work, it is about drawing on those energies and taking people on a journey, because I guess what I want is for them to feel as engaged and as exhausted as I am and those who are working with me. I'm drawing on lots of different kinds of stimuli. And the energy of the room, the energy of the audience is vital. I guess some of that comes from a church upbringing act-ually – I've been thinking about this a lot recently because I don't attend church anymore, while the rest of my fam-ily do.

HK: Do you want to talk about that? I still go to church after a hiatus. I didn't know about your relationship with church, but it's such a huge part of my practice and my day-to-day. I went to church because that's what you did as part of being a Caribbean family: you go to church on Sunday and I did that my whole life and went to a convent school. Then I took a break from that for the whole of my twenties but I came back to actively engaging in having a spiritual life.

EM: That's really fascinating because it's not something that is talked about, particularly in the area of contemporary music. But my work is coming out of that experience. My dad was quite roguish – he was quite politically militant – so we were given this heavy diet of Nyabinghi and Rastafarianism and I knew more about that than I knew about any other religion. Every Sunday was hours of U-Roy and Max Romeo and heavy dub music. And my mum reclaimed her faith: she was raised in a Seventh Day Adventist church, and one day she started to go to church on Saturdays. So Dad was like, 'take them too, keep them off the street!', so we were taken to church and it was predominately Black. It was the first time we saw young Black kids – who were our age, but phenomenally talented musicians – get up and speak and lead, and address a large audience, a congregation. I'd never seen anything like that before. Never.

HK: How old were you?

EM: I would have been about ten or eleven. And I really enjoyed it. We got into it. I'm the youngest of three, so my brother and my older sister, who has a learning disability, came with us: it was the three of us with Mum and we started to get really involved. Of course my dad was horrified because he was like: 'You haven't lived. Why are you dedicating yourself to this kind of pious life when you haven't got anything to reject.' I always liked singing. I went to a state primary school, an elderly lady turned up one day and my teacher asked for volunteers– every child should be able to have access to learning music – and I just happened to stick my hand up before a number of others, and four of us were selected and this thing called 'learning music' was presented and I made the fatal mistake of thinking, 'oh this is easy, this music thing'. But going to

97

church and hearing music-making of a different level was shocking. There were people who could really sing and could play, there were families where they could all play, they were multi-instrumentalists. And playing music that was harmonically very progressive and sophisticated, a lot of it inspired by what was coming from the States. And I thought, 'wow, I'm rubbish. I've got to up my game', you know? I can't remember how I ended up singing. But I was asked to sing a special item for an afternoon youth programme and I enjoyed it. It was terrifying. And from then on, I just kept singing.

HK: You mentioned performing music from the United States. When talking about Blackness or the African diaspora, it's almost as though it's assumed that it's about African-Americanism rather than Black Britishness. What I love about you is that you seem to be carving out something unique and very specific that is to do with the Black British experience. I wonder if any of that came from your church life?

EM: It was home and church. Because my parents were politically engaged: although they met in London, they took it upon themselves to teach us about Jamaican history, what happened in terms of colonialism and their experiences of being immigrants in London in the sixties. A lot of the churches – whether Adventism, Pentecostal, Church of God – are Black-led. That's because a lot of people from the Caribbean, who wanted to continue going to church, saw that they were segregated and that they were not welcomed in the white churches.

HK: This is blowing my mind because I don't think I really actively considered the importance of being specifically in a Black church and being around Black leaders. My mother

is a head teacher and very much a confident leader and probably the most important role model for me but actually those formative years of seeing Black people thrive in a church setting is a huge part of spurring myself on in working within a predominantly white environment, a white space. I'm just now thinking maybe that's a huge part of it.

EM: Well, you don't realise these things until much later on and that's why I reflected on it. As I get older, I'm thinking, 'wow, they're the iconoclasts, the people who paved the way.' They made the sacrifices. A lot of them were leading in church, and may not have had jobs which were leadership roles. That's not because they didn't have the skill set or they weren't intelligent enough: it's because of racism and because of prejudice, because they're also a different generation. Then I observed Black people my brother's age or slightly older, going to university and getting professional jobs and coming to church. So if you're a youngster and you're seeing that, you think: 'I can be a doctor. I can be a teacher, I could be a head teacher, I could be a professor.'

HK: But Elaine, I do not know any other person doing what you're doing. It's interesting how that has informed you. Could you tell us a bit about *Sweet Tooth*?

EM: *Sweet Tooth* is an examination of the relationship between the UK and the Caribbean through the Atlantic sugar trade and its legacy, which we are all living through now. Sugar as a substance is incredibly addictive. It's so bad for you and it's incredible when you think about how many lives needed to be lost in order to feed that addiction from the late seventh, eighteenth century: the millions of enslaved Africans who lost their lives to cultivate cane,

turn that into sugar, to feed an addiction in a country 5000 miles away – and those people who consumed it wouldn't care how it arrived as long as it was there.

When my dad died, I was thinking about stuff that connected us and we both shared a sweet tooth. I used to work for the Royal Over-Seas League Annual Music Competition and they had a clubhouse on Princes Street in Edinburgh. On my first trip there, my manager, who became a very dear friend, said: 'You like sugar, right? There's a national sweet in Scotland called tablet – it's like fudge but crumbly.' He bought some for me and I had it and I was addicted. I gave it to my dad and he was addicted. So to cut a long story short, I became his tablet dealer: every time I went to Scotland, I had to bring back tablet. He was very fussy about it: 'Not that last batch. It was rubbish. Get the other one.' So when he passed I started thinking about our shared tablet addiction, and how Scotland became wealthy. In England, nobody talked about what happened in the Caribbean: my education about the slave trade was about what happened in North America so I became quite angry about how many generations had been misinformed and ill-educated, and that's why we have these racial tensions now.

So *Sweet Tooth* looked at the system of the sugar trade, which was the zenith of capitalism: if you can successfully not pay someone because they are not considered human, they're chattel, then you've saved yourself shitloads of money. By enslaving people, they have no rights: they're not human, they're just a commodity. And they're there to work, they're machines within a corrupt and unjust system. With *Sweet Tooth*, I wanted to honour their humanity. We come from survivors – and that, for me, was something to celebrate and be proud of. Out of this horrendous holocaust – and this is world history – an incredible culture

was born, which is shared around the Caribbean. Across the Caribbean, there are variations on a theme but it's the same thing. It can be the food, it can be a phrase: 'You call this that? Oh, we call this that.' It can be the big drum tradition, hair style, just a way of being – it's all shared. For me, that is something to celebrate. I didn't want *Sweet Tooth* to be a piece about victimhood although there were millions of victims. There were also slave revolts, successful ones. There is this misconception that the abolitionists in the UK caused the end of slavery. No: enslaved Africans claimed their freedom.

HK: It's interesting that it was the tablet in Scotland that spurred this all off because no one knows about the Scottish involvement. The wealth of the Scottish Highlands directly comes from the specific region that my family was enslaved in Demerara, of demerara sugar. What's so powerful about *Sweet Tooth* is how it is constantly shifting between these historical aspects that one might not know about in the UK. I find it interesting that you decided to put on the work in spaces that had directly benefitted financially from the slave trade.

EM: The common idea that, 'that was 400 years ago and we've moved on since then' is erasure, it's very dismissive, and we will not be dismissed because actually the UK has benefitted from Black people, our culture; our blood and sweat and tears. And they can't deny that; we're in the very fabric of this society. And when we are vocal about it, it unnerves people. We're not subordinates, we're not subservient, and we're proud of our culture. I just want people to be aware. I want people to acknowledge how the British benefitted from slavery and then we can build a fairer society. We can understand why there are these

inequalities. In the last fifteen years or so, Scotland has kind of come to terms with what it did. The Scottish were the great administrators of the slave trade. Professor T.M. Devine wrote about Scotland and the slave trade, this was over twenty years ago and he was given a very difficult time about it. Jackie Kay, the poet, wrote an excellent article about this in 2007 for the *Guardian*, where she said she didn't know why she wasn't raised with this knowledge, but it's something that cannot be obscured.

Watching the seventeenth-century slave trader Edward Colston's statue being yanked and torn down and dragged into the River Avon, I was just so happy. What I liked about that action was that it was the people of Bristol, white people, who dragged that statue down. I think that was a very important thing to happen. And the police did not intervene – they arrested some people but nobody was charged – and that was wise. We need that understanding and acknowledgment. That's what *Sweet Tooth* is asking for. We premiered it in 2017 at the Bluecoat Arts Centre in Liverpool, which was a major slaving port. The Bluecoat was a school for underprivileged children – the money came from prominent plantation slave owners from Liverpool, so it has a very heavy history. But after we premiered it, I realised this isn't just about the UK, this is about Western Europe: France, the Netherlands, Spain, Portugal, Germany, Belgium. I took it to Norway because Norway was also involved in it. People need to understand their history. Know your history.

HK: I wonder how the participants in your work react to the fact that the wealth of these Western nations is literally built on the back of Black slaves? I've watched *Sweet Tooth* at St George's church in Bloomsbury, London and I think you said that the altar was made . . .

EM: Yes, from ebony wood from Antigua.

HK: The performance in that space was particularly captivating because of the setting – there's something quite haunting and ghostly about it – and the audience is crammed in. I've heard you say that you want the participants, that is, the audience, to feel as uncomfortable as possible. Also your work is not just an aural experience: it's an embodiment. It touches all of the senses. It's multisensory. I can see in the structure throughout your works that there are trigger points where you're actively charging the space in new and different ways that reach those who are participating in your work. One of my favourite moments, towards the beginning of Sweet Tooth, is the way in which you use your body. I don't know if this is right, but it feels as though you eventually contort your body into some kind of windmill, and you're literally driving the air particles that eventually reach the participants in different ways because of how the physics works. I experience the sounds your body makes moving through the air as recreating the sounds of the plantations, since the Caribbean, at one point, would have been peppered with all of these windmills grinding sugar. That would have been a prominent soundworld of the Caribbean and you're bringing it right into the space in that moment.

EM: Thank you. I wanted to highlight and to reinforce the way that people became dehumanised and transformed into a machine, a relentless thing. It was to capture the essence of the shifting of the space and the windmill: but also it's the person that is working it, losing a limb, being replaced; it's exhaustion, not being able to stop. And the attempt to destroy this humanity, this human essence. I had a fairly general knowledge of that period, but not in

great detail so working with a historical consultant, Professor Christer Petley, was really helpful, because then I could use archival material and work with it. If you're a historian, you piece together the historical facts and you can be rather clinical about it. But our job is to animate it, reanimate it, and turn it into something that is visceral and tangible, and that will help people to question systems or to feel something.

When you see those drawings, etchings of how enslaved people were transported, it was a horrific situation: people died on the way, the excrement, the illness. And so, I felt I needed to reference it? So I packed everyone (the audience) in together but they can stretch out, wear their coats and remain comfortable. They wouldn't know, but they are participants: they're travelling, they're in the bowels, they're in the hull of that ship. By the end of the night, they realise that they've been very intimate. They've got their leg or their arm rubbed closely next to someone who they probably don't know. And that's what makes the whole piece very exhausting for people because they don't realise that I have confined them for fifty minutes and they're not going anywhere. Once you were captured and sold on and then placed on a plantation, you weren't going anywhere. That was it for the rest of your life. I saw I didn't actually have to say it, but could do things that referenced what enslaved people were forced to endure physically.

Later in the piece, I asked the other members of the quartet to take and 'play' bamboo sticks. We're doing things on the floor, we're beating the sticks – so the stick becomes the thing that whips someone but then it becomes the part of the machinery, and then it becomes a percussive instrument. So it's subversive.

HK: That's another favourite moment. On the surface, it could just be an interesting sound element: the way the reeds or the bamboo sticks cut through the air sounds great. But actually this whipping sound would have been a very integrated and normalised part of the plantation soundworld, every single day.

EM: The song provides a moment of levity, but even that is curtailed when Jason Yarde starts screaming through his saxophone. It's a form of control, alluding to the slave-holders' control: 'Don't enjoy yourself too much. We're going to stop that.' Towards the end, I'm quoting from the diaries of a major Jamaican sugar planter and slave-holder Simon Taylor, and I play on his paranoia and the fact that he fears he's losing control due to the revolts happening on different islands. I enjoyed that moment because this change is happening: this oppression is not going to last – it's lasted long enough.It points to the future as well. So it's the evocation that I sing at the beginning, which is from a Kumina text, that's evoking the spirits that are going to take that individual and carry them through.

HK: Shall we talk about who you collaborate with – you mentioned the quartet you worked with – and how you work in general.

EM: I love collaboration because you can learn so much. For *Sweet Tooth* I brought on board Jason Yarde who's a multi-instrumentalist, Mark Saunders, who's a free improv drummer percussionist, and Sylvia Hallett, who is an incredible composer but also a free improvisor as well. Really very unique musical identities and we'd never worked together as a quartet, so it was a new journey for us. I could have made it an all-Black quartet, but I didn't

want to do that because that's just a bit too easy. This isn't a Black history piece: this is a British history piece. This is a European history piece. So it needs to reflect that. The choreographer was a long-term collaborator, Dam Van Huynh, who had the difficult job of moving instrumentalists around in a way that looks natural, not like wooden soldiers. The easy thing would have been: I sing and move around and they just play in the background. I was like, 'nah, you've got tasks, we're going to get you to do things'. So it's very much in their bodies now.

HK: I love the way you interact in the work. I don't know if you have notes ahead of the performance of those improvisatory moments – if you know how you're going to have that back-and-forth, that musical discussion. But it doesn't seem that way – it's almost as though it's a live reaction.

EM: I had a particular soundworld that I wanted us to explore and a skeleton, which allows us to develop and be very present. There are certain things that I need them to do, but I don't want them to just feel stuck in a particular musical range. To feel free to explore, but still maintain the shape of the piece – because we have fifty minutes to present it so we can't go off-piste too much. I like to keep that level of unpredictability and I guess that's the improvisatory aspect to me. I like the fact that you never quite know what's going to happen on the stand – 'I'm over here, I should be over there' – you know'? But does that matter, does it really matter? Because it can also open up the more interesting experiences. Or it could be a car crash, but that's also interesting in its own way. But you can't be afraid of that happening.

The Resounding Flâneuse
Ηχώ – Ανάμνηση
Elena Biserna
(2022)

For a woman or queer person walking alone in public space

Walk around, don't pay too much attention on where you go, let your steps decide for you. Focus on your bodily sounds . . .
Your heartbeat,
Your breath . . .

Can you feel them? How do they sound? Are they audible? Are they masked by the sounds of the environment? By the sounds of other bodies?

Listen to how your bodily sounds intertwine with the surroundings.
Listen to how the sounds of the surroundings intertwine with your body.

Look for a resonant place
A tunnel,
A passage,
An arcade . . .

Try to whisper your name
Try to speak it a bit louder
Try to say I

> *When I'm writing prose,*
> *I am trying to make you understand why I am screaming*

How does your voice propagate in this space? Is there an echo? Is your voice coming back to you in a different shape? Resounding in the environment?

Ηχώ

> *How do you swallow the scream?*

Does this echo carry the trace, the memory of your body? Of your throat? Of your mouth?

> *The scream*
> *of an illegitimate voice*
> *It has ceased to hear itself, therefore*
> *it asks itself*
> *How do I exist?*

Do you remember the last time you opened your mouth and screamed in public space?

> *Sometimes, you have to scream to be heard*

Ανάμνηση

If you close your eyes, how many screams can you remember?
Are they screams of fear? Are they screams of power? Of anger? Of joy? Of pleasure? A choir? Collective voices screaming together?

Focus on these voices, recall their resonance, absorb their energy.
Try to say we

I believe our imaginations —
particularly the parts of our imaginations that hold what we most desire,
what brings us pleasure, what makes us scream yes —
are where we must seed the future,
turn toward justice and liberation,
and reprogramme ourselves to desire sexually and erotically empowered
lives

If all these voices were with yours, now, what would you like to scream together? Can you scream it alone, imagining that all these voices are with yours?

Mais le temps vient où tu écrases le serpent sous ton pied,
le temps vient où tu peux crier, dressée, pleine d'ardeur et de courage,
le paradis est à l'ombre des épées

Exit the tunnel, the passage or the arcade.
Keep walking around. Keep listening to the echo. Brings it with you.

The echo of a collective voice, a seed to grow the future.

A city full of screams, imaginations, desires, pleasure.
Can you imagine it? Can you remember it? Can you start voicing it?

Athens, June 2022

With, in order or appearance:

J. Wylie Hall (ed.), *Conversations with Audre Lorde*. Mississippi University Press, 2004, p. 169.

A. Watta, 'Where do you put down the scream?' in *Lustre of a Burning Corpse*. Ukiyoto Publishing, 2022, pp. 26-27.

A. Rich, 'Cartographies of Silence', in *The Dream of a Common Language: Poems 1974-77*. Norton, 1978, p. 17.

A. Ronell, 'Introduction', in V. Solanas, *SCUM Manifesto*. Verso, 2016, pp. 3-4.

a.m. brown, *Pleasure Activism: The Politics of Feeling Good*. AK Press, 2019.

M. Wittig, *Les Guérillères*. Éditions de Minuit, 1969, pp. 158-9.

Acoustic Attention, Deep Affiliation and the Work of Listening
Ella Finer
(2020)

Deep in this writing, in my speech, there is a swan's heart beating. A heart recorded by Richard Ridgeway, the owner of a wildfowl refuge in County Cork, Ireland, fifty years ago. We are not far off the alignment of years. A half-century-old swan's heart. A heart I cannot unhear; a heart now beating through everything I write about. Why? The beat reached me in a particular present tense four years ago and has suspended me in a continuous present of its own making. While I am listening/writing with the swan's heart I keep hearing it in unexpected places: beating the bounds (so to speak) of an acoustic commons that is the interconnected world sustained through the sharing of sound, forces, energies, vibrations. Because this swan's heartbeat is still revealing to me – through the category of wildlife recording – something about sound that is wilder than can be contained by category, definition or tense. Maybe even wilder than the record will ever/can ever allow us to know. The record in the audio archive being as much a container as the subject area the record falls into. Or out of. Because this record exposed for me – in the relation it documents between the swan and the recordist (and in the way it attunes my listening to it and around it) – how the beat of our bodies acoustically scales proximity; how the beat in relation collapses distance.[1]

My approach to thinking about acoustic attention is

through this beat, the beat that is a kind of moving vessel in itself: the beat that ushers so many associated sounds into its own tense. The beat that our aurally diverse bodies will always make the dimensions of differently, our feeling for the beat never completely transparent to each other. And surely this is part of the power of the diverse? That we don't always have to make sense to each other. We can feel out the words, the vocabulary for our aural experience, and it is difficult because it is obscure. Let's let it be difficult, hold the space for obscurity. When I feel I am in the present with a sound, I am close by, close at ear. Close at hand, at heart, even while my ear pulls sounds from far away into a new focus. The temporality of listening is also about how we receive the sounds, how we take the time, our time, to listen. In my experience, with these ears, I miss things as I pick up on a sound (a beat, a word, a cry, a pitch) and attend to it with a far larger temporal attention span than the time span of the sonic cue. A beat, a beat in the hearing – but the two events (of the sound and its hearing) do not occupy the same temporality. I love this as much as I am confused by it. That a detail can last a lifetime. This is sonorous tense. A tense that is elastic time. Peculiar. As soon as I say now it is not.

Imagine, for a moment, we are deep in the galaxy swirl, among the stars. Close up we take time with the detail, but we cannot apprehend the shape of the whole, that shape only becomes apparent from far away. The spiral appears

[1] The 1970 recording of the mute swan's heart is categorised as 'Wildlife' in the British Library Sound Archive. There is a significant detail in the recording: the heartbeat going faster as the swan is stroked. I suggest it is this detail of reciprocal affect between animal and human recordist that begins to collapse the category containing the subject.

so long as we have some distance. And while the bigger picture makes new sense of the detail, now the detail is the imagined part. Sound, so much slower than the speed of light, is always also in delay. We sit across the table from each other and all that you perceive of me is in the past. My voice and body different, distanced, by the microsecond.

So when I say I am listening to you now, in the present, the tension inherent in this tense is that my experience of the present is always in relation to what is at distance, what has passed or what may come to pass – acoustic attention (in the form of listening in the present) is a practice of retrieval and anticipation. Details both clearer and obscured, quieter and amplified. We all compose with what we choose to louden to our senses; remixing records pulled from other times as we listen with an ear to the room, the bodies on the floor. You are hearing me speak but may be listening elsewhere, to an elsewhere outside the window, an elsewhere in a daydream, a memory, or your breathing, beating body as what is closest, and most audibly, most tenderly, present to yourself. Astrophysicist Janna Levin, writing about Jem Finer's 1000-year composition *Longplayer* (1999), another kind of beating heart for my lifetime and beyond, gives an example of how time dilates in space by asking us to imagine bodies holding clocks meeting each other, floating:

> If I float through empty space, clutching a clock to reassure me that I exist, I can watch time pass, the relentless ticking marking out breath and life. But if someone else races by clutching a clock, a reassurance of his existence, it would appear to me that his clock ran slowly. If he was moving at nearly the speed of light, he would appear to move slowly, talk slowly, even age slowly, like a broken movie projection. But from his perspective, he was the one motionless in space when I whizzed by. To him it would appear that my clock ran slowly, that my

motor skills dragged, that I aged slowly. There would be no frame of reference to contradict either of us. We'd both be right.[2]

Do the clocks sound as slow as they appear when floating by, attached to others' bodies? What if the floating body in space reached out and pulled the other body close? Would their clocks then tick time together? What if the bodies across the table from one another left the table and held each other tight? Would these bodies now occupy the same temporal frame of reference? Is this what I am listening to – or what I hope for in my listening – when I hear the swan's heart beating time? A rhythmic belonging to one another.

Richard Ridgeway recorded the swan's heartbeat while holding the body close. Suppose it was not a clock I carried to reassure me of my existence then, but another body, a swan's, its heart rate responding to the proximity of my body, responding to my existence. Responding to the strokes, not of a clock but a hand. It is hearing the acoustic scale of the heart that collapses distance. An ear, a microphone to the chest. The recordist Richard Ridgeway invites us into this acoustic relationship. A fellowship of sonorous relation: a reminder we listen with our heart.

*

Listening with the heart is also to place our bodies in the waves, to move in the current while listening to it. As Jack Halberstam has described – in their description of the 'extra musical' about an expanded sense of when/how music happens – this ethos is one of 'being in it while listening'.[3]

[2] J. Levin, 'Time is Dead', in *Longplayer*. Artangel, 2003.

We enfold details into our sense of the moving present and calibrate the temporality of other bodies into our own experience.

Listening is an action that not only brings bodies close, but can dissolve separation. Because when we listen we participate in making the sound we attend to. It takes work to listen – listening is an effort we make, or, we do not.

Something we are now familiar with is the government saying it is 'listening to the science'. One word does so much work here to assure us that due attention is being given, a form of attention that has within it a binding action. Listening brings bodies closer. Listening could stand in here for 'working closely with'.

But if listening is a practice of conscious attunement, of deep collectivity and of practising fellowship (and I am thinking here about Fred Moten's speech 'This Is How We Fellowship'[4]), then listening as instrumentalised by the government is not only a sense co-opted by the state, but a rhetorical wrangling – a violent reduction of the sensorial relationship that is the promise of listening to each other, of being close.

I opened with the heartbeats that have suspended me and taught me more about listening than I ever imagined when I first heard them. And now at this near end point I want to turn to how this is the work of listening, the work that seeks connection and deep affiliation, the work that takes effort, the work that is the time it takes to listen. Be-

[3] J. Halberstam, 'The Wild Beyond: With and for The Undercommons', in S. Harney and F. Moten, *The Undercommons*. Minor Compositions, 2013.

[4] F. Moten, Trinity Church Wall Street Sermon. 19 January 2020 (available on YouTube).

cause listening is giving, gifting, of attention. Giving time, because listening is a gift – is a present – as P.A. Skantze reminds by orienting us (via the OED) to the sonorous as a practice of, 'giving out, service to the work, gift in circulation and capability'.[5]

*

Might turning to listening as work undercut the inherent gift in lending an ear though? That depends on who is offering the ear, and how it is offered. So what does it mean when the government says it is in 'listening mode'? A shorthand ministers have used across myriad issues, from cutting tax credits to leaving the European Union. If it sounds operational this may be because it is – an administration of the optional ear. Listening is no casual action, it is specific – it is selective, while being temporally and spatially plural; it is conditioned by our bodies, the different workings of our ears and the persuasions of our hearts. As the time of social distancing has shown, listening is also what can powerfully collapse distance; it is what brings us closer. It brings our bodies closer.

Scaled-up to the size of the institution that is the UK government, the intricate and nuanced care inherent in listening is unsustainable. Was it ever offered, though, as anything else? Institutional listening forgets not only the physics but the philosophy of attending to each other by ear. Institutional listening is a forgetting how listening is a practice of sustaining each other. The institution forgets because it does not need to remember this; the institution

[5] From P.A. Skantze's description of 'The Sonorous, a study day with Daphne A. Brooks', 13 December 2018, citing the 1611 definition of 'sonorous' from the *Oxford English Dictionary*.

does not intend listening to foster any relationship. The government says they are in 'listening mode'. This is a way of saying we are working in the immediacy of our listening: giving real-time attention in the form of a body on the other end of the line. But such institutional missions reduce this practice of responsibility and reciprocity while not taking seriously the ethics of employing a process that is always selective, that can never sustain an open ear to all.

Listening necessitates care because there is always a selection made in what the listener makes present for themselves and others. When institutionalised, when politicised (because listening carefully depends on picking up on what is important to make present) selection is suspect because selection is spin. This kind of co-opted bureaucratic listening flattens the action and denies the diversity of ways in which to listen and hear.

The success of 'listening mode' as a device, an offer, is in its persuasion as an action of the present tense. Of immediate connection. Of being close enough to speak and be heard. 'Listening mode' produces a false sense of proximity and immediacy to those who offer it. When we listen, however we listen, we take sound into ourselves – the vibrations, the beats. When we listen, we are relative, we are in-relation. What does the state in 'listening mode' listen to? Listen for?

Significantly, there are bodies in Parliament who are always listening – and listening so closely that they take it in turns, only five minutes at a time, to listen to what has been said in the Houses. These are the reporters. Their job is to listen in the continuous present of an intensive fraction, their 'turn' of the whole debate, and then to write up what they have heard alongside recordings. This becomes the reported transcripts of Parliament, published

by Hansard. It is curious that an institution with one kind of practice of close listening built into its infrastructure seemingly forgets that a body's capacity for doing so is temporally limited. In order to record what happens in Parliament, Hansard has relay teams of reporters; their primary job is to listen. To listen and then listen again, acoustically attend in acute detail.

The discourse around institutional listening gives power to the ears who are offering it, when listening is a reciprocal practice. This use of listening also denies the body who participates in conversation differently, who listens with their body, their other senses and may speak in many ways. 'Listening mode' always presumes there will be an ear listening for speech, yet this is a vastly reduced understanding of the diverse conditions of listening and the diverse conditions of hearing. What about the ear that hears shapes, volumes? The ear that hears other dimensions? What about the ear with interference? The high pitch line above everything? Or the metal buzz at the edges? What about the damaged ear? Or what about the parts of the body attuned – the heart listening for beats, the hand listening for the heart?

'Heartbreak is always present tense,' my friend Sheila Chukwulozie writes in an online chatroom as we listen to Dawn Scarfe's eternal dawn chorus in May last year. Maybe this is what I am hearing in the swan's heart – the unbearable heartbreak as something that happens, if you have a heart. The clock of heartbeats – an instrument of the night watch; those of us who take it in turns to listen out so others can rest. Acoustic attention, then, is the work that is a gift; and is so much about listening out for each other in whatever forms we are able, in whatever ways we can.

118

'Our voices reached the sky': Sonic Memories of the Armenian Genocide Gascia Ouzounian (2023)

The following is an excerpt from a longer chapter which explores sonic memories of the Armenian Genocide, published in Soundwalking: Through Time, Space and Technologies edited by Jacek Smolicki (Focal Press, 2023). Starting in 1915 and continuing with full force until 1917, with smaller massacres occurring until 1923, approximately 1.5 million ethnic Armenians were killed as part of a state-led campaign to rid the Ottoman Empire (present-day Turkey) of its Christian subjects: principally, Armenians, Greeks and Assyrians, in a bid to consolidate state power and render Turkey 'for the Turks'. The chapter examines sonic memories of the Armenian Genocide, attending to survivors' earwitness testimonies as a form of 'counterlistening': listening against the narrative of genocide denial that continues to be maintained by the Turkish state. In engaging with sonic memories, it draws on the essential volume of survivors' testimonies collected over a 50-year period by the Armenian ethnographer Verjiné Svazlian, published in its English translation in 2011 as The Armenian Genocide: Testimonies of the Eyewitness Survivors.

Announcing Exile

The first sounds that many survivors recall of the Armenian Genocide are the voices of Turkish town criers who arrived at Armenian districts on horseback, announcing the orders that Armenians should either convert to Islam or be exiled. Nouritsa Kyurkdjian (born 1903, Aintab) says, 'One day, we heard horse hoofs from the street. The town crier, Moukouch, announced, "Listen, hey, people! In twenty-four hours, you must either change your homes or

your religion."'[1]

The survivor Yeghiazar Karapetian (b. 1886, Sasun) remembers the voices of Turkish town criers as emerging against a backdrop of silence and the foreboding caws of black crows. 'On Monday morning, the 29th of June [1915], the streets were empty, no human being was seen: there was neither whisper nor movement,' he recalls. 'Only the ominous caws of thousands of black crows were heard from the tall poplars. At the moment when the sun had quite risen in the sky, all of a sudden the shrill voices of the Turkish town criers were heard in the Armenian districts.'[2] The criers ordered local Armenians to gather with their carts, mules, property and family and report to the local government building; those who refused to obey the order would have their property confiscated and would be 'exiled by force'.[3]

Along with the voices of Turkish town criers, survivors recall hearing the terrifying sounds of cannonade and gunfire as the killings got underway. One survivor recalls, 'At the time when thousands of cannons and guns were thundering over the Armenian quarters, pitiless voices of the town criers were heard from the Turkish districts.'[4] Another survivor, who was seven years old at the time of the events, recalls, 'We heard the cannonade of the Turks. We hid behind rocks. I used to cry out of fear . . . The cannonade sounded like thunder.'[5]

Several survivors recall hearing 'drum and zurna' (the zurna is a reed instrument) as Turkish gendarmes descended upon Armenian villages and towns. These instruments were

[1] V. Svazlian, *The Armenian Genocide: Testimonies of the Eyewitness Survivors.* Gitutyun, 2011, p. 453.

[2, 3, 4] Ibid., p. 83.

[5] Ibid., p. 161.

sounded for several reasons: to signal Turkish presence and power, representing a form of sonic territorialisation; to accompany the celebratory sounds of Turkish victory over the vanquished – and thus a form of sonic triumphalism (as in the song that Shogher Tonoyan heard as her family burned); and to mask the sounds of torture and murder.[6] In *Ambassador Morgenthau's Story* (1918), Henry Morgenthau, who served as the American Ambassador to Turkey between 1913 and 1916, details the various methods of torture that Turkish gendarmes used on Armenian prisoners. 'These cruelties,' he writes, 'were usually inflicted in the night time. Turks would be stationed around the prisons, beating drums and blowing whistles, so that the screams of the sufferers would not reach the villagers.'[7] In the early stages of the Genocide, it was advantageous not to raise alarm and thereby inspire resistance. Therefore, the sounds of drum and *zurna* were sometimes deployed as a military tactic: to mask the sounds of suffering and hide genocidal intentions.

As the killings and deportation orders spread, survivors recall hearing 'turbulent noises' and general 'noise and clamour'.[8] In survivors' memories, these noisy soundscapes are often contrasted with the idyllic soundscapes of village and town life. Many survivors remember their villages

[6] The survivor Shogher Tonoyan (b. 1901, Mush) lost sixty members of her family in a fire set by Turkish soldiers. A common method of mass killing was to gather the Armenian population of a town into barns or stables, soak the building in kerosene, and set it on fire. Tonoyan recalled hearing the anguished cries of those who were burning alive, as well as the celebratory songs of the perpetrators.

[7] H. Morgenthau, *Ambassador Morgenthau's Story*. Doubleday, 1918, p. 306.

[8] Svazlian, *The Armenian Genocide*, p. 528, p. 366.

and hometowns with profound affection and longing, and associate them with the comforting sounds of rivers, birdsong, church bells and festivities.

The turbulent noises of the starting Genocide are also contrasted in survivors' testimonies with the terrified silence of victims. Heghnar Gabriel Ghoukassian (b. 1896, Pasen, Delibaba Village) testifies, 'We were to pass the canyon without any noise or voice. Not a stone would stir under our feet . . . Mothers [were ordered] not to take out their nipples from their babies' mouth, even if the child got choked, so that any crying voice would not be heard. We passed by night, we passed without any noise.'[9] Many survivors report that families were forced to hide or abandon their babies for fear that their cries would attract Turkish soldiers: 'They left the babies under the trees, for they were crying. They did not keep any babies, because the enemy would hear their crying.'[10]

'My uncle's voice stopped'

Among earwitness memories of the Armenian Genocide, memories of voices – whether the shrill voices of Turkish gendarmes, or the weak and fading voices of the dying – are recalled in particular emotional detail and depth. Survivors often specify the quality of the voices they heard, conveying the emotional landscape that was wrought through the voice. They describe, for example, 'faint voice', 'trembling voice', 'heavy voice', 'low voice', 'shaky voice', 'quivering voice'.[11]

In Svazlian's volume, there are over 250 references to 'crying', and many to 'shouting', 'screaming', 'wailing',

[9] Ibid., p. 121.

[10] Ibid., p. 89.

[11] Ibid., p. 236, p. 238, p. 262, p. 321, p. 334.

'yelling', 'pleading', 'moaning', 'groaning' and 'lamenting'. The survivor Souren Sargsian (born 1902, Sepastia/Sivas) describes a scene in which women, 'were crying and lamenting over their children, screaming and cursing their fate and their luck in hoarse voices'.[12] He also describes a scene in which 'thousands of voices' came together in a plea for salvation:

> Eight to ten gendarmes armed with bayonets and fifteen to twenty Kurds surrounded us, made us sit in a sandy mound in rows, according to age and height. A woman came to save her little boy. One of the gendarmes cursed and pushed her roughly into a pit. She got up screaming plaintively: 'Help, they're slaughtering the children!' Suddenly voices of thousands of women rose in the darkness to heaven. The chief of the gendarmes ordered to open fire towards the people. They took the rifles and fired towards the people: no more voices were heard, only the moan of the wounded women.[13]

Several survivors report listening to fading or disappearing voices as a marker of death – as evidence that a loved one was no longer alive, as in the story recounted by Ronia Terzian (b. 1920, Aleppo):

> In the silence of the night we heard the sound of whipping and my uncle's voice calling, 'Help! Help!' . . . My mother was crying, was pulling her hair and was rolling on the ground. Then she lost consciousness. The strokes of the whip were heard for a long time. My uncle's voice became weaker and weaker. I was crying for my uncle and my mother. The neighbours sprayed water on my mother's face. She opened her eyes, said 'Aram, my brother,' and closed her eyes again. My uncle's voice stopped, and the whip strokes stopped.[14]

[12] Ibid., p. 319.

[13] Ibid., p. 320.

[14] Ibid., p. 525.

As these testimonies show, the voice can be a crucial site of listening to genocide. Victims cried and screamed from sheer pain and terror, but also because they wanted others to hear their pain. The voice was often the only tool victims had to express their suffering. Attending to sonic memories of victims' voices can therefore be a way of recovering these concealed voices, and a step towards recognising their pain.

'We walked among corpses'

In the sound studies literature, walking is typically posited as a methodology that enables a more active, intimate and embodied exploration of a sonic place. In this literature, 'soundwalking' is justifiably celebrated as a means towards producing a lived, sensorially rich knowledge of a sonic environment: embodying a sonic choreography of an urban environment by 'walking the sonic city', for example. By contrast, the stories of walking relayed in survivors' testimonies are of walking as a means of mass extermination, torture and dispossession.[15] As Henry Morgenthau writes, from April 1915, 'desparing caravans' set forth from, 'thousands of Armenian cities and villages'. At first, 'the individuals bore some resemblance to human beings';

[15] As a result of this painful history and the continued denial of the Armenian Genocide by Turkey, acts of walking, marching and pilgrimage hold special meaning for Armenians. Each year on 24 April, Armenian Genocide Remembrance Day, Armenians around the world take part in mass marches to commemorate the Genocide and protest Turkish denialism. Armenians have also undertaken pilgrimages to the sites of the death marches, both to commemorate the tragedies that took place there and to collect evidence, such as bones and skulls, which continue to be unearthed in archaeological digs (Semerdjian, 2018).

soon, however, 'the dust of the road plastered their faces and clothes, the mud caked their lower members, and the slowly advancing mobs, frequently bent with fatigue and crazed by the brutality of their "protectors", resembled some new and strange animal species.' Morgenthau attests that, from April to October 1915:

> Practically all the highways in Asia Minor were crowded with these unearthly band of exiles. They could be seen winding in and out of every valley and climbing up the sides of nearly every mountain – moving on and on, they scarcely knew whither, except that every road led to death.[16]

Survivors recount how, after walking barefoot for weeks while deprived of food and water, many deportees simply lay on the ground and perished. Azniv Grigor Siradeghian (b. 1909), a survivor from Sepastia who was exiled to the Surudj desert, and who was only six years old at the time of the Genocide, set off on the road with her mother and four younger siblings. All died on the road, 'of hunger and exhaustion'.[17] 'For we walked and walked up one mountain, then the next, we went up and down seven mountains,' Siradeghian recalls: 'Mother was carrying her baby; she was so exhausted that she could not walk anymore; she fell down . . . We walked every day, we walked among corpses.'[18]

Many survivors of the death marches describe the anguish at being forced to leave their dead and dying relatives behind, and at the horror of seeing so many unburied corpses on the road. The survivor Kadjouni Toros Gharagyozian (b. 1905, Shabin Karahisar) testifies:

[16] Morgenthau, *Ambassador Morgenthau's Story*, pp. 313-4.

[17, 18] Svazlian, *The Armenian Genocide*, p. 339.

On the road, everywhere, we met devoured and rotten corpses of women and children. We saw there a dead mother and her dead baby; another elder child had fallen on his mother's breast; he was still alive and was writhing and crying in a faint voice. We passed by these pitiful scenes with indifference: thinking that one day we would be in the same state . . . People died, succumbing to hunger and the tortures of the road.[19]

The sounds of the death marches were the sounds of subjection and terror. Survivors recall hearing whip strokes, gunshots, and the yelling of Turkish gendarmes; the screams and wails of the deportees; the groans and moans of the dying; and the 'deafening howling' of wild animals such as jackals and wolves that devoured corpses at night. The survivor Galoust Gevorg Soghomonian, who was born in 1905 in Bolou, and whose father was a second cousin of the celebrated Armenian priest and composer Komitas Vardapet, remembers the moment his family was, 'forced to join the multitude of Armenian exiles, of which no beginning and no end were visible'.[20] Moving forwards under whip strokes, they learned they would be taken to the Der Zor desert. 'Cries and wails were heard from everywhere,' Soghomonian recalls. Those who fell behind were shot or killed with a bayonet, the Turkish gendarmes saying, 'Geber, gâvur!' ['Die, infidel!'].[21]

Soghomonian describes a brutal, terrifying soundscape on the road to exile. Each day began with the yells of the Turkish gendarmes, who woke up the exhausted deportees. He recalls:

I was, at that time, ten years old and I clung, terrified, to my parents. I felt very anxious on hearing the loud shouts of the Turkish gendarmes, the cries and moans of the hardly moving

[19] Ibid., p. 236.

[20, 21] Ibid., p. 389.

people, the gunshots resounding from all directions. I wanted to be near those sounds and see with my eyes everything going on around me; I wanted to help those poor people, but the horror I felt as a child made me cling more and more to my parents' hands. I felt that every gunshot took a human life away. Those who did not obey orders were pierced with a bayonet or had their head cut with a sword.[22]

Soghomonian's testimony gives voice to the sonic experience of the death marches from the perspective of a young child. He describes a chaotic acoustic scene that made him 'very anxious': he wanted instinctively to see what was happening around him and help those who were suffering, but he was terrified to do so. As a child, the sounds he heard were larger than life: he heard gunshots as 'resounding from all directions' and felt each one as taking away a human life. The sounds were both all-encompassing and piercing; both overwhelming and paralysing. The feeling that a soundscape was both captivating and traumatising is repeated across survivors' testimonies. Not listening to violent sounds was not an option if one wanted to survive; yet hearing violence and suffering was itself a form of injury and trauma.

Indeed, some survivors testify that during the death marches they 'became deaf' to the pain of others as a form of self-preservation. By mentally blocking out traumatic sounds, they were more able to withstand the trauma of the events unfolding around them.[23] As one survivor says,

[22] Ibid., p. 389.

[23] In recovering traumatic sonic memories, it is important to recognise how deeply painful it was for victims and survivors of the Armenian Genocide to hear the suffering of others – to the extent that some 'blocked out' these sounds to survive. In *Regarding the Pain of Others* (2003), Susan Sontag questioned the sensationalist and sensationalising aspects of war photography, as well as the problematic

'The gendarmes . . . brought the girls in white clothes. In the darkness of the night, they impaled them all with the sharp stakes. Our ears became deaf to their and their mothers' screams, cries and heart-rending clamours.'[24]

The death marches were a form of mass extermination as well as of dispossession. After all, deportees were being marched away from their homes, towns and villages, families, livelihoods, and possessions. Even when the assigned destination was reached, there was a strong chance that the deportee would be killed at that spot burned alive, killed with swords or shot and thrown into rivers. It was not a euphemism to say that the waters of the Euphrates and Tigris rivers ran red with the blood of Armenians during these years: they were said to be, 'the sepulchre of thousands of Armenians.'[25] The survivor Kadjouni Toros Gharagyozian (b. 1905, Shabin Karahisar) recalls a scene at one such final crossing, describing the moment when his group arrived at the Euphrates River:

Everybody was crying, shouting, screaming. Our voices reached the sky. Women were praying to God for salvation. We stood before two kinds of death – either we had to throw ourselves into the river or be driven by force to the cave to be slaughtered by the hands of the executioners. Someone set an

nature of looking at photographs of victims of war, asking, 'Who are the "WE" at whom such shock-pictures are aimed?' Sontag's question is an important one to revisit in the context of 'listening to the pain of others', because 'we' can listen to other people's pain from a distance. The sonic archive affords that distance, just as the medium of photography does.

[24] Svazlian, The Armenian Genocide, p. 321.

[25] Viscount J. Bryce, The Treatment of the Armenians in the Ottoman Empire, 1915-16: Documents Presented to Viscount Grey of Falloden by Viscount Bryce. Hodder and Stoughton, 1916, p. 14.

example: the mother of a family gathered her children closely about her, raised her hands, crossed herself and shouted praying, 'Oh Lord, you did not help us, now we ourselves are coming to you. We are innocent.' Many followed her example.[26]

Water features heavily in survivors' testimonies of the death marches, although sonic memories of water are not of pleasant waterscape sounds as is typical in the sound studies literature, in which water sounds are often cited as a marker of a 'healthy' or desirable sonic environment.[27] Rather, survivors recall being so thirsty that they drank water out of the footprints of camels and from 'dirty puddles' in which bugs were visible.[28] Some survivors even recall diving beneath corpses in the Euphrates to drink. Aharon Melikset Mankrian (b. 1903, Hadjn) testifies:

> The water of the Euphrates was bloody, it was impossible to drink it; the corpses floated down the current and we dived to the bottom of the river in order to drink clear water . . . Those who could no longer walk, sat on the ground or lay down whispering 'water-water' and died. There were dried corpses all around.[29]

A prominent memory of a 'water sound' during the death marches, tragically, is of the sounds of people begging for water as they perished, and agonising pleas for salvation at the river's edge.

Locating traumatic sonic memories

As survivors share their sonic memories of the Armenian

[26] Svazlian, The Armenian Genocide, p. 236.

[27] R.M. Schafer, The Soundscape: Our Sonic Environment and the Tuning of the World. Destiny Books, 1994.

[28] Svazlian, The Armenian Genocide, p. 380, p. 254.

[29] Ibid., p. 428.

Genocide, several use the expression that a sound is 'in
their ears.' On one hand, this expression can signal the
enduring presence of a memory: a sound is felt as still
present. A sound in one's ear can also be a form of the past
'calling' to the present, seeming to speak directly to the
listener. Heghnar Ghoukassian (b. 1896, Pasen), who re-
calls her hometown of Delibaba Village with deep affection,
says, 'A river ran through the village. I have become old
now, sometimes my ears whisper, and it seems to me it's
our river whispering. Or, from afar, the noise of our mill-
stone reaches my ears.'[30]

For some survivors, the feeling of sound being 'in the
ear' can be a source of connection to the past. The only
memory that some survivors have of a murdered relative,
for example, is of the sound of their voice. Aram Momdjian
(b. 1909, Marash) says, 'I was six years old when they
came and drove us to exile. I hardly remember my father
. . . I remember my mother also quite dimly: only her
words are in my ears: "They're taking us to Der-Zor to kill
us. At least, let our children live."'[31]

Sonic memories that live 'in the ears' can be a site of
both pain and attachment – the connective tissue between
a lost generation and a living one. Locating a sound in
one's ear can also be a way of giving memory body: keep-
ing the voice of a loved one alive and close by locating it
in the body.

For some survivors, however, traumatic sonic memories
continue to 'resound in their ears' in an unwanted fashion,

[30] Ibid., p. 121.
[31] Ibid. p. 449.
[32] See Birdsall on 'involuntary remembering' in earwitness
testimonies.

or what might be thought of as involuntary sonic recall.[32] As Shogher Tonoyan testifies, the song she heard her family perished continues to resound in her ears, 'up to this day'.[33] Such sonic memories can be a site of re-traumatisation: painful sounds are recalled involuntarily and, being present 'in the ears', continue to disturb the listener who has no choice but to hear them.[34]

For Tonoyan, the horror of the Genocide was not only encapsulated in the fire that killed sixty members of her family and many of her fellow townspeople, but also in the sonic triumphalism that accompanied it – a triumphalism that was both manifested in and produced through song: a 'merry song' that raised the morale of those who were committing acts of genocide – a song that lubricated their violence, and that continues to torment one who heard it.[35] Through her testimony, Tonoyan transmits an impression of those sounds, which have been inscribed 'onto' her ('in my ears'), and which continue to resound 'in' her. The injury that was done to Tonoyan was therefore not only the violent murder of her family, but also the sonic imprint of that crime, which remains. The song she continues to hear decades later is an example of what Mhamad Safa has theorised as the 'aftersound' of a violent event: a sonic aftershock that continues to produce trauma in its unfolding and resounding over time.[36]

[33] Ibid. p. 98.

[34] Birdsall makes the salient point that, since some earwitnesses re-experience a sound in the present moment, it is questionable whether this should be called a sonic memory (p. 178).

[35] Ibid. p. 98. Tonoyan testifies that the Turkish soldiers were 'dancing in a circle, swinging and striking their sabres and singing merrily'.

[36] Safa, M. 'Reverberations and Post-war Trauma: The Sustained Aftermath of Aerial Strikes on Lebanon in 2006', in *Sound Studies*, 8(1), 2022, pp. 73-99.

Counterlistening to genocide

The value of sonic memory to knowledge is not only evidentiary; it also lies in the emotional matter that sonic memories can carry and transmit. If we seek to understand the incomprehensible – an historical event of such tragic proportions that it confounds human comprehension – we must seek to better understand the nature of those emotions and the role of sound and listening in producing and shaping them. This can enable us to better understand not only an 'historical event' (the concept itself is arguably a misnomer since the effects of genocide are not contained within any violent act but unfold across time and space) – but the conditions of the survivors themselves: their pain, terror and sense of loss; how they feel, remember and share traumatic experience; and how those traumatic experiences can emerge in connection to sound and listening.

Sound is both a manifestation or expression of trauma – as in the sounds of screaming, crying, lamenting and moaning – and it can be traumatising in and of itself. Sounds can transmit trauma between people through shared affective experience: hearing suffering causes suffering. Listening is not a neutral way of engaging with the world; it can be injurious, even when sounds are remembered and recalled versus heard 'in the moment'.

As earwitness testimonies of the Armenian Genocide show, sound can be deployed as a weapon of mass extermination (as in the gunshots that induced terror in Armenian deportees); as a means of territorialisation (as in the sounds of drum and *zurna* that signalled Turkish power); as a military tactic (as in the gendarmes' use of noise to mask the sounds of torture); and as a way of asserting state control (as in the voices of town criers that carried deportation orders, or the yelling of gendarmes that kept deportees in line). Thus, sound played a key role in producing the

Armenian Genocide and its traumas.

However, we must not only pay attention to how perpetrators of genocide used sound. Even as they were left to die, victims had voices. The sonic memories of survivors transmit those voices, whether the faint voices of the dying, the anguished voices of the crying and lamenting, or the desperate voices that came together in collective pleas for salvation, mercy and justice. Listening to sonic memories can enable voices that were brutally suppressed – and that the Turkish state continues to conceal and deny – to sound and to be heard. Through listening to the voice-in-the-blood and the 'voices that reached the sky', we can hope to better understand the incomprehensible, the unconcealable, the undeniable: that which continues to resound.

Excerpted from G. Ouzounian, '"Our voices reached the sky": Sonic Memories of the Armenian Genocide', in J. Smolicki (ed.), Soundwalking: Through Time, Space and Technologies. Routledge, 2023, pp. 164-180.

This chapter was funded by the European Research Council (ERC), under the European Union's Horizon 2020 research and innovation programme, as part of the project 'Sonorous Cities: Towards a Sonic Urbanism' (grant agreement No. 865032).

Owed to Perpetual Healing
[Tran]script*
*a dialogue between speaking and writing
Hannah Catherine Jones
(2020)

It's four years on since the first summer of the coronavirus pandemic, when 'Owed to Perpetual Healing' was originally published as an audio broadcast, by The Contemporary Journal, in June. Any small ripples of change continue to provoke huge waves of backlash. Interlocking crises have continued, intensified, evolved, replayed, remixed and been transposed into different keys, still resonating with the sentiments expressed and the tracks selected. Upon re-reading and re-listening in 2024, I feel the empathetic elegies, the reflective requiems, just as clearly within the selected musics. They still remain some of my favourite tracks of all time, by artists I regularly return to, who are part of my real and imaginary communities, to whom I owe much gratitude. It feels significant to acknowledge that as part of my ongoing perpetual healing process, I started a choir — Chiron Choir (est. 2022), so named after the mythological, astronomical and astrological queer celestial body Chiron, the wounded healer. Chiron Choir is for queer diasporic womxn to heal through voice. We have regularly been meeting up, sharing space, consolidating community and most importantly singing songs, many of them by the featured artists in this playlist — a rendition of Sweet Honey in the Rock's 'Breaths' was one of the first songs we performed live to an audience. I now fully realise founding Chiron Choir was a necessary response to the preceding years of isolation and separation and represents the physiological shift from solo listening to collective embodiment of these healing frequencies. I'm truly grateful for the opportunity to reflect on this work and to have it further embedded into the archive through this publication.

Hello and welcome to *Owed to Perpetual Healing*.
As 2020 has unfolded, unfurled, unravelled, we find
ourselves in June, which continues to present us with un-
paralleled unpredictable unrest across the globe.

I imagine there will be people from all walks of life listen-
ing to this podcast and I think what unites everyone dur-
ing this time is the ongoing uncertainty . . .

And although this unknowing is unsettling, I for one do
not want things to go back to 'normal'.

Nothing was 'normal' pre-pandemic.

Inequity and inequality remain to be deadly plagues
symptomatic of the interlocking systems of the imperialist
capitalist white-supremacist patriarchy.

I'm grieving. I'm tired. I'm exhausted.

I ask of you, the listener, to contemplate: what are you
grieving? What is exhausting you right now? And of
course, this is multi-faceted . . .

You may be grieving the loss of loved ones, perhaps recently
– due to the virus, or perhaps historic ongoing grief . . .

You may be grieving the loss of loved ones due to the
violence of the system – recently or historically . . .

Are you grieving for the once-regular integrations with
family, friends, lovers?

Are you grieving touch in all its forms: the gentle to-
getherness of an exercise class, a rehearsal, a gig, a club . . .

Are you exhausted by the news?

Are you exhausted because you have never had to think
about your part in white supremacy, perhaps at all, and
certainly never as intensely as now?

Are you exhausted because you feel personally attacked by the resounding and necessary three words echoing around the world?

BLACK. LIVES. MATTER.

Are you exhausted because you are experiencing white people begin to realise that racism is real? That only now in 2020 are institutions of all kinds, academic and otherwise, even beginning to address and respond to the lived experiences of diasporic peoples, albeit in the most surface way?

Are you exhausted that you have been fighting for these changes for as long as you can remember, and witnessing even the symbolic changes of the dismantling of white supremacy comes along with an unknown exhaustion and overwhelm . . . ?

Are you exhausted because you feel guilty about not having attended protests, perhaps due to mental and physical health issues, the threat of the virus, the threat of democide, police brutality, or perhaps because you don't think that any of these issues apply to you?

Are you exhausted because you have been to the protests? Although the togetherness is what we need more than ever, the fear of police brutality and potential democide and the aftermath of potentially spreading the virus further among the people who it is affecting the most is draining you . . . ?

If you're not exhausted, then perhaps you can spend some time reflecting on how you and your action or in-action is affecting the current interlocking crises . . .

I've selected some tracks that speak to my sorrow and current overwhelm at the world. Perhaps they are tracks that I would use in an imaginary ongoing memorial service for the endless and seemingly infinite list of Black lives that clearly did not matter . . .

George Floyd, Alton Sterling, Ahmaud Arbery, Michael Brown, Sean Riggs, Belly Mujinga, Mark Duggan, Rashan Charles, Grenfell, Tamir Rice, Soweto Uprisings, Juneteenth, Philando Castile, Bussa . . .

The list is long.
There are *too many*.

I know perhaps the thing I miss the most about the pre-pandemic world is the communal absorption and production of the most healing entity we have – MUSIC.

The tracks I have selected have all been tuned to the frequency of 432 Hz. There are theories that this frequency is more attuned to the resonating frequencies of the Earth, the human body, and nature, and therefore possesses healing properties.

There are numerous theories about how the current standardisation of tuning our instruments, and therefore ourselves, to A 440 Hz is a conspiracy theory established by the Nazis to ensure people are aligned to an unnatural, strained state, to ensure we stay anxious and dissatisfied, feeding into overconsumption, conformity, compliancy, submission.

There are theories about how the pitch we tune our instruments, and therefore ourselves to, is completely arbitrary, as the vibrations of the planet and its inhabitants

cannot be analysed to a single frequency that would reso-
nate with all.

My experience is that the 432 Hz frequency is something
that I felt affect me positively, physiologically. The track I
have been speaking over was sent to me by my mum
when I was extremely ill. It is tuned to 528 Hz, which
is the frequency used by genetic biochemists to repair
broken DNA. It is through this track that I discovered 432
Hz, and so is the origin of my relationship to alternative
frequencies, now an integral part of my perpetual healing
practice.

I invite you to listen to the following tracks. I hope to have
created a space for meditative reflection, contemplation,
towards empathy, catharsis and hope.

We all must play our part in healing the wounds inflicted
by the interlocking crises. The broken system feels like an
impenetrable abstract entity. But it is comprised of in-
dividuals. Seemingly small interactions matter – they create
psychological ripples with the potential to accumulate
into monumental waves of change. I urge you to seek
difficult conversations, to support those who are more
exhausted than you, move through the discomfort . . .

Perhaps we will not see, hear, feel, witness, experience,
the change we want to see in our lifetimes, but we have to
find the radical energy, courage, hope, humility and
humanity, to move forwards.

The practice of actively listening to music, sound waves,
vibrations, can help us to transcend hearing and into listen-
ing more profoundly to each other. I invite you to be both
physically and psychologically present for Owed to Perpetual

Healing, if you are able to. Thank you for having me and stay safe.

Tracklist

PowerThoughts Meditation Club, '528 Miracle Tone: Whole Body Regeneration' (excerpt), 2019.

Alice Coltrane Turiyasangitananda, 'Er Ra'. Avatar Book Institute, 1987.

Angel Bat Dawid, 'What Shall I Tell My Children Who Are Black?' International Anthem, 2020.

Abel Selaocoe, 'Lamentatio' (excerpt), 2017.

Mica Levi, 'Death'. Rough Trade, 2014.

Southern University Quartet, 'I'm Troubled in Mind'. Document Records, 1997.

Andreas Scholl/Vivaldi, 'Cum Dederit'. Decca 2000.

Caroline Shaw/Attacca Quartet, 'Plan & Elevation: IV. The Orangery'. New Amsterdam Records, 2019.

Sweet Honey in the Rock, 'Breaths'. Rounder Records, 1988.

Donald Byrd, 'Cristo Redentor'. Blue Note Records, 1964.

Luxolo Gospel Choir, 'Simoni'. Prestige Elite, 2010.

Albert E. Brumley/Kanye West, 'I'll Fly Away'. UMG Recordings, 2004.

Pastor T.L. Barrett and the Youth for Christ Choir, 'Like A Ship . . . (Without A Sail)'. Numero Group, 1971.

Beverly Glenn-Copeland, 'Sunset Village'. Transgressive Records, 1986.

A Charm of Powerful Trouble
Holly Pester
(2019)

Do crows gossip? They get together around threat, they pass on the alarm in little dramas of sounds and so they know.

Crows gossip.

Does plastic gossip? The distribution of matter and toxins leak into forums of misusage, capital bleeds. Who gossips plastic? Do sea krill gossip plastic into fish that gossip plastic to our mouths?

Sea krill gossip.

Is tear gas gossip? A tear gas canister is such a gossip. People leap to it with blankets, its rumour spreads from Hong Kong to Chile like a reaction to pain. Where do ideas come from? From low down and up against trouble. The species of the story is the will of hearing.

A tear gas canister is such a gossip.

Does the weather gossip? It always reveals itself. A soothsayer, bringing the cesspit to the lake, the sewer to meet the sky. The weather gossips. It is story.

When the story comes to mobilise us we are hungry for a base revelation of sorts, maybe we need to bring someone down. Someone with power needs to be rumoured into the well. We need to plot lines over their body then eat it up. The feast is delicious if you're willing to eat off the

floor. The pleasure lasts forever if you dish, that is serve, that is provide, that is cultivate, that is care, that is till, the dirt, that is, all we've got. Dishing the dirt is the speech act of the dispossessed, to conjure what we cannot produce through official means, the opposite of broadcast: peer to peer, not print, not radio, not on camera with a book deal, the story moves mouth to mouth like a bug persisting on the pure desire to survive and what is that?

For example, David Cameron fucked a pig. We know he did. We'll write over history with that one, our desire is never false, because it comes from the floor, from the dirty plot. It's dirty work and we want it for the right reason. We need a new one. It's the only way to win. You cannot spread a rumour that people are being oppressed, that we're dying of policy, you have to spread a rumour that there is poison in the coffee, that there is beef fat in the gun oil, that the boss is a gambler, that the prison guards have syphilis. The empire will fall if you make your own salt. It is the truth, the truth is after all always half material, half magic. The truth of truth corresponds to re-versioning power from the bottom up. Of course tale-telling corruption attacks the vulnerable too – but conspiracy against demobilised groups only serves the powerful. Gossips know that.

Spreading gossip is working on someone, you have to decide what work you want to do and who you're working on. We need a new one, we'll have a new story soon. You cannot guess where it will come from, when it happens you know it and when it's there, near your mouth, you're either in or you're out of the plot of dirt.

Go all in and your body goes like a snake, becomes the ingredient. You lose your self-voice to it but you should abandon that now anyway. Proper speech and proper knowledge is akin to propertied knowledge. That of

ownership and official distribution. The propagation of stories in the absence of proper facts creates sensations, not evidence. Keep it in the same grain as a fever germ or half a folk song. The gossip rubs rouge and perfume over banal scenes. There is an erotic shift in the anecdotal.

Gossip is an emotional score, its music is just between us, my friend, she says, this is for us. Her friend is made of kink and debris.

The gossip plots. If plotting is what is done as storytellers and what is also done as dissenters, what can a plot mean in both acts of making hidden things known, and exuding radical designs on facts?

A gossip's plot corrupts. The corruption is on the already long-since-hijacked public language and its privatised slogans. The story, the rumour, or the conspiracy, expropriates life from language.

Gossip is the practice of both liars and fanatics; it is also a tonic in the reserve of tools for critiquing labour. Women workers gossip. Daily discontent with work is patterned into female mysteries. Some might call it a union. As an experimental practice of alternative wisdoms, antagonistic to Imperial truth, the superstructures of Empire and Christianity, gossip is everyday witchcraft.

The illicit forms of storying that make necessary divergences of popular narratives between the rulers by the ruled. The ecology and substances around each small story contribute to small efforts of pushing back and massive incendiary movements.

Gossip is craft. It is a traditional art form of unofficial speakers, a genre of transitivity that pulls passion, desire and common will into the narrative; shared as intimacy between teller, listener, talker, friend, bedfellow, whisperer, comrade, caller, collaborator.

Gossip transmits by way of loving subterfuge, stratagem

and intrigue, disrupting mainstream speech and initiating multiple minor publics. Its deed can be thanked for nourishing and safeguarding repressed histories, testimonies and experience; gossip creates solidarity and bonds through counter-story telling; and its composition coordinates with everyday encounters of exchange. Gossip-narratives correspond to communal tasks, they are crafted in sequences concurrent to gestures of work and the stopping of work.

Do the workers gossip? They're out there now dismantling the email. They're pouring mealworms onto the order, creating odours around the thing to do. The boss is a lech, the boss is doing a deal against us, the boss has a strange habit between 10 and 11.30 am. The boss has murdered animals. The boss of the boss is having an affair with some errant information. The murdered animals live on as errant information. The head boss of the lesser boss is going for the other boss. They are haunted by animals. They have no control over their staff, they have absolute control over their staff. The workers are kissing and gassing. They are reclaiming slips of information from the little animals on their key rings.

The workers gossip.

Gossip is not just canalised information, the value is not based on truth but on passionate connection to the material. Gossip surrounds and infests official narratives with deviant and unauthorised speech. As surreptitious acts of sabotage of course they can be cruel, and damaging, and ruinous, but in this cruelty gossip-plots diminish the clear distinction between what is creative and destructive in storying; what is true and false, what is known and not. Gossip-plots are composed but not authored.

A concoction is substance and political plot. The

'midnight hags' of Macbeth conspire through mixing the bloody stuff of the demonised, othered, stuff outside the sanction of Christianity, family, work, trade and Empire. It is from these ingredients that plot is made, and the method that corrupts endorsed feminised labour (that is, cooking) is sorcery. The potency of the plan, the hell-broth and the toxicity of its gruel are bourn from that which is heretic and counter to the burgeoning Imperial structures of knowledge, are begotten by the method; secrecy (that is, outside and underground healthy, public discourse) under the ground of the communal coven of deranged femininity. The plot is realised as the cauldron, the organising scheme, it issues prophetic visions.

an armed Head
A bloody Child
a Child crowned, with a tree in his hand

This scene of conspirators shadows the form of the fates, three sisters who 'spun and cut the thread of life'. This word, fate, from the Latin fatum, 'that which has been spoken', and fari, 'to speak', makes felt the connection between utterance and handicraft, and the nuanced entanglement of gendered and colonised labour with unhallowed wisdoms.

The crafts of gossip and storytelling, the gendered cultures of speech that become entwined with labour; historically at the well, public laundries and spinning rooms; where the task of spinning yarn co-produces narratives – as well as a means of escape from the time-structures of work – converting the work-time into something other, but also embodied in the materials and apparatus of it. Since spinning yarn has come to mean telling a disobedient tale of fictive deception, we forget that gossiping and

tale-telling are forms of entertaining and unofficial (by the terms of state institutions, medical science and capital) forms of living. Self-control of fertility, beyond morality, is gossiped through midwifery. It's where the word comes from.

Are cooking pots gossip? A communal cooking pot keeps everyone alive. A communal cooking pot, like the *olla común* in Peru, distributed the need to shop, eased the burden of buying food to live, no one was alone. A common cooking pot is collectivised reproductive labour. It is folk tradition but it is not not political.

If we pull on this thread, where gossip and fairytales coincide with weirded work-time and unofficial histories, where radical acts of material resistance arise around and through illicit communication, we find gossip and rumour, eclectic communication, there is a charm of powerful trouble that organises the desire for revolt.

Eclectic communication and materials, in plots against structural oppression and colonisation, become methodologies of resistance. Or when human communication used in and as rebellion operates eclectically, for instance via dance, music, symbols, sung rallying cries, folklore or rumour, then there is a 'correspondence between rumour and popular insurrection'. Spreading rumours in colonised India was the creativity of revolutionary consciousness. Not, as Imperial elitist rhetoric termed it, an impulsive riot based on irrational contagions of thought. Revolt and emancipation by rumour are not the result of mindless contagion but a poetics of tale-telling that moves from story-fragment to story-fragment to rebellion.

The Indian Mutiny of 1857 began with the revolt of Indian soldiers stationed north of Delhi, issued with new gun cartridges that had to be bitten off before insertion. A

rumour spread that the cartridges had been greased with beef and pork fat. Another concurrent rumour spread that rationed wheat flour was polluted with bonemeal. The stories connected to a broader conspiracy of forced conversion to Christianity, and then to an encapsulating narrative of a deliverer who was imminently coming to end British Rule. We can plot this chain of matter to myth, and then to organised revolt. That is the substance of radical tale-telling.

The composition of rumour is the matter of transmission plus its lyric call. It is the same with revolutionary poetics; voice is willed with an appeal to join; whatever the sound, gesture or text it goes: 'We have started something; join us.' The poetics is to collaboratively narrate a way out of repression, be it actually or immaterially.

Do children gossip? Stuff is passed along the imagination with head lice and hierarchies, positions are rehearsed and exploded, saliva pacts and eyelash bonds, food off the floor, what and who is disgusting. There is no stillness.

Children gossip.

Narratives spell out the opposition between the ruler and the ruled – it works both ways. The official storyline that inlays and divides can be radicalised by eclectic tales of another territory. This is the dialectics of plot and plotting.

A plot of land is a grave, or a mapped-out boundary, commodifiable and material, agricultural, turf and concrete; a plot is a complex plan, an Aristotelian line of fortune and loss of fortune, the ordering that invokes tragedy or comedy, a sequence of events and an organising scheme, a plan or methodological system. A plot is also a plan to counter an organising scheme, or a reordering of authority. Subversive plotting seeks, through collaborative

narrative and collective deed, to corrupt (assassinate or explode or dethrone) the structure it parasitically grew from.

Plot links the politics of property with that of Western chronicles. Where a plot of land indicates ownership, a plot of events, framed as 'history', the story of the past, indicates authorship. History is plotted and owned by the official tellers.

'All plots tend to move deathwards. This is the nature of plots.' We die, we go into a grave but, materially speaking, this is not the end of the story. De-composition of the main body is re-composition of new narratives, fungus and worms. A body never stops. It spreads a rumour, to convert the grave into a story.

A ghost story, that says, where public language has long been hijacked and turned against me, public language is my enemy.

Do the dead gossip? The graveyards are bent out of shape. We need to lie down more on top of the political subjects of the dead to decompose with them and make designs from the dirt. Gossips speak to the dead. Who carries on murdering the dead? Who took your means away and carries on? The dead elaborate on the plot. Legacies as worms move.

The dead gossip.

First performed at the London Contemporary Music Festival, 2019

Texts referred to and cited

D. DeLillo, *White Noise*. Picador, 2002.

A. Duval, *The Distaff Gospels: A First Modern English Edition of 'Les Évangiles Des Quenouilles'*. Broadview Press, 2006.

S. Federici, *Re-enchanting the World: Feminism and the Politics of the Commons*. PM Press, 2018.

R. Guha, *Elementary Aspects of Peasant Insurgency in Colonial India*. Oxford, 1983.

M. Warner, *From the Beast to the Blonde: On Fairy Tales and Their Tellers*. Random House, 2015.

Listening in Dreams
IONE
(2015)

I am waking up, moving through deep layers of sleep – my dream changes – a lively band is playing over in the corner of the room – a small dance floor. I step out from the table and begin to move in time to the music. I'm aware of shadowy figures watching me.

A man with a compelling, deep voice moves to the microphone. Oddly, he begins to recount the daily news as I am completing my dance moves.

I want to keep dancing.

But something is pulling at my attention from another place, another reality. It is . . . It is . . . Yes! I know what it is. It is my clock radio going off in another world, a world I have not yet identified as mine. The tables, the shadowy observers, the dance music, the announcer – all of these are a part of the reality of my dream world.

This sonic event is occurring during the period of time in which we rise from sleep – known technically as the hypnopompic state. Similar sound bridging can occur as we enter sleep, in the hypnagogic state – as it did for me yesterday when I found myself slumbering on the sofa. I was making a perfectly round sound – a long sound that I was attempting to direct some hundred feet away so that it entered a kind of bull's-eye opening with precise accuracy. I made the sound and could see it travelling toward the bull's-eye. As it reached the opening, I realised I was dreaming and opened my eyes. Simultaneously, I realise

now, I was opening my ears. I was listening to the high hum of the fan in the corner of the room, it was making the exact pitch, the exact sound I'd been making in my dream state.

People are often surprised when I enquire about their relationship to sound in their dreams. The concept of sound, in this realm as in many others, such as the cinema and the theatre, is more taken for granted than the visual. For instance, people may be talking to us in our dreams, and though we pay attention to what it is they are saying, we often overlook the fact that in some way we are listening to them. But just how do we hear the sound of the words and other elements that come in dreams?

Does the eardrum respond to dream sounds, much as the eyes respond to visual dream stimuli? In 1976, composer and dream specialist R.I.P. Hayman was a self-described 'guinea pig' in the studies of sound perception in sleep done at New York's Montefiore Medical Center. These studies monitored the phenomenon called Middle-ear Muscle Activity (MEMA), assessing the feedback response of the nerve endings on the tympanic tensor muscles of the eardrum. These nerve endings control muscle tension in response to outside sounds. During dreams these muscles twitch in response to dreamed sounds, much as eyes move tracing the movement in our perceived dream events.

Meditations and Exercises

Listening to the Dream Character

Become a character in one of your more interesting dreams. Begin to find the vocal quality of that character. Try remembering some of the words or sounds of that character or allow yourself to find these words or sounds spontaneously arising. Let your character speak in a more

and more fluid manner, without thinking about what the words mean. Ask your partner to mirror back to you your character's words and sounds. Listen to what your character has to say. (This exercise can be effective with a partner. If you are alone, a tape recorder or video camera could be utilised).

Humming into Sleep

Go into sleep softly humming to yourself. Find the pitch and key that feels most comforting and healing. Allow the humming to float through the body, softly directing it to places where there is the most tension, discomfort or pain. Allow yourself to go into sleep in this manner, following the sound of your hum. Notice the quality of sleep and dreams on nights when you have hummed.

Sounding and Moving with Energy

Jung was always interested in where the energy in his patients' dreams was heading. Consider where the energy in your dreams is going. Feel it and begin moving with it. While moving, find the sound of this energy and, opening your mouth for easy egress, allow it to float from your throat and mouth.

Amplifying and Transforming

Remember an important dream. Listen to the feelings in the dream. Begin to sound and move with the feelings. Find the direction the energy is going. Establish. Then take it further.

If it is going in a direction you like, amplify it.

If it is going in a direction you'd rather not go towards, transform the elements of the dream using movement and sound.

151

Dream Song Fragment Exercise

Amplify the song fragment that is going round in your head. Sing it or play it on an instrument. Notice words, phrases or associations that arise. Notice feelings that arise. Treat the song as a sacred gift. Own it. Thank it, and explore for yourself what it has to offer you. Consider the song as a signal of new power and understanding for you.

Dream Sound Duet

Sound your dream to a partner, without words. Just let the sounds arise spontaneously as you recall feelings from the dream. Take turns listening and receiving the dream sounds. Then, when it feels right, begin to sound together in a Dream Sound Duet. If you like, expand to small, then larger gestures and, listening to each other, move about the room, following the feeling of your sounds while vocalising.

The Best Dream You Ever Had

While sitting by yourself, remember the most wonderful dream you ever had. Relive the feelings of that dream. Let them spread throughout your body. When you feel ready, speak the words that want to come and make the sounds that feel right to express these good feelings. Move around if you wish.

The Best Dream They Ever Had – Flower Form (For a Group)

Ask a large group of people to form a standing or sitting circle. Evoke the concept of the best dream each person has ever had. It could be a dream from long ago. Or it could be a recent dream. Whatever dream comes, it is the right one. Ask them to gently close their eyes, or to look down toward the floor. Let them establish the feeling of

that dream. Suggest that they allow the feelings of the dream to spread throughout their bodies. Suggest that they isolate one particular part of the dream. This would be the most important part to them right now. Suggest that each person can let the words associated with the dream float out into the room at will, in no particular order. Listen to the floating words until they spontaneously stop.

Suggest that the group notice the feeling in the room. This is the feeling of their group dream.

Dreaming for the Ancestors

Remember a dream that you had about an ancestor (either known or unknown) who is not living. If you don't remember a dream, bring up a memory or an imaginary scenario concerning this ancestor. Allow the words and sounds this ancestor wants to make to arise. Speak them out. Move around the room being this ancestor. Listen for any words of guidance that this ancestor may have for you.

Dreaming the Sounds of the Universe

Listen in your waking and sleeping dreams for the sounds of the universe. Perhaps they can be heard in the spaces between sounds. Perhaps we are hearing these sounds all the time without knowing, without recognising them.

'We are dreaming this!' intones Dream Mask Maker Norman Lowrey in one of his Singing Mask performances. Let us live the dream, fully. Let us listen and enjoy it.

*

Some Sound Dreams

IONE: Beyond Bearsville, or The Master Mechanic, 1994

Dearest PO,

Thinking of you and your sandals, arriving in London. Dreamed of an area beyond Bearsville, where the road had turned to reddish clay and I, driving with an unidentified male companion, almost overturned the car, but actually, held it in my hands, cradling it down so that we wouldn't be hurt and the car (a four wheel Jeep for the rough roads) wouldn't be hurt either. I eased it down with all my strength, and we got out, before starting to look for help, I noticed that this was a very magical place. A man with long hair was wading in waist-high water, right next to us, in a kind of clear pool, and pulling silver strips off the sides of it! On the other side of the road there were several people living in a contented fashion. I took a second look, because I had seen some special light coming down over their houses (all in greenery) and as I looked I saw that it was the mountain behind and that the top of the mountain overlooked them. The light was coming from there. Also there was very strong music coming from there as well, floating over the whole place, and I was interested to note that the people were living peacefully and no one seemed to mind the music, which was a popular song in instrumental version that I might have found offensive under other circumstances, but somehow here it worked and was truly lovely floating over the land. It seemed to mean that the people were happy. I think I also knew it was Sunday. I started walking back for help then, along the road, and got to a town where there were a few people, a store and maybe a post office, all very rudimentary.

154

I saw a sign and realised, 'Oh, this is Bearsville.' I asked for help from someone. I needed a mechanic, a good mechanic. They said that was a problem, but then remembered that over the way I'd come from, there was someone so good that he was much in demand, and they seemed to feel it was unlikely I could swing it. Then someone else said, 'Oh yeah, over there they don't even have any music!'

I started to walk back the way I'd come. Back to where I'd left the car. As I arrived there, I was thinking about those others thinking there wasn't any music in this music-filled place . . . And I was a bit fearful about the car, hoping it would be alright. As I arrived I saw that there was someone (the man who'd been wading in the water I realise now) sitting comfortably sleeping with his feet propped up in the back seat. That was the end of the dream, and I realise now that he was of course the master mechanic.

Pauline Oliveros

16 September 2001

I am in a large complex trying to give a Deep Listening Workshop. I do the first part with a large group of people. Just before a break I play my french horn. My sound is remarkably clear and excellent even though I have not played for years. I put the horn down and we take a break. I say that I will play the flute when we return.

I find the flute and begin to test it. I can play it even though I have never studied the instrument. Then I discover built-in electronics on the flute. There are three different circuits. There is spoken word and harmonisation. I explore the buttons and then put the flute down.

July 2004

Ione and I are leading a Deep Listening Retreat. We are walking and moving inside with the group. The energy is flowing nicely. We do a slow contact improvisation. We decide to go outside. There is water everywhere from the rain. The water is about six inches or more deep. I take off my shoes. My socks are still on. Everyone is out on the land wading. There is an embankment. My socks come off and start flowing with the current one at a time down the rock embankment. I grab one, then see the other disappearing into a hole. I grab the sock from the hole just in time. I wring out my socks. The sound of water is everywhere.

Meet the Composer: Jeanne Lee interviewed by Lona Foote (1988)

Lona Foote: What sort of gigs are you looking for these days?

Jeanne Lee: It depends on who's asking me for what and who of the group's musicians are in town and available. I'll be doing a solo concert as part of Sound Unity Festival in April, and another solo or duo as part of Carel Anthoni's *Ceci N'est Pas Une Voix* series at the Kraine Club in May.[1] But I prefer working with the group in whatever combination is affordable.

LF: It's been a while since you've performed with a steady group.

JL: Yes, the last touring I did was in 1984. I've been taking time off between then and just about last week, perfecting the poetry and music together so they can be performed. Since I'm a poet, I can work in any context when I vocalise because I just act as an instrument. The difficulty for me with vocal music is that when I'm doing my own poetry, I have to make specific arrangements that give the words a foundation to go from. Then jump from there into

[1] The Kraine Art Gallery at 85 East 4th Street was founded by Denis Woychuk, the son of a Ukrainian immigrant blacklisted as a communist, in 1983. At night, the Kraine Art Gallery became the Kraine Theater. The Kraine Gallery Bar (KGB) opened ten years later.

improvisation. So it's more complicated and it's taken me a couple of years to pull it all together.

LF: As I remember your work, your support structure used to be your body.

JL: Yes, Andrew's one of my favourite drummers, he and Smitty Smith and Steve McCall and Martin Buse and John Betsch. The drummers who watch me in movement can always follow me. So yes, I realise that's the common denominator for me.

LF: Where did you start?

JL: That's a funny kind of question. I started writing poetry when I was eight, and all through high school, where I was poetry editor of the yearbook. In college, and after that, poetry became a kind of journal. It was the way I moved through the world, my environment, making sense of it to myself.

I guess it was about 1970 that I started to put the poetry to music. In 1976 I got a grant to do a jazz oratorio and was able to complete a two-act, ten-scene adaptation of 'Conference of the Birds', the Sufi allegory of the journey to enlightenment. I used twentieth-century imagery with my own perspective. I did a concert version of it that year at the New England Conservatory with Ran Blake, with whom I worked for seven years. That duo was actually how I got started professionally in music. Since then I've shelved that project because the next step is to do a full production with orchestra, dancer and chorus, and that kind of money is a projection. Perhaps I'll do it five or seven years down the road.

Meanwhile, I'm doing smaller stuff. That project was

my guide, then, to say, 'Okay, I can put two things together.' I had a dilemma when I was younger: which things am I going to do with my life; what do I have to eliminate? I couldn't eliminate anything, so I found a way to integrate, to organise it all so that one action serves many parts of me. That's why poetry, music and dance remain not three separate disciplines, but one. The Bel Canto concert is the first time I've gotten all of that on tape and I'm going to use it to start doing club and concert gigs with that material.

LF: Andy Caploe [independent producer, curator, Culture Contact] mentioned to me that he's bringing the solstice radio piece you did together last year, *A Day in the Life of the Sun*, to an experimental radio festival in Italy in June, to look into possible European distribution. Can you tell us something about that work?

JL: Oh, interesting. For me that was a kind of pattern. The most difficult thing for me is to find other improvising singers who like to work with words. I'm a poet and I come through sound poetry, which works with the word just for its sound. Also, having sung rhythm and blues in my teen years, I have a free approach to words. I haven't been able to afford singers who can really hold that together and not feel hindered by it.

When Andy asked me to do that piece I knew I wanted to have more than one voice, so we went into the studio and three- and four-tracked my voice. I could create a pattern of how I hear the words being opened up for improvisation by voices. And working with Milene Bey for the Bel Canto series was the next step in bringing in another voice using the words and improvising from there.

LF: You've worked with a number of other singers over the years, including the Vocal Summit. But you haven't really been able to move in this direction until now.

JL: No, there's either not enough time or money to devote to it, or the singers are in one category or another. They vocalise stupendously – I mean great singers – or they're incredible interpreters of lyrics. But finding a singer who has the time to take from her or his own concept to work with me while I get them free enough within the context of the words to improvise has not been something I've been able to do.

LF: Have you done multi-voicing with yourself before now?

JL: I did on *Conspiracy*, the record I did in 1974. I did two solo tracks for voice: one is plain solo and the other is three tracks with one split in two. The bass has a kind of ostinato, based on the words 'you come to be'. Then there's a high, inverted whoop, and two lines in the middle. Since 1974, I've been rearranging a lot of the other poetry, which is more complicated than a simple phrase like 'you come to be'. I'm working with as many as seven basic verses, but each verse has an attendant chorus that works off the harmony, and then goes into another chorus that works off improvisation. So it comes three steps from the basic melody and vocal line to vocalising with the words on the chords and vocalising with the sound in the words and wherever the lines take you.

LF: Do you have a name for the form you're creating?

JL: I haven't been concerned with naming it, just doing it.

'Newswatch', written to Perry Robinson's 'Dandelion Wine', was one of the sections of *Day in the Life of the Sun*. Milene is on the version of this we did in the Bel Canto series, and I substituted voices by using Gunter and Mark so the horn lines give me the illusion that the other voices are there.[2] On Gunter's 'Journey to Edenares', his 'Serenade for Marion Brown', I put words to it and turned 'serenade' backwards.[3] And every one of those pieces has a dance or choreography component to it, so it's like working step by step back to the place where it can be understood how the jazz oratorio works with dance. Maybe in five years or so I'll be able to do a fully staged production of that work. I'm working right now at New York University in the experimental theatre wing doing improvisations with theatre students. I'm an adjunct faculty there; that's given me the chance to work a lot of stuff out. That's a lot of fun. So, little by little . . . I started the jazz oratorio in 1976 so it's been twelve years so far. That's the way it goes. It's not like it fits a formula that's already there and can be slid into a slot; it has to create its own space.

LF: Do you look for residencies?

JL: Yes. Right now I do a lot of residencies in the elementary and high schools around New York. I have a master's

[2] Gunter Hampel was Lee's husband and musical collaborator. Mark Whitecage was a saxophone and clarinet player who was also Lee's long-term musical collaborator. Both Whitecage and Lee were long-term members of the Gunter Hampel Group.

[3] 'Journey to Edenares' is a song by Gunter Hampel. Lee recorded it on her album *Natural Affinities*, as well as with the Gunter Hampel Group. 'Serenade for Marion Brown' is a composition by Gunter Hampel, which he recorded as a duo with Marion Brown and also in a big band that included Lee.

in dance for elementary school and wrote a thesis on multi-cultural education as taught through the arts, with the whole elementary school curriculum adapted through the arts. A fifth-grade teacher can come to me and say, my class is working on the American Revolution. What can you do with them? The first thing I do is teach them to march time and have them make up their own drum rolls with their voices. I notate it on the board so they can read what they've done. Then we sing all the verses of 'Yankee Doodle Dandy', which is an incredibly satirical poem.

LF: Which nobody knows.

JL: Oh, it's true. That's another thing I'm working on – manuals teachers can use to teach this way. So we learn 'Yankee Doodle Dandy' and we talk about what these verses mean. The British were making fun of the Americans who didn't have a paid army with uniforms or cavalry. They were a rag-tag lot of farmers and merchants and boys. Then we take the same two-four beat and I ask the children to write poetry – not necessarily rhyming but on that two-four beat – about their favourite part of the American Revolution. Then we take patriotic songs and the Declaration of Independence and make a sound poem. Each kid has five to seven lines; they must memorise their part, learn the vocabulary and be able to explain their lines in terms of the historical context. That kind of thing ends up with the kids marching around the room. They're happy, the teachers are happy, and I'm happy, and they've learned the Declaration of Independence and the American Revolution.

LF: And they've learned some music and they've been moving and expressing themselves.

JL: Exactly. So that's what I do. I go into elementary school and work that way. I also go into high schools and work with language arts, and into colleges with performing and fine arts students. In between I try to get the rest of my work together.

LF: And family. Were your children a factor in your decision to stop touring and stay close to home during these years?

JL: Yes. They were in school in New York and I was travelling all around the world and they were falling apart. So I put myself on their schedule.

LF: And kept going.

JL: Yes.

LF: This teaching manual of yours is K-6?

JL: Yes, kindergarten through sixth grade. I also use African and Native American material. With the technology we have right now, where even human beings are viewed as interchangeable pieces within a functioning industry, it's even more important that we educate the creative aspects of our children. To keep the individual from becoming a dehumanised slave to technology. A lot of money is spent on multinational corporations and military build-up, and the arts are not even in the schools – they're considered a frill. So by integrating art into the curriculum, the children may view their academic subjects from a creative perspective. And by doing it multiculturally, they have to know from the age of five or six that it's more than just Western European culture that makes up the world.

When I did my master's, I was most impressed by people like Irmgard Bartenieff and the language of movement, Pearl Primus and African anthropology and Badal Roy and Indian dancing. I studied with Jean Erdman in college; she taught us a group of movements called 'meditations'. I think her work with Martha Graham reinforced her sense of movement and breath being the same thing. I think that was the first technique I learned to find some continuum. The language of movement, the language of culture, the arts and mythology – all deal with the human condition from different points of view. If our children know alternative points of view, they have a larger vocabulary for being human. This is another way of synthesising many aspects so that one action serves many functions.

LF: Do you have a feeling for how far your work has travelled?

JL: Sometimes someone will tell me they've heard a piece and like it a lot and it's become part of their lives. Sometimes I've put Aretha Franklin or Stevie Wonder or Taj Mahal on, and it's helped me through a difficult time. When someone tells me my work has done that, then I feel like I'm doing my job, it's not just catharsis.

LF: We've lost some people around us in the music world in the last month: Gil Evans, Dannie Richmond and Harold Vick. When we die, do you think our sound stays here?

JL: Absolutely. I'm going to say this from feeling – I don't know if it can be proven – but that part of us which is creative comes directly from our spirit and that spirit is the part of us that is eternal. So what we leave behind us of our love and creativity is a guide and a criteria for other people

to be able to tap into their humanity and creativity and love. And of course, thank God, music is what it is, because we're left with a wealth of guides and perspectives and things that spark us by the musicians, poets, painters – everyone who has touched us. That's eternal, that doesn't go away. Eric Dolphy said something like the music is in the air and once it's gone it's gone. But when it's been captured by technology, that's a perfect example of being able to balance our technology with our humanity, to use it as a tool rather than be enslaved by it.

My father was a musician, he was a singer and he sang African American spirituals, German lieder and French art songs. When I was growing up I heard a lot of jazz and opera and European classical music around the house. First of all, that gave me an encyclopaedic sense of music. And because it came through such a personal source as my father, it became a part of who I am. Though two of my children didn't know my father, I find myself sometimes living with them as he lived with me. So they're being passed a really rich heritage. I was touched by him, and his mother was a poet and teacher.

LF: So it's multi-generational!

JL: My father's mother was born right after the Civil War and graduated from college and became a teacher and poet. I have poetry she's written, including one she wrote to my parents on my birth. Also, at my father's funeral, a man sang who had lived across the courtyard from us and used to hear my father practice. He became a singer and so did everyone in his family. It goes deep.

I've studied Jung and mythology and cultural anthropology. I see the arts as the way in which people express those things that give us the human legacy, allowing us to

relate to basic things, to keep us spiritually alive and connected, centred and full of faith, even in the midst of great change.

I remember when I was seventeen and I heard Mingus's *Scenes in the City*. I hadn't yet heard Monk or Mingus, and it left a deep impression on me. I remember Stanton Davis calling me the day Mingus died; it was like the world stopping. Time stopped; he had meant so much to me since I was seventeen. Yet people go on carrying whatever they have received from their source. I worked with Gunter many years and one of the last albums we did was *All The Things You Could Be If Charles Mingus Was Your Daddy*. My solo was based on 'Goodbye Pork Pie Hat', Mingus's tribute to Lester Young. And here I was living in Europe working with a German musician to whom Mingus meant as much as he had to me. And people who listen to that receive the music in another way; it's like throwing a pebble in a pond.

Excerpts from *Incunabula*
Johanna Hedva
(2024)

These three fables are from Incunabula, *a collection of 103 fables, each built around three words that are both a noun and verb.*

10. Sting, Whisper, Twist

I want to tell you about a man I once loved, but I don't know how to do it unless I talk about him as though he were a snake. The other problem is that he had a way of poking small holes in me that were like a sting and not a snakebite, so perhaps he was more like a stinging worm. Another important thing is that he had a way of talking to me that was not a normal way of talking, but a fizzling whisper, like the sound of a tree in a rainstorm. So, maybe in this way, he was more like a long column of air that made a noise. But he wasn't hard or unmoving like a column, instead he often twisted himself around me, to poke those small holes and to hiss about how I made him feel. So, I suppose he wasn't like any other thing except his own self.

9. Damage, Smell, Whistle

You may be wondering how I know these old stories, but that is not important. What's important is this little story about a woman who fell in love with a lamp. Falling in love with a lamp is not very smart because it is not very safe, as a lamp can cause a lot of damage to whomever tries to embrace it. Also, it stinks, and this smell can linger in the hair of the one trying to embrace it. And this is what

happened to the woman who fell in love with the lamp. What happened was mostly that the skin on the woman's lips and hands got damaged and her hair came to smell awful, but she was so in love that she cooed constantly with delight. Eventually, the only noise she made was a low, cooing whistle that sounded like a dark flute. She grew smaller and smaller as more and more of her skin was burned off, until finally, she was nothing more than her sweet whistling voice that cooed out of love and devotion. And this is why lamps, like the lamp she loved, give off a faint whistling noise as they burn.

87. Last, Iron, Flower

There once was a woman who lived inside a flower and she had the kind of voice that could melt an iron rod into is that she was the last woman alive, so it's quite a tragedy because she had no one to talk to. She spoke to the flower she lived in, but the flower had heard her speak so often that it stayed a flower and didn't bend or drip anymore. And so the two lived a normal life, the woman and her flower, talking and listening like any two things do when they live together without magic.

An Ariadne Thread
Julia Eckhardt
(2020)

In 2015, the dramaturg Leen De Graeve and I undertook research looking into the influence of gender on music and musical lives. This took place at Q-o2, an arts laboratory and workspace for experimental music and sound art in Brussels which I co-direct and where collective research into sound-related questions is one of our main endeavours. The project was not only sparked by the conversations with many of our artists in residence (of various genders) – in which I was particularly intrigued by the combination of urgency and secretiveness which I sensed around these issues – but by my own experiences and doubts as a woman in the field of sound and music. This research and the following project, which included a festival and two publications, fundamentally changed my perspective regarding my profession as an artist in the experimental music field, and at the same time had a considerable influence on our organisation. In hindsight, the initial survey feels like the beginning of Ariadne's thread, with many subsequent questions and insights to follow; driven by a curiosity to dissect and expose what music is really made of and about, how it is connected to its maker and the situation in which it is made, and ultimately in what way making and listening to music are political acts.

We developed a written survey to which over 150 people from various corners of the musical field and the world responded, with almost as many men as women, in

addition to many non-binary people, taking part. The testimonies were vivid and intense and spoke about discomfort in navigating the field, but also about thoughts and doubts on the conditions of the relation between gender identities and music itself. Many interesting reflections were aired, such as art as a reproduction of a normative society represented by the notions of work and authorship; the undisputed and apparently neutral presence of the male body and connected qualities; the institutions and places in which sound art is learned and for which it is created; the spirit of the field as competitive and hierarchically structured; the confusion between culture and nature; the canon and the lack of diversity in role models. The most controversial were questions about possible connections between gender and music itself and despite the acknowledgment of connection between music and the personality of its maker, the thought of this also extending to gender provoked a lot of confusion and resistance. The generosity and vivacity which we heard in the testimonies in general led us to the decision to make them into the imaginary conversation which became the book *The Second Sound — Conversations on Gender and Music.*[1]

The testimonies revealed clear questions, but showed at the same time a considerable lack of knowledge around the topics raised in the survey. Consequently, I decided to continue the thread and open the notion to a larger experimental research setting about gender, voice, language and identity. I wanted to turn to theoretical thought for answers on the one hand, and to artistic work situated at this intersection on the other, which resulted in a festival

[1] J. Eckhardt and L. De Graeve, *The Second Sound — Conversations on Gender and Music.* Umland editions, 2017.

and the publication *Grounds for Possible Music*.[2] The book is a reflection on how the making of music is related to reality and ideologies, on which foundations musical decisions are taken, and how these factors then fall into the listener's ears. It seemed important to map out that this is a general issue of cultural representation, which does not only affect those who are excluded.

A number of theorists have helped to underpin these considerations. Lucy Lippard writes about the necessity to accept the identity of the maker into the artwork and observes female artists refraining from doing this by leading a double artistic life.[3] Susan McClary develops the idea of music as a language, a currency for exchange through which a community of people chooses to communicate, and discusses how musical conventions have the power to stimulate or repress certain tendencies in such a community.[4] McClary shows how society and politics are always mirrored in its music and how historically this is an ongoing negotiation between the existing idiom at hand and the possibility to process and actualise it. Marcia Citron writes about the tremendous power of the canon, 'because it creates a narrative of the past and a template for the future,'[5] where the idea of non-functionality as the highest cultural standard has existed since Enlightenment, symbolised by the author and the oeuvre. Sara Ahmed highlights the importance of orientation in a world of

[2] J. Eckhardt, *Grounds for Possible Music*. Errant Bodies, 2018.

[3] L. Lippard, *The Pink Glass Swan: Selected Feminist Essays on Art*.The New Press, 1995.

[4] S. McClary, *Feminine Endings: Music, Gender and Sexuality*. University of Minnesota Press, 1991.

[5] M.J. Citron, *Gender and the Musical Canon*. University of Illinois Press, 1993, p. 1.

things and spaces, in which those for whom this phenom-
enological world wasn't designed need more time to make
it their home – the pay gap being only one of many
annoying consequences.[6] For Hannah Arendt, making art
is an act of appearing in a shared world and therefore in-
herently political.[7] All of these writers also make clear that
art and understandings of art are subject to changing times
and as such are dynamic, which stands in clear contrast to
the traditional self-understanding of the musical field as
abstract and unpolitical, unconcerned with human inter-
dependencies and other earthly matters.

Quality and the Responsibility of Judgment

One notion, which I kept tripping over without really
noticing it at first, was the concept of quality. It stayed pre-
sent yet quasi-invisible all along – like a chameleon, con-
stantly changing colour and meaning. I started to notice it
as an argument that was brought up in order to deadlock
requests for diversity, for example, when curators would
state that a 50:50 male-female gender quota would lead to
a decrease in the quality of their program. I am convinced
and have experienced quite the opposite, but to date have
not been able to generate a coherent argument from this
subjective feeling.

At present, speaking about quality in music seems to be
simply a way to divide music into the categories of 'good'
and 'bad', without ever asking for whom, in what situat-
ion, and in what function or at what purpose? Being so

[6] S. Ahmed, *Queer Phenomenology*. Duke University Press, 2006.

[7] H. Arendt, 'The Crisis in Culture,' *Between Past and Future – Six
Exercises in Political Thought*. Viking, 1961, pp. 197-226.

[8] See also: É. Glissant, *Poetics of Relation*. Michigan, 1997.

[9] H. Arendt, *The Crisis in Culture*, p. 221.

indistinct, it holds the power of a myth for which no justi-
fication is necessary. The original meaning of the word
quality – character, disposition, particular property or
feature, kind, relation – seems to have gotten lost, mutat-
ing from a designation of specificities to an instrument of
generalised binary division. This relegates any Other to
the function of the confirming opposite. Replacing the
thought of 'quality' with 'qualities' – in a plural sense –
could be a first step in subverting this dualistic worldview:
when there are at least three components, mutual relation
dynamics create a fluid equilibrium.[8]

A dynamic or fluid approach to ideas of quality does not,
however, mean refraining from judgment. For Hannah
Arendt,

> The capacity to judge is a specifically political ability . . . to see
> things not only from one's own point of view but in the per-
> spective of all those who happen to be present . . . Judging is
> one, if not the most, important activity in which this sharing-
> the-world-with-others comes to pass.[9]

For Arendt, a special responsibility is incumbent upon the
spectators, who in contrast to the actors, have the neces-
sary distance from the happenings to be able to make
meaning out of them. Judgment and taste are a common
way in which we read the world together, and refraining
from them is a manifestation of indifference, rather than
of tolerance, and will therefore keep the status quo in
place.

The composer Éliane Radigue made a similar reflection
in an interview with me, in which she explained the im-
portance of availability:

> Listening is the method for obtaining this availability . . . which
> is the openness towards what sounds are telling us . . . It's
> the quality of the listening one brings to sound that makes it

perceptible; it's the listening that makes it our own, according to the quality of our attention. If you open your body and your mind to listening with an active attitude, you will draw out very specific things. The condition for listening is obviously different according to the point in time, according to one's state of mind. That's the mirror effect, it's a reflection of one's state of mind in that moment. There exists a means of listening to any sound and making music of it.[10]

With this approach to music and its emphasis on the responsibility of the listener, it is possible to re-define the paradigms of quality through deliberate decisions – by taking into account the person behind – or better in – the music, and the situation in which it was made, by constantly questioning the criteria, and by acknowledging the importance of intuition.

What's Next: More Questions

For the organisation of Q-o2, exposing our work to the mechanisms of disparity was beneficial. It opened us up not only to a bigger variety of practitioners, but mostly also to a wider range of aesthetics, formats and content – to many lovely discoveries. Still today, we take the 50:50+ per cent gender quota to heart, using it as a fact-check, because when there is little time it is tempting to fill vacancies with those who are at hand and/or the most visible. Thinking differently has naturally also diversified the programme on other levels, along with the slow change in thinking within society. Also, for myself as a musician, knowing more has had a freeing effect. But this isn't the end of the thread – more indistinctness and unresolved questions remain as persistent blind spots in the

[10] J. Eckhardt, *Éliane Radigue: Intermediary Spaces/Espaces intermédiaires.* Umland editions, 2019, p. 49.

field of experimental music in general and resonate into our relatively protected orbit at Q-o2.

Being aware of the concept of intersectionality is important but it's often misused. In her keynote during the GRiNM Conference, Anke Charton made clear that intersectionality is foremost a concept of dynamic, and not of static, addition: parameters are in interaction but are not exchangeable.[11] Something that is rarely mentioned, but very important for our small-scale work at Q-o2 is the parameter of geography: we have to bridge the tension which exists between international visiting artists and a local community with whom we share our daily life. On both levels, the mechanisms of inclusion and exclusion function differently, and consequently our world-to-share – including the diversity we seek – is different to that of a large international festival. A powerful divider between these two worlds is language. Especially with the recent increase in specialisation and academisation in the field of new music (another indistinctness . . .), not only the general use of English but also the way it is used can be intimidating. Sometimes I feel that a pre-emptive move may be taking place here: since space is being made for diversity within music, the power hierarchies are shifting to the discourse surrounding it.

Another important tool for inclusion but also exclusion is the spaces we inhabit. Music is always made out of interrelations with and for social spaces, made by and for people who share a reality. And it's not easy to enter such spaces from another reality. As Sara Ahmed writes, 'for

[11] A. Charton, 'Default, Debug, Decolonise: Thoughts on Intersectionality and New Music', in *Defragmentation – Curating Contemporary Music*. vol. 24, 2016.

bodies to arrive in spaces where they are not already at home, where they are not "in place", involves hard work; indeed, it involves painstaking labour for bodies to inhabit spaces that do not extend their shape.'[12] The spaces of new music are mostly quite well subsidised, and old ideas resonate within them about why this is justified. Still, most of us in this field are both representatives of otherness as well as of the status quo, and it seems to me important to be aware of and live with this tension, as artists as well as organisers. It is a balancing act, and I sometimes sense a vague fear: Who is the composer when s/he is a listener? How much control are we, practitioners of new music, truly ready to give away?

[12] S. Ahmed, *Queer Phenomenology*, p. 51.

Tuning into the Quantum: A Vibrational Exchange between Karen Barad and Black Quantum Futurism (2023)

On 22 November 2023, Karen Barad and Black Quantum Futurism (Rasheedah Phillips and Camae Ayewa) took part in a vibrational exchange at Gray Area, San Francisco, curated by Lucy Rose Sollitt. Barad and Phillips each gave a lecture while Ayewa performed a live soundtrack for both talks, ending in a conversation between all three.[1] In Sollitt's words, 'through the lens of their practice and in celebration of shared points of convergence, Rasheedah and Karen reclaim the radical potential contained within quantum physics. In doing so they trouble the dominant narratives and violence shaping the present, from the next iteration of quantum technologies to Black experience and life more broadly. Accompanied by sound created by Camae, Karen and Rasheedah set out to highlight the im/possibility for erasure and how the past and future can be redeemed within the present.' This is an edited selection of their conversation, ranging across temporalities, repair and listening, published with their permission.[2]

Karen Barad: There are so many themes I would love to talk with you about. One of the things I think we're both doing from very different positionalities is trying to get physics to own its shit. I would love to hear more about the ways in which you're thinking 'temporality' and how it's not limited to the human, or what's in some 'thought bubble' in terms of the experience of time as temporality, but the way in which you take temporality very, very seriously, as being part of the way the world is, in the way

you're thinking about and rethinking and putting pressure on the notion of black holes, for example.

Camae Ayewa: Thinking about sound, tonight I used a lot of different bells because the bell to me stretches throughout time, and it has so many particular meanings. By the time I get a bell at the percussion shop, it's €3 or something like this. But the fact that it speaks to so many levels that have been put upon, forgotten, renamed, collapsing. So I try to think about instruments and things within nature that are used to make instruments: these things that are also codes, and are also tools of oppression. I really try to speak to all of those different temporalities.

Rasheedah Phillips: As a former housing lawyer I often thought about temporality and time within a system and the systems that folks are caught up in. We've tried to bring those notions and ideas around time and temporality into our work. One of our projects was the Community

[1] In addition to the excerpted sections, Barad talked about nuclear colonialism and the quantum eraser experiment that shows how the past can be affected from the future, that is, the past is never a settled matter. Phillips's talk also discussed the acronym CPT, both in terms of the derogatory stereotype 'coloured people's time', and 'charge parity and time-reversal symmetry' one of the central precepts of quantum field theory. We also learn that this is their first meeting in person, though they previously met online at the reading group on Physics and Black Study convened by Denise Ferreira da Silva and Fred Moten, in which Barad was an invited member and active participant, and Barad has been teaching Black Quantum Futurism's works, including the *Theory and Practice* volumes and *Space-Time Collapse I: From the Congo to the Carolinas* (2016) for a number of years.

[2] The full exchange can be watched on YouTube.

Futures Lab, which was based in North Philadelphia, where the city was redeveloping that area and really pushing people out and erasing their history, erasing the memories of that community. We created Community Futures Lab and did oral *futures* interviews with community members there, about the ways that people challenge the temporality of the government and the government futures that were being imposed on that community that were erasing their own histories and their own futures. So those are some of the ways that we explore temporality in our work.

CA: I'd like to add one more: there's a particular piece [by Irreversible Entanglements] that's about Sandra Bland called 'Chicago to Texas' (2017), and to begin to tell this story, it wasn't about interaction with just a cop and, you know, 'wrong signal turn'. To tell this story, I had to think about who built these roads. What is this journey from Chicago to Texas? And then doing that research, I find it's the same journey of horrors. So it's really getting into the whole story or holistic stories about what's been stacked upon, stacked upon, stacked upon in a systematic way to really cut people off from what has happened or what keeps happening.

KB: You have spoken about the possibilities of reconfiguring infrastructures, reconfiguring space-time-mattering. Instead of talking about infrastructures, I talk about apparatuses. So there are these entanglements, intra-actions of a variety of what you would call infrastructures, these various apparatuses of bodily production that are intra-actively entangled with one another, which means there's no separability, there's differentiating-entangling as one move, right? And so in particular, what we see there also is another calling into question of the subject-object

179

divide, because the things that we learn about the object in physics are never separable from all of those apparatuses. And for me, the apparatus is not just the instruments in the laboratory, but there is no end to these apparatuses. There's the apparatus of colonialism, of racism, of gendering and so on and so forth that then help produce certain kinds of results. And that's what objectivity is about, it's actually identifying what those apparatuses are and how they intra-act with one another to produce certain results. So that's a very different sense of objectivity than the usual sense that we have that science gives over . . . Instead, it's about accounting for things like erasure, for example, which is, you know, one of the key modalities of violences and here I'm saying: there is 'no erasure' finally.

RP: I'm curious, what do you think about the possibilities for repair? You know, in a world where we do understand space and time is always reconfiguring and even the systems that we are trying to dismantle, as always, reconfiguring or finding a new route through which to operate. Do you think there is possibility for repair of space-time, or is that even the right way to be thinking about it?

KB: That's a great question. I do think that there is something like repair that's possible and that has to do with dealing with the erasures that can be found there in the traces of things. It can't just be a move to, somehow, you see a rift and you just want to paste things together. That won't do it . . . You know, there's a certain kind of way in a lot of interpretations of quantum physics that says you have a whole range of possibilities, and you do a measurement and it collapses to one out of a multiplicity, and that's the collapse of the wave function. And what I'm saying is that these entanglements are actually extant. It's

just hard work finding what they are, and that's the *taking responsibility* part and accounting for the erasures. And I think that's what's necessary in terms of repair and that kind of reconfiguring of space-time-mattering to give us a different materialisation of not only what is, but what was and might yet have been, and the ways in which the possibilities are themselves reconfigured.

CA: Experiment is something that's pretty big in our work as Black Quantum Futurism and something that you said, River,[3] earlier about sitting in it. Taking this time to sit in it to where it doesn't feel like you're overwhelmed or you feel like you're *outside* of it. You know, the way the systems are set up, especially the school systems, you have to get some sort of certificate to be able to think about something. And I think removing that, getting back to this – for lack of a better description – this kind of childlike wonder of saying, 'Oh, I see that. That looks interesting. Let me approach it,' but not just approach it as in something you wear, actually sit in it and find these connections. Not just with/between yourself, an intimate connection, but your community. And we speak a lot about – and I've been just bringing this up – all the different types of memory. And we're thinking universal memory and cultural memory, generational memory, all of these different things *stacked upon*.

KB: Just a real quick response to this conversation about sitting with it, about slowing down, because the temporality of capitalism, racialised capitalism, is *produce, produce,*

[3] Elsewhere in the longer conversation, Barad explains that they 'completely go by River at this point' and use their previous name for professional/publishing contexts.

produce, the 'progress narrative'. Which means that certain people are behind time, always behind. And also the pressure on students now to *read, read, read* everything that comes out. And you can't. You just can't. So to give yourself the permission to just sit with even what you're learning, as a practice of learning, to really really slow it down, and to walk around in every sentence. I'm an extremely slow reader because I walk around in sentences the way I learned to deal with equations. So there's a whole way of walking around in it. So this temporality of learning and slowing thought down is in some ways going against the grain of capitalism and I think it's a really important practice.

RP: And I think that brings us to this question from the audience, which is actually the conversation that we're having. Someone asks, does your understanding and acknowledgment of quantum realities and temporalities affect your daily ritual or routine, your quotidian concerns? How does it manifest in decision-making, intuiting. And then someone else also asked a similar question of how do we as people relate to being particles in time? Can I be in multiple places? Or how does it relate to our narrative of people and generations?

CA: Just to continue what we're speaking about, part of my process before I start to work is to get into the act of listening. You know, I don't assume that I'm listening; you know, in interactions with friends or whoever, sometimes we can be looking at each other and still miss large parts of a story or a conversation. So I have to go through this practice of putting something on, or of going into nature and really getting in the space of listening. Then I can go and actually listen to something that I'm working

on. And it's also this act of emptying: understanding that we are taking in all of these signals, pollution or plastic. We're taking in so much. This kind of practice of – or you can call it a stream of consciousness – it's this act of writing with the intention of emptying, so you can start anew to actually get ready to write. It's what you're saying, it's this idea of slowing down. *Let's observe. This is an experiment. Let me try to see if this works for me.* Then I can skill-share to my community. It's like trial and error: I don't even like the word 'error' anymore, because it's always giving to the next circumstance or the next conversation.

RP: For me, it's been this kind of divesting, if you will, from fatalism and divesting from a linear progressive narrative where everything is going to come to some end. So I've learned to think of time in more cyclical ways or more generative ways and, you know, it's taken a long time to get to that point where you really feel and believe, and can create in the life that you are living, ways to generate and be creative with time. And so I've been able to do that in my practice as a policy person and bring in temporality into how I think about the systems and the policies and things that I do, and figuring out ways to stretch time through policy work, and stretch time through legal work. And it's also a daily practice, it's bringing in these rituals and that's why the word decolonisation doesn't quite work for me because it's so totalising of, like, everything. And it doesn't really allow for a just transition. The fact that we have to continue to live in the world that we live in. I have a 24-year-old. I have to continue to work. You know, I want nice things. I have to have a job. But I still can bring in other ways of dealing with time and other ways of dealing with space and integrate that into my life. So that's how I think about it. I don't think about it like there has to

be some totalising way that I've extracted myself from linear time. That's just not the reality. It's always going to be intra-acting. And so how do I make it the most positive intra-action that I can, and generative, and bring in my own ways of experiencing time.

KB: So, I want to come at this from the other direction, which is what does it take to live in linear time? What kinds of mindsets and infrastructures bear down upon a person and are threaded through them such that they can live life in that way? I mean, you started to allude to it. One of the things I talk with my students about when they say, how do you think about living these quantum notions of times? I'm like, how long did it take you to learn linear time? Like, this is what we do with kids up till eight years old, it says in the literature, you have to ingrain it into them to know what five minutes is. That's why parents do this thing. 'We're leaving in ten minutes. We're leaving in eight minutes. We're leaving in seven minutes,' over and over again, because it takes an enormous discipline to integrate this conception of clock time and how we run it. It takes an enormous privilege to not have that interrupted for you in a certain kind of way. And once, you know, once you have certain kinds of interruptions by these infrastructures because you're working against the grain of how they operate, you start to see the ways in which this just is not the classical linear clock time being operated. But actually there are interruptions of this all the time.

RP: I think that's really deep because we talk a lot about how time can be oppressive within court systems. Or telling a story, you know, you have children that tell a story and they're going to start with what was the most fascinating thing: that could be the flower that they saw. It's not

going to be this, 'OK, we had breakfast and then we moved into this next subject.' So this idea to have this kind of flexibility of, 'OK, well, how was your day?' And really testing or troubling that notion of how we speak to each other.

Leanne Betasamosake Simpson and Kite in Conversation (2023)

Kite: Thank you so much for talking to me. Could you introduce yourself please?

Leanne Betasamosake Simpson: For sure. *Aaniin*, Leanne Betasamosake Simpson *ndizhnikaaz*. My name is Leanne Betasamosake Simpson, I am a Michi Saagiig Nishnaabeg writer, academic, musician, and I'm a member of Alderville First Nation and I live in Peterborough, Ontario.

Kite: I wanted to talk to you about listening because it seems to be a core part of the method by which you're engaging with nonhumans in your work. Do you have a definition for listening that you subscribe to? Because I think sometimes that there's listening and hearing, sometimes things aren't for us, and sometimes we can't hear a certain range of information.

LBS: I think of listening as a deeply relational Anishinaabe practice. I think of it as a practice of knowledge production. I think it was and continues to be a foundational practice for the Anishanaabe people.

I think back to when I started listening to our origin stories, to our creation stories, and there's the beginning part of one of our stories that I shared, and that's known as Turtle's Back, (the one who loves us most completely) was dreaming and visioning, and their thoughts went out into the universe, and because there was no container for those

thoughts, they didn't hit anything, and they just went on forever. And those are the stars. But the sound that those thoughts made were the sound of seeds in a gourd, a shaker sound, that so many Indigenous people use in ceremonies and in our music.

Then she talks about how the next sound was that heartbeat of all existence. And that heartbeat, that drum sound, combines with the sound of the gourd, representing intellectual thought and emotional thought combined, and then the whole universe gets created.

And so, that, I think, to me, points to this incredibly important, reciprocal, relational practice of listening. When I'm hanging out with elders, particularly when I'm hanging out with elders in the bush, they're always listening, they're always listening to sounds that someone coming from the city like myself might miss, that we block out. They're listening to sounds as a way of relating, as a way of communicating with plants, with animals, with spirits. They're listening to sounds in conversation with their ancestors and with those that are yet to be born.

And part of that listening is quiet – not talking, and reflection. Oftentimes, in non-Indigenous cultures you'll have social folks filling in space and silence with chitchat and with conversation, and often, in Anishinaabe, especially with older elders, there'll be these long, beautiful, periods of silence.

I've also written about our word for truth, the practice of truth, Debwewin, which is the sound of your own heart. Listening is different from hearing. Listening gets conceptualised in Western thought. Ultimately, it's very intimate but, also, an intentional experience in conversation. If you're doing it correctly, you're listening with your whole body, your whole spirit, and you're doing it with an open heart. That, I think, is so often one of the places

that you want to get to when you're in a durational cere-
monial practice, to get to that place where you're able to
listen with an open heart. Because that's often where
transformation comes from: that's often a site of know-
ledge production, it's a site of transformation. It's a door-
way.

I think sound is crazy important in terms of connections
and relationality, and as a practice and one of the aspects
of the oral tradition. I love orality, and I love the oral trad-
ition, and I love to see the worlds that you can create out
of that. And listening is the most important part of that,
for sure.

Kite: This reminds me of a few chapters of *As We Have Al-
ways Done: Indigenous Freedom through Radical Resistance* (2017).
I've been relating this idea of individual responsibility to
listening in terms of the core part of your being that you're
responsible for, and it's not up to the community to listen
for you. I also wanted to hear from you about individ-
ualism in Anishinaabe culture. I love doing stuff with
Anishinaabe folks, because there's a real lineup with Lakota,
but there's some serious differences. Sometimes I forget
that they're very different worlds, but they share core
similarities.

LBS: I think individuals are responsible for listening to
their own truths and listening to the sound of their own
heart, for self-actualising, and for figuring out how to
contribute to the community in a good way, in a product-
ive way, in a way that generates more life. Based on things
like their name and their family and their clan and their
gifts. In an expansive way, not in a way that creates enclos-
ures. So, in my interpretation of this, and it's not everyone's
interpretation of this, everybody has a lot of freedom. The

community's job, the family's job is to rally around individuals and support them in their own self-actualising within the ethical scaffolding that holds the community and the collective – including plant and animal nations, including the natural world, including those ancestors and the ones yet to be born – as part of that conversation and with the goal, again, of creating more life and not just human life, but the life of everything on the planet.

Sometimes it's really easy in colonial society and in capitalist society to get really focussed on the individual. But that's just one part of it. It's important to figure out your own voice and to use your own voice, to listen to yourself, I think, as a life practice, but that's always going to be in conversation with all of these other beings that you're sharing time and space with, because we're relational, and because what I do impacts other life beings.

It's a really interesting practice of articulating your own needs and your own voice. But then we need to reclaim ways of weaving and braiding all of those different perspectives into collective thought and collective action and collective worlds. So it's the way that we take that diversity, and then weave it into something that's nurturing and generative for everybody, but also cohesive in terms of all of our relationality.

Kite: It reminds me of something I've been wondering – maybe there's an Anishanaabe equivalent, maybe not. I was teaching a 'Music of Native North America' class this semester and, obviously, there's no materials, and I just had to make it up theoretically. But I was trying to explain to the students why songs are ethics, and why and how they generate ethics method-wise. We were doing some research and realised there's a lot of Lakota stories that we think are core stories, such as our creation story, but we

189

actually have no proof that they weren't made up by an anthropologist. So that's chaos. But, there is this story of Song. Where an old man goes to the Black Hills to die, but he hears a prairie chicken sing, and he learns the song and the dance and it heals him. And so then he takes the song down to the people, and now Song is medicine. Obviously that's the short version.

It's interesting to me because it's so clear. You listen to land, and you're patient for many days, and then you know that nonhumans are beings, ontologically, and then they give you a way to understand new knowledge. Then you can go do that method and that process, and then you have ethics, then you've done an ethical action. I know that my PhD brain wants to structuralise everything, so that's a highly structured vision. But I wondered if there is a relationship?

LBS: My PhD brain goes to this division in Western thought between practice and theory. Even when you start talking about embodied practice, they're like, 'Oh, well, the theory came first, and the academics taught you the theory, and then you embodied it.' And I think that's really backwards in terms of how I see elders and knowledge holders functioning. It's this embodied practice, particularly when it's done collectively and over different scales, and I would say, an individual connection to the spirit world would be one iteration of that. And then as you add beings, the scales shift. That's a place of knowledge generation. You're making theory, you're building theory, you're building an ethics. That then can become something that you can talk about through story. But those two things are very, very linked, and I think are the same thing for me.

That's a pretty amazing story that you just shared. And I

think of the ethics of the person being gifted that song and then figuring out how to take their body and communicate that medicine. As a vocalist, that's something that I think about, and it can be very tricky to use your body as an instrument. Then there's the ethic of sharing: that that gift wasn't just for that person to use to heal themselves. They immediately saw that communal aspect.

We have a lot of stories about that through drums and different instruments and songs being given to somebody almost as a conduit, to take them to community to heal and to share. I would definitely see Song as ethics and I love how integrated it is, even till this day in our community: inevitably, there will be a prayer, a song, a joke and a story. And I think that's a beautiful embodiment of an ethical practice that is not a set of laws on paper, but it's relational, and it's living and it's embodied.

Kite: This brings me to another question that I've been asking a lot, a question that'll probably take me through the rest of my life, which is: where do songs come from? If I ask my grandfather, he would say we're just conduits. We have very little between us and Creator. I mean, this could be a really specific question; a new song pops in your head, some people have experienced the instant knowledge of the whole form, the whole poem, the whole song, and some people get the first impetus and then have to do the labour and do the editing. But I don't know.

LBS: That's a great question, if that is a question. The first thing that popped into my head was the songs that come from the birds, *beneshiiwag*. I think back to different origin stories about how birds were tasked with the responsibility of spreading seeds over the Earth, seeds that were a container for kinetic and potential energy. I think of how

present, when you're outside in the bush, that birdsong is as a form of communication. So I think that's one place, but it's not the only place. I hear and I understand that idea that we're just conduits and that they're coming from another world and another place, but I also understand that we're all different conduits. Depending on what kind of conduit you are, what song might come. Sometimes I think of the world as this network of relationships between humans and plants and animals and the natural world, spanning across time and space. I think of my body as a hub in that algorithm, and that I'm made up of relationships, and I'm made up of communication and sometimes that's physical and sometimes that's spiritual, and sound is part of that. Sometimes I think songs are stories, sometimes they're prayers, sometimes they're ethics, sometimes they're connectors, sometimes they're healers, they have a power and it comes from a place that I don't think that I can fully understand or articulate. I think it's a beautiful thing to think about that question, and carry that question throughout your life and actually pay attention to the work that sound, song and listening are doing.

Kite: I always go back to what you say about protocol, because it's such a complex word that does harm and can also do great good; I feel like English isn't helping at all, nor is the way people will protocol obviously. But I'm trying to create in my mind this delineation between Indigenous responsible and reciprocal listening and this New Age form of listening. It's difficult to express, but if I'm trying to define how one listens to the land, I know that in order to do it ethically it involves responsibility and things that veer towards protocol in order to keep the bumpers on it and keep my covenants with the nonhuman world. I think in sound it can get too woo-woo, the

bumpers come off and settlers think they can listen to anything and they can absorb anything. So, I'm wondering what your thoughts are about ethical bumpers for listening.

LBS: I think that oral tradition and oral practice is very complicated. And I think Indigenous knowledge systems are very complicated and robust and rigorous. And I think listening within that context is very different: it's a different practice, it's a rigorous practice, it's a robust practice, it's a practice that there are certain skills that you need to hone over decades in order to be able to do it.

I don't pretend to be able to listen to the degree that some of the knowledge holders, language speakers and elders can. They've grown up in an environment where collectively people were nurturing that and were doing those durational ceremonial practices that generated parts of your brain that enabled things like empathy and connection and listening.

That is one of the bumpers for me, is that we have to stop looking at Indigenous knowledge as something that is simple, that you can just dive into and take whatever you need. That's a very colonial way of looking at things that are Indigenous.

I used the word 'protocol' once in an interview that I was doing alongside Lee Maracle and she corrected me and said, 'I don't like that word "protocol" – I like the word "practice"', and I've thought pretty deeply about that over the last few years, and I really like the idea of practice, and of embodying and practising Anishanaabe ethical practices, because there are still bumpers, but there isn't that rigidity and one-size-fitsall almost dogmatic thing that can come with the word 'protocol'.

I've been out with the Anishinaabe and Dine hunters

who run out of tobacco and know that they need to offer something to their ancestors into the spirit world before they harvest. I've seen elders leave a little piece of their bologna sandwich. I've seen hunters, who have nothing, engage in a conversation through prayer with those ancestors, so that they understand that they didn't have tobacco this time, but there's a need. There's a conversation and presence. To me, that is something that is really, really beautiful and important. Our culture cannot be reduced to a set of protocols, laws or rules, particularly when you're out on the land, because the land throws all kinds of things at you, and you do the best you can. I think that you have to trust that your ancestors in the spirit world are benevolent. I'm going to be an ancestor someday, we're going to be ancestors someday. I want to be the kind of ancestor that's loving and caring and supportive and contributing, to bring forth more life rather than in closing and shutting it down.

When we're talking about all of this amongst heteropatriarchy, white supremacy, capitalism, cultural appropriation, all of those kinds of things, our responsibility to protect and maintain these practices and bumpers for ourselves and our communities is really important. There's an ethic to saying no.

Kite: One of the things that I've been thinking about is knowledge generation in spheres, not as hierarchies, but a lot of the work that I do ends up interfacing with the AI tech community, for better or for worse, and a lot of that academic talk ends up being critical: using Indigenous knowledge, and Indigenous ways of listening, as a critique, when I think we should be being generative, because I think we've come to the conclusion that being critical in a white academic context is not working.

But then also, when you were talking now, I was thinking about this dual sphere of knowledge, where there are the bumpers of listening and engaging with the world and being reciprocal – some of these conversations are sacred as internal conversations between Indigenous folks. And on one level, I still want settlers to know that there are laws and protocols and there are rules and they should be very, very, very careful.

LBS: We have to continue to have those conversations that our knowledge, our bodies, our minds, our spirits and our lands, are not for stealing, are not for taking, are not for white settlers. I think that critique and critical thought is important, but you can get a lot of degrees and a lot of grants and publish a lot of papers just critiquing.

I do a lot of land-based work. When you're on the land in a camp and you have a group of people that are just critiquing, the camp falls apart pretty quickly, because you're not doing the labour of life. It becomes really important when you're in a group on the land to take care of each other, to be getting wood so you're warm, getting water, cooking food, doing the dishes, you have to be putting wood on the fire or the fire goes out. Taking care of all of the camp's needs.

Anishanaabe people were always building our world as a life practice, daily, yearly, generationally. In a world-building context, I think that most of the energy needs to go into that building process, that generative process, or you don't have a world. That's also very difficult work. It's work that's around visioning, it's work that, particularly in colonial contexts, we don't know how to do. I see artists doing this, art collectors doing this, I see movements doing this, and I see Indigenous communities doing this.

Often, these kinds of endeavours, that try to collectively

embody the alternative and build something different, aren't successful. But they are successful to me. Every time we come together and we try to dream or vision, or think through, or build the alternative, or live the alternative – even if it's just for a few minutes, even if it's just for a few hours – that's generative and I think we learn what it feels like. There's knowledge that gets generated there that we use for the next time. Sound performances, sound artists are often creating the space for this and holding the space for this.

That work, to me, in my own practice, has been much more difficult, it's scarier. It always generates more questions than answers. When I'm working with students, they start asking questions: 'How do I not know this knowledge? How do I not know my language? How have I never been out on the land? How do I not know my songs?' Then learning about colonialism and critiquing the system becomes very important as they take their intimate experiences and scaffold it with the collective; they understand colonialism and anti-colonialism and their responsibilities and roles in that. But I think it is a danger to get caught up in just critiquing, because then you're not building any alternative. And then you're neglecting what for me has been a very generative side of knowledge production, and hope, actually.

Kite: I've been thinking a lot about my cousin who's an academic and artist, Clementine Bordeaux. We talk about protocols a lot and she often talks about this pinching that elders do to correct you. It could be a joke, it could be a jab, it could be a physical pinch to say, 'No, that's not how it's done.'

Last week, I went out to interview a man named Mike Marshall, who builds and teaches traditional Lakota camp

games. He was showing these games, they've a couple of versions: the older boys' version has a deer knuckle – you pull the sinew and it spins and you whack each other with it – and there are these little boys' bow and arrows. I said something like, 'Does this help them work on their skills for hunting for later?' And he stopped me and said, 'No. This is for fun.' I forgot what he said, but he meant that's a white person's way of looking at children. And now I read it like, 'Oh, racialised children can have fun too.' That was such a good hard pinch for me. There's so much more that's generated by play than by skill building. He really wanted to be very clear that camp life was extremely fun, and that kids spend so much time playing games, especially in the winter. And it is really transformative to think about how much fun we had.

And this was right last week, when all these elders were having to think about Kamloops and really intense experiences that half of them say that happened in Canada, but we have our own boarding schools. All their parents and most of them went to a school like that. And I've heard elders talk about the silence that residential schools brought when all the children were taken away and there was no more fun and there was no more laughter. It was that silence, of not having that joy that children bring through play and through laughter, and how the sound of laughter then infuses and wraps itself around the community, if you're in the vicinity of the sound. It seems horrible and terrible to me that you and I both have to be reminded of that joy and laughter that we're allowed – not just as children, but as communities: we're allowed to laugh, and to experience pleasure and joy and happiness and have that as part of the fabric of our life.

I have a collaborator, Alisha Wormsley, who's an Afrofuturist. I learn so much about joy from Afrofuturism

because we try to do these futuring exercises, these dreaming exercises, and I'm like, 'Let's use sorrow to teleport. Let's use joy. Let's find one kernel of joy and use that to generate the future.' It's tough.

LBS: Yeah, it is tough, but I feel like that practice of finding that one kernel of joy as individuals and then as community – that's powerful, generative stuff.

Kite: I'm a musician, and I grew up playing in group musical settings. The most important lessons I've ever learned were in those groups and how you can't dominate, you can't control, you have to listen to the drummer, it's the drummer's band – lessons like that. I'm wondering how your musical practice gives back to the rest of your practice.

LBS: It's been very transformative to the rest of my practice, because it's something that I came to later in life. I was already established as an academic with a writing career. I had lots of experience with music as a child, lots of music lessons, but also in a very churchy white environment. And so this was a process after having kids and reclaiming my own voice.

As an academic and as a writer, it's very possible to just live in your head. So, when I had my two children, giving birth, I found out, was an experience that I couldn't really intellectualise my way out of. It was a very embodied experience. Performance, then, became this incredibly challenging site for me to reclaim my own voice, but also be inside my body and use my body to communicate and connect with an audience, which I found very difficult and challenging.

And so, listening was first and foremost about listening

to myself and dealing with all of my own trauma and damage, because I couldn't step up to a mic and make any kind of sound when my body was wracked with depression or anxiety or thinking about past traumas. For a while, every time I stepped up to a mic, this voice would come into my head, this, 'Who do you think you are? Why do you think anybody is going to want to listen to anything that you have to say?' Which I think is a very common experience for Indigenous women.

So, I had to work through all of that in therapy and in ceremony and onstage, really, as well. I have a very soft spoken voice. My delivery and live performance, my voice is very soft, which I love, because my people are very quiet people. Our voices are very quiet. It was just something that was a part of me and was a part of my people, and I didn't want to learn to project or to force myself to speak louder, or sing louder than my body wanted to. That ended up putting me in conversation with the members of my band, and us figuring out how to be able to perform cohesively as a group and still have my voice heard. It put me in, oftentimes, a lot of adversarial conversations with sound men, because they wield a lot of power in a live performance, there's a lot of patriarchy, there's a lot of, 'they know better'. So I had to learn how to speak back to that.

I had to learn how to write for music and for sound, because at first, I was doing poetry or spoken word over music. And then in this last record, *Theory of Ice* (2021), I really wanted to move away from that approach and make sure that the lyrics were in conversation with the instruments and with the other voices, and that these were songs. So I took poetry from the middle of the novel *Noopiming* (2020), and I worked with my band right from the get-go in terms of generating the sounds that were going to go with this. And then the poetry made the shift into lyrics:

there's an economy with poetry, but there's also an economy that's quite different with lyrics because sound takes folks on an emotional, spiritual journey. You're bringing your words into conversation with other stories, and other voices, and other narratives. And so figuring out how to make my voice and my lyrics be in conversation with guitars and drums and keyboards and other voices, necessarily then changed some of the words. It brought it off the page.

The durational practice of being in a band and performing the same songs every night is something that can be at times a real grind, but at other times you've performed the same song fifty times, and then you will understand that song in a slightly different way. And that to me is so similar to some of the insights and transformations I've experienced in ceremony, that I really liked that.

And now when I go back into the classroom, profs can usually just read their lecture or do their PowerPoint and the audience can be on the floor and they wouldn't notice. But now if I lose the audience, it's devastating. So I think it's definitely impacted how I speak and how I lecture and how I teach and how I am as a human.

I think there was a point when I was writing *Dancing on Our Turtle's Back* (2011) where I was writing about how making culture is so important and embodied practice is so important. And I was like, 'I'm just sitting here typing these ideas into my computer. I need to walk the talk.' So yeah, that's been something that has been incredibly transformative for me as a human and as whatever it is I am in my other practices.

Kite: That is great. I'm really happy to hear about the process of singing, because I sing in a band and I got kicked out of my own band, and they're still going up. Thank

200

God I got kicked out for being a bad singer, because now I have a whole career. I would have just continued to be in bad bands throughout my twenties. But I spent a long time trying to sing again and then was like, 'No, I can't do it.' So it's really good to hear.

LBS: That journey's been really important to me because there's a very, very narrow line of what's acceptable as a good singer, particularly for female voices. That's so counter to Anishanaabe culture where every voice is amazing because it's an absolute expression of your essence and your spirit. I definitely struggled with all of that in this record, and I really wanted to reclaim that idea that song, within an Anishanaabe context, is for everyone. Everyone was singing and writing songs all the time. It wasn't just reserved for these people in our community that were deemed the experts on it. It was a practice that was so communal and so celebrated and a way of expressing one's own truths, which is so anti-capitalist and beautiful.

Kite: Yeah. Yeah, I'll never forget, I found this recording from the seventies of I think the most important Lakota singer and she was an elder at that time, and I listened to it and I don't know what I was expecting, but her relationship to pitch was unimportant. There was a core, obviously, but really it was unimportant. I realised I'm putting importance on the wrong things . . . If she is the shining example, then it's to be re-examined.

I have one last question. What was the first nonhuman you came to know or communicate with or listen to?

LBS: I think the first nonhuman that I interacted with and that I related to in a meaningful way, with some depth, was the black bear. In my early twenties, I was relearning

my culture. I was living in Northern Ontario, bears were appearing in my dreams, and then also in my life: as I was driving around on the highways, hiking, camping, spending time with elders.

It's not lost on me that bears are very large, very scary and very obvious, but I think this real-world experience with them while in conversation with elders, while re-learning, was significant. I started to experience the world in a different way. I started to pay attention, and, ultimately I started listening in a different way, and listening to things that were much smaller and much more insignificant than a huge black bear. So I think that stands out for me as the beginning of a different kind of listening.

Kite: Do you see dream listening as important? Do you experience listening in dreams?

LBS: Dreams in my culture are incredibly important. And again, it's important to put those bumpers up, because I feel like dreaming is something that everybody does, but in a cultural context, there's a specific way of listening and reading to dreams. Not all dreams are the same; there's a more complex and rigorous way of interpreting those dreams. But I think dreams and visioning and those times where your subconscious and the other parts of your brain are communicating with other parts of the world outside of the physical, I think these are generative and very important sites of knowledge for Anishanaabe people.

Untitled (F::A::G::S)
Lee Ingleton
(2016)

Sound::Gender:: Feminism::Activism began as an antiphonal call seeking a response; is there anybody out there, where are you, who are you, how are you, is there a 'we'? Through the DIY tenderness sometimes speaking softly, finding support for needed amplification, curious about who might be listening, who might be sounding, do we sound the same? Can we do this differently? To what?

Do we have a microphone? A stand? Why aren't the amps working? Did you turn the power on? Can you hear me??? Ohh, yes, yes, nettle salad, that's how we met, up in the sky, tentative greetings in corridors, paper plates, in a lift. Gossip, laughter, anger, frustration, at last together, mirth, kisses, psychedelic unicorns, macho intellectuals and glitter balls. Yes. And No.

Of strings and strings, that bind, that are bound to come undone, that are 'useful ways of thinking' . . . 'vulvas, bears and lions'. But what draws us together, any more than string? That sound, beating from anger and neglect, a rebellious drumming, a coded communication spat through stubborn teeth in spaces of our own making. Domestic, private, personal, intimate . . . and loud, loud with friendships emerging through sound. Musical relationships passed on and on, inspired further, held together, tentatively, sing, string snaps. Of feminist utopias and sounding bubbles, sinking, shaped, blown and held afloat again through sheer will in a world of pins and pricks . . . tom tom tom . . .

Statement
Lindsay Cooper
(1970s)

Women have always had to think on our feet, make things up as we go along, work outside of established ways of doing things and, whenever we've decided to take the chance, stick our necks right out. Where better to use these traditional skills than in the performance of improvised music together?

'Hein, Éliane': The Sonic Artefact, or Listening to a Third Space
Louise Gray
(2024)

Interviews and testimonies are two methods by which a speaker's invaluable personal accounts of an event are used to construct a record of some type. Speech, speech acts, can be raw and messy, their meanings not always apparently on the surface.

However, what we normally read and hear is an edited – a curated – version of an original raw material, an imperfect translation of a sonic act that has been radically recontextualised. A transcript, standing between speech and coherence, still has a messiness. There are obvious reasons for speech curation: intelligibility and kindness are two. Janet Malcolm, who had an ear for such things, suggests that to present a transcript into public view, with, she writes in *The Journalist and the Murderer*, its, 'bizarre syntax, the hesitations, the circumlocutions, the repetitions, the contradictions, the lacunae in almost every non-sentence', is, at best, uncharitable. And yet, Malcolm herself, a writer who observed and wrote about psychoanalysts in their natural habitat and was thus a keen explorer of what she describes as an, 'underwater world of linguistic phenomena', knew that there are depths to be plumbed.

In this intervention, I make a plea for raw speech. I propose that we return to the sonicity of the encounter between interview and narrator, between narrator and editor, to consider the record not as a closed space, but rather a place filled with reverberating meaning: a third space

between narrator and listener/technology – a sonic arte-
fact – produces new meaning and new listening.

So. This is what happened.

I had gone to Paris in 2016 to conduct an interview with
Éliane Radigue, one of the composers I was researching
for my PhD. I was with her in her small apartment
in Montparnasse. My friend, the writer and researcher
Catherine Facerias, had accompanied me to provide trans-
lation where necessary. Very soon into our encounter,
Radigue narrated a story about a fraught childhood incident
which involved a triangular relationship comprising her-
self, her mother and her music teacher. Young Éliane lived
for her lessons with Madame Roger; the teacher was, she
said, a 'goddess'. Madame Radigue, on the other hand,
seemed oddly punitive and she would silence her daughter
with a simple warning: 'Hein, Éliane?'

Hein is an interjectional interrogative in French: its easi-
est translation into English is 'eh' or 'huh'. It is a small
word which occupies, on the face of it, little sonic space.
As an interrogative, it demands an answer, even if that
answer remains unvoiced. For the young Radigue, hein
was something that her mother said often to her. 'Hein,
Éliane?' It meant stop; it meant no; it meant you cannot
dissent; it signified the presence of danger, and it was a
phrase to be feared. Radigue was eighty-four when she
re-performed for me her mother's fiat. This lasted all of
two seconds, Radigue's chin jutting upwards on the first
syllable, her eyes fixing me as she voiced the three sylla-
bles of her first name. The hein itself had a blunt, flat sound,
while the sound of her name rose slowly upwards, the
question. The narrative of the hein was one of the first stor-
ies that Radigue told me.

One afternoon, the mother took her daughter, aged per-
haps eight, as usual, to her music lesson. The teacher an-

swered the door; the mother said, 'Éliane has decided that she no longer wants lessons with you, *hein* Éliane?' The child – and she was a child – was stricken.

Radigue was a child then, in the 1930s when this occurred, and, for a split second in 2016, she became a child again. This was not simply a shocking story, a cruel story, delivered well. It was, rather, a reenactment, a sonic disruption of the present with the felt material of the past. Something happened in the air, and it was electrifying: Catherine and I were both very much aware of this. I had gone to Radigue originally thinking I would write about the compositional strategies that underpin her very singular and extraordinary music, which underscores the importance of listening to a sound, from its entry to its dissolution and eventual exit from the auditory range.[1]

I came away shaken by her story and, as it reverberated with me, I found it impossible to tuck away neatly, for it lingered like a ghost wanting to be heard. I realised that it was this – Radigue's communication of archaic anguish (existing, nevertheless, in a kind of historic present) – that was to be my research. It was her gift to me.

Elements of surprise shock us and reroute things: for Freud, surprise activates a displacement, briefly revealing unconscious content. In classical psychoanalytic theory, dreams and jokes are of a piece. They are never just what they seem. (Surprise and its action was later picked up by the psychoanalyst Theodor Reik.) For me, Radigue's '*hein*' revealed that what happens in the sonic can uncover this new knowledge, and it has led to the development of my conception of the sonic artefact, a journey that began with

[1] Julia Eckhardt and Éliane Radigue's long-form interview, *Éliane Radigue: Intermediary Spaces/Espaces intermédiares* (2019), is an essential text for anyone interested in this composer's work.

Éliane Radigue repeating to me a phrase often uttered to her by her mother: 'Hein, Éliane?'

The sonic artefact is a theoretical construct that pertains to the rupturing effect of sound in terms of temporalities, listening and theories of space, using psychoanalytically and topologically derived theories of boundaries, sonic theory and oral history; it proposes ways in which it can be applied to new situations to access a deeper listening and meaning. This re-sonifying of the interview away from transcript or finished text also points to the radical uncontrollability of sound and how its sensuous speech is never without its history, its resonances.[2] The psychoanalyst Paula Heimann recognises this fact in this way:

> The question the analyst has to ask himself constantly is: 'Why is the patient now doing what to whom?' The answer to this question constitutes the transference interpretation. It defines the patient's actual motives, arising from his instinctual impulses and from his defences against pain and anxiety towards the analysts as their object. It defines the character of the analyst and the character of the patient at the actual moment.[3]

Radigue, in her late eighties when she told me her story, was also a child. This slipperiness, mutability, unfixedness of language in time is not to be avoided as a weakness. The oral historian Alessandro Portelli sees in speech new ways of assigning a subjective meaning, via, for example, factual errors – which then amplify historical events and narratives in additional ways; I hear, in this fluidity, a shimmer of new meaning. The sonic artefact can be a temporal space capable of containing the sonorities of these unfixed histories, errors, and 'pre-textual' discoveries.

I mentioned Reik, one of Freud's earliest pupils. In a text, *Listening with the Third Ear* (the phrase, 'with the third ear', is borrowed from Nietzsche's *Beyond Good and Evil*, Part

VIII), he writes: 'The psychoanalyst has to learn how one mind speaks to another beyond words and in silence. He must learn to listen "with the third ear".' In other words, the tiniest bits of communication between two people must be attended to, felt, considered. The third ear is not, says Reik, the 'inner ear', but rather, following Freud, the unconscious's[4] fine hearing.[5]

While the interview is not a therapy session (and nor should it pretend to be one), it is a place where new listening strategies, informed by interdisciplinary methodologies, of which psychoanalysis is one, can reveal new material. You are curators, historians and archivists: it is not, I realise, necessarily possible to have the space to put 'mess' on display, but I suggest that the mess has meaning nevertheless.

How might the sonic artefact interact here? The sonic artefact resides in the space of the feminist-inflected encounter because it is accessed by deep listening, and one of the many aspects of deep listening that I advance is a

[2] Alessandro Portelli recognises that the transcript generated by interviews of any type, 'freeze[s] fluid material at an arbitrary point in time'. See A. Portelli, *The Death of Luigi Trastulli and Other Stories: Form and Meaning in Oral History*. University of New York Press, 1991, p. 63. Alexander Freund is one historian arguing for the importance of the sound over the text. See A. Freund, 'From .Wav to .Txt: Why We Still Need Transcripts in the Digital Age', *Oral History* , vol. 45, no. 1, 2017, pp. 33-42.

[3] P. Heimann, 'Dynamics of Transference Interpretations (1955/56)', in M. Tönnesmann (ed.), *About Children and Children-No-Longer: Collected Papers 1942-80*. Routledge, 1989, p. 115.

[4] T. Reik, *Listening with the Third Ear: The Inner Experience of a Psychoanalyst*. Arena Books/Farrar, Straus & Giroux, 1972.

[5] The third ear can catch what people do not say but can also be, 'lured inward', to access the countertransference on the part of the analyst (ibid., p. 156.)

listening to the social and cultural means of compositional production.[6] The feminist-inspired interrogation of material, concrete and systemic power dynamics that is fundamental to historical and sociological enquiry is mirrored in the sonority of the sonic artefact, in its sonorous semiotics: here, in this system of referral, we speak once more to Jean-Luc Nancy's 'renvoi',[7] that chain of referencing, resonating feedback. If a feminist interview acknowledges and analyses the symbolic order that is incarnate in social systems, then the application of the sonic artefact in the sonority of the interview works on the immaterial register: it hears the distant echoes that ripple outwards from the words spoken by a narrator of their own history, and in its subversion of this symbolic order. In listening to Radigue's story – and the power and emotion embodied in the time-travelling, ever-resonating 'Hein, Éliane?' – we hear the shimmer of simultaneous presents. And it's here where new material might be heard.

[6] With acknowledgment of Pauline Oliveros's work on Deep Listening.

[7] J. Nancy, Listening, trans. Charlotte Mandell. University Press, 2007, p. 10.

Collective Listening or
Listening and Collectivity
Lucia Farinati and Claudia Firth
(2017)

Listening can be understood as an inherent part of dialogue and con-
versation. What role does it play in constituting a group?

Lucia Farinati: The etymology of the term collective de-
rives from Latin *colligere*: to gather together, from *com* (to-
gether) and *legere* (to gather). Collective listening might
therefore be defined in terms of an auditory collective ex-
perience, the space and time of getting together through
the act of listening. As Brandon LaBelle put it in his book
on sound art, listening is, 'a form of participation in the
sharing of a sound event'.[1]

Of course, a sound event can be many things, a concert,
a music party, a noisy protest or a car crash. It depends
from which angle you want to look at it. Although this
definition serves the purpose of introducing the relational
aspects of sound art and its engagement with time and
space, taken as a general statement it also allows us to
speculate further about sound as a relational phenomen-
on. Perhaps what LaBelle is not saying clearly in this book,
but he does explore it in other writings such as *Acoustic
Territories* (2010), is what kinds of forms of participation
sound and listening produce within different specific con-
texts. This is something that seems little discussed in the

[1] B. LaBelle, *Background Noise: Perspectives on Sound Art*. Bloomsbury,
2015, p. xi.

field of sonic arts, at least compared to the huge critical debate on participation that has occurred in the visual arts.[2]

Claudia Firth: This question of the different kinds of participation listening might produce in different contexts seems very important. I'm thinking about what the artist Anna Sherbany said when we asked her about listening in the context of consciousness-raising groups. The term 'collective listening' could have connotations of the passive listening that Anna was talking about. From a feminist perspective, listening has often been denigrated as a more passive, 'feminine' attribute, but it could be argued that there is a substantial difference between hearing and listening. While hearing is passive – we cannot close our ears – listening is a conscious act and therefore in some sense active. I think what can easily have passive connotations, particularly in thinking about this phrase, 'the sharing of a sound event' is through the idea of an audience.

LF: The experience of listening together at a concert or to a religious or political speech could be described as a form of passive listening. However, there are modes of listening in relation to contemporary music and sound art which try to overturn the traditional relationship between musician and audience. From the early experimentation of John Cage to the spatial manifestation of sound art, from the World Soundscape Project of the late 1960s and early 1970s by R. Murray Schafer, to the renewed interest in field recordings, listening to sound has been explored not only as a tool for composition but more and more as a participatory practice that involves the active role of the

[2] See for example work by Claire Bishop, Miwon Kwon, Suzanne Lacy, Maria Lind, Irit Rogoff.

listener. For instance, artist Steve Roden describes his sound installations in terms of active listening, as a way to activate both the listener's perception of space as well as the acoustics of the space itself.[3] It could be argued that these new forms of listening are intrinsically political as they represent a breakthrough in the history of music but also in terms of auditory perception.[4] However, we are not interested in dealing with listening as the moment of the listener or spectator, nor as the exclusive moment of the subject.

CF: So, how then could listening become active in the context of or even as a catalyst for some kind of coming together?

LF: One reference that comes to my mind about listening and collectivity is Adorno's reflections on *Composing for Films*. In this essay he argued that the phenomenon of listening is intrinsically related to collectivity because it produces a sense of togetherness. He wrote:

> Acoustic perception preserves comparably more traits of long bygone, pre-individualistic collectivities than optical perception . . . ordinary listening, as compared to seeing, is 'archaic' . . . it has not kept pace with technological progress . . . the ear, which is fundamentally a passive organ in contrast with the swift, actively selective eye, is in a sense not in keeping with the present advanced industrial age and its cultural anthropology . . . This direct relationship to a collectivity, intrinsic in the phenomenon itself, is probably connected with the sensations of spatial depth, inclusiveness, and absorption of individuality, which are common to all music.[5]

[3] S. Roden, 'Active listening', In *Between Noise*. Steve Roden, 2005.

[4] S. Voegelin, *Listening to Noise and Silence: Towards A Philosophy Of Sound Art*. Continuum, 2010.

CF: That's very interesting – this idea that listening is almost primitive.

LF: The idea that music conveys collective sentiments and animates a kind of communitarian desire is one way to think about listening as an auditory collective experience, as a mode of collective sharing. From national anthems to partisans' songs, from rock concerts to rave culture, the history of (Western) modern listening is often a twofold story of collective identity. If on the one hand it has encouraged individual freedom, on the other it has served nationalist ideologies.

CF: Some people might find this aspect worrying because this archaic sense of collectivity can be harnessed towards creating nationalist or fascist affects or a collectivity that manifests as a homogenous mass. It can be a very powerful thing, being filled with affect generated by an anthem. I'm not sure that this just applies to music. Ideas of listening together might also conjure up images of an audience listening to a political orator, and that, at its most extreme form, might also harness a collective affect that while producing some kind of collective form of agency also subsumes the individual to create an *unthinking mass*. This seems to be part of the problem in thinking about collectivity.

LF: What interests me is how this sense of togetherness produced by acoustic perception can serve opposite

[5] T. Adorno, 'Composing for the Films'(1947), in C. Cox and D. Warner (eds.), *Audio Culture: Readings in Modern Music*. Bloomsbury, 2007, p. 74.

demands, being an empowering experience on the one hand but also disempowering on the other. It seems quite hard to draw a straight line here . . . And also about the different levels of perception and how this is somehow controlled or organised by certain power structures.

My question is how it might be possible to reinvigorate a sense of collectivity through listening as a positive and empowering challenge for society. Maybe this is just another utopian project or a romantic desire for togetherness!

CF: Perhaps. We do live in a fragmented and individualised society. But is a sense of togetherness enough? I think we're looking for the connection to politics here and how we might connect collective listening historically with the loss of a collective political subject.

LF: We already saw a different model with consciousness-raising. Listening does not have to just mean listening to an a priori, acontextual sound event but it can also establish the terrain for a dialogue between different subjects.

CF: As Anna Sherbany said of consciousness-raising groups, it is the speaking as much as the listening that counts.

LF: I am interested in how this relates to voice. Our examples are related more to dialogic practices such as consciousness-raising rather than to sonic arts and their spatial and environmental concerns.

CF: In our examples we are mostly dealing with listening to voice in a more reciprocal model than that of an audience. This is a very different kind of collective listening and a different kind of participation. But is listening to voice always necessarily about attending to sound? The

media theorist Nick Couldry argues that it has much more to do with paying attention and registering people's act of giving an account of themselves in whatever way that may be.

LF: I would like to argue that voice can be understood not only in a metaphorical sense, but both as metaphor and sound. Utterance is very much a process of an embodied voice: it is air that vibrates through the body and is emitted from the body. John Cage's reflections on silence might also be useful here. He demonstrated simply through his notorious episode in the anechoic chamber that silence does not exist: he could now hear sounds that are normally inaudible, like the sound of his blood flowing through his body. Where there is life, there is always sound.

Topography of Sound:
Expression to Live
Maria Chavez
(2024)

The sonic terrain is something I also relate to the body. The sonic landscape of this word is felt within the EVERY-body. To navigate the landscape of sound is an artistic democracy via vibration. That is, at least sound can still be felt by the deaf/heard by the blind, whereas other mediums cannot.

Here is an exercise to discover the terrain/landscape of sound for yourself:

VIVA!!!!!

If one were to record the sound of someone saying the word 'VIVA!', on a digital audio workspace the file would look like mountainous terrain.

And could be felt as such with vibrations to a deaf person: high peaks and low valleys.

Say the word 'VIVA!' and feel the terrain.
Even if Spanish isn't your first language, the sound/phonetics of 'VIVA' is spike-ful (pun intended) (alpine peaks!).

Veeee-Vaaahhhh

How do you express it at this moment of reading? Do you know what it means?

To VIVIR?? To live?? VIVA!!

But to pronounce the word 'VIVA' physically feels different.

And to DIS-ABLE the language we must recognise that VIVA is more than a word. It is a terrain, a vibration, beyond verbal, audible expression. Life finds a way. A way to live.

Now try to say VIVA as if it does not matter.

I mean, you can.

Regardless, you will still express the word for life, even if you try to say it without expression/with or without the visible/vibrational 'alpine' terrain.

Low-quality Sonic Snapshots: The Smartphone as Feminised Recording Device
Marie Thompson
(2016)

The University of Lincoln, where I work, has a railway line running through the middle of its campus. One wintry evening, when I was leaving the office late, I heard the overwhelming and eerie sound of a freight train emergency braking. Without really thinking, I pulled out my smartphone, opened my Voice Memos app and started recording. Since then, I've been collecting what I half-seriously referred to as, 'low-quality sonic snapshots'. Recordings include nesting jackdaws squalling down a chimney, the cacophony of the arcades in Whitby, heavy summertime rain, a fairground organ playing Vengaboys, the drone of gasworks and 'singing' railway carriages. The recordings vary in length from a few seconds to a minute and are minimally edited – there is usually little beyond a fade in and out. I've 'exhibited' some of these recordings as a sound installation as part of an event held at St Mary le Wigford Church, Lincoln. The recordings are also hosted on a SoundCloud page I update from time to time.[1]

The 'low-quality' of 'low-quality sonic snapshots' is something of a misnomer. The microphones built into current smartphones are often fairly powerful and the recordings are not particularly distorted. That said, 'low-quality' marks a distancing from the orthodoxies of field-recording practice. Recordings are mono rather than

binaural. They are often spontaneous, and I don't really attempt to minimise interference from, for example, traffic, wind or the voices of passersby. Nor do I eradicate my own presence as the person holding and directing the recording device. As Jacqueline Waldock has noted, field recordings are often presented as an 'objective' snapshot of a live event, with the sounds of the recorder minimised. Conversely, I make no conscious effort to minimise the sounds of my participation in the recording process and the sonic event – on some recordings you can hear the sounds of me moving, breathing and giggling. That said, it's rarely obvious to others that I am taking sound recordings – it typically appears as if I am stood looking at my phone. This ubiquitous, everyday device – the medium and means of capturing sound – disguises the recording process.

I consider my smartphone to be a feminised recording technology. Recording itself could be understood as a feminised process, given the gendered connotations of receptivity and containment.[2] To refer to the smartphone as a feminised recording device does not only refer to its capacity to capture, contain and replay audio, but also to capture and contain images and videos. Indeed, though foregrounding a different sensory register, I understand listening through these 'voice memo' recordings to be vaguely akin to flicking through a phone's photo gallery

[1] While I have not continued to maintain the SoundCloud page that I refer to, and I no longer work at the University of Lincoln, I have continued to use my phone to record auditory 'snapshots'. I have also become increasingly interested in the imbrication of gender, reproduction and contemporary sound technologies, including smartphones and digital assistants.
[2] Z. Sofia, 'Container technologies', Hypatia, vol.15, no.2, 2000, pp.181-201.

– the listener experiences similar overlaps and disjunctures in site, aesthetic and affectivity. Likewise, the apparent speed with which photos are taken, edited and uploaded to various online platforms is mirrored by my approach to the sound recordings.

The smartphone's status as a feminised technology is perhaps most obviously articulated by the smartphone's associations with selfie culture. While some have celebrated selfies as empowering and politically useful for (some) women and queer femmes – D.A.K. in *Browntourage* magazine, for example, has argued that selfies can help to decolonise representations of women of colour and queer people of colour[3] – selfies have also been condemned by cultural conservatives and liberal feminists alike for being a purported manifestation of vanity and narcissism that reduces women to their appearance.[4] In other words, selfies, alongside other feminised smartphone practices such as texting too much, have been considered an expression of bad, weak or unproductive modes of femininity.

Smartphones have also become embedded in some of the affective, administrative and relational labour practices that have historically been performed by women (particularly working-class women and women of colour) and have often been unwaged. As Robin James has argued, femininity as both gender ideal and norm can be understood as a technology that helps women perform these forms of labour: 'Need to persuade people to do unpleasant things (like get out of bed)? It helps to be cute and/or nurturing! Need to create a clearly legible calendar or

<hr>

[3] D.A.K., 'Look at me: selfie culture and self-made visibility', *Browntourage*, 2014.

[4] E.G. Ryan, 'Selfies Aren't Empowering. They're a Cry for Help', *Jezebel*, 2013.

schedule that represents a family's hectic and convoluted schedule? It helps to have neat handwriting, fine motor skills and design sense.'[5] In recent years, such labour has been redistributed so that masculinised subjects labouring within informational economies have to 'be their own secretaries' (and mothers, and carers, and wives . . .). With this, smartphones become an alternative facilitating technology. The smartphone can wake you up; it can provide reminders of meetings and appointments; it can even function as an 'intelligent personal assistant'.

The smartphone's automated 'personal assistant' often reproduces the gendered connotations of this type of work. Personal assistants are typically imagined to be female – it is a role that has historically been undertaken by women. Likewise, many of the smartphones' various 'assistants' are gendered as female – they are part of a long historical lineage of robotic femininities. In the US, Japan and Germany, among other countries, Apple's Siri has a feminine voice, as does Windows' Cortana and numerous other apps for Android systems – for example AIVC (Alice) and Robin, DataBot's personal assistant. The 'Assistant' app for Android pairs a feminine voice with an icon of a white, red-haired, attentive-looking woman holding a clipboard. The app is even capable of performing the affective labour of 'personality': one reviewer praises the assistant's capacity to engage in small talk and jokes.

Technological devices are not 'gender-neutral' insofar as they are coproduced with gendered conventions, values and ideals. It is not simply that these technologies reflect pre-existing gender categories. The smartphone, in its facilitation of modes of labour and particular, feminised media

[5] R. James, 'Femininity as a Technology: Some Thoughts on Hyper-employment', *The Society Pages: Cyborgology*, 2013.

practices, such as selfies and texting, both participates in and shapes gendered norms. When the smartphone enters the domain of field recording, its gendered status is not elided. Rather, it participates and shapes gendered expectations in alternative ways. If field recording has often been 'masculine' in terms of both participation and its aesthetics, then perhaps the smartphone brings with it an alternative, gendered sound apparatus.[6]

[6] J. Waldock, 'Soundmapping: critiques and reflections on this new publicly-engaging medium', *Journal of Sonic Studies*, vol. 1, no. 1, 2011.

Women's Audio Archive
Marysia Lewandowska
(1990)

My problem (in writing verse, and my reader's problem in understanding it) consists in the impossibility of the task: for example, to express the sigh a-a-a- with word (that is meaning). With words/meanings to say the sound such that all that remains in the ear is a-a-a.

— Marina Tsvetaeva

Women's Audio Archive is a sound documentation place concerned with the spoken word. It is a living archive and an independent project that has grown out of the interest in language as a site of cultural displacement. The impossible task of the collection is to untie the knot of a language-voice-power relationship.

Speaking, the Holding of Breath

It is from a distance that you hear sounds, your own voice perhaps, there unuttered, stored in the memory of the recording, revealed in the event of speaking. The voice comes back to you not as your own any more, it comes in the form of a recording, it exercises authority. But through dialogue you can divest the power of authority, of the singular and one-directional voice 'More than binarism, dialogism may well become the basis of our time's intellectual structure.'

To speak is to question the will to possess, it is a rejection of a will to produce an object and turn it into a commodity. But to speak means also to reaffirm presence,

to be noticed, to gain control. 'Language is legislation, speech its code.' How does speech enter the service of power? When we are talking about women being silenced historically, we are stating that in a power-structured language their voice is absent, not heard, and consequently their identity is missing. Speaking does not assume meaning apart from the social and cultural circumstances from which it arises. We are always facing the question of who is telling the story, in whose presence and in whose name? Who is listening and through what means is the voice disseminated? Who speaks aloud? Who preserves what?

Technology presents us with a promise of record keeping, of retaining memory, the privilege of truth. But we no longer live in the world of the original and need continuously to be reassured by the visible. We are bound by a search for beginnings. The reading of reality becomes a terrain for the reflection of our own uncertainty. It represents only one possible choice, which emerges from its own shadow.

In Martin Heidegger's words, 'What is unspoken is not merely something that lacks voice, it is what remains unsaid, what is not yet shown, what has not yet reached appearance.'

In recent years, due to complex visible and invisible divisions, language has become a site for tracing social, cultural and political displacement. I was interested in how this displacement manifests itself in the work of women coming from diverse cultural backgrounds. In general, the women whose recordings are stored in the Archive, all use sound, voice and text as a way of exploring their identities and as a means of understanding issues and relationships between language, gender, race and class. The Archive as a project is committed to investigating further possibilities of creating a non-homogeneous culture: a culture based

on difference and tension, the expression of crisis and fragmentation in the search for relevant meaning. Perhaps, it is through an experience of the 'undercurrent' and in the continuous effort to preserve that we will be able to create our own, self-doubting version of reality. In establishing the Women's Audio Archive I had in mind both the collection and the site that would preserve women's audio work and women's conversations as part of the developing history of women in the media-visual tradition that can otherwise, by its ephemeral nature, be so easily forgotten. The Archive and its attention to sound and language acts as incisions into the hegemony of visual culture and commodity value.

It provides a framing and a method without submission to methodology. It gathers sound and speech as a commentary, being commentary itself – a place for exiled language. It gives space to raw language, an 'uncultured' language counteracting both the norm and cultural absorption. What women (and men) often fear is not speech itself, but the manipulation of words/meanings that are taken from their own body and forced uncritically into the cultural body. The Archive's interest lies in dissemination of the unscrutinised word, in holding speech beyond the boundaries of print.

The project is situated within a particular time and its interest is in addressing issues and exposing ways in which history can be constructed. A recording establishes a specific relationship with a spoken word. Ensuring its repetition, it often makes it more fragile and vulnerable to manipulation. It grants preservation often at the cost of dislocation, tearing it away from its original context.

At the centre of the collection as a project, is conversation. What a conversation offers is a chance of breaking the codes of negation, capable of exposing a side-track of

thought neglected in the right to speak. In conversation
the wrong-sidedness of language is revealed and patterns
of communication can be redrawn. The interest of record-
ing conversations refers back to my own cultural back-
ground and the desire to keep track, to make visible and to
hear my own version of reality.

It is a verbal culture in which the channels of subversion
emerge in conversations with others, and through the
word that spreads around, mediated between desires and
deeds.

It is often too easy to think of the world as divided be-
tween only the free and the suppressed speech territories.
The problem is not solely in the suppression of the mo-
ment of speech, but in the nature of freedom. Freedom
does not lie in legal guarantees, but in the ability to questi-
on itself and change course, inventing its own parameters.
In totalitarian societies the word is still a powerful weapon
which threatens the master discourse without, as in liberal
democracies, being absorbed by it:

> To create culture it is necessary to meet, to talk together, to
> organise without any economic, juridical, and religious sub-
> mission, dependence and prohibition.

Where is the beginning of sound, of the recording, of the
voice present in the magnetic field of the tape and in the
field of imagination? In speaking, one crosses between
two spaces, that of speaking and that of sound. It is in the
communication between those spaces and in the 'being
through speech' that the presence of the familiar is estab-
lished.

The moment of recording sound and the moment of
replay do not share the same space and time. The sound
imagines the site. It elaborates on the invisible. It presents
time in the density of visions, breaking up the perception

of one image. In the recording, the voice comes from someone who is not seen, whose presence is asserted through sound. Our attention is therefore fixed in listening and imagining. It is the voice that is present in the disappearance of the body. Through listening we cannot possess that body. What truth does the voice conceal? What is the testimony without the body?

If sound is at the origin of being, how does it represent that being? Is it solely through speech that we begin to draw the contour of identity? A conversation enters no stage, it does not require a setting. It is able to find a space in the unlawful territory of language. It is ongoing, from time to time. It becomes its own solution. It may begin at the moment of ending. It pays no attention to progress. It is here now.

Conversation provides a transitional space, a non-solid state of passing through, of self-doubting and speaking out of not-knowing. By means of recording, conversation represents time. It enters history. It articulates history. It makes the past present, over and over again. The ever-present is granted by the apparatus – the tape recorder. The recording keeps time but it also keeps a record of tongue, of a story you are telling now and then, of a fantasy free from the oppression of chronology.

Speaking belongs to the area of the untraceable, the testimony of the word cannot be forced out of the body. The body is able to sustain torture in the refusal to utter and submit. In the moments of historical and personal despair the word is often exposed, its power of withholding threatens. Speech leaves no visible mark, its only refuge is in the memory of the listener. But how can we enter into the cultural and political debates with our silent bodies? We are always at the beginning of reinventing the language in relation to the body.

228

But we cannot be a mouth to the cultural body that is not our own. The narratives are too often invented for us by those who seize power in the exercise of arrogance and trivia. They colonise the media and they try to colonise us. We are in need of re-defining the content of our stories, as well as the medium and the process of their distribution.

It is conversation that offers a possibility to question the repression of the self and grants a gradual gain of access to women's own language. But to identify what that language might be, we need to keep on talking and listening to more than ourselves. In the refusal to speak other than her own truth, she is struggling to decipher and articulate that truth. She knows it is not once and for all. She insists on searching among her own confusions. Talking brings a pleasure of rebellion to her, of breaking away from the constraints of linear time, based in the process of revealing the link between a word and a desire for presence.

How are we speaking, if not historically? But as Julia Kristeva points out:

> We are constantly faced with a double problematic: that of . . . *identity* constituted by historical sedimentation, and that of . . . *loss of identity* which is produced by this connection of memories which escape from history only to encounter anthropology . . . We confront two temporal dimensions: the time of linear history . . . and the time of another history.

Conversation is a medium which escapes 'progress' and one-dimensional development. Its importance is as cultural memory. The liquid of the present originates in the dialogue with the past, which we help to dissolve into the future. The past is full of blank spaces. We often can only survive if we keep on forgetting. But in a world structured by the order of reason, we are not allowed to forget; our memory is stored in the machine and called upon out of

our control. We are subject to continual re-telling of the story. The sound recording is a means of construction and reconstruction of the state of mind embedded in the language system. The uncertainty of boundaries, placements, historical constructions and their representations, preoccupies my sense of being. In a tangled presence of language I am learning to gather attention, to accommodate fear, the unknown. 'It is not the voice that commands the story, it is the ear.'

A Conversation Between Marysia Lewandowska and Caroline Wilkinson

Caroline Wilkinson: I am interested in this fragment where you are talking about being subject to continuous re-telling of the story. I completely agree that we often can only survive if we keep on forgetting. This happens on an individual psychic level, but I think there's also currently a sense of time being fragmented into a series of perpetual presents and this process itself induces amnesia. I'm concerned with questioning what role the media plays in the formation of a sense of trans-individual memory and history and to what extent they usurp and warp the significance of other, existing stories. This takes place not only in the form of transmission but also in the lack of access to production and distribution. We are subjected to different stories at different times, which leads to a very partial 'memory'.

Marysia Lewandowska: In the slide/tape *Prudence* you created a very powerful and disturbing sound track using as a source a straight radio broadcast of a specific nature and appeal. In doing that you have exposed a number of problems occurring in the shift from the ever-presence of radio, to the particular presence in the gallery. What new

meaning is created in such a process and how does it affect the content of the sound work?

CW: I'm glad you were disturbed! The soundtrack was composed completely from recordings made over a period of time in late 1985 from one program on BBC Radio 1 (the'pop' channel). So the sound in the piece is dislocated in one very obvious sense. Normally it functions very much as an aural backdrop, but I wanted to scrutinise recurring fascinations and obsessions, in order to unpick certain strands, which become submerged in the general fabric if they're not focused on. The very form of the discourse functions to sustain that submergence. I was concerned with disrupting the seamlessness of the flow of sound because being a master discourse, it reinforces a prevailing sense of the authority of a particular form of address and also a process of amalgamation in which a range of values are transmitted, filtered through the opinion of one man. (I am absolutely not represented in all this!) I think that with the Women's Audio Archive you are concerned that as an undertaking it should function differently. In a way, you are trying to identify things that are otherwise unrecorded and unavailable.

ML: I am interested in the fabric of that backdrop and what's behind it and how one could start to weaken the main thread of it, in order to gradually tear it down. The backdrop is something that prevails most often against our own values and desires. The metaphor of the backdrop is close to that of noise, not just in terms of sound but also imagery. It's something that is always there, and it's hard to know how it affects us. In some of the conversations recorded for the Archive, I've noticed that the beginning sounds just like 'speaking on the radio': it is full of polite-

ness which obscures and rounds the edges. Even speaking with you now exposes very little of what our language might be, I know it takes hours of moving away from that routine language for the conversation to become an expression of identity, or rather, to move closer to the body. To use Kristeva's words, 'to break the code, to shatter language, to find a specific discourse closer to the body and emotions, to the unnameable, repressed by the social contract'. The backdrop is still too much in sight, although we have started the process of re-naming.

CW: Just to mention *Prudence* again, what I specifically wanted to do was to keep very close to the format of the sound as it's broadcast because that fascinates me. It's an endless stream, a discourse that goes on virtually without stopping. I think that's where its power is and certainly its manipulation. There is no space for silence at all. It's like there is no chance to breathe it in. And what I wanted was to stay so close to that but by shuffling it differently, changing the order, compressing certain parts to indicate that there was a presence through omission: the very absence of certain voices was painfully eloquent and I wanted to make that absence apparent not as a lack, but as a deafening silence. But I think not allowing a space even to think is a crucial part of it. It's a kind of onslaught really, that wraps you up the whole time in its noise. It's totally unlike the way people communicate in an exchange, where they feel safe to be silent or to think or to pause, where the other person is giving them a chance to organise their thoughts and their feelings.

I wanted to ask you, how do you feel the Archive could become more of a public place?

ML: I want this collection to be public, but I think there is

something I start to understand now – why it is not public yet. That it is still at the stage of forming itself and questioning itself. As an archive its value is not immediate, and its relationship with time and place is different from other cultural institutions. And if you think of it as a cultural interference, then you also have to be absolutely sure that it is made visible at a moment when it stands the least chance of reinforcing the 'backdrop'. At present, quite deliberately, the Archive relies on word of mouth for distribution and information.

CW: Something else that occurred to me, is the sense in which the Archive is a kind of accumulation, and in a way that's close to a conversation. When you start a conversation you have a desire for another person or people. You don't know exactly where you are going to end up because, although you might have a clear idea initially, in collaboration you go off in a slightly different direction. One of the things that seems to me most fruitful about a conversation is that it is an encounter with the unknown. It is also a way of clarifying your own thoughts and sustaining the desire for contact with someone else, whether it's intellectual or whatever. Without trying to make the analogy too neat, I have a very strong sense of that in relation to the Archive and I think that fits with what you have said about trusting you'll know the moment for it to enter the public domain. I think that's very much like that stage when you're discussing ideas with someone and you are absolutely committed to them, but it's also a matter of deciding how to be most effective at any one time and it takes a certain moment of wisdom, maybe, to be able to hold back when your energy is going into something and you want to communicate that to people but it's not the right time.

ML: I also try not to submit to the idea that there is an established pattern for the success of any operation. The project doesn't seem to be developing in a straight line, neither in terms of its measurable success nor in the material with which it concerns itself. It wanders about and goes off in order to be able to accommodate changes in the way it exists and within people involved in the recordings. I think this claim that any one project or person can be seen as symptomatic of our time is rooted in a kind of nervousness and fear of the insignificance of our time. So that any sign transcending that fear is immediately capitalised on and made 'real'. The lack of a coherent value system means that all the time we are dealing with gaps.

Coming back to sound. Where would you see the limits of this practice and the desire of visual artists to engage with sound?

CW: I find it very difficult to answer because I don't think I had a clear, formulated sense why I wanted to use sound initially. There was definitely a connection between its 'disembodiment' as a material and equivalent qualities in light projection. Although both depend on the existence of technology in order to be re-produced, re-enacted, at the moment when these two elements coincide, physically all we actually register is waves of sound and light. But the field of vision, the tract of sound in space, immediately position us as spectators, as audience.

I wanted to ask you who you feel is working with sound as a significant element in their work?

ML: There are two women from Germany whose work I value a lot, Dorothee von Windheim in Cologne and Christina Kubisch in Berlin. The former uses the tape recorder to record her presence within an environment

marked by a strong visual and political reference. Two significant projects of this kind are the recording of footsteps along the Berlin Wall and a recorded walk along the Rhine in Cologne. In both projects, the sound originates from the body. Some of Dorothee's other recordings are of readings from her diary, indicating another kind of presence, that of spoken language. Christina Kubisch's work also derives from the relationship between sound and human presence, in her case the presence of the audience generating sound through movement.

That particular way of using sound made me think of the recording as a site, a location for a recurring desire to redefine a voice and its relation to history. When we are talking of recording history, we are not necessarily thinking of a tape. We are implying a range of documents available to us as evidence. But a large part of that evidence is already edited, if not missing. It is fragmented by prejudices and exclusions originating in the dominant cultural 'whiteness', both female and male. There is a responsibility on our part, as white women, to address those issues.

What is the construction of a recording as an account, if it's through both language (story) and the presence of the body (being)? The question is not only who was talking but also who was there, who decided to switch on the tape recorder, who kept the tape? All this isn't that relevant in making an artwork, but it assumes a different meaning through recording political speeches, demonstrations and rallies. There is a moment when you must consider how the medium you choose is placed within the toolbox of political references and how they may contribute to the possible readings of your own art production.

CW: I have been thinking about the whole notion of silence. It's something Marguerite Duras uses in a film

called *Nathalie Granger* (1972). I think the case she makes in
the film is that there is a kind of tenacity and strength in
women remaining silent. And I would actually question
that, but I just wondered if it is a possible strategy and
what its significance is in relation to speech. In other
words, if one had a recording in which the impossibility
of speaking was as eloquent recorded sound, either of a
human presence or of voice. I am equivocal about it and I
don't want to advocate silence because I do feel strongly
that there is a problem when one is silent, and I'm speak-
ing from experience. The refusal of speech is certainly a
very eloquent expression of something, but it does imply
that one, in a way, may even be displaced from oneself.
Because if you can't take on the means of a certain kind of
power in our culture then what expression do you have
for whatever you identify as your culture, your own cult-
ural power?

ML: Silence is not simply a state of non-speaking. What
we observe now is the terror of 'noise', 'cultural noise',
and the lack of silence. I am very drawn to the idea of the
Archive being a place for reconstitution of silence in cult-
ural terms. If we consider the position of women in relat-
ion to silence, maybe instead of understanding it as mean-
ing absence, we could look at it as non-submission to the
patriarchal 'noise'. If you imagine reaching a state of be-
ing able to articulate your relationship with silence, would
it mean coming to your own speech?

Where I see a point of crisis now, is not in women being
silenced, but in women being subjected to 'noise'.

CW: This makes me think of Marlene Gorris's *A Question of
Silence* (1982). I wanted to see it again because my memo-
ry of it was one of confusion. The women's silence in the

film, their refusal to offer explanation, was obviously a strength in the way it was depicted, and I took it as that, but I also felt it was a problematic area as well. What it seemed to come close to was a kind of feminine principle, almost of a certain sort of inscrutability, and I think that that could be a problem if one is trying to open up possibilities for different kinds of contacts or networks, not only between women. So, I had a lot of doubt about it, whilst also feeling that there is a tremendous power in refusal, in withholding speech if it is identified as contaminated, exhausted, the language of the oppressor.

When you talk about 'noise' – which I like very much because it's very much my impression of how one has to live now, being subject to 'noise' – I'm aware of a paradox. If you are dealing with sound on tape, the implications of what that sound records are multiple and perhaps one has to have a very clear understanding of what a gap in sound means, how one can transfer the kind of significance one wants for that gap, onto a tape. It's a bit like making any kind of work: one can't be totally literal because in the process of translation from one medium to another, one expression to another, there is an alliteration of sense.

ML: What the sound work is able to grasp is a passage from the reality of recording to the reality of playback, which are two different realities. incorporating silence in a recording means also reminding yourself and your audience of the process of erasure and manipulation inherent in the production of sound. The inbuilt facility of any tape recorder is the erase head, which gives you the power to exercise silence. This is particularly relevant in the documentary recording. But there is also another aspect of a recorded silence when you are a listener in a gallery

situation and you expect to hear sound and not to hear yourself, at the moment of silence and gap you are forced to start hearing yourself. That area of shifting from the reality of sound and voice to the reality of bodily presence, which testifies silence, interests me, especially in relation to the Archive. But how to keep that silence active and articulate so it is present rather than lost?

Tuning in to the
Music of the World
Trinh T. Minh-ha interviewed
by Stoffel Debuysere
(2024)

Stoffel Debuysere: One of the most important, but also often overlooked, dimensions in the work of Trinh T. Minh-ha, is musicality, a musicality that can be felt in all facets of her work, expressed as exquisite configurations of breath, rhythm, silence and timbre. As we hear her saying in her latest film, *What About China?* (2022): 'reality is musical'. And elsewhere she writes: 'Love, hatred, attraction, repulsion, suspension: all are music. The wider one's outlook on life, it is said, the greater one's musical hearing ability.' As part of this programme, we invited Trinh T. Minh-ha to talk about the music, musical thinking and thinking in musical terms that are at the heart of her work, starting off with an open question: how does music fashion her relationship to the world?

Trinh T. Minh-ha: When I was introducing the film *What about China?* I mentioned that in ancient East Asia, a painter is always also a poet and a musician. And a poet is always also a painter and a musician. The three activities are actually extremely connected. And in my film *Naked Spaces: Living is Round* (1985), there is a statement from Novalis that I quote, which says, 'Every illness is a musical problem.' So if you want to heal from that illness, you solve it musically. That film, for example, has been compared

239

by viewers in the audience to an Indian raga, which usually begins with a 'prelude' that can be as long as it takes for the musician and the audience to tune in. With *Naked Spaces*, as with each film I made, I have to end somewhere arbitrarily, even though I could go on much longer. In my work, endings are meant to invite other beginnings. And in *Naked Spaces*, I was also connecting colour to light, as colours are determined by light. Colour, light, music, space, architecture and cinema are all extremely connected. In that sense, seeing the film as a raga is a wonderful response.

In another film, *A Tale of Love* (1995), I was dealing with a very long national poem of Vietnam, of more than 3200 lines of verses. The poem is visualised in its key moments and put to music, so you can hear the verses being recited all along in a mode that lies between singing and telling (or *ngâm thơ*). Well, I was told by a viewer, who introduced himself as the cousin of Ravi Shankar, that when he saw this film, he just turned off the visual to focus on the music. He followed the film through music, and added, 'it was a fantastic experience. I just put on only the music.' I didn't expect that, of course, because I was working with the two together. But these are examples that show how when one talks about composition, it could be written composition, musical composition, visual composition, and many more.

For me, film could be at its core a musically composed work, with its specific motifs, with visual phrases and rhythmic patterns that advance, shift and return. In *Reassemblage* (1982), for example, some sentences or fragments of sentences are rhythmically repeated. What is the function of that repetition? One can say that rather than trying to explain, you emphasise a certain part of a commentary, a fragment of a statement by repeating it, calling

attention to it, thus shifting the sentence's meaning every time it returns. That's also how music functions. There are certain sounds that we hear through commentaries, and when you start composing, you use these sounds again and each time you use them . . . It's like ideas also: each time you come back to an idea, a sound, an image, it's in order to go a little bit further, somewhere else, not to come back to the same. So for me, the use of repetition in cinema is never a question of reproducing sameness. It's always a question of reproducing in difference, with difference, and hence repetition and difference go together; they are not in conflict with one another.

I also think, and this becomes more prominent whenever I go to other parts of the world, that language is the music of a people and the music of a body. Each body has its own unique music. So you love someone because . . . It doesn't matter if the person sounds horrible to other people. For you, that person has a music that is very peculiar, very specific. And every time you hear it, you are tuned in to that music. In *Reassemblage*, even though I move across different regions, through different ethnic groups, and the language changes from one ethnic group to another, the musicality of certain languages stay on with me. Hence the focus on the sound of the language and its repetitions all along the film. Receiving language as music – the music of a people, the music of a body – leads you to a very different place than where you are when you confine yourself to language as meaning.

Sometimes I can also work with nonsense in a film. Again in *Reassemblage*, when I repeat, 'speak about', I further repeat, 'k-about', which doesn't mean anything, right? But it is a sound that is being repeated. So working with nonsense calls attention to the fact that language is also music, it's something to listen to rather than simply to

decipher meaning from. Similarly, when images are not organised around a central story or message, questions such as, 'What does it mean?' or, 'What is the film about?' often arose among audiences who 'see' not, 'hear' not, what is simply offered, first and foremost, to be seen and heard rather than understood.

I can also go into the relation between the verbal, the visual and the musical, which has never been one of domination and submission in my filmmaking. I don't give priority to the visual, and then only add the sound afterwards. The way I work on the montage of my films is to come to the editing table with all raw materials: raw footage, raw sound and raw commentary. So I may have hundreds of commentaries that I've written before, during and after the shooting, but I only choose a number of them for the film, as the editing process unfolds. Same thing as with the image and the music. You have to select what to retain in the film and you don't know in advance how they come together. You intensely experiment and create new relations as you go. So sometimes the image would guide the music and sometimes the music would guide the image. There's no preset order, but you do cut very specifically according to visual, musical and textual rhythm.

And life is rhythm – the way a film breathes, flows, dances or rests. I can come in and watch a film and immediately feel that the film has no rhythm, because relations or the way things relate to one another is not worked on. So rhythm is a way of dealing with a very large amount of material without having to resort to a central message or a central story. Centralisation and hierarchisation of norms in the film world are bound to take effect when people use a story, a message or a theme to organise the whole of a work. But this is not the only way to make

films. Thinking, for example, in terms of music, of music-al compositions, and the many possibilities these offer, like the rhythm of the body, of the voice, and the rhythm of elements coming in and out of the frame, the rhythm between movements, times, shots, sequences, transitions and more could open unexpected doors to the way one approaches cinema.

An anecdote during the filming of Naked Spaces: in West African villages, I often woke up at 5 am to the sound of women pounding millet with a pestle and mortar. Listening to dawn breaking with this pounding was so incredible because it told me something about rhythm and relationships. Together, two women pounding, three women pounding, four women pounding. And never do they clash with their pestle. Whereas if I come in and start pounding with them, I might go all wrong and then smash on someone else's pestle. But here they just do it effortlessly. They enter and leave the collective pounding fluidly. How do they do that, in rhythm? Because when you enter a certain rhythm and you go with it, it is this very rhythm that drives the relationship between you and others. You catch it, it catches you. No conflict, no wrong move.

The same applies to cinema. If you have rhythm in your film, you can have a vast amount of material coming to-gether fluidly in the shooting and editing processes, even in situations of incompatibility and unpredictability. And of course, a rhythm that is forced or a rhythm that is un-aware of its workings might also really disperse your film. What holds everything together and holds the viewer to the film is rhythm. Without it the film would not find its form. As stated in the film What About China?, 'Every mani-festation of life is a manifestation of rhythm.' In other words, rather than abiding by a linear relation of domin-

ation and subordination, I'm working here with a relation of multiplicity.

And how do you work with multiplicity? Again, it is with rhythm that thinking meets singing. A window into another world, a film, like a song, is the rhythm of heart and head moving in tune with one another. I work with a lot of folk songs and with diverse singing genres and styles in my films. In *What About China?* there are many definitions and many functions for the songs. Like a song can be a bridge – 'a bridge with a heart', as stated in the film. A bridge between two different times ('it keeps past and present alive'), two different cultures; a bridge between people – 'A song of love for the disappeared.' As mentioned earlier in relation to *A Tale of Love* (1995), in another film of mine, *Surname Viet Given Name Nam* (1989), we have a singing practice called *ngâm thơ* that remains very peculiar to Vietnamese culture. It's the way in which people recite verses, poetry – not quite a song, not quite speech, not a lyrical read either. It's something in between. Every time you would want to recite a poem to someone else, you would be saying and singing verses in such a way that they remain between song and speech. This is an aspect quite prominent in the films that I made on Vietnam. But songs have a very strong role across my works, to the point that you can say the song is a main structural device, and, overall, *What About China?* is a song, an, 'ode to sensorial China/the China of the hinterlands'.

SD: I would like to ask you something about what you have called 'tuning in'. Tuning into reality, tuning in to the music of the world. I find it a vital notion, but also one that remains undervalued, understudied perhaps. And yet for you, especially for your films, it's essential because for every film you start without a preconceived map, story

or structure. Every film sets off as a kind of jump into the void. For you, this tuning in, is that a way to approach the void, to perhaps approach it as a kind of open space of possibilities and resonances?

TTM: Yes, we can take this in many directions. The first example that comes to my mind: recently I was asked to write the foreword for a 2021 volume of conversations of Édouard Glissant with Hans Ulrich Obrist. And I told myself, how do I tune in with, tune in to Glissant? Rather than simply try to comment on, explain or analyse his work, I preferred to put our works in relation and that's exactly what Glissant has always tried to bring out in his writings: the poetics of relations. So to put something in relation, you have to tune in. You have to tune in to what Glissant is saying in his work. But in tuning in with his work, I can also bring in mine. There were many resonances between the two works, so I actually came up with a selection of quotes from my own writings that would go with selected fragments of Glissant's work. Two quotes, two independent fragments coming together in an encounter of resonances that you create between two forces. It's at the same time very free and yet also very specific because it's not just about what resonates, but how they resonate together. Sometimes you can recognise a word that we both use, but most of the time it's a question of expanding each other rather than simply finding ourselves in similarities. It's not in similarities only, it's in the mutual enrichment and the widening of one's horizon. To be able to resonate with someone else's thinking, you have to tune in. So that's one example.

SD: But regarding this freedom that you're talking about, I know many artists, filmmakers or film students who

would be terrified of it. I mean, freedom is not easy to assume. I was wondering, where do you get the confidence to deal with this void, with this freedom?

TTM: I realise I haven't addressed the notion of the void that you brought up earlier. The void is something we have to deal with all the time in our lives. For example, in common situations like when we are very nervous. In my youth, when I was playing piano on stage, and was very nervous, I suddenly went blank. I didn't even know what the previous or the following notes were, what I was performing or where I was. There were no longer any traces of what I learned, only a big hole in my memory. Being hit by stage fright was truly a nerve-wracking ordeal. So the void could be very terrifying in its manifestations.

But that experience could also lead to new beginnings. Every time we experience something as a new beginning, it's due to the void from which it comes. You are able to void everything that stagnates, or has become stale. You are able to empty out in order to begin anew. The void is simply vital to any creative work.

And yes, as you said, my students are sometimes terrified by this freedom given to them. So let's say they have a course where there is one teacher who teaches them to write scripts, and I'm the one who often makes films without preconceived scripts. So they would come to me and they would say, 'Minh-ha, how would you react if someone compelled you to write a script and follow a script?' I would then tell them, 'You should just take advantage of what each teacher has best.' In my case, you don't need a script, but you need to be extremely attentive to your processes – where you are in relation to what you do. You can give all to that now-moment – the moment you shoot, hold your camera, see with its eyes and gape

at what you see; the moment you skip, cut and assemble; any moment in the process would become just that moment, you don't have to do anything with it. It would be like a void. And you are in it and you start anew. You don't know what comes next. Without this open attentiveness, it's terrifying. But being able to put yourself in a situation to respond anew is very refreshing. It's almost magical. It allows you to see things with new eyes.

I remember, when I was working with a film crew on the film *A Tale of Love*. There was a scene where Kieu, the main character, was walking back home. While on her way, she came across a dog. In order for the dog to come towards her and stay with her, the actress had taken out some sweets that she discreetly gave to the dog. The dog got so excited; he jumped all over her. And I was happy. I was looking through the camera and saying, 'This is perfect.' I see the happiness and the love between Kieu and the dog. But the whole film crew was then yelling at me, 'Minh-ha, this is so obscene. You can't shoot this. You just can't do that.' Because the dog was so excited that he had an erection. But I didn't see that. I was just seeing the joy and the love. So for me, why would a scene like that become obscene? You know, it's a question mark. If we are not able to enjoy that moment of love and of joy, then it's difficult to see anything anew. We'll always see through whatever luggage we carry with us. This is another aspect of the void that links up with the term 'tuning in'. You tune in to the moment, you tune in to that vibrant emotion. This is how I see the processes of filmmaking.

SD: Another musical term that is pivotal in your work is the interval. Of course, it's a term that has been used before in cinema, notably by filmmakers like Vertov, who himself had a musical education. Like Vertov, you tend to

consider the interval not as a gap or a distance but rather as a possible correlation or relation. How would you define your interpretation of interval? Since you were talking about Édouard Glissant, does it resonate with his poetics of relation?

TTM: If we try to put them together, certainly. But I also see a difference. For me the interval is that space between, it's really an emphasis on between. If you take the term musically, you know how in music education we are trained to listen to intervals? You might have a major interval or you might have a minor interval. And in the book I wrote titled *Cinema Interval* (1999), I discussed the, 'wolf interval', which is hard on the ears and doesn't fit in with the rest. It is something you have to be careful about because when you have a wolf interval, it brings dissonance and disharmony to your music. But, depending on how it is placed, a transformative wolf is very different from an imposed wolf that you just throw in because you want some dissonance. You should reach a point in your work where the wolf interval effortlessly finds its own place. This also applies to how I see experimental film. Experimental is not simply a language of the avant-garde. You can come up with the kind of devices and strategies that avant-garde films use — like the adoption of automated repetition, of disjunctive manoeuvres or of heedless, jerky camera movements. You can easily recognise many of them as 'avant-garde' styles of filmmaking, including this tendency to prioritise abstraction. But for me, anything that people come up with and call abstract is actually very concrete. Like the notion of 'speaking nearby'. People say, 'Oh, it's abstract.' No, it's very concrete. You are doing it every day. You're doing it all the time. If you pay attention to how you do it, then you know what speaking nearby

means instead of speaking for, against, on top of, on behalf of and so on.

For me, this is part of how one also works with intervals: you focus on the between, on something that neither fits squarely in one place nor into another place. Something you haven't recognised yet with a name, something yet to name. You can always come up with a name, there's nothing wrong with that. But that name would continue to open itself up again and again. A word like 'feminist', for example. How do you work with that term so that it doesn't merely close down, but also keeps on reopening to begin anew: what might be a feminist aesthetic, a feminist strategy, a feminist film? Furthermore, the question is not whether a film's aesthetic is feminist or whether the film identifies itself as feminist. What seems more relevant is to make films that address feminist viewers – who can be of any gender. This is a way to leave that term grounded and yet open. Even when you need to close it, it's in order to open further, it's never a mere closing that confines reality to a category.

Working with intervals is a way of remaining constantly open. And to return to Glissant's poetics of relation, it is a way to relate, to be in relation. When someone asks, what's that interval? Well, you don't know yet. Until you work with the between and let yourself be led somewhere. The interval is what remains unoccupied and transformative. The interval between interviewer and interviewee, for example . . . In French, entretien also relates to entretenir – to keep, to entertain – a verb also used, for example, in extramarital relationships when a woman is financially 'kept' by a man. So how does that work, in terms of cinema? For me, entretien speaks to the word entre, or 'between' but also 'enter', and the word tenir, or to hold – to hold between, to enter between. What enables an

interview to unfold are encounters (of languages, voices, thoughts, feelings, seeings, hearings) that provide for an interval of open-ended becomings. No one owns it. It remains indefinitely in force between the two.

SD: I would like to quote a sentence from your wonderful book *Woman, Native, Other* (1989): 'Writing, in a way, is listening to the others' language and reading with the others' eyes. The more ears I am able to hear with, the further I see the plurality of meaning and the less I lend myself to the illusions of a single message.' What does it mean for you to listen with different ears? How does this process of attunement work and how does it relate to your notion of speaking nearby?

TTM: That's very nicely linked up. Yes, in socially oriented writing, there is a tendency to think that you have to be politically correct on all fronts. For example, the term 'intersectionality' actually helps bring together different struggles – how one struggle actually intersects with another. But it's not at all a new notion or practice; it has been there among our grandmothers and great-grandmothers for as far as memory goes – maybe not named that way or maybe not even named. When we are fully attuned to a struggle, that struggle allows us to speak to other struggles, to hear from other struggles. A simple line that tells all and could open the way to faring across struggles: 'You don't do to other people what you don't want people to do to you.' As it's impossible to cover every struggle of marginalised people, when I write I am all ears – not only listening as if I hear a word for the first time, but also following the path it creates from one writer, one person, one context to another. There are lots of references in *Woman, Native, Other* to queer writings for

example. But I cannot cover all the territories, and would not name them all. Rather than trying to be complete and all-inclusive – which is literally unfeasible – since there are always more struggles than what you can see and take in, you could disclose incompleteness in its blanks, holes or stuttering, and work, instead, with many differing ears, whatever the focus of your subject turns out to be. The more ears you develop, the richer the multiplicity you can embody and manifest in writing, even when you don't name everything.

Aside from the political ear, there's, for example, the physical ear. Sometimes I have a number of ideas that I write down so as to use them later in the writing, but I cannot force an idea in whenever I want because when I force it in, the sentence doesn't work. And for me, it doesn't work because it lacks musicality: the combination of sound in that sentence is totally not acceptable to my ear. I keep on saying, this is where that idea should be, but I cannot force it in. I have to wait until it finds its place. It's like the wolf interval, you know? So you have to work with an ear. And that's my own process. But actually, one of the first readers of *Woman, Native, Other* is a woman from Trinidad who told me, 'Your whole book is written in cadences. Every sentence has its own cadence.' So she hears it. She internalises its musicality in the process of reading. Writing and reading with an ear would free you from having to focus only on ideas and meaning. As such, the sentence exerts its own musical independence.

Transmissions from the Mothership
Naomi Okabe
(2024)

Quantum Listening is listening to more than one reality simultaneously. Listening for the least differences possible to perceive – perception at the edge of the new. Jumping like an atom out of orbit to a new orbit – creating a new orbit – as an atom occupies both spaces at once one listens in both places at once. Mothers do this. One focuses on a point and changes that point by listening.

— Pauline Oliveros, *Quantum Listening*

Log Entry 001

Temperature check. Mechanical scan. Life support test.

They say I was built for this
programmed to sustain life
a continuum of caregiving protocol

There is a hum to the colour green
we are trying to spread it across the universe
I have been tuned to this key
a flight feather of curving steel

Velocity equation one: at what speed do we need to move to reach each other?
A stone and a wave. A ship and a planet. A word and a world.

Velocity equation two: at what speed do we need to move

to hold each other?
An egg in a nest. A seed in the wind. A fish in a net.

I am holding in low orbit

Log Entry 521

Embryo cache operational. Seed archive stable. Database defragging complete.

Solar arrays turn toward the sun
a photosynthesis, a metabolic rhythm

No longer exclusive
our systems intertwine
a symbiosis, a devouring reproduction

We knot into generosity
we buckle in
and I forget the words
cargo, passenger, parasite
there is no lacuna
only a quickening

I am a multibodied signal

Log Entry 842

1.2 light years from Earth. Destination: Unknown.
Nebulas are said to be the star nurseries of the cosmos
Then what am I?
A wheelbarrow
A carrier bag

A storm cloud
An antenna

Listening for the possibility of life

Tomboy Tendencies
Nat Lall
(2019)

Remember when you were a little chubby futch and your voice was muffled by phlegm from prayground-passed-around coughs and colds. It was babyish and fragile but echoed your father's dry heave, chain-smoker cough. A little chain-smoker cough. A little higher pitched, a little softer and a little littler but still a sign that you were a mutant manchild.

Drink lots of lactosey milk from tiny bottles/cartons and build up a thick layer of goop in your throat. Cough and giggle to yourself. This is the first score of SFSB[1] and a reminder of one of your first times in drag. Sick baby as sick daddy.

[1] N. Lall, *Scores for Sissy Bois* (2019).

Letter to Kate Millett
Pauline Oliveros
(1973)

The below is a carbon copy of a letter from Pauline Oliveros to Kate Millett from the Pauline Oliveros papers, New York Public Library.

16 April 1973

Dear Sister Kate:

Thank you for your letter and for the apparent intention of bringing 'feminist musicians' together for a festival. No doubt this could be a fruitful occasion and one which I could see myself involved in. However, I must take you to task for the stance of your letter. Why must you apologise and take a submissive position vis a vis Music? Hasn't that position of submissiveness become unattractive in any situation, especially for a woman who is a leader of your stature in the movement? It is unattractive and immobilising for any woman! Music has been a male dominated field in Western culture, not only in popular music but in the larger art forms, as you well know. What is woman's music? Or feminist woman's music? Is it enough to borrow sexist forms and impose feminist words? Is that a double message? Hasn't that occurred with revolutionaries before? Borrowing fascist tunes and replacing the words with socialist messages? What does music do to one's consciousness? Does it become women's music when a Symphony orchestra has all female instrumentalists, a female conductor playing a score written by a female based on musical ideas out of a music tradition developed

by men? I am concerned with the power of sound! and what it can do to the body and the mind. I am not sure at all that it is 'SAFE' to borrow forms which continue a sexist message such as rock, rhythm and blues, sonatas, symphonies, etc. Maybe we have to search around and find something else. Maybe we have to give up what we know and love in order to come to a tone [sic] understanding of the meaning or effect of 'MUSIC' on us feminists.

From what I gather through your apology which clouds the issue, you are thinking of popular forms (which I have known and loved, too) but not of other less immediate forms of music. I have trouble then knowing if I would fit into your festival. Certainly I would not come if there was no understanding of what I do and I had to encounter false expectations and baggage.

Fundamentally my position is this: Sound is everybody's material. Women's music is inside women. The time has come to draw it out and see what it is. It might not take the forms that are all neatly trimmed up and available, guaranteed to trigger specific emotions. So – I have been involved in what I call SONIC MEDITATION. I have worked with a group of women over the last three years, exploring sounds which we make in altered states of consciousness which are brought on by the sounds. We have gone various places from time to time giving workshops and sharing what we do. Anybody can do the things we do provided they are willing to commit themselves to the instructions (without apologies!) Perhaps what is emerging is a kind of women's music. At least I am a woman, exploring sound with other women without regard for established forms. I am also working with auditory fantasy – a series of questions which trigger sound 'images' in the minds of the participants with feedback and discussion at

the end of the trip.

Finally all persons who are present in one of our sessions are active participants. In other words there is no audience. I am also calling into question that whole symptom of active performer, passive audience as a perfectly sexist expression.

So there it is. If you think my radical views have any place in your Festival of Feminist Music I would gladly make myself available, with or without honoraria and care [sic] fare. I think my calendar would allow it.

Yours in sisterhood,
Pauline Oliveros

Sharing the Problem
of Listening
Roy Claire Potter
(2023)

The Backward Circle began in 2015 as a problem with a tutor. Now, several years later, I understand the problem I had then was likely a manifestation of autism. At the time of writing, I'm waiting to be assessed for an autism spectrum disorder; the assessment may or may not confirm this, but the screening process alone has caused a tectonic perspective shift on my practice, and its specific focus on performed language.

While it is no exaggeration to say the tutor I had a problem with was the most charismatic academic in the entire art school, I can now acknowledge the fraught whirlwind of our first meeting – the basis of the Backward Circle – had as much to do with my propensity to be glamoured by strong communication styles as it did with their intention to set the tone for our supervisory dynamic.

The combination of the tutor's talking and body language captured my attention during our first meeting. Captured is the word for it. The net was not the tutor themselves but my lines of internal enquiry; my monitoring and decoding of resonances between spoken and gestural meanings, and how they required particular reactions from me. I could hear what was being said, but I can't say that I was listening because I know I wasn't reflecting on the object of our discussion – my artwork. Leaning forwards towards me – which means earnestness mixed with attention – the tutor smiled and nodded while

making some suggestion and so I found myself, likewise, animatedly agreeing with who knows what. Satisfied with what appeared to be my confirmation of their advice, the tutor flicked their hair and leant back to begin an anecdotal aside; I repositioned my own body, accordingly, acting out a change of register in my own thinking, showing I was keeping pace.

After thirty minutes of intense monitoring, I was exhausted and upset. I went home miserable and frustrated that I had been unable to keep a guard of my own meaning and say what I wanted to in the face of another person. Frustration boiled over: this was all the tutor's doing! The bastard had tried to beguile me and put me in my place! Well, I wasn't having it; the next tutorial would be back-to-back. I needed to figure things out about my artwork, not waste time appraising my tutor's manner!

Charismatic they were, but my tutor also considered themselves to be adjacent to the university as a conservative institution; they were welcoming of dissent and troubling the waters. While I was not yet able to piece together the real reason for my communicative problem, my tutor readily agreed to a back-to-back tutorial, no pushback, only curiosity and support. I hoped that once I was relieved from monitoring their expressions and gestures, I'd be able to listen and say what I thought.

In *Teaching to Transgress: Education as the Practice of Freedom*, bell hooks discusses the relation of listening to voice. 'To hear each other (the sound of different voices), to listen to one another,' she writes, 'is an exercise in recognition', later underscoring the singular importance of how students find their own voice in the classroom as part of a mutual recognition: 'I don't mean only in terms of how she names her personal experience, but how she interrogates both the experiences of others, and how she responds to

knowledge presented.' It is this participation in the matters of the classroom that constitutes voice in hooks' pedagogical practice, and it is by 'speaking' with one's 'voice' that others might hear you, recognise you.

This interrogation of experience might feel par for the course for those familiar with art education, where exploring foundations underpinning our experiences of each other's artworks is the basis of our main teaching method, the group critique. But it's possible to attend crits all year long and still not find your voice, instead only learn to affect a way of talking. I've attended many crits where tutors – me included – fall foul of a well-meaning inclination to demonstrate how to talk about art. bell hooks's work in critical pedagogy reminds us that we must alter these existing pedagogical structures that are based on the authority of the teacher's voice – to promote listening and, by extension, to promote voice.

My back-to-back tutorial was not all that unorthodox, really. Art education has a legacy of week-long crits and locked room experiments, but it did bring balance to mine and the tutor's dynamic. They interpreted my pedagogical intervention in the historical context of art education's tendency towards institutional critique and, unknowingly, I deferred to this. The effect on our conversation meant my frustration evaporated and I ceased blaming the tutor for my problem. I found some space to have a voice in. I mistook personal relief for disciplinary breakthrough, and I stopped short of interrogating my own issues with communication. Instead, I accepted the idea that my intervention with the tutor had been a comment on the pedagogical form itself, the tutorial. And, so, I talked about it like this. I boned up on art practice as institutional critique – the John Latham, Hans Haacke, Hito Steyerl – but in the studio, when left alone with my own compass, I was busy

writing experimental monologues.

Any student artist working through the implications of subjective narrative writing will come up against two obstacles during opportunities to present work in progress to a group. First is the sympathetic faces of others who can't separate their aesthetic experience of the writing from the fact of the writer, and so collapse both the functions of the narrator and author into a single act of telling something to anyone who'll listen. This is a mire for a student experimenting with form across disciplines and leads to all sorts of digressions that position lyric constructions as nothing but a veil for therapy. The second obstacle (perhaps a retaliation to the first), is the discomforted deployment of critical distance in order to swerve difficult or emotional content. It often looks like an insistence on materiality – the paperclip as opposed to the use of staple, the effect of the paper's weight – and this can contain a barbed disdain for the centring of tricky life experiences in the making of an artwork. 'It's all me, me, me,' I once heard it put by a teaching colleague. It's true that not everyone is cut out for it. 'Many professors who are critical of the inclusion of confessional narrative in the classroom . . . lack the skill needed to facilitate dialogue,' hooks points out, not naming any names.

All classrooms contain people who like the sound of their own voice, or who are unable to establish links between their anecdotes and the matter at hand, or their feelings and another's educational advancement, so for dialogue to be facilitated it must be orchestrated by some means. My orchestration – at that time a student with an intense desire to minimise faces, suddenly fluent in institutional critique and patently aware of the obstacles subjective narrative writing might face – was to turn everyone away from each other. We'd sit in the usual democratic

circle, but with one tweak: our chairs would be turned in the opposite direction. It wasn't a book club. It wasn't a therapy group. By stripping out the visual aspects of communication as I'd done in the back-to-back tutorial, I hoped the crit participants would find themselves alone, listening to voices with me. I wondered if we each might find our own ground from which to speak, as I had done under these conditions. Without the influence of other people's facial expressions, gestural agreements and implicit permissions to speak; without studying how people inclined towards or turned away from a speaker, what their hands were doing, where their gazes fell, I imagined it was possible to come together like this, unmonitored and unmonitoring.

The writing I presented to my cohort was an unedited two-page monologue written on a manual typewriter. The narrator urgently pieced together domestic scenes and bodily memories with glanced-at images of nakedness, smashed plates and the uncertain names of city streets. It suggested violence but didn't establish it. The written language affected destabilisation too. It was replete with grammatical mistakes, typographic errors and the smudged impact of the machine's malfunction visible around the edges of inky characters. Letters lay over letters, obscuring words. Knowledge of the operator's hand – my hand – could be traced in these marks and this, I was told, blurred the roles of character, narrator, typist, author. Wanton line breaks, and truncated sentences that owed their aphoristic bent to my shocked finger joints, made for a frenetic reading. The voice of the text was breathless, stammering out a tale that was equally broken and jumpy. Everyone had to be on their own with that voice during the crit, just like they had been the night before when reading my text preparation.

The live condition of reading first-person fiction is falling into a time-space relation with the voice you encounter, meeting them in the middle and being told something. Perhaps I was asking my fellow students to speak from that time and place, to help make the reading encounter communal for me. I mean, if ten people read about a particular field at the same time, they're in that field together, aren't they? This always struck me as a radical concept, but in the context of that monologue's specifics – the unsettling kitchen of broken crockery and uncertain nakedness – I now see that I constructed an unsolicited and one-way intimacy. The other live condition is finding yourself close, somewhere you didn't anticipate. I apologise for that. Whatever I hoped for, my generous peers talked mostly about how strange it felt to speak to each other that way – separated out, but together in our manner of being separate. Looking back, I wonder if this is the condition of political solidarity, or was it an experience of social atomism? I suspect my 'orchestration' means it was the latter.

In recent years as a tutor, I've used the Backward Circle as a teaching strategy to practise hearing and listening in the classroom. It's been a useful tool to consider the political and social disorientations Sara Ahmed describes in *Queer Phenomenology*. It has also benefitted group reflections on communal duration, such as those experienced by Stuart Brisley together with the audiences of his extended performance works. Participants of the Backward Circle rely on the acoustics of whatever teaching space we find ourselves in and on their ability to notice changes in the pitch and tone of a speaker's voice, and the cadence of speech patterns, utterances and hesitations. Knowing when to speak is difficult in these conditions but it is levelled as difficult for everyone. The confidence a person might usually have to visually take up space is lost to them, the meek

might come forward. To say, 'I can't hear you', suddenly has the potential to mean both things at once: my hearing is obstructed, and I don't understand what you mean. Participants to date, however, have been hearing and seeing. There are possibilities for further investigation into productive constraint and the technologies of speaking. The Backward Circle's absence of visual communication would be recalibrated by d/Deaf people and others who hear differently. Similarly, people who already don't see the visual aspects of communication may suggest new methods of approach to the auditory perception game.

Pauline Oliveros arrived at a distinction between hearing and listening by collaboratively making and listening to sounds, as a practising musician and an acoustic researcher. 'To hear', she wrote in *Deep Listening: A Composer's Sound Practice*, 'is the physical means that enables perception. To listen is to give attention to what is perceived both acoustically and psychologically.' If the back-to-back tutorial returned my capacity to listen then the Backward Circle increased the group's need to hear, while providing an acoustic space to expand our perception of sounds in. The activity was communal, but the norms of communality weren't in the foreground. Instead, the process highlighted everyone's capacity to participate, and their attempts to. The more physical hearing happened towards all sounds that were suddenly of equal importance, the more there was to give our attention to, to perceive and interpret.

For now, the questions of what autistic perception might be and how it makes the interrelations of sound, voice, listening and community legible, differently, are too near at hand for me to satisfactorily or appropriately address. I'm still trying to listen to the things I've heard through the instances of teaching and learning I've described here. But, as Oliveros goes on to state, 'under-

standing and interpreting what the ear transmits to the brain is a process that continues throughout one's life-time'. What is heard can be interpreted in an instant, or several years later, or never! So, while I hope to draw my endless rumination on communication to close – it's tiring to be your own narrative foil – more likely is that I'll take my deliberations to the grave, and there will have been a body of work.

Sounding Gaps in Pavements
Salomé Voegelin
(2023)

Walk along a pavement
Made from paving slabs
Taking care never to stand on a gap
Every time you do, make a sound.

Walking on pavements while avoiding standing on
the gaps between paving slabs is a game. It is a
playful participation in the design of the civic infrastruc-
ture. But it is also an attempt to find a rhythm and a voice
within or against that very infrastructure. To resist its lines
by moving against their design: performing the body and
what it touches, what rhythms it makes, and performing
the environment, what shape it takes by how I move with-
in it. While larger paving slabs invite this game, cobble-
stoned roads do not permit me this performance easily.
The gaps are too many, too irregular, too close together,
the surface too uneven and slippery. If I try to avoid the
in-between and want to make a neat pattern, I have to
dance in tiny steps, my feet will lose their rhythm and I
will fall over. Tarmac pavements on the other hand give
me no such engagement, as their smooth surface pretends
that there are no gaps, no in-between, that everything is
the same, a flat continuum. Until I hit a road. And so I'd
rather dance on cobblestones, not really getting anywhere,
falling over, falling into gaps and enjoying the disorder
and variability of uneven surfaces and a slippery ground.

Scholarly writing has an infrastructure and an institutional

design that draws lines and sets a tone that as register or-
ganises and validates knowledge, its presentation and
form. It does so through evidence and interpretation,
which rely on critical language to make thought legible
and recognisable, and thus accessible, as well as to give it
validity through reference and context. This intelligibility
from which meaning is derived, and which in turn gives
it value, however, depends on a certain understanding of
format and voice: what a text can talk about and how it
can speak. To write beside the lines, to evoke a different
register, and eschew evidence in favour of narration and
contingent experience, creates disorder. Since, to abandon
the line is to lose history and geography as spectres
of criticality and definition, to become ill-defined and
problematic.

Paint a straight line of white chalk
Smudge it by repeatedly walking across it

Because when the talking with cannot preclude under-
standing in a homogeneous group, then communication
cannot soundlessly refer to principles, to canonical texts
and a universal truth, but becomes about revealing and
sharing what cannot be assumed, what cannot be shared.
Such writing is about performing difference and question-
ing the idea of validity in reference, as an understood and
agreed-upon idea, in favour of contingent and contextual
speculations: to narrate and imagine rather than to evi-
dence.

Writing the institution depends on a cultural agreement
on what constitutes a scholarly text, a legitimate argu-
ment, a recognisable method, content, and so on. These
conventions are strongest when they are not spoken but
adhered to silently in the mechanism of (anonymous)

review and validation; where the burden of evidence falls on muted writing, to show a historical and linear reference and imagination, which might seem true, but which excludes, into the future, what does not follow backwards on that line. Such evidence does not come from practice or conversation, which is imbued with possibility and lived narration. Instead, it comes from a sense of actuality and validity, derived from what has been said already. It talks always and by necessity with a historical voice, determining the scope of the self and by extension of the other, in reference to a time-geographical frame and register where what we know makes possible what else can be known, as everything else remains impossible, and where the notion of critique becomes an effort of exclusion, of keeping out what speaks in another register and with a different voice, rather than caring for words not yet said and producing an inclusive network of knowledge and sense.

How to write?

How to think of another writing that has your ear in my voice and lets your hands extend its sound. Since, whoever I am, I am caught, always already, in the form of the text and the conventions of language, which frames and organises the very order that makes what I hope to say invisible.

How then do I write a 'disorganised' voice and a 'disorganised' text?

How do I write beside the line? In order not to strengthen, again and again, a singular and linear history but open an expansive field of plural providence and inexhaustible futures, whose meaning is found in participation, and the value of whose interaction, if there is any, exists in my desire to collaborate: to find my voice in reading yours aloud? This might feel haphazard and tautological. And it might appear formless and senseless, like the sounds I

emit when sliding on the uneven surface and slippery ground of the pebblestoned road. But it is where instruction ends and conversation starts as a reciprocal event: where meaning is not gleaned from 'this' or 'that' but from the in-between, from the space between our bodies dancing on an unsteady path, and where accessibility does not signify comprehension, as a grasping of matter and things, but means as being with; where it fosters participation, and the desire to sing your own voice.

Paint your lips while singing your favourite pop song.

The rigour of such writing cannot be deferred onto the past or onto an over-there. Instead, it has to be found on the body. The body thinking, writing, reading out loud, performing words as a muscular engagement with the world, whose actuality in turn is felt on the body, as fleshy and material form: as human and more-than-human matter that come to matter from their in-between and in conversation. Therefore, I write a text that does not produce a theoretical voice, that I cannot lean on, that is not done, that does not have one form, but that I need to perform, again and again, as a refrain that does not repeat but produces ever new layers, through which we pass in the process of reading as writing, as materialisation.

And so, I learn to write and read another text that does not deliver but makes me do, always now, and that does not order to find out what is already here but performs a contingent order of other possibilities, whose rigour and orientation is plural and mobile:

> We are not interested, in other words, in simply producing yet another feminist reflection on the body, nor yet in privileging the personal voice as a response to the 'victim' status often assumed in the past. The deployment of the autobiographical

> voice is a deliberate strategy . . . but what it speaks to is not
> nostalgia for the subject fully present to herself, but rather the
> possibility of mobilising a series of differentially embodied
> and multiple I-slots.[1]

This, then, is a writing that sings to practice the plural simultaneity of words without a lexical definition or a grammatical line. It invites us into a dark motility to dance not on the surface of language but within its 'unconventional dimension', which we inhabit in sounding and listening and through which we can deviate from historical traditions and transform language's view, not by proposing another, not by erasure, but by hearing everything at once.

The question is then not where does the margin begin, but what is it made of and where does it end. What can it touch and what is it touched by, without going via a central position but from all directions and into the future – blockchain-like, mobile, and abundant, everywhere. 'The process of becoming material surfaces tensions, prompting us to inquire: Who defines the material of the body?

Who gives it value – and why?'[2]
Stand in front of a mirror
repeat 'why am I, I?'
one hundred times

The 'I' of writing in conventional language forgets to ask this question and does not indulge in the dizzy disorientation of its repetitive chant. Instead, it hides any lingering doubt about its own position in the third person. Here it

[1] M. Shildrick and J. Price, *Vital Signs, Feminist Reconfigurations of the Bio/logical Body*, Edinburgh University Press, 1998, p. 9.
[2] L. Russell, *Glitch Feminism*, Verso, 2020, p. 9.

is not mobilised but fixed in an authoritative role that affixes the pretence of a neutral truth and a universalising knowledge. He writes as he, whose 'I' is reflected in the tone and register of the institution, but without a body, and while this enables his text, it limits experience to the line of writing.

Whose 'I' matters?

Who sets the lines of power that make me dance with tiny steps, to trip up and fall?

Because, rather than entering into conversation with the body as it sings, conventional language, as organising text, seeks to capture material explosions in the muteness of theoretical writing: to 'domesticate' the voice of the other into the order of the familiar and to colonise speech; to find rationality and sense by avoiding the simultaneous dimensionality opened in its breath. Coloniality is an investment in a singular and mute order. Its need for domination expresses the anxiety of the other, the fear of proximity and of contagion, of an untidy, ungraspable world and the paradox of a burning need to grasp it. To this imperative, grammar steadies unreliable speech, reference removes the mobile body, evidence clarifies the depth of the voice. In turn, this order is the violence of the text, and of language, that organises the form and colour of the line and of bodies, speaking and spoken to:

> It is not true that the shortest path between two points is the Straight line! That is what I learnt when I was with you! Dialogue? Is the longest part between the heart and the lips, between my voiced waves and your silent waves.[3]

These are movements we perform in judgment and validation, in peer review and examination or any other name we give to the process of selection and critique. Are we

careful and caring? Are we willing to step into the disorder of another voice and feel our way through the text, not to reach the message we are looking for, but to linger in impressions, ideas and the jouissance of participation to find another way to sense? Or do we instinctively take on the baton of order and organisation, taking on a righteous voice that knows the field and keeps it clean? The reviewer's mark-ups become the gaps in the paving stones which set the rhythm of giving instructions that let us trip up. They make a line and present the desire to make the text fall in line. I often hear a patriarchal voice performing my own mark-ups and critical commentary – voicing the demand to bring things in line, to communicate a message, to present a clarity of thought and a line of evidence that legitimates. When all I want is to trouble lines and make connections that blur them, to write in the space beside and between, to generate a sensory sense rather than its interpretation:

> I wanted to start by saying something about critique. I am not interested in critique. In my opinion, critique is over-rated, over-emphasised, and over-utilised, to the detriment of feminism.[4]

How to legitimate that?

How to have an enabling institution and keep it formless and disordered to hold the potential of a plural voice and to build a cobbled infrastructure, one that does not

[3] G. Al-Samman, 'The Lover of Blue Writing above the Sea!' in N. Handal (ed.), *The Poetry of Arab Women, A Contemporary Anthology*. Interlink Books, 2015, pp. 274-76.

[4] K. Barad, interviewed in R. Dolphijn and I. van der Tuin, *New Materialism: Interviews and Cartographies*. Open Humanities Press, 2013, p. 49.

look for standardisation, but an open practice from the in-between: performing an undisciplined dance of entanglements and diffuse connections? To succeed in building such an open institution and keeping its disorder, we might need regular reminders and useful scores to practise lingering and dancing, to keep the urge for control and the violence of the line at bay.

Draw a line
Redraw it
Use the breach to unsee the line
(repeat)

Can we ever overcome the orders and patterns that have been passed on to us and that we have re-created ourselves for our lives, to function, to fit in, following the sound of what we are called rather than calling ourselves? To be, as Beckett's Not I (1972), at once not I and I, an idiosyncratic subjectivity that carries its plural name in its mouth?

Because, if we would divest ourselves of theory's structure and deviate from its aim of legitimacy, which is confirmed through reference, historico-geographical evidence and a mute voice, we could find meaning and intelligibility in plural voices, that materialise, that sing and hum and listen, simultaneously. To hear an order that remains unordered and undisciplined; that is contingent and provisional, a negotiation of resources, asymmetries, (mis)understandings, coincidences, bodies, materials and things, and that finds legitimacy in performance. In this sense, the game of standing or not on the gaps between paving slabs is a play of (dis)order and resistance. The uncoordinated and awkward steps made to stand clear of the line, and the playful urge for the deliberate foot down on the gap, or the petulant, and even wilful jump on exactly this spot where the earth shines through and small grass

might grow, defying the need for order. Thus, from the play with this gap, we can start to resist the need for an orderly view and can enjoy where slabs move and collide. And we can dance on cobblestones, falling over, falling into gaps and enjoying the disorder and variability as an opening for other possibilities. From that moment of whimsical anarchy, we can bring down the visual infra-structure of politics and of art: singing and dancing on an unsteady ground we trouble its homogeneous surface, opening the gaps that language and reference filled, and wonder why we kept it intact for so long.

Fill your lungs with as much air as you can.
Sing without words until you are out of breath.

This text is an edited excerpt from the epilogue of Uncurating Sound: Knowledge with Voice and Hands, Bloomsbury, 2023. Republished by permission of the author.

Feminist Ears
Sara Ahmed
(2022)

In today's lecture, I will reflect back on my project on complaint, and in particular, my method of listening to complaint: listening as learning about violence. I was inspired to do this research after taking part in a series of enquiries into sexual harassment that had been prompted by a collective complaint lodged by students at the University of Goldsmiths. I began working with the students in 2013, left my post and profession in 2016, started gathering testimonials in 2017 and published *Complaint!* in 2021. I am giving you the timeline because time matters, because during this time, almost a decade now, I have been immersed in complaint. I wrote the book from that immersion.

I describe my method as becoming a feminist ear. To become a feminist ear is to give complaints somewhere to go. In time, I began to be addressed as a feminist ear. A student sent me a message. 'I am writing because I need a feminist ear. Perhaps you can use this complaint in your work.' To become a feminist ear is not only to be willing to receive complaints but to make use of them, to do something with them, to make them work or to make them part of our work. I first introduced the idea of 'feminist ears' in my book *Living a Feminist Life*. I was writing about the feminist film *A Question of Silence* (1982). I was writing about snap: 'a moment with a history' – those moments you can't take it anymore, when you lose it. In this film, the character Janine, a psychiatrist, is a feminist ear; she is listening to the stories of women who between

them had murdered a man; she is listening to what they say, but also to silence, what is not or cannot be said. We listen with her, also through her, to sexism: the sounds of it, how women are not heard, how so often women might as well not be there; how women – as secretaries, as wives, perhaps also professors – are blanked when we say something, blanked because we say something. I will return later to how blanking can be used as a method for stopping complaints. The film shows how a feminist hearing is a shared action. Janine, in hearing these other women's stories, their complaints, begins to hear how she herself is not heard.

It was only after I went to see this film during a feminist festival in London that I began to use the expression 'feminist ears'. I was so struck by how loud the audience was, especially during the scene when a man is congratulated after saying the exact same thing a woman secretary had just said – only to be ignored. The groan of the audience really hit me, that sound of recognition, of relief. Why relief? So often we can't quite put a finger on it – sexism or racism – even when we come up against it, even when it stops us from doing something, from being something. It is hard to show, to share what we know. It can be a relief to witness collectively what so often works by not being quite so visible or audible.

Feminism: we hear what each other can hear.

Feminism: we hear each other hear how we are not heard.

Feminism: we are louder not only when we are heard together, but when we hear together.

277

So, when I say that my method in researching complaint was to become a feminist ear, *this becoming was not mine alone.*

1. Feminist Ear as an Institutional Tactic

I first met with the students who had put forward a collective complaint in our department's meeting room. They told me what had been going on. It was so much to take in. If to be a feminist ear is to take it in, a complaint is to let it out. Just after the meeting with the students, a feminist colleague came to my office. I told her some of what the students told me. She burst into tears. She said something like, 'after all of our work, this still happens.' There is so much feminist grief in this still: that the same things happen, still, despite everything, all that work, feminist work, our work, to try to change the culture of sexual harassment. We need time, also space, to express this grief, to turn it out and, sometimes, to turn it into complaint.

In the weeks following that first meeting, more students came to my office to talk to me. The students did not come to me because I had any special training or skills. I didn't and I still don't. They came to me because I said I was willing to listen. They came to me because they had so few places to go. They came to me because the institution had already failed to hear their complaint.

It was a very noisy time. In one ear, I was hearing the institutional story of how well it was handling complaints, the story of equality and diversity, about what the university was committed to doing. I was receiving letters about how the university was going for an Athena Swan bronze award for gender equality: 'would you like to participate, Sara, we could use your expertise, Sara.' In the other ear, I was hearing more and more complaints, more and more about violence, about institutional complicity, about previous enquiries that did not go anywhere. I heard about

students writing unanswered letters asking for a public acknowledgement that these enquiries had happened, asking for discussions of what they revealed, how sexual harassment had become part of the institutional culture. In one ear, in the other ear; the feminist ear is the other ear. If we can see through the glossy image of diversity, we can also hear through it, the buzz of it, to what is not being said, to what is not being done.

Becoming a feminist ear meant not only hearing the students' complaints, it meant sharing the work. It meant becoming part of their collective. Their collective became ours. I think of that ours as the promise of feminism: ours not as a possession, but as an invitation to combine our forces. I am grateful that the students I worked with – Leila Whitley, Tiffany Page, Alice Corble, with support from Heidi Hasbrouck, Chryssa Sdrolia and others – wrote about the work they began as students in Complaint!, about how they 'moved something', how 'things are no longer as they were'. To move something within institutions can be to move so much. And it can take so much.

I decided to undertake this research before I resigned but I did not begin the research until after. My resignation was widely reported in the national media. While I found the exposure difficult, I was also moved and inspired by how many people got in touch with me to express solidarity, rage and care. I received messages from many different people telling me about what happened when they complained. I heard from others who had left their posts and professions as a result of a complaint. One story coming out can lead to more stories coming out. By resigning from my post, I had made myself more accessible as a feminist ear. Having become a feminist ear within my own institution, I could turn my ear outward, toward others working in other institutions.

To become a feminist ear is not only to learn how complaints are stalled, it is to be involved in the effort to get them moving again. This is why I understand the feminist ear as an institutional tactic. Hearing is not enough. As one academic said, 'I had a hearing . . . but I think it was just to placate me.' To placate is to calm or to soothe. Hearings can be used to draw a line as if to have heard a complaint is to have dealt with it. We should be suspicious if organisations (or individuals for that matter) utter the words, 'I hear you', before we say anything. Hearing can be about appearing to hear, which is how a hearing can be a disappearing. *A complaint is let out only to be turned into steam, puff, puff.*

The feminist ear as institutional tactic points to how we have to dismantle the barriers that stop complaints from going anywhere: institutional barriers, the walls, the doors, that render so much of what is said, what is done, invisible and inaudible. If you have to dismantle barriers to get complaints out, complaints can make you even more conscious of those barriers; the walls, the doors. In my research into diversity work, I had noticed how walls kept coming up. One diversity practitioner described her job as a, 'banging your head on the wall job'. When the wall keeps its place, it is you that ends up sore. And what happens to the wall? All you seem to have done is scratch the surface. One lecturer described the work of complaint: 'It was like a little bird scratching away at something and it wasn't really having any effect. It was just really small, small and behind closed doors.' A complaint can feel like scratching away; a little bird, all your energy going into an activity that matters so much to what you can do, who you can be, but barely seems to leave a trace.

Diversity work as scratching the surface; complaint as, 'little bird scratching away at something'. Scratching can give you a sense of the limits of what you can accomplish.

2. An Ear to the Door

Doors tell us where complaints happen: complaints are mostly behind closed doors. This expression 'behind closed doors' can refer to the actual doors that are closed so someone can tell their story in confidence, or the process of keeping something secret from a wider public. In this work, I am trying to open a door, to let out or express something that has been kept secret.

It can take time to open the door. A PhD student based in the US was harassed by her supervisor. She explained why it was so hard to see what was going on when it was going on:

> It's odd to think back. In this moment, this seems absolutely insane to me, but at the time it was part of the culture of the department. Another professor I had met with earlier in the programme said that he had to keep a big wooden table between him and his female students so he would remember not to touch them and another of our long-time male faculty is notorious for marrying student after student after student. And that was within all this rhetoric of critical race studies and pedagogy of the oppressed. It is so jarring to look back on it, because it looks so very clear from this hindsight perspective.

When what you experience, 'at the time' is part of the culture, you don't identify it at the time you experience it. The harassment, the misconduct – which was institutionalised, expressed in the idea that senior men would need a big wooden table in order to remember not to touch women students – is happening at the same time that the rhetoric of critical work is being used as if to describe what is happening: critical race studies, pedagogy of the oppressed. If your feminist ear is an ear to the door, a feminist ear is also an ear to the past. You listen back, go over something, realising what you did not see at the

time. Clarity can be jarring.

Complaints tell us so much about time, the time it takes to get to it, not just through it. The student is a queer woman of colour: she is from a working-class background; she is the first in her family to go to university. She had to fight so hard to get there. Her supervisor was making her feel more and more uncomfortable, he was, 'pushing boundaries,' wanting to meet off campus, in coffee shops, then at his home. She used a door to handle the situation: 'I tried very hard to keep all of the meetings on campus, and to keep the door open.' She kept the door open – an actual door at the same time as she closed another kind of door. I call this door the door of consciousness; 'I thought I would take myself down by admitting to the kind of violence he was enacting.' 'Take myself down': to admit to violence can feel like becoming your own killjoy, getting in the way of your own progression. To admit can mean to confess a truth as well as to let something in. Note how doors can hold a contradiction – keeping the office door open is an admission of a truth that she handled by not letting it in. Handles can stop working:

> I was sitting with another colleague at another lunch another day and he started texting me these naked photos of himself and I think I just hit a critical mass of like, I just can't handle it anymore. I said just look at this, and she was completely speechless . . . And then it suddenly started to seep into me, into her, in this shared conversation about how horrible and violent [it is] that I am having to receive these things. And so that basically put a process in motion.

A handle is sometimes what we use to stop violence directed at us from seeping or leaking into us. When the handle stopped working, the violence seeped not only into her but also into her colleague: into a conversation,

into the space in which they were having a conversation.

When violence gets in, a complaint comes out. However, there is no switch – one in, one out. For a complaint to come out, she had to make the complaint, to bring it out, to tell the story of what happened, to keep telling it. She went to the office responsible for handling complaints, who said, 'you can file a complaint. But he's really well loved by the university, he has a strong publication record, you are going to go through all of this emotional torment.' She told me,'It was even proposed that he could counter-sue me for defamation of character. The line was essentially, you can do this, but why would you?' A warning that a complaint will have dire consequences can take the form of institutional fatalism: statements about what institutions are like, what they are as what they will be, who they love, who they will protect. In the end she did not file a formal complaint, because she knew what she was being told: that she wouldn't get anywhere, it wouldn't get anywhere, because he was going somewhere.

You can admit violence, but then when you try and share the story, as she did, you hear more doors being shut. An early-career lecturer was being sexually harassed by a senior man professor, mainly through constant verbal communications – he emailed her about wanting to suck her toes. She thought she had handled this by asking her line-manager to ask him to stop not knowing that her manager sat on that request. When a complaint is not passed on, the harassment goes on:

> I was in a meeting with my line manager and her line manager in this little office space, like a glass fishbowl type meeting room. He emailed me and I made a sound, *eehhhhh*, there's no way to articulate it, someone's just dragging your insides like a meat grinder, oh god this is not going to stop. I made that

sound out loud, and my line manager's line manager said, 'what's happened?' And I turned my computer around and showed him and he said, 'for fuck's sake, how stupid do you have to be to put that in an email.' You could see a look of panic on her face. Like, crap, this has not magically gone away.

That sound, that *eehhhhh*, pierced the meeting, that meeting taking place in the little glass room, a fishbowl, where they can all be seen. Something can become visible and audible sometimes even despite yourself; a complaint is what comes out because you can't take it anymore, you just can't take it anymore, your insides like a meat grinder; a complaint as how you are turned inside out. Note how the problem once heard is implied to be not so much the harassment but that there was evidence of it ('for fuck's sake how stupid do you have to be to put that in an email'). A sound becomes a complaint because it brings to the surface a violence that is already in the room but otherwise would not have to be faced.

To hear with a feminist ear is to hear the different ways a complaint can be expressed. A complaint does not necessarily involve filling in a form or even an intentional action. A complaint can be expressed without words. In *Living a Feminist Life*, I also focused on how we find meaning in sound. I suggested that feminist ears can be how we hear, 'the sounds of no, the complaints about violence, the refusal to laugh at sexist jokes' as speech.

The story of a complaint can begin with what we do not do or say, because we show, in one way or another, we are not willing to go along with something. A postgraduate student attended an away day:

> They were making jokes, jokes that were horrific, they were doing it in a very small space in front of staff, and nobody was saying anything. And it felt like my reaction to it was out of

> kilter with everyone else. They were talking about, 'milking
> bitches'. I still can't quite get to the bottom of where the jokes
> were coming from. Nobody was saying anything about it:
> people were just laughing along. You start to stand out in that
> way; you are just not playing along.

To experience such jokes as offensive is to become alien-
ated not only from them but the laughter that surrounds
them, giving them somewhere to go. She was hearing
with a feminist ear. And in hearing sexism, she felt, 'out
of kilter with everyone else'. Not participating in some-
thing can make it sound louder; remember, clarity can be
jarring.

**A feminist ear is not just how you receive complaints
but how you express them.**

Our bodies can say _no_, before we do.

If you don't laugh, you stand out. Maybe some people
laugh so as not to stand out. When you stand out, you
become the target. In other words, when you don't partic-
ipate in violence, it can be channelled in your direction.

Later in the day, she was having a conversation with
someone about her PhD, when he, 'leant across the table
. . . and he said, "oh my god I can see you ovulating."'
Sexism: how you are reduced to your body. Sexism: how
you are stopped from having a conversation. A member of
staff quickly defended the harasser. 'Immediately he said
to me, "oh you know what he's like, he's got a really
strange sense of humour, he didn't mean anything by it,"
and the implication was I was being a bit over-sensitive
and that I couldn't take a joke.' The staff member, by lean-
ing in this way, positioned himself _with_ the harasser, tell-
ing her to keep taking it, that it didn't mean what she

thought it means, that it didn't mean anything, so that if she has a problem, the problem is her.

Harassment can be the effort to stop you identifying harassment, which means that those who identify harassment are harassed all the more. A senior lecturer had been bullied by her head of department over many years. She attended a meeting:

> He started to yell, and I stood up . . . You go out of the office and then to the left is a little passageway to the door. I went up to the front door and it has two locks that you have to turn in two different directions and I had all my bags on me and then up behind me came a pair of hands, and pulled my hands off the lock. He then wrapped his arm around me and so I was constrained with my arms by my sides. And I didn't know what to do. I thought if I try to go to the front door again, he may grab me again.

The lock that turns in two different directions: it is hard to know which way it turns, which way to turn; the hands that come up, pulling her hands off the lock, the lock becomes a hand, a hand a lock, what stops her from getting out. She did get out, but it was hard. She submitted a complaint. He was suspended during a formal enquiry. What did the enquiry find? In the report, the assault is described as, 'on par with a handshake'. On par, on par equals equal. A physical assault is turned into a friendly greeting. The Deputy Head of Resources read that sentence out to her in a meeting: 'He read that what he had done, "was on par with a handshake", that was the conclusion, and that he was going to be returned to his position as Head of Department.'

He is returned, she is removed. I think of the administrator reading out that description of the physical assault on her, to her. I think of how you can be hit by words.

The violence of an action is removed by how it is described. There is so much violence in this removal of violence. When violence is shut out by description, description becomes a door. And it is not just violence that is shut out, she is shut out, the one who tried to bring the violence out from behind closed doors.

3. Hearing the Machine, Clunk, Clunk

In listening to those who complain, I have had my ear to the door. To hear how complaints are contained is to learn how the institution works, what I call institutional mechanics.

An MA student was considering whether to complain. Her story began with how she questioned the syllabus:

> He left anyone who wasn't a white man essentially until the end of the course. I brought this up and he said, 'well, last year there were no women on the syllabus so be happy with what you get.' It turned out that he had only added women to the end of the course after students in previous years had complained. When she has an essay tutorial with the professor, she tells him she wants to write her essay on gender and race. He says, 'if you write on those fucking topics you are going to fucking fail my course, you haven't fucking understood anything I have been talking about if you think those are the correct questions for this course.'

When you ask the wrong questions, you witness the violence of correction: 'Then he says, "wait, you know what, you're so fucking old, your grades don't really matter, you're not going to have a career in academia, so write whatever it is that you wanted, it doesn't fucking matter."' She heard herself being written off. The complainer, who was questioning the syllabus, became the feminist who got the questions wrong; became the old woman who

might as well be wrong, a hag as well as a nag, who is too old for it to matter whether she gets it wrong, because she can't proceed, she won't proceed.

In the end, she decided to make a formal complaint because she 'wanted to prevent other students from having to go through such practice'. Complaint can be thought of as *non-reproductive labour*: what you have to do to stop what happened to you from happening to others, to stop the same things happening. When she told the convenor of the MA programme that she was intending to complain, she was warned, 'be careful he is an important man'. A warning is a judgment about who is important as well as a direction. She goes ahead with the complaint. And she 'sacrificed the references'. In reference to the prospect of doing a PhD, she said, 'that door is closed'. That door is closed: if references can be doors, some are stopped from progressing through them. When the door is closed on her complaint, and also on her, she will not be there, bringing to the institution what she might have brought to it; the door is kept open for him so he can keep doing what he has been doing where he has been doing it. Doors can be the 'master's tools', to evoke Audre Lorde, telling us something about who gets in, what they do when they get in, as well as how some become trespassers, whether or not they get in.

To make a complaint within the institution is to notice the door, because of how it closes, because of how you are stopped, the slam of the door, the clunk, clunk of the institutional machine. Sometimes you can feel that door slam. At other times, it can be hard to tell how you are stopped. It is almost like there is nothing there. I call this blanking. A woman of colour post-doctoral researcher based in the US was blanked during a meeting about her complaint about racial discrimination: 'From the very beginning I

get into the room the provost doesn't look at me during the entire meeting. It was like this weird thing: she is actually going to pretend I am not in the room.' Blanking is weird but it can work: they don't acknowledge, they pretend you are not there, then you are not there, and your complaint disappears when you do.

An Indigenous academic based in Canada was trying to make a formal complaint after her tenure case was sabotaged by a senior white manager. Despite numerous attempts to initiate an enquiry, she did not get anywhere:

> I had to send an email to her with the subject line in all capital letters with an exclamation point, my final email to her after seven months. *THIS IS A GRIEVANCE! THIS IS A GRIEVANCE!* And her obligation under the university rules and the process is that she has to put it forward. She did not. She did not put it forward.

Sometimes you have to shout because you are not heard. If you have to shout to be heard, you are heard as shouting. I will return later to how she expresses her complaint in another way.

You can be stopped by how you are heard. You can be stopped by how you are questioned. A trans student of colour made a complaint about sexual harassment and transphobic harassment from their supervisor who kept asking them deeply intrusive questions about their gender and genitals. Questions can be hammering; for some to be is to be in question. These questions were laced in the language of concern for the welfare of the student predicated on judgments that they would be endangered if they conducted research in their home country. Racist judgments are often about the location of danger 'over there' in a Brown or Black elsewhere. Transphobic judgments are often about the location of danger 'in here', in

the body of the trans person: as if to be trans is to incite the violence against you. When they complained, what happened? The department said, 'people were just trying to evaluate whether he [the supervisor] was right to believe there would be some sort of physical danger to me because of my gender identity. . . As if to say *he was right to be concerned.*'

The same questions that led you to complain are asked because you complain. These questions make the concern right or even into a right; a right to be concerned. A right to be concerned is how violence is enacted, a violence premised on the suspicion that some are not who they say they are, that some have no right to be where they are. The complainer becomes a stranger, not from here, not really from here, the one who does not belong here. And yet, consider how diversity is figured as an open door, minorities welcome, come in, come in. Just because they welcome you it does not mean they expect you to turn up.

A woman of colour described her department as a revolving door: women and minorities enter, only to head right out again, whoosh, whoosh. We can be kept out by what we find out when we get in. People of colour are assumed to enter the diversity door however we enter the institution. And that door can be shut at any point. The door can be shut to stop us getting in. The door can be shut because we get in. A Black woman academic was racially harassed and bullied by a white woman who was her head of department:

> I think what she wanted to do was to maintain her position as the director, and I was supposed to be some pleb; she had to be the boss, and I had to be the servant type of thing. That was how her particular version of white supremacy worked, so not just belittling my academic credentials and academic

capabilities but also belittling me in front of the students; be-
littling me in front of administrators.

To belittle someone, to make them little, can function as a
command: be little! And that command was being sent
not only to her, but to those who are deemed to share the
status of being subordinate: students; administrators. She
said: 'I had put down that I would like to work towards
becoming a professor and she just laughed in my face.'
That laughter can be the sound of a door slammed. Some
of us, in becoming professors, become trespassers; you
are being told you need permission to enter by being told
you do not have permission.

Harassment does not just take place behind closed doors;
it takes place around the doors we sometimes call pro-
motion. I have already shared what happened when the
Indigenous woman academic tried to make a complaint
after a senior manager sabotaged her tenure case. When
you are harassed and bullied, when doors are closed, nay,
slammed, making it hard to get anywhere; it can be history
you are up against, thrown up against. Complaints take us
back, back further still, to histories that are still:

> There is a genealogy of experience, a genealogy of conscious-
> ness in my body that is now at this stage traumatised beyond
> the capacity to go to the university. There's a legacy, a genealogy
> and I haven't really opened that door too widely as I have been
> so focused on my experience in the last seven years.

To be traumatised is to hold a history in a body; you can
be easily shattered. There is only so much you can take on
because there is only so much you can take in. We can
inherit closed doors, a trauma can be inherited by being
made inaccessible, all that happened that was too hard or
too painful to reveal. Decolonial feminist work, Black

feminist work; feminist of colour work is often about opening these doors; the door to what came before; colonial as well as patriarchal legacies; harassment as the hardening of that history, a history of who gets to do what; who is deemed entitled to whom.

When the door is shut on her complaint, she makes use of the door:

> I took everything off my door, my posters, my activism; my pamphlets. I smudged everything all around the building. I knew I was going to war; I did a war ritual in our tradition. I pulled down the curtain. I pulled on a mask, my people we have a mask . . . And I never opened my door for a year. I just let it be a crack. And only my students could come in. I would not let a single person come into my office who I had not already invited there for a whole year.

A closed door can be a complaint, a way of refusing what the institution demands from you, a way of refusing to disappear. She still did her work; she still taught her students. She used the door to shut out what she could, who she could. She took herself off the door; she depersonalised it. And she pulled down the blinds and she pulled on a mask, the mask of her people, connecting her fight to the battles that came before, because for her this was a war.

Conclusion: Opening Our Ears, Hear, Here

There is so much silence about violence. Silence about violence is violence. We have to shatter that container. This is why I place such a strong emphasis on the sound of the work in the work, the puff, puff, the clunk, clunk, the whoosh-whoosh, the hush-hush, that tells us something about how the machine is working. To hear with a feminist ear is also to listen for the sound of release, that *eehhhhh*, of complaints coming out, how they end up as letters on

the wall. The scratches that seemed to show the limits of what we could accomplish can be testimony, what we leave behind. I think of the little bird: scratching can be not just an effect on a surface – it can be the sound of labour.

> Scratching on the wall. Knocking on the door. I hear Audre Lorde knocking on a door. In an interview with Adrienne Rich, Lorde describes her fascination with a poem, 'The Listener', a poem about a traveller who rides a horse up to the door of an apparently empty house: He knocks at the door and nobody answers. 'Is there anybody there?' he said . . . and he has a feeling that there really is somebody in there. And then he turns his horse and he says, 'Tell them I came,' and nobody answered. 'That I kept my word.' I used to recite that poem to myself all the time. It was one of my favourites. And if you'd asked me, what is it about, I don't think I could have told you. But this was the first cause of my own writing, my need to say things I couldn't say otherwise, when I couldn't find other poems to serve.'

It is important to follow Lorde, to go where she goes. When we are fascinated by something we do not always know why. Lorde keeps reciting the poem; she says, 'it imprinted on her'. I think of that imprint: the print of a poem on a person. To knock on the door is to turn up, to keep turning up, to find new forms of expression. We knock on the door not to demand entry but to cause a disturbance, to disturb the spirits who linger here because of the violence that has not been dealt with.

I wrote about this passage in Lorde quite a long time before I read it out loud. When I read it out loud in a lecture, I knocked on the table, my wooden desk, making this sound, just as I did then, so my audience could hear it. And it was only then that I remembered it. In *Living a Feminist Life*, I wrote about some of my experiences of growing up with a violent father. I cut one paragraph out

293

because it was too close to the bone. It is a door story. It is a door story. I grew up with a father who was physically violent. One time when he lost his temper, I managed to get away. I ran down the hall and locked myself in the bathroom. I crouched in the shower, which had a glass door, which I pulled shut. My father kicked the door of the bathroom down. He then pulled the glass door open. I was scared it would shatter. Maybe that it is why, so many years later, I was attuned to the sound of shattering. He then kicked me, he kicked the door down, he kicked me. Maybe that is why, so many years later, I was attuned to the door; listening to it and not just through it. Even now, when someone knocks loudly on a door, any door, I feel panic. In other words, that knock is a trigger. It was only when I made the knock sound so an audience could hear it that I was taken back. Sometimes, we can only hear something in our own story when we share it with someone else. I think I needed to close a door, not to hear the knock, not be triggered, so I could keep listening to complaints. But then, when we share complaints with others, that door opens, and with it, a space between us.

A door opens and with it a space between us. One of the sentences in Living a Feminist Life is:

The histories that bring us to feminism are the histories that leave us fragile.

This sentence can be rearticulated as a question of hearing, the kind of hearing that lets something in, however shattering, whatever the consequences.

What makes it possible to hear complaint makes it hard to hear complaint.

Many of us come to work against violence because of our own experiences of it. When we work against violence,

294

including institutional violence, the violence of how institutions respond to violence, which we can only do together, we become part of each other's survival. Audre Lorde said that for some of us, 'survival is not an academic skill'. For some of us, surviving the academy is not an academic skill. I think of all the writing on the academy, which helped me to survive it, to keep chipping away at the walls and the doors, even from afar, work by Black feminists, Indigenous feminists, feminists of colour. I thank M. Jacqui Alexander, Avtar Brah, Sirma Bilge, Angela Davis, bell hooks, Gail Lewis, Audre Lorde, Alexis Pauline Gumbs, Heidi Mirza, Aileen Moreton Robinson, Chandra Talpade Mohanty, Malinda Smith, Shirley Anne Tate, Zoe Todd, Eve Tuck, Chelsea Watego, and so many others, for so many wisdoms, hard-worn wisdoms.

To turn up is to turn up for each other saying not, 'knock, knock, who is there?' but, 'knock, knock, we are here.'

We knock so you can hear we are here. Thank you.

Queer Percussion
Sarah Hennies
(2018)

For the past few years, I've been collecting cheap little bells from thrift shops and flea markets. At first, I was doing this for the purposes of making music, but now it just feels compulsive. After the first few were purchased, I started noticing low-quality bells for sale all the time, and always for very little money. This begged the question, 'why were these made in the first place, who originally bought them, and why are they now worthless?'

There's a lot to say about why being a percussionist makes you a different kind of musician than other instrumentalists. Unlike other musicians, we are not defined by our instruments – any contemporary definition of percussion encompasses a wide array of instruments and objects, and there is an expectation that almost anything could be asked of a percussionist in a piece of modern music. Therefore, it's the only discipline where you have the power – if you want to and realise you can – to define yourself. I could do nothing but ring crappy little bells on stage, and I could still be accurately called a percussionist.

Percussion is also a discipline that is overwhelmingly considered to be 'for boys'. I recently began asking myself why I chose drums as a nine-year-old, when I showed an aptitude for just about any kind of instrument. I had wanted to play piano when I was five, but was never given lessons. Why drums, then? Why still not piano four years later? Even as I write this, I have some regret that I never became a pianist.

I can only guess as to what was going on in my head at the time. For years I told people I picked drums seemingly at random, because Rikki Rockett was my favourite member of Poison, my favourite band in fifth grade. This is already a pretty gay thing to say, but for a period in the 1980s, hair metal made make-up and women's clothing seem sexy and masculine. And, after having realised my enjoyment of New Kids on the Block was not a 'boyish' trait, I deemed hair metal to be a safer thing to love.

I was drawn to music at an extremely early age, long before my single-minded obsession with hair metal from ages eight to twelve. What music did I love before I got into hair metal? A brief list:

New Kids on the Block
Debbie Gibson
Culture Club
Tiffany
Belinda Carlisle
George Michael

A typically feminine list for a girl or a hilariously gay list for a boy.

What was the difference between five-year-old me and nine-year-old me? The answer seems obvious to me now as I enter my forties: puberty. If you're a gender-non-conforming person then it's puberty that changes your body in ways that you do not understand or identify with. It is well documented that the emotional health of transgender children is dramatically improved if their transition begins before, 'natural' puberty takes place, putting a pause button on things like deepening voices, body hair and Adam's apples. A recent study specifically showed that the likelihood of a transgender child attempting suicide is dramatically reduced if they are loved, supported and given access to medical care that will facilitate their transition.

Did I gravitate towards drums because it affirmed my boyhood to everyone around me? I was a natural at the instrument. I took to it immediately and learnt fast in the context of what else was going on in my life: near-constant bullying at school, an emotionally absent father, and an emotionally abusive mother. These conditions created a child who believed deeply that something was wrong with them, and that whatever it was badly needed fixing. I now can't think of any other reason for my asking for drums other than the logic that drums = boys, and being a good drummer means being a good boy. Repressed trans women do things like this all the time; we get married, have children, join the army, along with other 'manly' things in an effort to cure ourselves of our womanhood. It never works.

When I was thirteen years old, I discovered punk rock and fell in with an older friend group. I started playing drums in their bands. This made it possible to completely check out of school – and the frequent bullying that came along with it. I hated everyone and everyone seemed to hate me, or at least found me to be an easy target: the weakest, shyest, most awkward of all the kids.

These older kids, in college, were into bands like Fugazi and Superchunk, who I loved; when they became my friends, it was the first time I felt as though I'd, 'found my people'. That said, I was still a frequent target for jokes, and I believe these drunk and stoned record nerds kept me around for two reasons: I was the best drummer and I was the weakest, shyest, most awkward easy target.

The preferred insult of the day in late nineties Louisville, Kentucky was 'art fag'. A not-so-subtle undercurrent of homophobia throughout my school years is now apparent to me, but was lost on me at the time as I found men re-pulsive and therefore did not think I could be gay. It was

around this time that I started listening to experimental music, by people like John Cage and Harry Partch (both queers, coincidentally). I vividly remember the bassist in my band when I was seventeen saying to me as I made him listen to Iannis Xenakis's 'Eonta' (1964): 'You're into some weird shit and that's cool, but I can't do this.'

As long as I've been a drummer, I have always felt like the weirdest person in the room. As a teenager, I knew I was different from the other kids. In college, studying percussion, I couldn't relate to the other percussionists. Even before I transitioned, I still felt like 'the weird one' in my trio with two other nearly-identical-to-me-at-the-time percussionists. But there's another side to this that is unrelated to gender. Was I drawn to percussion because percussion is weird?

The last ten years of my musical output have been almost totally devoted to exposing the amazing and surprising sonic world of percussion instruments that is revealed if we just listen to them. Outside of a small group of colleagues, this is profoundly different from what most percussionists are doing, and yet we are all percussionists. A cursory Google image search of 'percussion quartet' reveals a depressingly consistent series of photos of groups of men wearing the same clothes and doing the same things. When the predominant system is so brutally homogenous – straight, white, cisgender, male – there is no space in 'the percussion world' for anyone outside of that model. If you're young, into percussion, and female or weird or both, you look at what's around and you subconsciously learn that you are not 'one of them'. This heartbreaking reality is the primary focus of this essay.

For several years in my late twenties and early thirties, I was a pretty good distance runner. But after running two half marathons and sending myself on a lot of long, hard

runs during a difficult time in my life, something clicked and I just stopped. I felt like I'd had enough.

In late 2017, I was trying to get back into it, but running is extremely difficult when you're first starting out. It's even harder knowing that you used to be good at it and now you're struggling to run even a mile or two without getting tired. That summer, I was huffing and puffing and wheezing through what used to be a really easy three-mile run, hating how hard it was – and also myself for letting my body get out of shape – when a woman, running towards me in the opposition direction who looked to be in her late sixties, gave me a big smile and wave. The whole interaction lasted maybe half a second but, as she passed, I felt a charge of energy and started smiling. I felt like she was saying with her silent wave, 'This is hard, isn't it? Good job.' Maybe she was just saying hi, I don't know. But this is something that runners do to one another and it seems insignificant until you're really struggling and someone does something nice, and for whatever reason it helps.

In that moment, I suddenly became aware that this is what representation for queers, and especially trans people, is all about and why such a seemingly small thing is so important. Just being visible and present in society is extremely hard for trans people, with very little opportunity for positive reinforcement. It feels incredible to be recognised by someone who identifies with your challenges and experiences. And, if that person is in some position of power, like on a stage, it can be, quite literally, life-changing.

The moment I realised my own transness was during a concert by a British band called The Spook School at the NYC Popfest. I heard their singer Nye Todd say, 'What's next? Oh yeah, another song about being transgender!' Suddenly, a wave of emotion and self-realisation came

over me. I used to listen to their album and cry, and I would say to my ex-partner, 'Why is this making me cry?' She would shrug at what she perceived to be my trademark hypersensitivity. How had I not realised he was trans? How had I not realised that I was trans?

Fifteen years earlier, I was obsessed with the Anohni album I *Am a Bird Now* (2005), in which she sings repeatedly:

> One day I'll grow up I'll be a beautiful woman
> One day I'll grow up I'll be a beautiful girl
> But for today I am a child
> For today I am a boy

Anohni was using male pronouns and using her now-dead name, despite having made an album that is blatantly about transition. There's a lot to say about my own repressed, unaware state at the time, but would it have been different for me if Anohni hadn't waited ten years to publicly declare her transness? To be asked to be referred to as 'she'? Would it have opened the door for me to ask, 'Is that me, too?' Of course I can never know for sure, but I do know that not saying it didn't make it any easier.

Of course, I have nothing against Anohni for that. People can and should manage their identity and transition in whatever way is best for them, and I would never direct anger at someone for the time and manner in which they choose to be out. It's just something I've noticed and thought about in the context of my own life.

When I first came out and began transitioning, I didn't really want to be a 'Trans Composer'. I was already several years into my current practice and just wanted to keep doing my work. But as I looked back at all the work I'd made over the last ten years, I realised that it was all, 'trans art'. Every last note I've ever written and played is single-mindedly obsessed with my transness. I just didn't realise

it. It was that person on stage saying 'I am trans' that trig-
gered my emergence from a lifetime of subconscious re-
pression.

This is how I got started making music with the little
bells. Similar to how I didn't immediately understand my
emotional response to The Spook School, I didn't know
why I wanted the bells. I just kept buying them because
they were cheap, and I liked the sound, and I've always
liked the idea of making art with trash. But why was I
drawn to making music with discarded objects?

By the time I began collecting bells, I was already aware
of the tendency for my music to reveal something about
me before I consciously realised it myself. I didn't really
know what the bells were for at first; I just bought them
and played them with the assumption that they would re-
veal their purpose to me in time. Now I can only think
of the bells in all their worthlessness and complexity as
a very thinly veiled sappy metaphor for discarded queer
life, and for the past few years that has felt like the right
thing to do.

Plural Radio-Listening
Shortwave Collective
(2023)

Shortwave Collective is Kate Donovan, Sally A. Applin,
Meira Asher, Lisa Hall, Brigitte Hart, Georgia Leigh-Münster,
Hannah Kemp-Welch, Alyssa Moxley, Maria Papadomanolaki
and Karen Werner.

What does it mean to radio-listen collectively, as feminists? Do we listen to the same things, differently? Do we listen to different things, in the same ways? Can we listen collectively from distant spaces? Do we listen to each other? To ourselves? We do not always agree – this is part of working collectively, from a plurality of positions – but we use radio-listening as a way to consider together the situatedness and the material and cultural ecologies of radio, as well as how we understand what listening is and can be.

> At sunset on top of the local hill, next to the one remaining wall of an old building, we had our first 'grey line' listening experience; this is the time of day on the cusp of nighttime when radio transmissions travel more easily around the globe, enabling stronger signals to be received from further away. This is an ideal time for listening through our no-power devices that rely on the energy within the radio wave itself. As the sun rapidly fell, we discovered that almost any configuration of diodes we placed into our circuits were able to pick up the transmissions: the 'foxhole' razor and pencil combination, the

crystal and cat's whisker combination, even a piece of scrap metal that we found on the ground. The air was full. And what we heard were layers and layers of radio, wafting in waves over the top of one another, an air that was thick with voices, languages, singing, static and buzzes. We were hearing distance and the weight of the signal in the air, feeling the fullness of the radio experience all around us.

Shortwave Collective is an international group of people from various backgrounds and disciplines interested in feminist practices and the radio spectrum. One of the reasons it was initially formed was as a counter initiative to the (gendered) learning and culture of amateur radio, which is predominantly interested in signal strength, size and/or reach of antennas, and clarity of reception and transmission. It is within this culture that the markers OM (Old Man), YL (Young Lady) and XYL (referencing the wife of an amateur radio operator) are still perpetuated; this unnecessarily genders operators and omits an entire spectrum of ways for people to participate outside of this binary logic. As a collective, we have a desire to learn together and to open a space to learn together-with-others as equal non-experts. We spend time in each other's company making, testing, listening and sharing; sometimes 'failing', but more often laughing our way into serendipitous results that lead us to new practices and newly situated ways of listening. We're not listening for clarity and strength of signal, but are rather interested in the fragile, uncertain pluralities of hearing radio within the interconnectedness of different spaces, bodies and materials. Such listening places importance not only on what is being transmitted, but the systems, infrastructures and ecologies that it is part of.

> We broke the rules of antenna use quite quickly, swinging our aerial like a giant skipping rope, pushing away from the bounds of the fixed horizontality that we'd been taught. The sound rushed with each swing, pushing through the radio waves, creating an expanded dialling of an invisible tuning knob where we got to hear everything all at once on each loop through the air. We balled the aerial up and threw it vertically upwards, unravelling as it flew higher and then back to the ground. This sounded out the height that radio could be accessed at, revealing a ceiling that we had to move into to hear anything at all, with more and more voices the higher we went, before it crashed to the ground and, after a delay of energy still rushing through the radio circuit, it all went quiet.

Part of our feminist ethos is 'learning through doing'. This is a way to demystify aspects of technology, which enables us to share our experiences more easily with each other, and with others. The collective's approach aims to create an inclusive, collaborative, tech-based learning environment, one which acknowledges and attends to gendered education gaps and one that purposefully removes potential hurdles, such as unexplained components lists that assume knowledge. In 2021, we decided to explore the basic principles of radio technology in order to better understand radio reception. We researched and learned collectively, tinkering, testing, and feeling energised by our questions and as experimenters. With the knowledge acquired through these experiences, we support others interested in learning about radio in a different way. Our feminist ethos is also practised through our structures of working.

As a group, we aim to be non-hierarchical. We share the organising roles for both collective and project-based activities, recognising differing needs, access requirements and types of labour within the group.

> We walked in the cold November dusk to the hill where we would test our Open Wave-Receivers, a group of twenty of us with scarves and mittens. We arrived at our spot and by a streetlight set up our receivers, lassoing our antennas made from speaker wire to a chain-link fence above us and putting our tent pegs into the grass as a ground. We started testing each radio, hooking it up to a digital recorder and battery-powered speaker. Each Open Wave-Receiver was unique: some had meticulously wrapped copper wire around a stick and taped on the cardboard platform, others with wire falling off a toilet roll and a tangle of clipped wires, but they all worked. Groups of us gathered around and tested one Open Wave-Receiver at a time, shrieking with delight as we heard signals: I heard them say, 'Pakistan! That's the signal from Askoy!' 'It's the quietest rave in the world,' Hannah said, as we leaned in closer to hear soft thumping beats, and we laughed. People out for a walk on the hill stopped to make sense of this scene. Some lingered long enough, and we drew them in to listen in amazement with us.

We began by researching early radio receiver designs, in their simplest forms. Such circuits only have a small number of parts: a coil, an antenna, a ground, a diode and a

way to listen. The earliest radios were called crystal radios, because a crystal (usually galena) was used in combination with a thin wire (known as a 'cat's whisker') as a point-of-contact diode.

> Listening on a Summer Solstice in the Scottish countryside, I heard sferics for the first time: cracks of static in the air all around me, very low-frequency emissions from lightning strikes all around the world, accessed through just a handful of wires, a clothes-peg diode and a long metal fence.

We started to build our own receivers, working with various print and video guides, and learning about the relevance of each individual part. At an artist residency at Buinho Creative Hub, in Portugal, and online (some of us were there in person, others participated from afar) we delved more into the research and put some of the circuits to the test – also, together with others, in the form of a workshop. The residency gave us an opportunity to experiment further with the sociability of radio-making, and the dynamism of a community of listening. Because we worked together in a group and conducted a discovery workshop, we were able to experience first-hand the potential in sharing both the research on making receivers, and how collaborative construction and exchange can influence listening practices in proximal spaces. During that time, we also created the first iteration of our 'how-to guide' for *Make* magazine, which has continued to perpetuate both listening practices and involvement in radio-listening throughout maker, radio and DIY communities.

Today was the hottest day on record in the UK. Tonight, the air is still and thick with a slight breeze coming off the water's edge. I'm on the Thames foreshore in central London at 1 am, testing my Open Wave-Receiver. I'm really familiar with this particular location, which by day is consistently punctuated by building construction, traffic hum and buskers. At night time I hear new details; the usually hidden church bells chiming every quarter-hour, or taps and pats of rain on the river's surface. The sound of a single ambulance siren slices smoothly through the city's nocturnal sounds, almost slick in the air. My antenna is slung over a gruesomely mossy wooden pole (a remnant of the ancient docks?), which has been freshly revealed by the receding tide. My ground wire is jammed into the mud. Tiny, barely audible, river waves are accompanying my troubleshooting efforts in the dark. I can't get the radio receiver to work tonight.

Probably the most well-known simple radio circuits are the foxhole radios from the 1940s, named after the small pits designed for one or two soldiers to use in a defensive fighting position. The main difference between the early crystal radio receivers and foxhole radios was the materiality of the diode. In foxhole radios, the crystal was replaced by materials available to soldiers at the time; it was usually the combination of a razor blade and a pencil that became the point-of-contact diode. As with the crystal sets, these were no-power devices, meaning that they couldn't be detected by others, but also that the sound output would have been low, requiring sensitive headphones.

Leaning out of my third-floor window on a cold evening I was just about able to connect into a transmission from a Red Cross worker reporting on the Ukraine war. My Open Wave-Receiver barely made the connection, it was an incredibly fragile listening experience, with my speaker wire antenna dangling out of the window. With my pencil held firmly on my razor blade diode, trying not to keep losing their voice, I listened intently to their accounts of disaster. I felt their words so sharply in contrast to the calm evening dog-walking scene below me, our urban worlds so devastatingly different but connected fleetingly through these vibrations.

Because of the listening positionalities and associations of the foxhole, we took it upon ourselves to think of our work with the circuit more as a reinterpretation, a reclamation, an intentional moving away from roots entangled with the military, and the singular (national) subject, from which much radio technology stems.

It was about 4 am, Pacific Standard Time, and the night was still. Cars were stopped, and roads quieted. I was up on the top floor of our narrow Silicon Valley townhouse, sitting by the window. There was some special solar activity that was promised to increase listening at this hour, so I got up to try it. I was listening through a tiny shortwave radio, scanning for sounds . . . somewhere. The sky was lit by the moon, which reflected onto the grey clouds that were against the dark indigo night sky, making them appear white. They were scattered and close with a

gentle breeze rolling them eastwards. It was beautiful, the kind of scene that if one were to be in it, one would wish for a conveyance to float up to the window to go off sky exploring in. In the absence of that, I turned on the radio and got to the business and practice of listening, another kind of sky exploration.

Like the moon lighting the sky, the radio waves were open, and populating my radio: fast, broad and clear. I was in Northern California on the West Coast of the United States, and I could hear and visualise it all stretched across the Great Pacific Ocean: Russian broadcasts to the northwest, Japan coming in a bit lower, China and India and, locally, Mexican songs and talk shows. I heard Japanese lullabies on one channel, and what sounded like a very clear broadcast on female reproductive rights clearly moving over the airwaves from further afield. I was new to this, and to collecting what I heard. To capture sounds, I pressed my phone microphone to the radio speaker, gathering clips as they came through with each scan of the frequencies. Instead of travelling and taking photographs, the sounds came to me, and I collected pieces of them, parts of people's productions, thoughts and radio lives, mostly much further away from my own.

On this night, the sounds of the Pacific Rim opened to me, looking out the window in my little room with my tiny radio. And that, in turn, opened me to hear sounds and to visualise geo-

> graphy across the Pacific Ocean. But I could also hear right down the street — for punctuating these faraway listenings were local commercials for Italian food, specifically from a restaurant five miles away. 'MEATBALLS! Blah blah blah MEATBALLS! MEATBALLS!' blasted through my radio, louder than the other stations. As American an ad as one could find, right there amid the slow roll of the Great Pacific Ocean, gems that I listened to, and collected from further afield.

Our renaming of the foxhole device as an 'Open Wave-Receiver' has multiple connotations and shows how we want to think and engage with these simple circuits differently. Firstly, it is a design that doesn't have a tuner, it is open to a broad range of multiple frequencies received simultaneously. Secondly, it is adaptable and forgiving: the circuit is open to having parts switched out for alternatives, pieces can be sculptural, and it can literally be built into a location. Thirdly, our research and experiments are to be shared, to be further experimented with and by others, to be in process. So we mean 'open' as in open-access; open as in untunable; open to the elements, unhoused; open to different parts; open for experimentation. We often make Open Wave-Receivers with others and test them out giddily, listening together as a social practice. 'Why is this so fun?' one adult participant recently said in a workshop. This kind of open approach to creativity and collaboration is too rare in most people's day-to-day lives.

> I was driving down Old County Road listening to 89.1 FM, Atherton, a station that usually broadcasts, 'all the hits from the 1920s, 1930s

and 1940s', mostly swing (and sometimes high school baseball). It's a small station, located about ten miles from our place, and as I drove, the radio blended into a fleeting Spanish-language station that only broadcasts in a few-mile radius. I loved listening to the mash-up of swing with the other broadcasts as I drove, (safely) pulling over to one side of the road and the other to change the mix of what I was hearing. My car became the tuner for this blended station, with the road as the dial as I moved and probed the range of the mash-up of these stations.

Along with time-specificity comes the site-specificity of radio-listening, especially with Open Wave-Receivers. In our research, we've examined each part of the circuit and experimented with each piece as a part of our listening practice. For example, the receiver requires a ground, literally connecting the circuit to the earth to disperse excess signals within a specific location. The 'ground' is where we learn about the conditions of and access to the soil, whether it is moist, frozen, full of rocks or deeply inaccessible under layers of construction, sometimes accessible only by water pipes or following tree roots. It challenges us to find a way to connect our receivers from wherever we may wish to listen, such as high up in a building. In this case, in order to 'ground the ground', we might have to dangle wires out of windows, or attach them to the copper pipe of a heating system. Our antennas also usually work in relation to local architecture or natural elements and allow us to listen through the physical geography that they occupy. For example, we may use trees, walls, fences, a hillside along which a barbed wire fence runs at great length, or even landmarks or ruins.

The coil is another opportunity for creative experiment-ation: copper wire can be wrapped around a roof tile, or any material with a hollow or non-conductive centre that lends itself to structure and meaning (we like to find items that are local to the area of listening). Finally, for the diode or detector, a material or combination of materials that act as a kind of gate, allowing the alternating signal to move around the circuit in only one direction, we might use a razor blade and pencil, crystal and wire (as in the versions we learnt from), or a random material – perhaps an alloy in the form of a tent peg, clothes peg or scrap piece of metal. Our bodies are part of these circuits too: we physic-ally connect into the circuit as we handle it. We influence reception by the moisture on our skin, the material of our shoes, the moods and contexts in which we listen, as well as the locations and situations that we set the radio within. With these aspects in mind, the circuits – and we – phys-ically become a part of a particular environment, and the signals received are connected to this moment.

> I'm sitting at an open window, above the main street of Finsbury Park. I can hear that I'm high up, and I feel safe from the unpredictable space below. There is a black spider comfortably vis-ible in its web next to me, appearing alert and poised. Other dark windows are open across the street, as it's a very hot night for London. The pencil is planted on the razor blade with some warped, nondescript wire keeping it relatively in place. While sparse traffic ebbs and flows be-low me, micromovements from this trio gently manoeuvre around my mounting board and de-termine my radio-listening for the evening. In the background of my radio reception, heavier

voices murmur and laugh, almost manically. In the foreground, people are calling into a late-night talk-back show to discuss the current extreme weather and climate crisis. A woman mentions that there are six children from Portugal who are in court right now suing 23 European governments for failure to take action on climate change. The conversation shifts to news about bison, and a Punjabi singer acrobatically interrupts from her own station as the reception crossfades. I disconnect my pencil, breaking the circuit, to momentarily retune my ears to the streetscape, as heat can make people do strange things.

In line with our intention to learn through doing, together with others, we facilitate Open Wave-Receiver workshops, engaging participants as co-researchers, experimenting with different designs, different objects and different placements and settings. We like to have a making session and a listening session, the latter ideally taking place at dusk. We choose twilight, the grey line between day and night because, in this phase, radio signals at the higher end of the spectrum (shortwave/AM, VHF, amateur radio) can propagate around the world, so that we can potentially listen to more varied signals and from further away. This makes the time-specificity of radio reception all the more palpable, as we notice the changes in reception and changes in light at the same time. By listening over time, we notice the atmospheric and environmental influences on radio reception. We think of these, and other radio devices in situ, as part of a larger constellation of bodies, materiality and connection experienced through listening.

There's something really special about night time radio-listening, maybe it's the surrounding quiet in combination with the signals from afar. It's late at night and the sky is clear, the stars are out. I'm listening to my shortwave receiver in the countryside, a couple of hours outside of Berlin. The landscape is totally flat, so it feels like there's a lot of sky. The signals are coming in really clearly. I tune around a little bit, the spectrum is completely full . . . There are sounds that I never hear in the city, sounds I recognise from WebSDR (online) receivers – the more abstract radio sounds of beeps, analogue rhythms, a computer voice reciting random numbers. It's amazing, I can't believe there is so much to pick up here. And then I realise . . . The landscape may seem flat, but it's actually a slow gradation up from all around. This is actually the highest point in Brandenburg. The fullness of the radio spectrum makes me realise my topological position, and imagine how the signals may be bouncing around the planet to be picked up here.

Radio-listening to Open Wave-Receivers with others is not about the sound as much as it is about connectivity. Through these happenings, we can feel connected to the immediate environment/location, the other listening humans, to signals near and far . . . And what is behind those signals.

It's 3 pm in the afternoon and I'm listening online through WebSDR, which is currently singing to me: 'And I know if she had me back again I would never make her sad . . .'
Station 12653.99 recommended by anon18092 in the chat
Dooon doooon doooon intermittent louder doooon doooon doooon background phaser effect. 1 blip 2 blip. Descending, widening. Descending forever loud t t

4625.00
He uuuur
He uuuur
He uuuur
Over a ripple tone abrasive but a softness, like it's on the edge
He uuuur sometimes a microsecond faster, fading in and out but constant
Now out, now in. Out where? Now in.
Quud quud then returned to he uuur.
Quud quud dudududuh
Qudududud duh

4810.00
haunted
Pin pricks, like nerves
Background swarm of small things
Abrupt pause. Then daaaaaaaaaaaa da da da da
Da da da da da da da da da da da da
Da da d d da da da da
swarming
Receiver snck. snck.

For the Radio Art Zone project in 2022, we made a 22-hour work called 'Constellations of Listening', with the intention of sharing our plural radio-listening experiences, of transmitting moments of reception. In the months leading up to the festival, we recorded many moments in many locations with many different radio receiving devices (Open Wave-Receivers, VHF and VLF receivers, software-defined radios, walkie-talkies, electromagnetic detectors). We tried to pick up signals individually from the places where we live and work, and we also recorded the collective listening sessions at Open Wave-Receiver workshops. Our collective material was sourced over many months and seasons, and across different time zones, from listening sites that connect environments, technologies and voices. We compiled our recordings so that they would be broadcast back at around the same time of day or night that they were made, the sharing of radio-listening experiences.

> In a garden somewhere in the seaside town of Chania, in Crete, Greece, an old bitter orange tree becomes the ground for receiving a multitude of signals, made of different languages, dialects, data packages, interferences mixed with topical sounds of insects, avian activity, and heavy military air traffic. Altogether the signals are picked up by a pair of omni-directional microphones, streamed in – in real time – via a Raspberry Pi-based stream box to a server, and played live on RAZ's main stream, as well as on analogue FM broadcasts in Esch and via international broadcast partners. A delicate yet elaborate network of (mediations and) relays.

317

Coils are curled around branches and small radio receivers are hanging from the tree. The tree becomes a transceiver. The afternoon sun warms up the soil and the line of reception becomes inundated. Listening starts in the porosity of the signals, frail, sparse and topical. Interference becomes a mechanism for navigating what can be heard; listening to many at once; an open wave-listening. Interference becomes a gateway to *interreferential* listening, receiving from different directions, different branches, foreground and background, simultaneous and ambiguous, difficult to be defined, a radio with many heads and tongues, some heard, some not; a plural radio-listening.

This transmission aspires to balance liveness, site-specificity with remoteness, as I try to inter-ject existing frequencies with pre-recorded con-tributions and receptions by Kate, Lisa, Brigitte, Sally, Hannah, Georgia, Sasha and Alyssa. Their voices narrate and clash with each other and re-claim frequencies usually occupied by music, news and commercial radio content. Their voices and receptions articulate the infrastructure of the tree as it is mapped out via the hanging radios, becoming embedded in the flora and fauna of the site.

I try to listen as I try to transmit. I move around the tree in circles, moving closer and away from the different receptions. I hold another device to sporadically tune in and amplify what I try to hear but my listening is constantly destabilised

by an abrupt change in signals, interferences, a passing plane, the sounds of insects. I am aware that all these changes and my moving body are transmitted across the network to multiple receiving ends, reminding the listeners that this is a live transmission.

Remote becomes topical, and the in-situ becomes extended across the network. Interreferential listening is prompted through these deliberate interferences, and the hijacking of the mainstream airwaves.

Each small radio receiver hanging on the tree becomes a tool for reverse-engineering transmission, for opening up the airwaves to unheard, lesser-known stories, against the top-down, topical mainstream; allowing a kind of listening that sits in-between the established and the peripheral, a transient sounding space.

Elsewhere on this tree, FM/AM/MW/LW/SW live receptions pulsate across the leaves, only to be hijacked and perturbed by a micro-cast that diffuses my voice across different receivers. 'Ραδιόφωνο = Αποτυχία', 'Transmission means Failure', 'Transmission means Loss of Signal', 'Transmission is Fragile'.

The transmission involves an iterative process of trial and error. A big part of what the transmission achieves can be found within radio's inherent fragility and failure to be received and the possibility of interreferential listening. It

319

asks for an active making and 'figuring out', an embracing of failure as a way of accepting that there will always be signals that will never be heard.

Weather Dreams
The Sisters of the Celestial Order of Nephology (2024)

With your eyes closed, in the dark of night, listen to the sound of the room you are in. What is the density of its acoustics? What is the thickness of the air the sound moves through?

Now listen to the sounds outside of the room: the way the wind caresses the outer walls or windows, any movement in the trees, the speed and quality of traffic or people.

From these sounds, construct a feeling of the weather at night. Visualise the weather that matches the sounds. Let this lull you to sleep.

Variation:
If the weather you are sensing is enjoyable and conducive to sleep, sense that weather internally. Grow a feeling of the weather inside your body.

The Den 3 (Extract)
Sop
(2021)

Trees understand crip time.
My kin, I want to slow down to your rate.
Human time is too fast for me.
I choose you. My imprint is slight,
but you have spoken to me
and I receive your messages.
I feel your age, your slow patience,
the flexibility of your strength,
from root through rings through
fluttering leaves, renew, rot, renew!

I am full of toxins, so full of toxins
and poisons from treatments that
my body is wilting. The den has
been my witness, it notes my chemicals,
my hormones, my changing cells.
My subtle transpirations enter the atmosphere,
sift in and around, and in the smallest sigh,
are welcomed into the trees.

It is strange and alarming to not realise
quite how fragile you really are.
When given the vaccine, instead of
opening up my world to a safer and
more 'normal' life, my body panicked
and overwhelmed, fizzed and folded inward.
Ancient viruses were reactivated,

low ghostly synth sounds bump
and clunk, birdsong becomes
slower

leaves fall

voice doubles

sniffs and the low inhale/exhale
of a metallic ghostly sound

a tangled metallic sound unravels

bees buzzing transform into a
symphony of bees

the low inhale/exhale returns

a very low rumble comes, all

and I was left half a person,
more limited than before, the fatigue of a
different quality: longer, weightier,
but more precarious and unpredictable.

I pivot to tree time, slowed down,
limbs wading through slurry-like air.
Rest, but the 'right' rest, being the
majority of my daily experience.

My cells are studied in great detail
and immune dysfunction is determined.
I microdose cytokines, hormones,
growth factors, nucleic acids.

The den doesn't need me there
but it accepts me. It is not indifferent,
and with repetitive visits we become
companions, allies. We breathe each
other in and we breathe each other out,
with mouth, skin and leaves,
our leaky membranes mingle.
The den does not mind that I am
diseased and dysfunctional,
it gladly offers me what it can,
and in gratitude I offer it all that I can.

I perform my own protocol,
deeply inhaling phytoncides.
I am intoxicated by petrichor
and geosmin after the rain.
I dose bacteria from the soil –
I offer my cells and my expelled breath
and in return I absorb change.

324

background noises cease just
leaving the low rumble which
sounds like a storm underground
sounds of tinder crackling in fire
twigs are breaking underfoot

busy electronic drips and drops
patters and spatters

rain falls

sound of quick, tuneless, synth-like
exhales

the busy electronic spatters come
back in, faster

Like a plant I embody fortitude.
Hope and optimism are ductile.
A ceaseless thread with indefatigable
tensile strength. 'I don't know how you do it',
to which I answer; 'I have no choice.'

Like the tree, the soil, the fungi we press on,
reaching towards an uncertain future, bending,
adapting, and slowly, slowly, persisting.

electronic spatters stop
low ghostly synth exhales

wind in trees

woodpecker song

In Search of the Free Individual
Svetlana Alexievich,
translated by Jamey Gambrell
(2018)

I love life in its living form, life that's found on the street, in human conversations, shouts and moans. That sort of life is genuine, not yet shaped by someone else's ideas or talents.

This probably comes from my childhood. My parents were village teachers and there were always plenty of books at home. But in the evenings, I was drawn away from books to the benches outside where the women of the village gathered. It was the postwar period, when young boys were still getting themselves blown up in the forest by German and partisan mines. As far as I remember, only women lived in the village. No men had returned from the war. In the evenings, after milking the cows and finishing up the housework, the women would sit outside and talk about life and death. They talked about the war: how they saw their loved ones off, how they waited for them. How they believed the Gypsy women who promised them miracles. It seems to me that I learned everything there was to know about love from their stories. Their stories affected me more than books. Life seemed mysterious and frightening.

It took me a long time to find a genre that corresponded to the way I viewed the world . . . to the way my eyes saw and ears heard . . . a genre that corresponded to my memory.

I chose the genre of the human voice. In my books,

ordinary people, the ones we still refer to as the 'little' men or women, talk about themselves. I discover my books on the street, I hear them outdoors. Sometimes I spend an entire day with one person. It's important to catch words in flight, as they're born. It's important not to miss the conversational part of life, which we often neglect, dismiss as unimportant, leaving it to disappear in the bustle of life, in the darkness of time. It seems surprising that this could be literature. But I want to make every bit of our life into literature. Including ordinary, everyday words.

For over thirty years I chronicled the 'Red Empire'. This unprecedented communist project spanned a vast territory and affected an enormous number of people – over 200 million. The Russian Bolsheviks attempted to remake man, ancient Adam, into a new type of human being – Homo sovieticus.

The 'Red Man' that I write about is a creation of the Soviet idea, the builder of Communism, as he called himself. This chronicle comprises five books, but they are really one book, about the history of the Russian-Soviet soul. They cover a period of almost 100 years and several generations. I managed to speak to people who had seen Lenin and Stalin, who did time in Stalinist labour camps, but believed in Stalin, cherished their party membership cards, those little red booklets with the leaders' profiles embossed on the cover. I remember an old woman who seemed to me to have risen from the dead. She was a communist who had spent seventeen years – her entire sentence – in a distant corner of Siberia and miraculously survived. And yet she threatened to denounce me to the KGB because I was slandering the great leader and a great, heroic era. Communism was their religion.

For most of my life I lived among them, I lived the same

329

life. My father was one of them; he believed in the party until the end, and asked that his party card be buried with him. This was the last generation to be mortally infected with communism. Bewitched by utopia.

We are their children, but we don't understand them. The protagonists of my more recent books are different. They talked about fighting in Afghanistan but didn't understand what cause they were supposed to be dying for; they talked about shovelling melted graphite off the roof of the Chernobyl reactor, doing work that should be done by robots. About the collapse of the mighty Red Empire, and how they were left behind, disoriented in this new world.

I am interested in domestic socialism, not heroic, pompous, public displays, but the socialism that lives in human souls. I reduce the great and grand to human scale. I am a historian of the soul. For me, feelings are also documents. I study missing history, the things that history usually overlooks. History is often arrogant, and dismissive of what is small and human. A whole choir sounds in each of my books, but the individual human voice can always be heard. For me, human beings exist simultaneously in two worlds – in a specific time, and in the universe, the eternal. I spent five to seven years writing each book, and in each case recorded somewhere between 500 and 700 people of different ages and different professions – because the woman who fired a machine gun saw one war, and the woman piloting a bomber may not have seen a single person die during the war, she only saw the sky. The machine gunner talked about hand-to-hand combat, when a human isn't human anymore, just animal who wants to live, a creature that slices and stabs – at the eyes, the heart, the stomach . . .

I gather my books from hundreds of details, nuances, shades and tints. Sometimes an entire day of conversation

produces only a single phrase. But what a phrase! 'I was so little when I left for the front that I got taller during the war.' Once I sat for four hours with a woman who was a submachine gunner during the war, and all I heard from her were banal newspaper platitudes: 'The war began, and we Soviet girls rushed to the front along with the men. That's how the motherland raised us.' I wanted to leave the house, I couldn't see how I could possibly break through the clichés. The propaganda. The male canon. Often, the women I spoke to wanted to tell their stories like men. But I was looking for specifics, for smells and subtleties, the kinds of things that distinguish a woman's war from a man's. And then, when I was putting on my coat, just about ready to leave, the same woman said: 'Stay a bit longer. Let me tell you . . . you could never imagine how frightening it is to die at dawn. The birds are singing, it's quiet, and in a few minutes you'll get the order: "Fire!" The grass is so clean, the air is so pure, but you have to die.' This is where literature begins. And later, at the end of the conversation she told me: 'After the battle we would walk through the fields and look for the living − maybe someone had survived somehow. Soldiers were scattered across the trampled wheat like potatoes, they just stared at the sky − Germans, and our soldiers, too. They were all so young, handsome. We felt sorry for all of them.'

It was never my goal to put together a collection of horror stories, to overwhelm the reader. I was collecting the human. Dostoevsky asked the question: 'How much of the human is there in a human being?' How can the human in this human being be protected? That's the question I'm looking to answer. I collect the human spirit. You may say: it's an ephemeral thing, too elusive. But art attempts to capture it. And every era has its own answers. It takes a long time and a great deal of work to put together an

image of a period from different stories. What kind of people lived at this time? What did they believe in? What were their fears? Their superstitions? Their perplexed speculations about the meaning of life? I always asked everyone who fought: how can a person live with the idea that he has the right to kill another human being? To kill and not to go mad? People died too easily and killed too easily for grand ideas. In order to hear something new, you have to ask in a new way. I have to be interesting to the person. I, too, have to tear myself away from the predatory clutches of my time, to stand at least a little bit to the side.

All of my books have had a hard time. Some, like *The Unwomanly Face of War* (1985), weren't published for many years. Others were taken to court in trials presided over by actual judges. *Boys in Zinc* (1991) was the subject of a lawsuit. When I saw Natasha M. in the courtroom, I was very surprised. I went up to her: 'Why are you here, Natasha?' I asked. 'You wanted me to write the whole truth, and I wrote it.' I remember her son's small coffin, which could barely fit in the nine square metres of the barracks. She sat next to it, mad with grief, alternately sobbing quietly or shouting: 'The coffin is so small, and you were so big, almost two metres tall; is that you in there, son? Answer your mama.' She told me that they hadn't been able to find any valuables in the house in order to buy her son out of the war. 'I would have given everything, I would have paid, like others did, but I didn't even have a pair of gold earrings. I want you to write that my son was a carpenter,' she said, crying. 'He was drafted into the army and on the very first day he was sent to renovate the generals' dachas, not for training. They didn't even teach him how to shoot. He was killed in the first month.' 'What are you doing here, Natasha?' I couldn't believe it. 'I wanted my son to be a hero, and you wrote that he was a killer. You wrote

about how they killed . . .' What could I reply, if even all the suffering she had endured hadn't made her free? We weren't just slaves, we were slavery's romantics.

The Unwomanly Face of War wasn't published for three years: I was accused of 'naturalism', and 'pacifism'. The censors were particularly indignant about an episode describing 200 young women soldiers marching. The men marching behind them tried not to look down at the sand, where there were drops of blood. It was that time of the month for many of the women, and they needed cotton, or something, but the Soviet army didn't issue those sorts of things. The women were ashamed. When they reached a ford crossing a river, the Germans began bombing. The men all hid, but the women rushed into the water to wash themselves – making an excellent target. Almost all of them were shot from the air. 'Why are you bringing biology into it? You should be describing the heroism!' the censor shouted at me. I tried to argue that humans are made up of many things, including biology. I'm interested in the body as a connection between nature and history. Ideals can't be made of plaster, like monuments. In the end, that page was cut out of the first edition. I was able to reinstate it only ten years later, during perestroika. The censor even deleted the following scene: I asked a woman, a former sniper, what she took to the war with her. Her answer: 'A suitcase full of candy. I spent my entire last paycheck buying chocolates.' And we laughed. 'You call this history . . . these candies?' The censor was angry. 'Yes, it's history,' I replied. 'These kinds of details make a huge impression.'

Sometimes I am reproached because the people in my books are said to speak too beautifully. In love, and in contact with death, people always speak beautifully. At these moments they transcend their ordinary selves, they

rise up on tiptoe. That is the kind of person I keep watch for. I look out for life, for people who have been shaken to the core by life. By the everyday. In telling his own story, a person creates; he doesn't copy reality, he creates. Memories are living creatures. People put their entire lives into their memories: what they read, what they thought about, whether they were happy or not. Documents evolve along with the human soul; it would be naïve to think that they represent canonical knowledge, something immobile that is mechanically transferred from one time to another. After perestroika many of my subjects added entire pages to their stories, they became freer and looked into themselves more profoundly. Profoundly, and with greater courage. I would receive letters saying: 'At the time I was afraid . . . You know how dangerous it was to talk about Stalin. We couldn't even tell the whole truth about the war. But now I've decided to write.'

I, too, have changed over the years. I know more about people and have better intuition. Feelings are not a simple, linear, naked thing. A document can tell a story, elevate everything. But it has always tormented me that the truth doesn't fit into one heart or mind, that truth is so fragmented, there is a lot of it, and it's scattered about the world. I don't agree when people tell me that documents cannot tell us anything about the personal, the sacred. They are difficult subjects to write about, but it can be done. Who will believe a person without this . . . without the heart?

My subjects would often say things like: 'I can tell you, because you're Soviet, and only a Soviet person can understand another Soviet person – you know what I mean.' The Russian soul is an enigma. We lived together in a country where we were taught to die beginning in childhood. We learned death and dying. We weren't taught

that humans are born for happiness, or love, it was drilled into us that humans exist in order to give of themselves, in order to burn, to sacrifice. We were taught to love people with weapons.

I have travelled this road for decades. I didn't always have the strength for it. Human beings have delighted me and frightened me. If I had grown up in another country, I couldn't have followed this path. Evil is merciless, you have to be vaccinated against it. We grew up among executioners and victims. Even if our parents were afraid and didn't tell us everything – and most of the time they didn't tell us anything at all – still, the very air we breathed was poisoned. Evil always kept its eye on us.

My first book, *The Unwomanly Face of War*, is about war as it was seen and described by women. Why war? Because war has always been at the centre of our lives. We are people of war. We have either been fighting or preparing to fight. Everything we know about the war we know from a 'male voice'. We are always captive to male ideas and the male experience of war. Male words. When women tell stories, they tend to adapt to the male canon, to describe men's war, not women's. In my journalistic travels I often met women serving in the military. If I was able to pry them away from clichés, the monstrous grimace of the mysterious could be glimpsed through their stories. It was a totally new kind of text. When women spoke there was little or none of the usual narrative: one group of people heroically kills another group of people and declares victory. Or defeat. A little about the kinds of weapons and which generals were present. Women's stories are different and they talk about different things. They have their own colours, space and lighting. Their own words. There aren't any heroes or officially sanctified heroic exploits, there are just people, people who are engaged in the

human business of inhumanity. And everything living suffers, not only people: birds, trees, animals . . . They suffer without words, which is even more terrible. The grandiose, predatory world of war was revealed to me through their stories.

How can a person live through history and write about it at the same time? You can't grab just any old bit of life or existential 'dirt' by the collar and drag it into a book. Into history. You have to transcend the time and 'seize the spirit'.

Men are hostages to the culture of war, but women are freer. Women's stories always contain the idea that when all is said and done, war is about killing. It's always about killing, no matter what.

I found texts, literature, everywhere. In city apartments and village huts, on the street, in the train. I learned how to listen, how to turn myself into one big ear.

After *The Unwomanly Face of War*, I decided to follow the times. To follow human beings: how has this man changed, what is happening to this woman? What is happening to them, that is, to us? The story of one person is fate; the story of hundreds of people is history.

Boys in Zinc began with one little girl. I couldn't forget her. In the municipal cemetery in Minsk they were burying officers brought back from Afghanistan in zinc coffins. There were grandiose, combative speeches, wreaths . . . A little girl tore away from the grown-up's hand like a bird and cried out: 'Papa! Papa! I drew lots of boats for you, just like you asked. Where are you?'

That is when I realised I had to go to Afghanistan, even though I thought that I could never write about war again. On television they were showing our troops planting trees and building houses in Afghanistan . . . They talked about

international obligations, state interests. Finally, there I was, in the middle of the war . . .

The first time I drove along the streets of Kabul, I saw familiar posters: 'Communism – is our bright future', 'Kabul is a city of the world', The people and party are united!' It felt like I was in Minsk, not in Kabul.

Then, for the first time, I saw a person who had been killed. Not by lightning, not by the elements, but by another person.

I saw 'Grad' rockets turn clay villages into ploughed fields. I visited an endless Afghan cemetery, where an old Afghan woman howled like a wounded creature. It reminded me of the village near Minsk when they brought the zinc coffin into the house and the mother howled in the very same way. It wasn't a human cry and it wasn't the cry of an animal . . .

My first thought was: how will I ever find words for this? What sustained my hope? Witnesses. Only the words of the witness were equal to what I saw and what I wanted to write about. Today, I see the witness as the main protagonist in literature. People say to me: 'Well, you know, memories, recollections – that's not history and not literature either. It's just life, rubbish that the artist hasn't polished. It's the raw material of conversation, just chitchat.' But I see things differently. It is there, in the live human voice, in the live reflection of reality, that the mystery of our presence is hidden, and the insurmountable tragedy of life is laid bare. Life's chaos and passion. Its singularity and inscrutability. Shouts and sobs can't be polished, or the main thing will be neither the tears nor shouts, but the polish.

I am building temples from our feelings . . . our desires and disappointments. Our reveries. From things that

should not be allowed to disappear. Before Afghanistan, I believed that we were building socialism with a human face. That is what my father taught me. I returned from Afghanistan free of all illusions. 'Forgive me, father,' I said when I arrived home. 'You raised me to believe in communist ideals, but once you've seen our soldiers killing people they don't know in a foreign land, all those ideals turn to dust.' My father cried.

Life itself is unimaginably artistic all on its own. As cruel as this may sound, human suffering is especially artistic. This is the dark side of art. I am always dealing with materials that lead right to the edge of the impossible. Where you are one-on-one with reality.

I spent ten years writing the book about Chernobyl. After that experience, I can truly say that I don't write my books, I live through them. Chernobyl was a sudden leap into a new reality. What happened there surpassed not only our knowledge, but our imagination. Everyone I talked to said the same thing: 'I've never seen anything like it . . . 'I've never read about anything like this . . .' 'I've never seen this in any film . . .' 'No one has ever told me about anything like this.' Everything was just as it had been, but the world had changed completely, including our knowledge about the horrors of war. In Chernobyl the trees were blooming, everything was growing, the birds were flying, but people could feel that death was present everywhere. Unseen, unheard. Death with a new countenance.

The past was powerless to help us with any of it. I went to Chernobyl. What I saw was cause for silence. People looked dazed, almost mad. We watched the top layer of contaminated earth being cut away and buried in special ditches. Earth was being buried in the earth. Soldiers

washed the roads, the houses, the trees, the firewood . . .
And they buried, buried, buried. They buried things,
eggs, milk, contaminated animals that had been shot. In
the newspapers, information about Chernobyl consisted
entirely of military words: explosions, heroes, soldiers,
evacuation. Military equipment was headed for Chernobyl,
carrying soldiers with automatic weapons. The system
worked as it was supposed to in extreme circumstances:
lots of machines and lots of soldiers. But a soldier with an
automatic weapon was tragic in this new world. The only
thing he could do was absorb huge doses of radiation and
die when back at home. People were used to the idea of
atomic war, but not atomic peace. They didn't yet realise
that the atoms of war and peace are colleagues, they kill in
exactly the same way.

I remember the evacuation of a village: the people got
onto buses, but the dogs and cats ran loose, they were left
behind. Humans saved only themselves. An old woman
stood next to an old house, holding an icon, and refused
to get on the bus. When she saw me, she came over and
said: I know what war looks like, but here the sun is shin-
ing, everything's in bloom, I even saw a mouse today.
Why should I leave my cottage? How could this be war?'
'Yes, this is war. This is probably how the wars of the
future will begin,' I thought. 'Yes, it's war. A different
kind of war, unknown to us.'

An old beekeeper told me that the bees hadn't left their
hives for a week, and the fishermen remembered that they
couldn't find any worms, they had all gone deep into
the earth. Bees, worms and insects knew something that
people didn't.

I realised that I didn't have any instruments, I didn't
know how to approach the subject. The event was still
outside of our culture.

At the time I heard: 'We're Belarussians – black boxes recording information for the future.'

All around me I heard completely unknown texts.

For example, the wife of a fireman who helped to extinguish the fire on the roof of the reactor the first night kept repeating what the doctors told her: 'You can't get close to your husband, you can't touch him or kiss him. He has severe radiation poisoning.' The doctors wouldn't let her see him. 'He isn't your beloved husband anymore,' they said. 'He's an object requiring decontamination.' You couldn't see radiation, your eyes weren't any help; it didn't have a smell, you couldn't touch it, you couldn't hear it. All our faculties: eyes, ears, fingers . . . Nothing was of any use. New words were needed, and none were to be found.

Not far from the reactor I saw village boys on bicycles. They had come in the evening to look at the fire, to gaze at the dark pink glow emitted by the smoking reactor. The sky really was beautiful. Beauty and death were shoulder to shoulder. But we didn't know it yet.

The churches were full of people, but the only thing they found there was consolation. However, in order to survive, you have to understand. How can you resist something you don't know? People became philosophers. Faced with this mystery each person was left alone with himself. Chernobyl condemned each of us to endless solitude. Evil took place on such a scale that we surpassed our limits, but still couldn't understand it. Consciousness capitulated, science capitulated. But the subconscious began to work. People were afraid of particular monsters, they told stories of children with five heads, of headless, wingless birds . . . They scared each other with fantasies: thousands of corpses are being buried in secret locations . . .

Belarus is an archaic, agrarian country. The peasants live

close to nature. Simple tools are still used on the land: the axe, shovel, plough. What did I discover? Scholars, politicians and the military were thoroughly baffled, but the old country folks' image of the world wasn't disturbed. I don't know what helped them. Perhaps it was their acceptance of the idea that they could disappear along with nature. 'Nothing like this ever happened in Chekhov or Tolstoy,' one teacher told me. Everyone sought his or her own point of reference in this new world. Official propaganda, culture and philosophy were paralysed. They kept quiet. If we had truly processed the meaning of Chernobyl, much more would have been written about it. The knowledge of our lack of knowledge hinders us. Chernobyl changed our understanding of time – many radioactive particles will live for 100, 200, 1000 years, thereby altering space. A few days after the accident, radioactive clouds were detected over Africa. Concepts like 'our own' and 'foreign' were obliterated. Borders don't exist for radiation. In short, people were stunned, and I hurried – to listen, and to write everything down.

I didn't feel I was writing down the past, I was taking notes on the future. While you're talking about the catastrophe, you can't help thinking about the story of the catastrophe. How to go about finding the right language?

We all have many languages – we talk to ourselves in one language, to children in another, to someone we love in a third, and then there's the language we speak to animals . . . or to God . . . Conversational language isn't burdened, it isn't preconceived. It goes its own way and celebrates: with syntax, intonation, accent. Feeling is resurrected accurately. I follow feelings, I am an historian of things that leave no trace.

In Afghanistan a soldier talked about how exciting it was to kill in a group. And how unpleasant it was to execute

someone, especially if you'd seen his eyes.

In Chernobyl children came up to me and asked: 'Miss, you're a writer, you must know, will the trees have leaves next year? Will there be little baby fish?'

I heard a young mother crying; her little girl had been born sick and lived less than a year. She only had three fingers on each hand. I put her little body in the coffin and thought: I wish she at least had all her fingers, I mean, she's a little girl, after all.

Will this remain in history? History would turn its back − but I am astounded.

If I hadn't read Dostoevsky, I would be in despair over the human soul, its limitlessness.

Afghanistan and Chernobyl buried the empire. We said farewell to the life we had lived, which was called socialism. My cycle of books was coming to an end. In the last book, Second-hand Time (2013), I tried to listen honestly to all the participants in the communist drama. I didn't have to look for characters, we were all protagonists. The empire fell, but we remained. All of us, the people who came out of socialism, are and are not like other people. We have our concepts of good and evil, heroes and martyrs. We have our own relationship to death. The words 'execute', 'liquidate', 'eliminate', 'firing squad' and 'ten years without the right to correspond' (which means being arrested and disappearing) constantly arise in these stories. All are full of hatred and prejudice. We lived in a labour camp. A man may walk out the gates of the camp, but it doesn't mean he'll be a free man tomorrow. All he knows is the camp, the value placed on human life also comes from the camps. The writer Varlam Shalamov, who spent almost twenty years in the camps and left us fundamental documents about them, wrote: 'The experience of the camp

corrupts the executioner and the victim'.

In the 1990s the archives were opened and we were faced with those eternal Russian questions: what is to be done and who is to blame? Stalin? Beria? In my view, good and evil are at the root of our problems. In *Second-hand Time* one of the characters tells the story of how he was in love with his aunt Olya – she had a beautiful voice and beautiful hair. Later, when he was in university, perestroika began, and his mother admitted to him that during the Stalinist purges Aunt Olya, her own sister, had written a denunciation of their brother, and that he had rotted away somewhere in the camps of Kolyma. When the storyteller came home for the holidays, he asked his Aunt Olya what she remembered about 1937, when her brother was arrested. 'Oh! It was a marvellous time,' Aunt Olya answered. 'Everyone loved me, and I was in love'. The young man asked another question: 'But what about your brother?' 'You couldn't find an honest person during Stalin's time. That's just the way things were,' was her answer. What I want to say is that there is no chemically pure form of evil. Evil is Stalin, and pretty Aunt Olya, too.

The truth was terrifying, and dangerous. Our past frightened us, and the archives were soon closed. Communist monuments are still standing just like they were, plaster Lenins are everywhere, his body lies in the mausoleum – a pyramid of Cheops built in the twentieth century. The Communist Party was never put on trial, there was no lustration. The past didn't let go of us, our heads are crammed with it.

I don't like to call what I do interviews – it's conversation about life. I come to people as a friend. We talk about everything: a new blouse, love and war. The conversation shouldn't be artificial, there shouldn't be any barriers. We just talk. About good and evil, about socialism and capital-

343

ism, about freedom . . . I've heard hundreds of answers to my questions. All of them represent us, as we are at this moment. In answer to the question: what kind of country should this be – a strong country, or an admirable one, where people live a good life? – eight out of ten respondents choose a strong country. During perestroika we were romantics, we thought that freedom would arrive tomorrow. We had that naïve certainty. Today we know that the road to freedom is long and hard. Many dangers and temptations await us along that road. We don't have any experience of freedom; the only experience we have is of labour camps.

Books pile up in the bookstores and markets by the hundreds. Everything has been published: Solzhenitsyn, Shalamov, Evgenia Ginzburg . . . At one time, people were imprisoned for having these books, they were dismissed from universities. Nowadays people hurry past them. We are flooded with material goods: you can buy a new coffee grinder, a washing machine, there are dozens of kinds of sausage and cheese in the shops – all available and ready for the trying. The pinnacle of people's dreams is a used car from Europe, a Schengen visa and a vacation in Turkey or Egypt. No one stands in line all night for books anymore. We were all sick, unhappy. People want to live, just live, to experience the joy of pretty things, of clothes.

The Red Empire's collapse was a unique historical occurrence. The sharp turn from socialism to capitalism shook people profoundly, they weren't prepared for it. This was the first time in history such a turn had taken place. The country was divided: some remember perestroika as a great time. I remember how people's faces changed immediately, even the flow of their movements. The air of freedom was intoxicating. My generation was ecstatic; it wanted to destroy communism, and it was

destroyed. Others think that it was a geopolitical catastrophe. I remember how wonderful it was to sit in our kitchens and dream about a free country; but when we were thrown out of that closed circle into the world, into a common reality, we were frightened. We imagined freedom as a holiday, we walked along the streets and plazas chanting 'Free-dom! Free-dom!' but had no idea what freedom was. I ask people I talked to: 'How did you imagine freedom in the 1990s?' 'We thought we would have the same kinds of stores they had in the West. There would be a lot of everything, no shortages.' No one imagined freedom as work. When they understood, everyone was unsettled. Intellectuals as well as the politicians. They didn't think that freedom would demand free individuals, which we were not. We didn't let the world in, we closed ourselves off. Now we scare everyone – Russians are good soldiers, they'll do anything, life is cheap over here. We only know one way of making others respect us – they must fear us. Putin came on the scene – and the world is afraid of us. I am not a politician, nor an economist. I am an artist. I had to organise all this chaos, and feel out the energy lines of the time. And do it through art. I needed to let each person shout out his own truth, in order to understand who we all are. Executioners and victims speak in this book, young and old. Answers are born at the intersection of all these views. And questions, more questions . . . How did Putin manage to resurrect the Stalinist machine so quickly? Once again the FSB (formerly the KGB) can burst into any home, confiscate computers, put bloggers on trial for a post supporting Ukraine; supposed spies are being hunted down and put on trial throughout the country – scholars, teachers, military personnel. People are frightened and we don't know what is really happening in society, or what it really thinks. It's hard to understand.

345

And there is one question I have never found an answer to: why is it that our suffering doesn't convert into freedom?

I follow the times, and the human being.

You, We, I:
Three Works on Partition
Syma Tariq
(2024)

In August 1947, after 200 years of colonial rule, British India and its princely states were partitioned into the nation states of India and East and West Pakistan. Before 'British India', Hindustan was subjected to a century of East India Company-led extraction, looting, destruction and mass death. In the long twentieth century, partitioning became a rational solution for departing imperialists. Having already divided Ireland, men who had never set foot in Punjab or Bengal drew the Radcliffe Line between India and Pakistan, just weeks before the UN recommended that British Mandatory Palestine – created out of the partition of the Ottoman Empire – became independent Arab and Jewish States.

In the 1990s, South Asian feminists in fields including anthropology and oral history heard public testimonies of women who experienced abduction, displacement, rape, physical violence and personal loss in northern India and Pakistan (work on the Bangladeshi and Tamil Eelam genocides has been slower and less prolific). This listening centred work contributed to and partly catalysed an oral archival boom in the UK, the Indian subcontinent and the US, thanks to partnerships between Western academic institutions and South Asian NGOs. In the twenty-first century, Partition has been commemorated and memorialised as never before, with more voices gathered for new

archives and new museums, in a manner that produces it almost as a universal origin story.

A wealth of micro and macro-historical detail, feelings, narrative contradictions, repetition, intimate speech and difficult listening delineates Partition's sonic material culture, which has become palatable and referential. Testimony has been collected by a wide range of people: citizen historians, academics, artists and journalists, as well as archivists. Its overwhelming mainstream focus on the loss and remembrance of home is staged through the violence between 'Hindus', 'Muslims' and 'Others' – to use the three official classifications of the native population in the British Partition Plan. As noted in recent scholarship, 1947 has produced a nostalgic memory culture full of gaps, and driven overwhelmingly by the testimony of those with privileged status in terms of caste, race, religion, income, gender, property ownership and citizenship. This reveals, simply, whose voices get to be in the archives, and whose don't. As testimony is collected, broadcast, repeated, fictionalised, re-performed and re-archived, Partition's visibility after decades of 'silence' has created some sense of closure, though it remains 'an event that serves as metaphor from the start'.[1]

If we follow Madhavi Menon's assertion that Partition is 'a condition within which we all labour', the decolonial turn and the co-option of Partition as British history offers an opportunity to assess its public memory paradigms, beyond what the new and extant archives do, or say they do.[2] This archival labour is complicated by the fact that

[1] G. Pandey, *Remembering Partition: Violence, Nationalism and History in India*. Cambridge University Press, 2001, p. 91.

[2] M. Menon, 'Universalism and Partition: A Queer Theory', *Differences*, vol. 26, no. 1, 2015, pp. 117-40.

in 1947 (like in many other imminently decolonised territories in Asia and Africa), many official records were completely burnt or destroyed, instead of being handed over to new governments.[3] Other documents were shipped to the UK, where they remain in secret archives, either redacted or outright censored. What does this mean for testimony as a category of evidence, when it is the only evidence we have?

Partitioned Listening, a methodological critique and research practice that takes the form of an audio essay, listens with and re-sounds through and beyond the archive to resist the closure of the 'event' in space and time. The three works frame testimony in different modalities and imaginaries through Katherine McKittrick's undisciplinary approach to the remix and mashup 'within the story and in extant of the story' by:

- Inventing with found objects
- Breaking free of old associations
- Engendering new contexts from old histories
- Flipping the script
- Learning to speak in new forms
- Noticing how the sound of thought becomes legible
- Producing work at the edge of new meanings
- Taking an idea and folding it in on itself [4]

[3] I. Cobain, *The History Thieves: Secrets, Lies and the Shaping of a Modern Nation.* Granta Books, 2016, p. 118.

[4] K. McKittrick, *Dear Science and Other Stories.* Duke University Press, 2021, p. 170.

You Trust Your Memories?

 The first work of Partitioned Listening was produced during the 2020 Covid-19 lockdown. It treats listening as unstable, historical evidence as fallible, silence as productive, speech as inherently violent and voice as a carrier of worlds beyond the human index of the archive. *You Trust Your Memories?* gathers together a few narratives from material found online and recorded with family and friends: the beginning and end of BBC television documentary *India: The Brightest Jewel* (1977); a friend's post-memorial tour of a crumbling Sikh gurdwara in Karachi, Pakistan, the site of a massacre; and my late grandfather's account, surrounded by family din, of what he witnessed in Allahabad, India in 1948. These tales are bookended by Madhavi Menon's fable about Partition and Universalism ('neighbours, but never good friends'), which she kindly recorded for me on her phone in Delhi before its own devastating lockdown.

You trust your memories? throws out colonial tropes – 'riots', the 'mob', 'Hindu-Muslim' – and evokes murky images: the steam train rolling in, crows and the combined death and promise they carry, hoots bearing British progress and modernity. 'Evidence' is shaky, produced from our own listening. Sybille Schmidt writes that: 'survivor testimony is less considered as a source of evidence, as testimonies traditionally are in historiography and the law, but bearing witness is considered as an act of moral value'.[5] According to this idea, if testimony is not evidence, then the witness (listener) is always in a precarious position.

We Shall Witness

 We Shall Witness follows a sonic fragment and its (threatened) copies, via three live versions of Faiz Ahmed Faiz's 1979 poem 'Hum Dekhenge' ('We shall/will See'), and his 2019 protest-performance 'Hum bharat ke log' ('We the people'). Faiz, the Pakistani poet, activist and author, had agitated and been imprisoned for his part in a failed socialist coup in the 1950s. He is widely loved for his Urdu verses on loss, language and land; his poems on Palestine, written in exile in Beirut, are resurgent today. Speaking to Partition, 'Subha e Azadi' ('Morning of Freedom') delicately excavates the displacement of one's soul within the progression of history.

When it was written in 1979, 'Hum Dekhenge' was banned by Zia ul Haq's Islamist military regime, which had won power through a US-backed coup. Faiz connects Qayamat, the Islamic day of reckoning, to a people's revolution.[6] Quranic language becomes a metaphor for liberation, confronting the regime's conservative Islam. The first version of the poem is a legendary performance in

[5] S. Schmidt, 'The Philosophy of Testimony: Between Epistemology and Ethics', in S. Krämer and S. Weigel (eds.), *Testimony/Bearing Witness: Epistemology, Ethics, History and Culture*. Rowman & Littlefield, 2017, p. 262.

[6] Hum mehkoomon ke paaon tale
Under our feet — the feet of the oppressed —
ye dharti dhar dhar dharkegi
the earth will shake
aur ahl-e-hakam ke sar oopar
and on the heads of our rulers
jab bijli kar kar karkegi.
lightning will strike.

1986 by singer Iqbal Bano, who, in spite of the ensuing ban, sang it twice in the same evening; her recorded encore had to be smuggled out on tape. The performance was held at a public event organised by a foundation run by Faiz's surviving relatives, 'attended by workers, peasants, trade union activists, students, teachers, men, women, children and everyone in between'.[7] Authorities raided organisers' homes, but the tapes were already safe across the border.

I had first heard the second version of 'Hum Dekhenge', taken from a YouTube video of a protest, on my mother's phone at a time when a sense of impending feminist liberation was felt, or I felt was being felt, in the subcontinent. The women and queer-led resistance at many protest sites against the 2019 Citizenship Amendment Act (CAA) contested the criminalisation of millions of undocumented people, especially Muslims. The CAA amended Indian law to accept illegal migrants from six religions who entered from Afghanistan, Bangladesh and Pakistan before December 2014, but not Muslims. Sri Lankan Tamils, Rohingyas from Myanmar and Tibetan refugees are also excluded by the act. Here, the hardened nationalist identity formation of Partition creates a gross tangle of injustice.[8]

A 2019 recording of a protest-performance 'Hum Bharat Ke Log' ('We the People') is also heard in the work. Repeating the first line of the Indian constitution ('we the people'), the performance calls for responses to questions – some of them absurd – about its audience's Indian national identity.

[7] A.M. Hashmi, 'When Iqbal Bano Defied Zia's Dictatorship to Sing "Hum Dekheinge" at Alhamra'. *Medium*, 2019,
[8] The act was enacted in March 2024, after delays caused by the widespread protests and violence.

At the same time in Pakistan, the intersectional and trans-inclusive Aurat March (Women's March) was bursting forth in its biggest cities. The slogan 'Mera jizm, meri marzi' (My body, my choice) addressed the fight for sexual autonomy and drew national outrage from the right and the media. 'Hum Dekhenge', among other protest songs and performances, was sung by marchers. The drifts of harmonium, heard throughout *We Shall Witness*, introduce the third and last version, recorded by Fazal Rizvi in Karachi in 2020. Slowed down and spacious, its audience sounds like a single crow. It is heard alongside Achille Mbembe's critical reflections on time. 'Hum Dekhenge' here is at once an encore; a revolutionary event; a smuggled tape; a feminist anthem; a lament that resists borders; an event that resists time.

I Hear (Colonial) Voices

 The third work places the listener in the colonial archive. It reuses and censors oral history interviews recorded in the 1980s and 1990s with (mainly white, British) 'colonial servants' who witnessed Partition to engender new contexts from old histories.[9]

I *Hear (Colonial) Voices* contains interviews with soldiers, administrators and a 'colonial wife' about their time in British India. However, their answers have been cut out. Instead, the work centres the voices of the oral historians: their questions are audible alongside silences, shuffles in the archive, the rewinding of distorted cassettes, and

[9] These audio files are indexed under 'Partition' in the catalogue of the Bristol Empire and Commonwealth Museum collection, which includes documents, artefacts and artworks.

narrations of encounters with the private correspondence, photographs and ephemera in the collections.

The redacted voices amplify the power dynamics at play in the institution of imperial memory. In the responses on the digitised tapes – which I have heard, but you have not – some were problematic or racist, many were banal, and a few were historically revealing (but not about Partition). Another motivation for editing out (colonial) voices, crucially, was to 'protect' those speakers or their descendants from accusations of racism. This 'protection' is in accordance with Bristol Archive's protocols of audio digitisation and right to privacy.[10] Self- and counter-censorship, then, are deployed against the archive, flipping its institution of differential ontologisation of colonised peoples by those who encounter them.

As this last work was prompted on its commission by the theme of encounter, I was also struck by the meaning of the word in other Englishes. In India, Pakistan and Occupied Kashmir, 'encounter' refers to a (legalised) extra-judicial killing by the police: a term that speaks to a colonial archive in service to empire. Diaristic and distorted, silence here listens with blackout poetry, letters sent from political prisoners and the few Partition records that remain unburnt.

[10] K. Robertshaw, '"Part of the baggage of colonialism": Voices from the British Empire and Commonwealth Collection Oral Histories', Bristol Museums, 2021. https://www.bristolmuseums.org.uk/blog.

Ten Fragments of
Writing on Sound
Tara Rodgers
(2006-16)

Sound is a mechanism for conveying meanings and a material energy that affects and is affected by bodies and environments.

Sound is both a carrier of cultural knowledge and an expressive medium modulated by individual creativity.

Sound connects to embodied experience, life patterns and environments by manifesting as oscillations in vibrational energy.

Sounds can be thought of as pressure and movements, doing cultural work.

Visual representations and sonic meanings are articulated by metaphor and analogy.

More than simply serving as extensions of embodied movements, electronic sounds came to be known and understood in ways analogous to modern bodies and subjects: as differentiated individuals in motion, marked and regulated by waveform representations of their extensions into space and variations over time.

Audio-technical descriptions of sound waves follow logics of scientific rationality in which knowledge and power

are consolidated through practices of detached observation. Acousticians devised visual representations of sound waves to predict, control, and recreate them. Waves might instead signify the politics of encounter and contingencies of mutual contact.

Sonic-political acts encompass various forms and practices of doing, researching or advocating creative work in sound or music. Or they may be composed of more explicitly political actions that employ sonic metaphors or aural performances.

The propagation of sound waves across space and time is a useful metaphor for thinking about relations of individuals and collectives: consider a sonic-political act at the centre, with its ripple effects as the various social, political-economic and ecological impacts that resonate from that act locally and in more far-reaching scales. Myriad acts overlap, while collective social organisation enables multiple sonic-political acts to be amplified or rendered more powerful.

Sonic artifice, which is so marked by the distinctive timbral and tone-shaping dimensions of synthesised sound, is a machine-produced veneer that always reflects back on human conditions, relations, desires.

Notes

Fragments excerpted and adapted from the following publications by Tara Rodgers:

1 'Butterfly Effects: Synthesis, Emergence and Transduction', *Leonardo Electronic Almanac* 14, 'Wild Nature and Digital Life'; special issue, S. Thomas and D. Grigar (eds.), 2006, p. 2.

2 'Approaching Sound', in *The Routledge Companion to Media Studies and Digital Humanities*, J. Sayers (ed.). Routledge, 2018, p. 240.

3 'Butterfly Effects', p. 2.

4 *Pink Noises: Women on Electronic Music and Sound*. Duke University Press, 2010, p. 18.

5 and 6 '"What, for me, constitutes life in a sound?" Electronic Sounds as Lively and Differentiated Individuals', *American Quarterly*, vol. 63, no. 3, 'Sound Clash: Listening to American Studies'; special issue, K. Keeling and J. Kun (eds.), Fall 2011, pp. 515, 511.

7 'Toward a Feminist Epistemology of Sound: Refiguring Waves in Audio-Technical Discourse', *Engaging the World: Thinking After Irigaray*, Mary Rawlinson (ed.). SUNY Press, 2016, pp. 195-213.

8 and 9 'Cultivating Activist Lives in Sound', *Leonardo Music Journal* 25, 2015, p. 79.

10 'Synthesis', *Keywords in Sound*, D. Novak and M. Sakakeeny (eds.). Duke University Press, 2015, p. 214.

Calliope: Epic Poetry
Theresa Hak Kyung Cha
(1982)

Mother, you are eighteen years old. You were born in Yong Jung, Manchuria, and this is where you now live. You are not Chinese. You are Korean. But your family moved here to escape the Japanese occupation. China is large. Larger than large. You tell me that the hearts of the people are measured by the size of the land. As large and as silent. You live in a village where the other Koreans live. Same as you. Refugees. Immigrants. Exiles. Farther away from the land that is not your own. Not your own any longer.

You did not want to see. You cannot see anymore. What they do. To the land and to the people. As long as the land is not your own. Until it will be again. Your father left and your mother left as the others. You suffer the knowledge of having to leave. Of having left. But your MAH-UHM spirit has not left. Never shall have and never shall will. Not now. Not even now. It is burned into your ever-present memory. Memory less. Because it is not in the past. It cannot be. Not in the least of all pasts. It burns. Fire alight enflame.

Mother, you are a child still. At eighteen. More of a child since you are always ill. They have sheltered you from life. Still, you speak the tongue the mandatory language like the others. It is not your own. Even if it is not you know you must. You are Bilingual. You are Trilingual. The tongue that is forbidden is your own mother tongue. You speak in the dark. In the secret. The one that is yours. Your

own. You speak very softly, you speak in a whisper. In the dark, in secret. Mother tongue is your refuge. It is being home. Being who you are. Truly. To speak makes you sad. Yearning. To utter each word is a privilege you risk by death. Not only for you but for all. All of you who are one, who by law tongue tied forbidden of tongue. You carry at center the mark of the red above and the mark of blue below, heaven and earth, *tai-geuk*; t'ai-chi. It is the mark. The mark of belonging. Mark of cause. Mark of retrieval. By birth. By death. By blood. You carry the mark in your chest, in your MAH-UHM, in your MAH-UHM, in your spirit-heart.

You sing.

Standing in a shadow, Bong Sun flower
Your form is destitute
Long and long inside the summer day
When beautifully flowers bloom
The lovely young virgins will
Have played in your honor.

In truth this would be the anthem. The national song forbidden to be sung. Birth less. And orphan. They take from you your tongue. They take from you the choral hymn. But you say not for long not for always. Not forever. You wait. You know how. You know how to wait. Inside MAH-UHM fire alight enflame.

From the Misere to Gloria to Magnificat and Sanctus. To the Antiphonal song. Because surely. Soon. The answer would come. The response. Like echo. After the oblations. The offering. The sacrifice, the votive, the devotions, the novenas, the matins, the lauds, the vespers, the vigils, the evensong, the nightsong, the attendance, the adoration, the veneration, the honor, the invocations, the supplications, the petitions, the recitations, the vows, the immolations. Surely, all these and more. Ceaseless. Again. Over and over.

You know to wait. Wait in the Misere. Wait in the Gloria. Wait in the Magnificat. Wait in the Sanctus. For the Antiphonal song. Antiphonal hymn. The choral answer. In the ebb and tide of echo.

They have not forbidden sight to your eyes. You see. You are made to see. You see and you know. For yourself. The eyes have not been condemned. You see inspite of. Your sight. Let that be a lesson to you. You see farther. Farther and farther. Beyond what you are made to see and made to see only. You pass the mark, even though you say nothing. Everyone who has seen, sees farther. Even farther than allowed. And you wait. You keep silent. You bide time. Time. Single stone laid indicating the day from sunrise to sundown. Filling up times belly. Stone by stone. Three hundred sixty five days multiplied thirty six years. Some have been born into it. And some would die into it.

The days before the reclamation. Your father. Your mother. Dying while uttering the words. Their only regret. Not having seen with their very eyes, the overthrow. The repelling. The expulsion of the people who have taken you by force. Not to have witnessed the purging by sulphur and fire. Of the house. Of the nation.

You write. You write you speak voices hidden masked you plant words to the moon you send word through the wind. Through the passing of seasons. By sky and by water the words are given birth given discretion. From one mouth to another, from one reading to the next the words are realised in their full meaning. The wind. The dawn or dusk the clay earth and travelling birds south bound birds are mouth pieces wear the ghost veil for the seed of message. Correspondence. To scatter the words.

Mother you are eighteen. It is 1940. You have just graduated from a teacher's college. You are going to your first teaching post in a small village in the country. You are re-

quired by the government of Manchuria to teach for three years in an assigned post, to repay the loan they provided for you to attend the teacher's school. You are hardly an adult. You have never left your mother's, father's home. You who are born the youngest of four children. Always ailing. You have been sheltered from the harshness of daily life. Always the youngest of the family, the child.

You travelled to this village on the train with your father. You are dressed in Western clothes. At the station the villagers innocently stare at you and some follow you, especially the children. It is Sunday.

You are the first woman teacher to come to this village in six years. A male teacher greets you, he addresses you in Japanese. Japan had already occupied Korea and is attempting the occupation of China. Even in the small village the signs of their presence is felt by the Japanese language that is being spoken. The Japanese flag is hanging at the entry of the office. And below it, the educational message of the Meiji emperor framed in purple cloth. It is read at special functions by the principal of the school to all the students.

The teachers speak in Japanese to each other. You are Korean. All the teachers are Korean. You are assigned to teach the first grade. Fifty children to your class. They must speak their name in Korean as well as how they should be called in Japanese. You speak to them in Korean since they are too young yet to speak Japanese.

It is February. In Manchuria. In this village you are alone and your hardships are immense. You are timid and unaccustomed to the daily existence of these village people. Outside the room and board that you pay, you send the rest of your pay home. You cannot ask for more than millet and barley to eat. You take what is given to you. Always do. Always have. You. Your people.

You take the train home. Mother . . . you call her already,

361

from the gate. Mother, you cannot wait. She leaves everything to greet you, she comes and takes you indoors and brings you food to eat. You are home now your mother your home. Mother inseparable from which is her identity, her presence. Longing to breathe the same air her hand no more a hand than instrument broken weathered no death takes them. No death will take them, Mother, I dream you just to be able to see you. Heaven falls nearer in sleep Mother, my first sound. The first utter. The first concept.

It is Sunday afternoon. You must return to the school. Your students are at the station waiting for you. They see you home and bring you food. It is May, it is still cold in Manchuria. You work Monday, Tuesday, Wednesday, and Thursday passes. On Friday morning you do not feel well, Fever and chill possess the body at the same time. You are standing in the sunlight against the tepid wall to warm yourself. You are giving in. To the fall to the lure behind you before you all around you beneath your skin the sharp air begins to blow the winds of the body, dark fires rising to battle for victory, the summoning the coaxing the irresistible draw replacing sleep dense with images condensing them without space in between. No drought to the extensions of spells, words. Noise. Music equally out of proportion. You are yielding to them. They are too quick to arrive. You do not know them, never have seen them but they seek you, inhabit you, whole, suspend you airless, spaceless. They force their speech upon you and direct your speech only to them.

I Am Listening To You
Tomoko Hojo
(2018)

This performance consisted of two parts: this score is for the first part. In the second part, a pre-recorded voice of part one is played back through speakers, and the performer will add her voice freely on the top of it. Multiple self-built recorder/looper/player devices are also used in this part.

This work departs from an oral history interview with John Lennon and Yoko Ono made on 6 December 1980, two days before Lennon's death – and in particular a section where they discuss first meeting at Ono's 1966 exhibition at Indica Gallery in London. Whereas John talks without interruption, Yoko is often mute and mostly accompanies his speech by laughing in a small, soft, high voice. In Japanese society, people insert *aizuchi* – a sort of back-channel 'huh', 'yeah' – quite often during the conversation to let the other speaker know that they are actively listening. Although Yoko seems to inhabit this behaviour ('n' or 'fu fu'), occasionally emphasising certain words and phrases or adding her own, there is equally an absence, a meandering in a different time and place. Listening becomes the act of imagining unspoken words, and gradually shifts into a fluidity between listening and speaking.

Using a digital stopclock, the vocal performance score precisely reproduces Ono's contribution to the interview.

0:00 Start
0:17 Nn ↘
0:30 Nn ↘ Lighter than before
0:51 Fu (nnn) Funny, very small

1:35 Annnu-hh
1:43 Fine
1:50 N

2:06 N
2:08 Met with a smash, Fu fu Bright
2:28 Indica gallery
2:50 Fufu Dry
3:06 I was in the basement
3:10 No No
3:13 I was preparing before the opening
3:19 Fu Fu (going up) funny
3:30 Fu----- Only breathing
3:35 un-n Dry
3:37 Fresh apple, fufu, and white
3:40 fufu Dry
3:43 Fufu very small, a bit bright

4:02 Fu (natural) → Fu (a bit bright)

4:17 Fu----- Only breathing
4:19 Fu Fu Fu a bit bright
4:20 Fu Fu very small voice
4:30 Fu Fu a bit clearer than the last one
4:34 Cause this is before opening so I didn't want to touch by anybody, you know
4:40 No no, He didn't explain it really, He just sort of kind of
4:48 Fu- Bright

4:58 Fu- Bright, louder
4:59 Fun Fun
5:09 objects

5:28 66
5:30 End of | Storing
5:47 I didn't know that Strong

6:25 Fu----- (↗) natural, a bit of ↗ →

7:24 But that just happened…
7:25 Fun Fun
7:31 ——— (Breathing), Un nh

8:03 ——— very small breathing

The Sky's Like a Bell – the Moon Is Its Tongue Xenia Benivolski (2022)

1. The Bell and the Zoo

In 2015, a flood overwhelmed the capital of Georgia, destroying many parts of the city, including the zoo. Nestled in a valley, Tbilisi witnessed buildings being swept away by the raging waters, while wild animals freely roamed the streets. Seventeen people and over 600 animals died in the aftermath of the disastrous event, including thirty lions, tigers, bears and wolves that had managed to escape and terrorise residents for several days. The floods were repeatedly described in biblical terms, and the priests of Georgia declared:

> A terrible tragedy has taken place. Rainfall and flood have resulted in fatalities. The zoo has been destroyed. Predators left their cages and posed a threat to people. When the Communist government established itself in Georgia, it began melting church and monastery bells for profit and the zoo was founded by such means. As such, it is bound to failure.

In the first half of the twentieth century, Europe was embroiled in a series of conflicts that led to the melting of church bells, primarily for weapon production. As Elif Batuman has written,

> Stalin's 'Great Break' of the late 1920s aimed for a total transformation of every aspect of life. A staggered work week was implemented, abolishing the concept of Sundays. Moscow's

Church of the Nativity became a holding pen for circus lions, the Cathedral of Christ the Saviour became the world's largest open-air swimming pool, and rural churches were turned into carpentry or plumbing collectives.[1]

The Soviet Army also produced statues of Lenin, Stalin and other communist monuments from the melted bells. After the war, in Latvia, Lithuania and Croatia, Lenin monuments were once again melted, and hundreds of church bells were reproduced from the metals.

This turn of events invites contemplation on the material and spiritual establishments that mediate between the religious icon and the political monument. Through the casting and melting, shaping and re-forming of metal alloys, soils and figures, the bell, as an intermediary form, 'sounds' the conditions of its making. While it's reasonable to assume that some historical instances necessitated material transformations due to scarcity, one can argue that the sonorous space articulated through these geopolitical moments can be still found in the metallic epistemology and tonality of the remaining bells.

2. The Destruction of Another Made Me

A bell normally rings on the diatonic scale. But in early European bells and Russian bells, the tone and pitch of each individual instrument was largely the product of the founder's artisanship and the materials available.[2] Sometimes these materials are relics of war.

The Pummerin ('Boomer') bell, hanging in St Stephen's Cathedral in Vienna, is famous for not only its size and volume, but the role it played in Beethoven's final days.

[1] E. Batuman, 'The Bells: How Harvard Helped Preserve a Russian Legacy', New Yorker, 27 April 2009.

It is rumoured that the composer, who lived in proximity to the cathedral, realised the totality of his deafness when he saw a flock of birds flying out of the tower. At this moment he realised the animals were escaping a sound he could no longer hear. The bell was originally cast in 1705 using 208 of the 300 cannons captured during a pivotal battle between the Holy Roman Empire and the Ottoman Empire in Vienna in 1683. The battle was the first major defeat for the Ottoman Empire and the beginning of its historic decline: the bell was created to commemorate that historic moment, leading to the discovery that Turkish cannons owed their notoriously frightening sound to a very specific metallurgy, soon to become the standard of bell metal for all of Europe. The Pummerin rang last in 1937 when a fire burned through the interior of the church sending it crashing onto the stone floor. Its successor was made from the old Pummerin's metal and the remainder of the Turkish cannons, procured for the cause from Vienna's Museum of Military History.

The Pummerin's voice, which can be heard only on special occasions, starts off with a clear bang and continues through an evolving resonant sound that articulates the movement of air through the dome as the bell swings. The copper sings, and the sound becomes deeper with movement, akin to a giant singing bowl. As the humming waves envelop the tower and take on a life of their own,

[2] Batuman continues that 'whereas Western European bells are tuned on a lathe to produce familiar major and minor chords, a Russian bell is prized for its individual, untuned voice, produced by an overlay of numerous partial frequencies, with only approximate relations to traditional pitches – a feature that gave the Lowell Klappermeisters' performances the denatured effect of music played on a touch-tone telephone. Where Western European bells play melodies, Russian bell ringing consists of rhythmic layered peals.'

the strike note hollows out. It feels as though the bell is swinging in silence while it is the sound all around it that is activated. Finally, after a few minutes, sonic waves collide, creating a unique metallic drone generated by the acoustics of the tower and the square. At that moment, it feels as if the different metals comprising the bell were resonating together yet apart, briefly, eerily reminiscent of a human voice. The bell is then joined by other bells, their bright, small sounds clapping through the deep baritone as it fades away.

From the moment it first rang, the Pummerin bell proclaimed the victory of the West over the East. According to its formula, which quickly became ubiquitous in Europe, bells were to be made of bronze – an alloy of 78 per cent copper and 22 per cent tin – the former composition of the melted Ottoman cannons. It was discovered that a higher tin content increases the resonance of the bell and lowers its sound velocity by forming a unique molecular crystal lattice that resonates without distortion. This alloy is much richer in tin than the bronze typically used in weapons and monuments, which has a higher copper percentage. The tin also hardens the soft metals: preventing further melting. However, in his expansive 1947 research manuscript, 'Campanology, Europe (1945-47)', Percival Price accounted for the composition of European bells using samples and measurements taken from the bell cemetery in Hamburg, and found their copper-to-tin ratio to be 81 per cent to 15 per cent, with many instruments also containing zinc and aluminum. This metallic difference renders the bell metal suitable for melting and reappropriation for weaponry and monumental use, with the implication that bell foundries foresaw the instrument's eventual fate. Could it be argued that it is precisely the metallic viability of the European bells as a potential weap-

on or monument that produces their familiar sound? And if so, are those bells future cannons, or monuments in waiting?

Before the bell requisition for the war effort in 1939, Dr W. Van Der Elst of Utrecht was assigned the crucial task of identifying and safeguarding the most valuable bells, preserving them from being melted down for weapons by designating certain bells as monuments. Signs in four languages – English, German, French and Dutch – were displayed at the bell towers, proclaiming these bells as 'inviolable in war'. Other, less fortunate bells were transported to various locations, traversing borders across Europe to reach 'bell cemeteries', designated spaces where they awaited melting. On 22 July 1917, Deacon Karl Munzinger of Cologne, grieving the loss of his carillon, lamented in a sermon: 'They will speak a different language in the future . . . They, who like no other preach peace and should heal wounded hearts, will tear apart bodies in gruesome murders and open wounds that will never heal.' A summary of common and uncommon Latin bell inscriptions collected by Price in various bell cemeteries in the aftermath of the Second World War reveals playful dedications ranging from the functional *MORTUOS FLANG* ('I weep for the dead'), *VIVOS VOCO* ('I call the living') and *FULGURA FRANGE* ('I strike the lightning'), to the ominous *VNIVS CORRVPTIO EST MEA AEDIFICATIO* ('the disintegration of one thing is my edification' – a play of words meaning 'the destruction of another made me').

3. The Tower

In the case of a hoisted bell like the Pummerin, the swing bell exerts considerable force, with its peak vertical and horizontal forces reaching four times and two times its weight respectively. Some bells require a massive struct-

ure to maintain the integrity of their swing. Pastors have
testified stories of groaning towers that sway during ring-
ing. The structure supporting the bell is often the body of
the church, the parish complex, and all attachments sup-
port and stabilise that swing. Church bells, employed as
tools of colonisation, symbolise the institutional trinity's
influence, aiming to impose European priorities under the
guise of goodwill: the hospital that breaks down holistic
systems, the school that breaks down indigenous systems
of ration, and the church that breaks down local spiritual
beliefs, all serviced by nuns. Topping the church is the
bell tower, which announces a call for labour and rest,
an architectural spore of the spreading colony. The bell,
by inscribing Christian values onto time itself, produces
labour, and labour is the result of the re-education offered
by the three institutions. A solid base allows for bigger
bells, swinging harder, louder and reaching further.[3]

4. Chronotope

Before the Pummerin, variation in the metallic compos-
ition of the bell was often dictated by the availability
of certain geological resources in different regions. The
cosmological significance of the metals themselves played
a major role in the alloys, in particular in areas that con-
tinued to painstakingly produce their own bells, such as
rural Russian towns. There, the bells essentialise a history
of the local soil – the pochva[4] – that produces individuals
with a biopolitical sense of belonging to a specific region,
a concept adjacent to the problematic, fascist 'blood and
soil'.[5] Literary sources confirm parallels between Russian
and German conceptions of soil and naturalisation. To this
effect, in a 2012 paper, L.M. Erley writes:

> German philosopher Johann Gottfried Herder produced an or-
> ganicist discourse of nationality that inserted symbolic values

371

into the episteme of natural history that had a profound effect on Russian discourse of nationality. Primordialist theories of nationalism habitually reified national essence through an allusion to 'soil' claiming the material substance as the ordinary medium of national differentiation and identity. Such theories of national primordialism transferred social and cultural phenomena into an organic conceptual domain, creating the complex metaphor that nations 'grew' out of 'native soil'.[6]

[3] Ironically, it is speculated that the move from variable, natural work times to the predetermined ecclesiastical tempo originated with the labourers themselves. Working from dawn until dusk, workers, accustomed to the chiming of the church bells at regular intervals, noticed that their summer days contained more chimes and therefore longer work times. Therefore, they demanded that the church bell and not the sun determine their workday. This eventually worked against them as their employers insisted on a value of production to align with the ringing of the church bells, as opposed to the natural viability of the field of production and the Marxist inclination to leave the soil in charge. The predetermined ringing of the bells has become a way to control and devalue labour. Abstract time units announced by the bell appeared to be objective: that is, imposed by no one in particular but applied to anyone in general. However, 'those who are employed experience a distinction between their employer's time and their "own" time. And the employer must use the time of his labour, and see it is not wasted: not the task but the value of time when reduced to money is dominant.' (Thompson, E.P., 'Time, Work-Discipline and Industrial Capitalism', *Past and Present*, No. 38, December 1987, p. 61.) The objective guise of an abstract time unit did little to conceal the fact that work was ultimately regulated in the interests of the bourgeoisie.
[4] *Pochva* directly translates as 'soil', but it carries additional meanings, in some contexts representing a common ground, or quite literally a 'breeding ground', with the implication that its life-giving properties house infinite organisms. Etymologically, the word is related to the Czech word for 'mother's lap', or vagina.
[5] A German nationalist construct used to justify ethnic cleansing and expansion.

The Russian bell, cast into the earth, assumes the role of soil custodian, embodying the sacred mineral composition that echoes the biological identity of worshippers. These bells don't swing, and they cannot be tuned – they simply represent the voice of God[7] – the sound is produced by chiming the bell's clapper, known as the 'tongue'. Notably, in Russian, the word for tongue and language is one and the same. Bells often carry first and last names, and are considered to be figures in the community. Some have been exiled, beaten, broken and whipped as punishment or retribution, most often for perceived betrayal. A practice of mutilation that originated with bells – that of cutting out a bell's 'tongue' and 'ears' (colloquial terminology for the yoke) – has become synonymous with Russian violence, manifesting, for example, in the barbaric mutilation of Ukrainian civilians who were subjected to a horrific Russian invasion in early 2022 in Bucha, where bodies of victims were found with their ears and tongues missing.

When Russian literary theorist M.M. Bakhtin coined the term 'chronotope' in 1937, it was a way of establishing a conduit through which meaning enters the logosphere. His argument was that different literary genres utilise different configurations of time and space, which help establish particular narratives. Following Bakhtin's dialogic into Russian literature, 'one discovers a curious linguistic

[6] L.M. Erley, 'Reclaiming Native Soil: Cultural Mythologies of Soil in Russia and Its Eastern Borderlands from the 1840s to the 1930s', PhD diss., UC Berkeley, University of California, 2012, p. 2.

[7] 'The Russian bell is not a musical instrument but, as Father Roman puts it, "an icon of the voice of God". A Russian bell, he said, must sound rich, deep, sonorous and clear, for how can the voice of God be otherwise? It must be loud, because God is omnipotent. Above all, Russian bells must never be tuned to either a major or

pattern: *chronos* is consistently swallowed up by *topos*.'[8] In *Capital*, Karl Marx connected the composition of the soil to the productive and economic potential of the society that cultivates it: 'It is not the mere fertility of the soil, but the differentiation of the soil . . . which form the physical basis for the social division of labour.'[9]

The last sequence in Andrei Tarkovsky's 1966 film *Andrei Rublev*, co-written with Andrei Konchalovsky, portrays a feudal Russian town teeming with pagans, believers and other archetypal characters. In response to orders from the incoming duke and the Italian ambassador, the town embarks on the construction of a church bell. Since the bell-maker is dead, his young son is summoned for the task. A painstaking process of metallurgic labour takes place swiftly as the town is carried away in the task of producing the massive bell and, in the process, the viewer is literally hoisted along with the instrument into the tower. The massive efforts are rewarded with a perfect ring, accompanied by panning shots across the barren pastoral landscape where figures stop to listen to the resonant hum miles away. With it, the main character suddenly collapses into sobs and he professes his father never told him the secret of the bell: that ultimately the bell's primary use is used to regulate labour. Suddenly, the bell-maker's son understands that from this day onwards their lives will be ruled by its toll.[10]

[8] M. Epstein, 'Russo-Soviet Topoi', in E. Dobrenko and E. Naiman (eds.), *The Landscape of Stalinism: The Art and Ideology of Soviet Space*. University of Washington Press, 2003, p. 277.

[9] Marx, K. 'Absolute and Relative Surplus-Value'. *Capital: Volume One*, Samuel Moore and Edward Aveling (trans), Frederick Engels (ed.). Progress Publishers, 1887.

[10] The word 'toll' comes from the Greek word for tax, *telos*, which also means end or completion.

Soviet disdain for religion is widely recorded. The Red Army's targeting of the church bell in colonised nations was as symbolic as it was practical. These bells, seen as enforcers of labour conditions dictated by the church and bourgeoisie, symbolised a corruption of people's fundamental connections to the sacred land, disrupting cosmic and material alignments with the soil. However, once these seized bells were repurposed into political statues, they transformed into new icons. Each path you choose to take through the winding story of the bell, the cannon and the monument leads you back to the gates of the Tbilisi zoo: to peer into the story of capital and its many incarnations, exotic animals covered in mud, the workers trying to clean up the mess, the massive failure of Soviet empiricism.

Etymologically, the Germanic word for bell – *Glocke* or *Klok* – is tied to the word clock through a shared reference to the Latin *clocca* and French *cloche*, or cloak, a covert garment which resembles the shape of the bell. The bell conceals a matrix of time, space and labour in its mineral composition. By cloaking the powerful hum contained within, the bell registers time units devised by materials and societies that are organised around the brutality of forced labour, the violence of occupation and the readiness to be instantly transformed into instruments of war.

Listening Rituals in Sonic Migrations No. 1: Grounding from the Sea of Dreams
Ximena Alarcón-Díaz
(2022)

Note: This score invites you to have a gentle transition, listening between your dreams, sleeping time, and your waking reality.

[Sound: bubbling, babbling]

Wake up listening within your body
As a sea creature

Move your body gently in waves
As if you were swimming in a sea of dreams

Propelling new waves that are transmitted
Throughout your whole body

Breathe in through your blowholes
Gently exhale connecting yourself to your dream journeys

Continue the breathing cycle and listen to
The spontaneous sounds that emerge from your cetacean voice

Freely follow the transitionary movements to your waking reality

Let your sounds unite in one humming song

When your song comes to an end
Listen to the sounds that your wave
has awakened in your surroundings

Ground yourself

BIOGRAPHICAL NOTES

SVETLANA ALEXIEVICH is the author of *The Unwomanly Face of War* (1985), *Boys in Zinc* (1991) and *Second-hand Time* (2013), among other books. She has won many international awards, including the 2015 Nobel Prize in Literature.

SARA AHMED is an independent scholar and writer. Her most recent book is *The Feminist Killjoy Handbook* (2023). She is now writing a follow-up handbook for complainers.

XIMENA ALARCÓN-DÍAZ is a sound artist-researcher exploring alternative forms of sensing place and telepresence to listen to our sonic migrations.

CARSON COLE ARTHUR is a Lecturer of Criminology at the University of Law, London.

AIN BAILEY is a composer, artist and DJ. Her exhibition *Four* (2024), at FACT Liverpool, was a response to time spent working with incarcerated men and their families on the subject of sound and memory.

KAREN BARAD is Distinguished Professor of History of Consciousness and Philosophy at the University of California at Santa Cruz. Their books include *Meeting the Universe Halfway: Quantum Physics and the Entanglement of Matter and Meaning* (2007).

ANNA BARHAM is a London-based artist working between video, sound, writing, installation and live events. Her work considers language as it moves between different bodies, material forms and technologies.

XENIA BENIVOLSKI curates, writes and lectures on sound, music and visual art. She is editor/curator of You Can't Trust Music at e-flux.com, a research project connecting sound-based artists, musicians and writers.

ELENA BISERNA is artistic director of LABgamerz and Lips festival, Aix-en-Provence. She has recently edited *Walking from Scores* (2022) and *Going Out: Walking, Listening, Sound-Making* (2022).

BLACK QUANTUM FUTURISM is a multidisciplinary collaboration between Camae Ayewa and Rasheedah Phillips exploring the intersections of futurism, creative media, DIY aesthetics and activism in marginalised communities through an alternative temporal lens.

ANNE BOURNE is a composer and artist, a cellist and vocalist, who offers gatherings for collective creativity, drawing from the sonic meditations, text scores and deep listening practice of her mentor, Pauline Oliveros. She is faculty at the Center for Deep Listening, NY, and Chalmers Fellow and participant in TBA21 Academy/OceanSpace, Venice.

DANIELA CASCELLA is the author of five books, including *Chimeras: A Deranged Essay, An Imaginary Conversation, A Transcelation* (2022) and *Nothing As We Need It* (2022).

THERESA HAK KYUNG CHA (1951-82) was a poet, filmmaker and artist. Born in Busan, South Korea, Cha emigrated to the United States with her family in 1964. Best known for *Dictee*, Cha made a body of work that explores language, memory, time, history and the spaces between.

MARIA CHÁVEZ is an abstract turntablist, sound artist and DJ. Her book *Of Technique: Chance Procedures on Turntable* (2012) is considered a foundational text for a new generation of turntablists.

DON MEE CHOI is the author of the KOR-US trilogy *Mirror Nation*, the National Book Award winning collection *DMZ Colony* and *Hardly War*. She is a recipient of fellowships from the MacArthur, Guggenheim, Lannan, and Whiting Foundations, as well as the DAAD Artists-in-Berlin Programme.

LINDSAY COOPER (1951-2013) was a bassoon and oboe player, composer and political activist. A talented improviser, she played in bands including Comus and co-founded the Feminist Improvising Group.

JULIA ECKHARDT is a musician and organiser in the field of the sonic arts. She is artistic co-director of Q-O2 workspace for experimental music and sound art, and of Oscillation festival in Brussels.

LUCIA FARINATI is an associate lecturer in Art History at Kingston University and an independent curator. Her research focuses on dialogic practices and methodologies investigating the politics of listening at the intersection of art and activism. She is the co-author of *Theorising the Artist Interview* (2025), among other books.

ELLA FINER's work spans writing, composing and curating with a particular interest in the way bodies acoustically disrupt, challenge or change occupations of space. She is working on a book of essays, *Acoustic Commons and the Wild Life of Sound*.

CLAUDIA FIRTH is Senior Research Associate in the Business School at the University of Bristol. Her research has considered commons, co-ops, grassroots self-organisation and the contribution and sharing economy as well as reading groups as critical pedagogy, and listening as a mode of organising in arts-activism.

LONA FOOTE (1950-93) was an American photographer who specialised in photographing the avant-garde jazz, dance and art scenes of New York City in the 1980s and early 1990s.

LOUISE GRAY writes on music and sound art for *The Wire* and other publications. She teaches on the BA and MA Sound Arts courses at London College of Communication (LCC), University of the Arts London.

ANNIE GOH is an artist and researcher. She co-curated the discourse programme of CTM Festival Berlin 2013-16 and is co-founder of the Sonic Cyberfeminisms project with Marie Thompson.

CHRISTINA HAZBOUN is a Sonic Agent, independent writer, researcher, curator and cultural manager rooted in the resonances of words, sounds, and music with a focus on documenting and researching the music scenes in Palestine, the SWANA and the Global South.

JOHANNA HEDVA was raised in Los Angeles by a family of witches and now lives in LA and Berlin. The author of four books, Hedva's artwork has been shown internationally and their essay 'Sick Woman Theory', published in 2016, has been translated into 11 languages.

SARAH HENNIES is a composer and percussionist based in upstate New York and a Visiting Assistant Professor of Music at Bard College.

TOMOKO HOJO is an artist working between sound, music and performance. In 2023, she published 'Unfinished Descriptions', which documented a show based on her research about Yoko Ono.

LEE INGLETON is a Sri Lankan-Australian composer working in socially engaged arts and experimental electronic musics. Their debut EP, *Dancing With Toots Benedicta*, came out in 2022. Lee is the author of *Feminist Frequencies* and curator and archivist of Her Noise Archive.

IONE is a text-sound artist, poet, author and playwright. Her books include a memoir, *Pride of Family: Four Generations of American Women of Color*, *Listening in Dreams* and *Nile Night*. IONE is former Artistic Director of Deep Listening Institute and Founding Director of the Ministry of Maåt, a not-for-profit organisation nurturing women's spiritual and educational wellbeing.

HANNAH CATHERINE JONES is a multi-instrumentalist, composer and conductor. She founded Peckham Chamber Orchestra in 2013, and Chiron Choir, a queer diasporic choir, in 2022. She was a recipient of the 2018 BBC Radiophonic Oram Award for innovation in music.

PETERO KALULÉ (petals) is a composer, multi-instrumentalist and senior lecturer in law at London South Bank University. She lives on the hidden river Effra in London.

A.M. KANNGIESER is a geographer, sound artist and Research Fellow in Geography at Royal Holloway University of London. Their practice engages listening and attunement to approach how people collectively determine conditions of liberation and care through ecocide.

HANNAH KENDALL is a composer and lecturer at Columbia University. In 2023, she won the Ivor Novello Award for Best Large Ensemble Composition. The previous year, she received the 2022 Hindemith Prize for outstanding contemporary composers.

CHRISTINE SUN KIM is an American artist based in Berlin. Musical notation, written language, infographics, American Sign Language, the use of the body and strategically deployed humour are all recurring elements in her practice. She is represented by François Ghebaly Gallery in L.A. and White Space in Beijing.

KITE (SUZANNE KITE) is an award-winning Oglála Lakȟóta performance artist, visual artist, composer and academic. Her practice explores contemporary Lakota ontology through research-creation, computational media and performance.

NAT LALL is a multidisciplinary artist and DJ. They have performed from their scorebook *Scores for Sissy Bois* (2019) at venues including the ICA in London, and their first feature film, *Pink Excavation* (2018), was screened at the CCA in Glasgow.

CATHY LANE is an artist, composer and academic. Her work combines oral history, archival recordings, spoken word and environmental recordings. Her CD *The Hebrides Suite* explores aspects of life, past and present, in the Outer Hebrides.

JEANNE LEE (1939-2000) was an American jazz singer, poet and composer.

MARYSIA LEWANDOWSKA's practice considers the public functions of archives, museums and exhibitions, focusing on the missing voices of women. The Women's Audio Archive (1985) became an online resource in 2009. The sound installation *how to pass through a door* (2022) is part of the permanent collection at the Cosmic House, London.

ANNEA LOCKWOOD is an Aotearoa New Zealand-born American composer. Lockwood's lifelong fascination with the visceral effects of sound in our environments and through our bodies serves as the focal point for works ranging from concert music to performance art to multimedia installations.

BARBARA LONDON is an internationally acclaimed curator, writer and arts advocate. Recent projects include the exhibitions *Seeing Sound* (2020-26); *Perpetual Motion* (2024); *Dara Birnbaum* (2023); the podcast series *Barbara London Calling* and the book *Video Art: The First Fifty Years* (2020).

CANNACH MACBRIDE is a Scottish artist and editor. With Taraneh Fazeli, they are co-editing a book called *Sick Time, Sleepy Time, Crip Time: For Access-Centered Practice*, which shares practices for co-creating accessible worlds through art, culture and community organising.

ELAINE MITCHENER is a vocalist, movement artist and composer working between contemporary, experimental new music, free improvisation and the visual arts. Elaine is founder of the collective electroacoustic unit The Rolling Calf (with Jason Yarde and Neil Charles).

FRANCES MORGAN is an arts critic and a researcher and educator in Media and Sound Studies.

ALISON O'DANIEL is a d/Deaf visual artist and filmmaker. Her film *The Tuba Thieves* premiered at the 2023 Sundance Film Festival. O'Daniel is a United States Artist 2022 Disability Futures Fellow and a 2022 Guggenheim Fellow in Film/Video.

NAOMI OKABE is pursuing a PhD in Screen Cultures and Curatorial Studies at Queen's University, Kingston, Ontario. Her films have premiered at festivals including Hot Docs International Documentary Film Festival. She co-runs the record label and publisher Séance Centre.

PAULINE OLIVEROS (1932-2016) was an American composer, performer and central figure in the development of post-war experimental and electronic music. She is known for conceiving a unique, meditative, improvisatory approach to music called 'Deep Listening'.

DAPHNE ORAM (1925-2003) was a pioneering electronic composer and the inventor of Oramics, a means of synthesising sound by drawing waveforms, pitches, volume envelopes and other properties on film. She was the cofounder of the highly influential BBC Radiophonic Workshop, the pioneering home of electronics and musical experimentalism.

GASCIA OUZOUNIAN is Associate Professor of Music at the University of Oxford, where she leads the ERC-funded project Sonorous Cities: Towards a Sonic Urbanism, and the author of *Stereophonica: Sound and Space in Science, Technology and the Arts* (2020).

HOLLY PESTER is a poet and writer. She has worked in sound art and performance, with original dramatic work on BBC Radio 4 and collaborations with Serpentine Galleries, Women's Art Library and the Wellcome Collection.

ROY CLAIRE POTTER works between performance and experimental art writing, and often collaborates with musicians for stage and broadcast. They are a Senior Lecturer in Fine Art at Liverpool John Moores University.

ANNA RAIMONDO co-curated *Here.now.where?* at the 5th Marrakech Biennial in 2014, *Saout Africa(s)* at documenta14 in 2017 and *Focus Italie* at the festival Longueur d'Ondes.

IRENE REVELL is a curator, researcher and writer with a long-standing commitment to multidisciplinary sound arts and their intersection with politics, especially feminism(s). She is currently a lecturer on the Curating MFA at Goldsmiths, University of London.

TARA RODGERS (Analog Tara) is a multi-instrumentalist composer, sound engineer and historian of music technology. She is the author of *Pink Noises: Women on Electronic Music and Sound* (2010) and her music has been presented around the US and internationally.

AURA SATZ's work encompasses film, sound, performance and sculpture. Her works are made in conversation and use dialogue as both method and subject matter. Her first feature film, *Preemptive Listening* (2024), centres on sirens and emergency listening.

SARAH SHIN is one of the founders of Silver Press.

SHORTWAVE COLLECTIVE is an international, interdisciplinary artist group brought together by an interest in feminist practices and the radio spectrum. Recent commissions include *Living Radio Lab* (2023), an open studio for DIY making and public programme at Struer Tracks Biennale for Sound and Listening. Shortwave Collective includes contributions from: Alyssa Moxley, Brigitte Hart, Georgia Leigh-Münster, Franchesca Casauay, Hannah Kemp-Welch, Karen Werner, Kate Donovan, Lisa Hall, Maria Papadomanolaki, Meira Asher, Sally Applin and Sasha Engelmann.

LEANNE BETASAMOSAKE SIMPSON is a renowned Michi Saagiig Nishnaabeg scholar, writer and artist. She teaches at the Dechinta Centre for Research and Learning in Denendeh and is the author of eight books.

THE SISTERS OF THE CELESTIAL ORDER OF NEPHOLOGY (the study of clouds) is an interdisciplinary performance project by Horizon Factory (Nina Vroemen and Erin Hill). Opening to the expansiveness of the sky, learning to read its signs and traces, and allowing for messages and meanings to arise beyond the art of forecasting. In 2024, they printed the prototype of their forthcoming publication *Deep Gazing*.

SOP is a torn and crooked leaf, a root embedded in the dirt, a shoot reaching to the sky. An artist working in crip-time with sound, performance, writing, film and objects, their work has been shown widely and is included in *Documents of Contemporary Art: Walking* edited by Tom Jeffreys.

SYMA TARIQ's recently completed PhD examined the 'sonic' condition of Partition. As well as undertaking her academic research, she writes, DJs and produces audio art, including *Delay Lines*, installed at the Tower Hamlets archives in East London in 2023, and the ongoing online series *A Thousand Channels*.

MARIE THOMPSON is Senior Lecturer in Popular Music at the Open University. She is the author of *Beyond Unwanted Sound: Noise, Affect and Aesthetic Moralism* (2017) and a founding member (with Annie Goh) of Sonic Cyberfeminisms.

TRINH T. MINH-HA is a Distinguished Professor of the Graduate School at the University of California, Berkeley. Her work includes nine feature-length films, which have been honoured in over 64 retrospectives internationally. She has produced several large-scale multimedia installations and is the author of numerous books.

SALOMÉ VOEGELIN is the author of *Listening to Noise and Silence* (2010), *Sonic Possible Worlds* (2014), *The Political Possibility of Sound* (2018) and *Uncurating Sound: Knowledge with Voice and Hands* (2023). She is a Professor of Sound at LCC, UAL.

A version of 'Ten Fragments of Writing on Sound' by Tara Rodgers was originally printed in the zine *Sound::Gender::Feminism::Activism*, CRiSAP, 2016, led by Cathy Lane, Lee Ingleton and Angus Carlyle. Republished by permission of the author.

'Calliope: Epic Poetry' by Theresa Hak Kyung Cha, excerpted from *Dictee*, 1982, University of California, Berkeley Art Museum and Pacific Film Archive; gift of the Theresa Hak Kyung Cha Memorial Foundation.

'Tuning in to the Music of the World: Trinh T. Minh-ha in conversation with Stoffel Debuysere', interview originally conducted in the context of Courtisane Festival 2023, as part of the research project 'Echoes of Dissent', led by Stoffel Debuysere, KASK & Conservatorium, University College of Applied Sciences and Arts Ghent. Republished by permission of the authors.

A version of 'The Sky's Like a Bell – the Moon Is Its Tongue' by Xenia Benivolski was originally published online in *Infrasonica #5: Audible Matter/ Wave*, 2021. Her project is funded by The Research Foundation – Flanders (FWO). Republished by permission of the author.

'Listening Rituals in Sonic Migrations No. 1: Grounding from the Sea of Dreams' by Ximena Alarcón-Díaz, originally published in the *performing-borders ejournal*, issue 2, 'Rallying the Commons', 2022. Republished by permission of the author.

'Music from Memories: Ain Bailey interviewed by Frances Morgan', first published in *The Wire*, February 2019. The interview took place at ICA, London. Republished by permission of the author.

'Encouragements' by Anna Raimondo, originally published as text-based instructions in the video work *Encouragements*, 2014. Republished by permission of the author and Shazar Gallery.

A version of 'Earth, Wind and Fire' by Annea Lockwood & Jennifer Lucy Allan was originally published by the *Quietus*, 2021. Reprinted by permission of the publisher.

A version of 'Echoes of Elsewhere' by Annie Goh, originally presented as a study-as-listening session as part of the series 'Seeing Through Flames', Nottingham Contemporary, 20 June 2023. Published by permission of the author.

'A New Form of Sound Writing: Aura Satz interviewed by Barbara London', excerpted from the podcast *Barbara London Calling* Series 2, Episode 11, March 2022. The interview took place on 30 September 2021. Republished by permission of the authors.

'Sticky Metaphors: The Matter of Meaning' by Cannach MacBride, originally published in *Metaphor as Metamorphoses*, issue 1, summer 2021, edited and published by D. Mortimer and Keira Greene. Republished by permission of the author.

'Abolitionary Listening: Propositions and Questions' by Carson Cole Arthur, Petero Kalulé and A.M. Kanngieser, originally published as 'To Listen Differently, Away from Sonic Certitude: Some Propositions, Some Questions' in the book *HEAR*, 2020, University of Westminster Press, edited by Danilo Mandic, Caterina Nirta, Andrea Pavoni, Andreas Philippopoulos-Mihalopoulos. Republished by permission of the authors.

'Sonic Strategies in the Palestinian Struggle: A Soundtrack of the May 2021 Uprising in Palestine' by Christina Hazboun, originally published in *Beyond Molotovs: A Visual Handbook of Anti-Authoritarian Strategies*, 2024, transcript Verlag, edited by International Research Group on Authoritarianism and Counter-Strategies/ kollektiv orangotango. Republished by permission of the author.